PARIS FASHION

PARIS FASHION

A Cultural History

Valerie Steele

New York Oxford
OXFORD UNIVERSITY PRESS
1988

Oxford University Press

Oxford New York Toronto
Delhi Bombay Calcutta Madras Karachi
Petaling Jaya Singapore Hong Kong Tokyo
Nairobi Dar es Salaam Cape Town
Melbourne Auckland

and associated companies in
Beirut Berlin Ibadan Nicosia

Library of Congress Cataloging-in-Publication Data

Steele, Valerie.
Paris fashion.

Bibliography: p.
Includes index.
1. Fashion—France—Paris—History—19th century.
2. Paris (France)—Social life and customs—19th century.
I. Title.
GT887.S74 1988 391′.00944′361 87-11143
ISBN 0-19-504465-7

The illustration opposite the title page is an advertising poster
for *La Mode du Petit Journal.*

2 4 6 8 9 7 5 3 1
Printed in the United States of America
on acid-free paper

For John, again

Acknowledgments

Since *Paris Fashion* is a work of synthesis as much as it is one of original research, I owe a debt to many scholars. I would especially like to thank Aileen Ribeiro, Head of the Division of Dress at the Courtauld Institute, the University of London, for reading my pages on the eighteenth century and the French Revolution. My thanks also to Anne Schirrmeister of the Costume Institute at the Metropolitan Museum of Art for reading the chapters on art and fashion; to Betty Kirke of the Design Laboratory at the Fashion Institute of Technology for reading the pages on Vionnet; and to Professor Richard Martin, also of F.I.T., for reading part of the chapter on haute couture in the twentieth century. Naturally, any mistakes that remain are my own.

For saving me hours in the library searching for the present whereabouts of Alfred Steven's *Cup of Tea,* my sincere thanks to Leila Kinney. Thanks also to John Rewald for helping me track down Cezanne's *La Promenade.* Grateful acknowledgments to the individuals and institutions that have permitted these and other illustrations to be reproduced here: The Musée de la Mode et du Costume (Paris), the National Gallery of Art (Washington), the Koninklijk Museum voor Schone Kunste (Antwerp), the Trustees of the British Museum (London), the Tate Gallery (London), the Musée Carnavalet (Paris) and the Musées de la Ville de Paris, the Fashion Institute of Technology Library (New York), the Musée de Versailles and the Musées Nationaux de France (Paris), the Coleman Collection, the Bibliothèque Nationale (Paris), the Musée d'Orsay and the Musées Nationaux de France (Paris), the Saint Louis Art Museum, the Sterling and Francine Clark Art Institute (Williamstown, Massachusetts), the collection of the late Joan Whitney Payson and the Knoedler Gallery (New York), the Costume Institute of the Metropolitan Museum of Art (New York), the Musée Royale du Mariemont (Morlanwelz, Belgium), the Museum of Fine Arts (Boston), the Metropolitan Museum of Art (New York), and the publishers of *La Mode en Peinture* (Paris). While every effort has been made to give ac-

knowledgment wherever due, this has occasionally proved difficult. If insufficient credit has been given, the publishers will be pleased to make amendments in any further edition. When no source is given for an illustration, it is in the collection of the author.

I have learned a great deal from my colleagues and graduate students at the Fashion Institute of Technology, but I would especially like to thank Jan Reeder for sharing her information on Madame Paquin, and Donna Carmichael for her references on the Incroyables. Michael Maione of the Juilliard School helped with a difficult passage by Mallarmé and directed me to a recent study of Proust. Grateful acknowledgments are made to Random House for permission to reprint excerpts from *Remembrance of Things Past*, translated by C. K. Scott Moncrieff and Frederick A. Blossom. At the Musée de la Mode et du Costume, Françoise Tetart-Vittel, Chantal Fribourg, and Fabienne Falluel were most helpful, as was Guillaume Garnier. My thanks also to Ann Coleman of the Brooklyn Musuem, and Robert Kaufman at the Costume Institute, the Metropolitan Museum of Art. Thanks to the librarians at the Bibliothèque Forney, the Musée Carnavalet (Cabinet des Estampes), the Cooper-Hewitt Museum, the Sterling and Francine Clark Art Institute, the New York Public Library, and—above all—the librarians at F.I.T., the Bibliothèque Nationale, and the Bibliothèque des Arts Décoratifs.

If I have raised more questions in this book than I have answered, perhaps others will be inspired to press further. I can only recommend to them the pleasures of working in the Special Collections of the Fashion Institute of Technology Library. The Maciet Collection at the Bibliothèque des Arts Décoratifs is another essential resource, as is Series 0a20 at the Département des Estampes et de la Photographie of the Bibliothèque Nationale.

As with *Fashion and Eroticism*, my greatest debt is to my husband, John Major, to whom this book is dedicated. Thanks also to grandma for letting me use her Jean Béraud painting as a cover illustration.

New York, New York V. S.
May 1987

Contents

PARIS
FASHION

I
Mode and Meaning in the Capital of Style

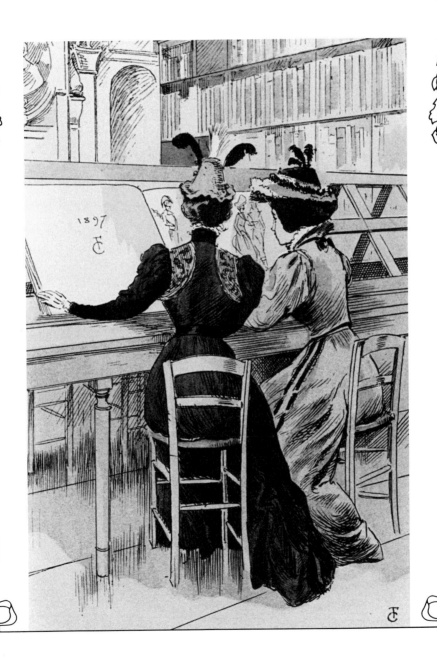

"At the Cabinet des Étampes—In Search of the Fashions of the Past" is an illustration by François Courboin from Louis Octave Uzanne's *Fashion in Paris* (1898). Uzanne was the author of a series of delightful fashion histories that asked the question: "Why do we dress the way we do?" He believed that looking at old fashion plates was both pleasant and instructive, and that books on fashion would always be popular, "because everybody believes him or herself capable of enjoying, of understanding, and of interpreting them."

This book is not simply a history of fashion, still less of haute couture. It is about the significance and symbolism of fashion in modern society, and an analysis of the reasons why Paris was for so long the international capital of style. The clothes you wear today still owe a great deal to Paris, even if they were designed and manufactured in New York City or Hong Kong.

A few years ago, a young Parisian man treated me to an extended diatribe on the barbarity of American life. When I suggested that (apart from questions of accuracy) this was not terribly courteous to say to an American, he dismissed my objections with the airy remark: "Well, after all, your *true* country is France," This classic example of French chauvinism is not quite as ridiculous as it seems.

"We are all Greeks," declared the English poet, Shelley, referring to the heritage of Homer and Plato. It might also be said that "We are all French," since for some three hundred years France has been—in Cecil Beaton's words—"the unique center of western culture" and the capital of the "art of living." Revolutions in politics, art, literature, and thought have begun in Paris (or reached their highest expression there) often enough to form a significant theme in modern history. But some of us are more French than others, and recognizing Parisian influence on the history of fashion should not blind us to the fact that fashion meant something rather different in Paris than in New York.

Foreigners have copied Paris fashions for centuries—while frequently complaining that they were unsuitable for the more virtuous inhabitants of other nations. Foreign copies of Paris fashions were not always exact, but they were close enough to trace the line of descent. On a recent visit to Paris, for example, I found two fashion plates from the Empire period. The original print appeared in the *Journal des Dames et des Modes (Costume Parisien)* in the Year 9 of the revolutionary calendar, and showed a ball dress with such a low décolletage that the woman's nipples were visible.

5

The London copy appeared a few months later in *The Ladies Magazine* (February 1801). Not only was the second print inferior in execution, but the dress was conspicuously more modest in design. To compensate for raising the neckline of the dress, the English artist introduced a table supported by bare-breasted caryatids. When I bought the two fashion plates, the French dealer drew my attention to the difference between them and sneered: "*La pudeur anglaise.*"

Americans were especially ambivalent about Paris fashion, because their cultural identity was still being formed in reaction to Europe. Dress reformers complained bitterly that American women wore fashions that came

> from licentious Paris and infidel France! Where woman stoops from her high position of virtue and morality, to mingle with the vicious and impure, to pander to the low passions and base desires of compeers in the arts of hell!! Let American and Christian women *blush*, at the character of their Parisian models of fashion![1]

A fashion plate appearing in the *Journal des Dames et des Modes (Costume Parisien)* in the Year 9 of the Revolutionary calendar was quickly reproduced in *The Ladies' Magazine* (February 1801). But in the English copy, the "Paris Dress" was conspicuously more modest. This is one of the few primary sources that partly—but only partly—corroborates stories about the topless and transparent dresses of the Empire period.

Why should the "daughters of Puritan ancestors" imitate the clothing of "the fashionable courtesan class in the wicked city of Paris"? Instead, "all lovers of liberty" should join "to free American women from the domination of foreign fashion."

But American women obstinately refused to be "liberated," preferring to believe that they subtly altered French fashions. Thus, *Godey's Ladies' Book* repeatedly proclaimed that it featured "Americanized" fashions—although, in fact, its fashion plates were usually more or less copied from French originals. A fashion plate by Laure Colin Noël, for example, appeared in the *Petit Courrier des Dames* (4 July 1857): The figure on the left bends down to look at a "fashion doll." The same figure and the same doll wearing the same clothes from the Maison Fauvet reappear exactly a year later in *Godey's,* without any reference to artist or dressmaker, and accompanied by several new figures (which could probably be traced to other French fashion plates).

To understand why Paris was so important, we need to move beyond the self-serving mythologies of both Parisians and foreigners—beyond both the French belief in the "genius" of their couturiers, and the Americans' idea that they overthrew a Parisian "dictatorship." According to one myth, there are Parisians and then there are "barbarians or provincials." "Provincials put on clothes, the Parisienne dresses."[2] Paris is the capital of civilization, the place where all the refinements of civilized life reach their fullest expression—including the concepts of fine language and elegant fashion. Certainly foreigners and provincials may *wear* Paris fashion—even they can recognize its superiority—but they never wear it quite the same way, and are utterly incapable of creating anything as good themselves.

We "barbarians" have also developed some myths of our own—especially the theory that a cabal of Parisian fashion dictators (most of them men) long determined the course of female fashion. The "man-milliner" and "the demi-monde fashion-mongers of Paris" were held responsible for every new, expensive, and immoral fashion to emerge from the French capital. Two years before the death of Charles Frederick Worth, the *Ladies' Home Journal* assumed that everyone knew that women's fashion "originated with Frenchmen" (although they were then "made adaptable . . . by American women").[3] Of course, Worth was an Englishman by birth, and the vast majority of Parisian dressmakers were women. But it was psychologically more satisfying to blame fashion's "follies" on the pecuniary and licentious motives of dictatorial Frenchmen—just as the French preferred to believe that their own innate national genius was responsible for the beauties of fashion.

In particular, the popular myth that American women finally smashed the dictatorship of Parisian men actually prevents us from understanding the real history of fashion. Both the relationship between Paris and the

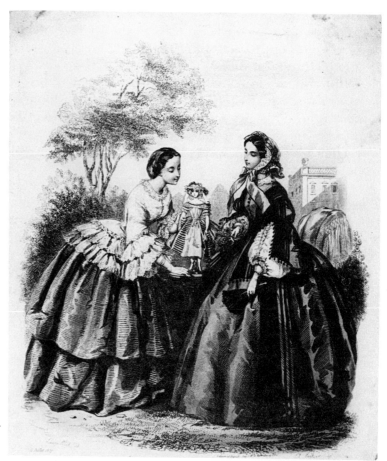

A fashion plate by one of the famous Colin sisters—Laure Colin Noël—appeared in the *Petit Courrier des Dames* (4 July 1857). Exactly a year later, it was copied by an illustrator working for the American fashion magazine, *Godey's Ladies' Book*.

Although the editors of *Godey's Ladies' Book* repeatedly proclaimed that the Philadelphia magazine featured "Americanized" fashions, this fashion plate from July 1858 has incorporated at least one figure from a French illustration. Neither the original artist nor the dressmaker is acknowledged.

provinces and the role of women in the fashion industry must be studied in an entirely new light.

The fashion leadership of Paris was not due to any particular spirit of frivolity or progressiveness on the part of Parisians. Nor is Paris fashion the product of individual creative genius, although this concept continues to play a large part in the mythology of fashion. The many anecdotes about the "dictatorship" or the "genius" of Paris fashion designers indicate a profound misunderstanding of the fashion process.

Couturiers like Worth, Chanel, and Dior were not so much dictators or radical innovators as they were astute barometers of fashion trends. In many cases, too, Parisian designers were actually foreigners: Worth was English, Schiaparelli was Italian; today, the German Karl Lagerfeld has assumed the mantle of Chanel, and Yves Saint Laurent's greatest competitor is the Japanese Issey Miyake. Moreover, many fashion designers throughout history have been women—from Mesdames Palmyre, Vignon, and Victorine to Madame Paquin, the Callot sisters, Jeanne Lanvin, Sonia Delaunay, Madeleine Vionnet, Coco Chanel, Elsa Schiaparelli, and Sonia Rykiel.

The 1960s "Youth Quake" may have launched an irreversible shift away from Paris fashion leadership. Think of Mary Quant and the miniskirt. Not only did London temporarily supplant Paris as the center of fashion, but it fostered a movement away from couture and toward ready-to-wear, which placed the American fashion industry in a vastly strengthened position.

But has New York finally overtaken Paris? The situation is not that clear-cut: Paris may still be the first among equals. As recently as Winter 1987, a new periodical called *Accent, The Magazine of Paris Style* was launched, featuring an article entitled, "Is Paris Still the Capital of Style?" According to the author, "The French capital may no longer hold the title alone." The designers, journalists, and retailers interviewed agreed that, "Today, *créateurs* in London, Milan, Tokyo and New York can no longer be ignored." Both fashion ideas and the actual selling of clothes were said to be "100 percent international." The Italians were praised for "practicality," the Americans for sportswear and jeans, the English and Japanese for adventurous, futuristic styles. The "merchandizing expertise of the Americans" came in for particular praise. And yet, many fashion professionals kept coming back to the idea that

> Paris is not the only fashion city, but High Fashion takes place only in Paris. . . . It's something in the air . . . Yves Saint Laurent and Madame Grès wouldn't have been possible anywhere but Paris . . . Paris is where it's happening.[4]

Paris fashion power is a subject that deserves continuing exploration, to which this book aspires to make a modest contribution.

Paris Fashion takes an essentially literary and artistic approach. It is a study of ideas about fashion more than a history of the fashion industry as such, and focuses less on the clothes themselves than on the context within which they were worn. Fashion culture is not the same as fashion. It involves new social roles, new forms of communication, ultimately new values and attitudes. Even a hundred years ago, Paris fashions were worn as far away as Japan, but one of the factors that made Paris the capital of fashion was the social relationship between performers and spectators. As sociologist René König points out, this symbiotic interchange can only take place within defined settings, where all players develop an "eye for fashion consciousness" and where the presence of knowledgeable observers has "a stimulating effect on the performers." Rivalry increases, as everyone is potentially a performer, but at the same time the "rules" are maintained, preventing fashion anarchy. The constantly changing details lead ultimately to a new style, as each fashion is run to the ground and "starts afresh."[5]

Paris was the ultimate stage on which to act out the drama of seeing and being seen. The fashions "moved and had their being" in "haunts of elegance" and pleasure. Indeed, they only acquired meaning within the context of the various scenes of fashionable rendezvous: the theatre, the park, the racetrack—where fashion performers and spectators interacted. The scenes of modern urban leisure were precisely those where fashion was displayed to greatest effect. In one way or another, all these scenes were intimately associated with the "libido for looking." The arcades of the rue de Rivoli were "set up like theatre scenery in a transformation scene." The boulevards were "a dream of gold" where "everything . . . overexcites you."[6] Both modern fashion and the modern city emphasized the erotic power and charm of novelty and display.

In the operetta *La Vie Parisienne*, one of the characters takes advantage of the Universal Exhibition of 1867 to quit his position as a servant and become a guide: "It is my business to take foreigners around the city and show them all the beauties of the capital." On this historical tour of Paris, we might also benefit from the special knowledge of several travelling companions, each of them with a particular interest in fashion. Among them will be Louis Sebastien Mercier, eighteenth-century chronicler of Paris, and Honoré de Balzac, failed dandy and successful creator of a gallery of Parisian types and costumes.

The poet Charles Baudelaire (1821–1867) needs little introduction, but even readers familiar with *The Flowers of Evil* may be unaware of the significance of fashion in his philosophy and personal life. Many Americans will be disinclined to believe anything said by a poet and a Parisian, especially one notorious for having been a decadent and a dandy. Yet Baudelaire has a great deal to tell us about fashion, art, and modernity, if we are

willing to listen. One of the benefits of studying Paris fashion is the potential for increasing our awareness of how we use fashion today. We Americans like to think of ourselves as practical and natural. We tend to fear that fashion is somehow being foisted off on us, whereas our clothing should be a natural expression of our true selves. Thus, we often complain about the difficulty of finding a personal style: How do you get dressed, and still be yourself? In Paris, as Baudelaire demonstrates, attitudes toward fashion have been rather different, and many Parisians have quite consciously used fashion as an adjunct to self-creation.

The writer Louis Octave Uzanne is less well known today, but he was the author of a series of delightful fashion histories published around the end of the nineteenth century. In works like *Fashion in Paris, The Parisienne,* and *The Frenchwoman of the Century,* he explored the social history and psychology of the Parisienne through a study of her changing fashions—primarily fashions in dress, but also more generally fashions in behavior and self-presentation, fashions in ideal beauty and personality. Writing for the modern woman, Uzanne tried to answer the question: Why do we look the way we do today, instead of like the people in those old pictures? In a sense, the primary purpose of my own book is to continue Uzanne's attempt to *reanimate* the fashions of the past, and to show how each fashion was the legitimate expression of that epoch's ideal of beauty and identity.

The last color illustration in Uzanne's *Fashion in Paris* shows two contemporary women wearing the dress of 1897 and looking at pictures of "bygone fashions" in the print room of the French national library. Some of the fashion plates they perused were almost certainly the work of a family of women fashion illustrators: Héloïse Colin Leloir, Adèle Anaïs Colin Toudouze, and Laure Colin Noël, along with Anaïs's daughter Isabelle Toudouze Desgrange. They are quite obscure today, except among certain collectors for whom they are the famous Colin sisters.

Although they cannot be said to speak for themselves the way Baudelaire and Uzanne do at length, their lives and work say a great deal about the position of Parisian women in fashion and art. Women like the Colins were not merely passive consumers of fashion, but rather active participants in the burgeoning fashion industry. The most famous couturier of the nineteenth century was the Englishman, Worth, but there were many women designers as well, such as the couturière Madame Jeanne Paquin (1869–1936). And by the middle of the nineteenth century, about half the women workers in Paris were employed in some branch of the needle trades. Indeed, "The Revolutionary March of the Dressmakers" began with the lyrics, "What does the little delivery girl demand/Of the House of Worth or of Paquin?/ A little more salary/ Less work to do."

You have already seen one fashion plate by the youngest Colin sister,

Anaïs Colin Toudouze was one of the most important fashion illustrators of the nineteenth century. Her photograph is in the collection of the Musée de la Mode et du Costume, Paris. So are a number of her sketches and watercolors, thanks to her nephew, Maurice Leloir, and her grandson, Georges Gustave Toudouze, both of whom inherited an interest in fashion. Photograph courtesy of Chantal Fribourg.

Laure. The second sister, Adèle Anaïs Colin Toudouze (1822–1899) is especially respected as "the most prolific and certainly the most popular of all the later fashion-plate artists."[7] Since the Colins (and especially Anaïs) will also act as our guides to Paris fashion, I must apologize now for referring to them alone by their first names, since I do not write Charles when I refer to Baudelaire, or Honoré when I mean Balzac. Because their careers began in adolescence and continued after marriage, I thought that it would be anachronistic (and hardly feminist) to call them by their husbands' surnames, while it would be confusing or prolix to have to keep using their full names to indicate which Colin I mean.

Combining the *vestignomonie* of Balzac and the *dandyisme* of Baudelaire is Marcel Proust (the last of our guides), who devoted a significant portion of his great novel to the analysis of the world of fashion. With the dawning of the twentieth century, Proust's youthful heroine Albertine adopted the sport clothes and avant-garde fashions of the future, thus moving a stage beyond both the seductive tea-gowns of the courtesan Odette and the magnificent haute-couture dresses of the Duchesse de Guermantes.

Along with this revolution in fashion, there was a revolution in fashion illustration that superseded the work of Anaïs and her colleagues. Although Proust does not refer specifically to the Art Deco fashion plate (any more than to the avatar of modern fashion, Paul Poiret), he describes Fortuny's modernist dresses in detail, and analyzes the influence on fashion of the *Ballets Russes* and the First World War.

The last section of *Paris Fashion* explores the meaning of fashion in the twentieth century, with particular emphasis on two women who dominated the field of haute couture—Chanel and Schiaparelli. What roles have women played in fashion? What causes fashion change? And again, why was Paris so significant?

I can only hope that what Uzanne wrote almost a century ago is still true, that

> Books on fashion will be sought and welcomed, to all time and in every sphere, with special favour, because they are both recreative and instructive, and because everybody believes him or herself capable of enjoying, of understanding, and of interpreting them.[8]

2
The Picture of Paris

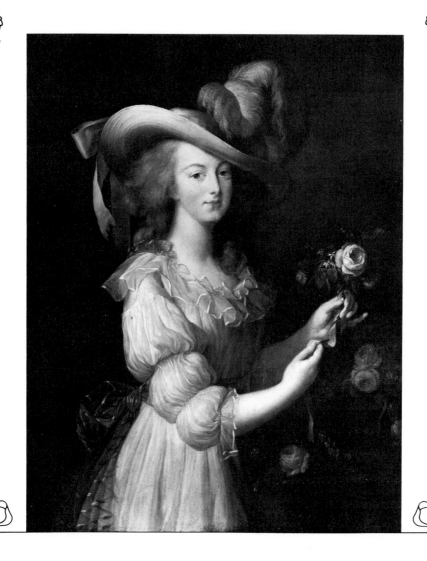

The *Portrait of Marie Antoinette* (circa 1783, and attributed to Elizabeth Vigée-Lebrun) provides visual evidence that sartorial revolutions were occurring even before the fall of the Bastille. "I painted several portraits of the Queen," wrote Vigée-Lebrun. "I preferred to paint her without grand attire . . . One of them shows her wearing a straw hat and dressed in a white muslin robe. . . . When this portrait was exhibited at the Salon, the evil-minded did not fail to say that the Queen had had herself painted *en chemise*, for . . . slander had already begun to make her its butt." Courtesy of the National Gallery of Art, Washington; Timken Collection.

Le travail des modes est un art: art chéri, triomphant, qui dans ce siècle, a reçu des honneurs, des distinctions. Cet art entre dans le palais des Rois, [et] y reçoit un accueil flatteur.

Mercier, *Le Tableau de Paris*, 1782–1788

I am going to talk about Paris," began Louis Sebastien Mercier—not about buildings and monuments, but rather about what people really think of their strange and constantly changing customs. "I may talk of . . . a cherry bonnet or one *à la fanfan,* meaning a bonnet too utterly sweet. . . . The color most in fashion as I write is puce" (which, translated, means "flea"). "Paris mud" is the latest color. And what a color, since "the mud of Paris is . . . filthy, black with grit" and with a "sulphurous smell. . . . A spot of this mud left on a coat will eat away the cloth." Yet another popular color is "soot of a London chimney."[1]

What are we to make of this kind of reportage? Although it might seem merely a charming triviality, it actually shows that by the eighteenth century fashion was beginning to assume a modern aspect. No longer was fashion determined by a centralized authority at court. Now the collective but ephemeral taste of many individual Parisians decided whether puce, mud, or soot was in fashion; the cherry bonnet, the porcupine coiffure, or the baby's cap. Moreover, the very names indicate a quintessentially modern sensibility, alternately sentimental and ironical, and a far cry from the solemn grandeur of Versailles.

To understand the meaning of modern fashion, we need to look briefly at the period *before* Paris was the capital of fashion—back even before Versailles set the mode for the entire western world.

The Birth of Fashion

As early as 1393, an ordinary Parisian (not a nobleman) warned his fifteen-year-old wife to stay away from newfangled styles of dress.[2] But it was already too late: The reign of ever-changing fashions had begun. Of course, strictly speaking, our bourgeois adolescent was breaking numerous sumptuary laws in her pursuit of high "Gothic" headdresses, wide sleeves, and

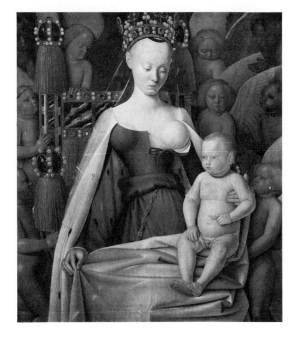

Agnes Sorel, mistress of Charles VII and known as the "Lady of Beauty," was probably the model for Jean Fouquet's painting *The Virgin and the Infant Jesus.* Among the characteristics of mid-fifteenth century fashion displayed are a scandalously low neckline, an artificially high hairline, and a laced bodice that would eventually develop into the corset. Courtesy of the Koninklijk Museum voor Schone Kunsten, Antwerp.

fur trimmings. Such sartorial competition was theoretically limited to members of the ruling class. Clothing that was honorable and magnificent for lords and ladies was presumptuous for mere townspeople, who were specifically (and repeatedly) forbidden to wear new styles of dress, luxury fabrics, and rich colors like scarlet and purple. The most outrageous fashionable innovation was the low-necked dress.

"Husbands complain—preachers denounce," summarized fashion historian Augustin Challamel. Actually, the men were at least as flamboyantly dressed as the women, but women's sartorial excesses were more vehemently criticized. Certain women like the beautiful Agnes Sorel (mistress of Charles VII) became notorious for their fashions. According to a chronicle of the time, her "train was a third longer than any princess in the kingdom, her head-gear higher, her gowns more numerous and costly." The so-called "Lady of Beauty" was probably the model for Fouquet's painting of the Virgin Mary—a most unvirginal figure in a low-cut gown, unlaced in front to expose one high, full breast.[3]

Did French queens and royal mistresses set the fashions, which then trickled down to bourgeois Parisians, and thence to the provinces and the world at large? *Au contraire!*

Fashion began, not in France, but in Italy, where it was closely associated with the rise of cities—and with the rising middle class. Paris was not

in the forefront of fashion, because it was not yet a very important city. Milan, Florence, and Venice (which were politically independent, economically advanced, and culturally flourishing) were all more fashionable than Paris. Indeed, fashion was only one aspect of a wider cultural Renaissance that spread from Italy throughout the western world—ultimately touching even a bourgeois girl in faraway medieval Paris.

She was not setting the fashion (although she was avidly following it), but some middle-class Italian adolescents *were* fashion leaders, launching such innovations as the ultra-short men's doublet. In fact, sexually explicit fashions were the order of the day, as both men and women abandoned their long, loose T-shaped robes, the women in favor of tight-fitting, low-necked gowns, the men adopting robes so short that they failed to cover the wearers' "privy members and buttocks." The short doublet and tights marked the birth of modern men's clothing. Appearing in about 1340, in Italy, it seems to have originated with new developments in military technology—specifically with the new style of short plate armour that replaced the coat of chain-mail when the cross-bow and the first firearms were invented.[4]

Italy was a proto-capitalist society, when France was still largely under the feudal dominance of a hereditary agrarian aristocracy. The structure of the Italian city-states favored the development of fashion innovation and competition, whereas it was obviously difficult to set any new fashions in an isolated castle. The court, however, provided an alternative fashion arena, and a type of proto-fashion existed in France from the eleventh to the thirteenth centuries, especially at the courts of Provence and Anjou.

The Crusades played a role in the development of courtly fashion, as the Europeans came in contact with the more luxurious costumes of the Middle East. Far from having "ancient" and "unchanging" costumes, many eastern cultures were characterized by intense (if restricted) fashion competition. At the eleventh-century Japanese court, for example, the highest term of praise was to call something *imamekashi*, "up-to-date." In both France and Japan, however, clothing was also rigidly prescribed according to rank: In medieval France, a prince might wear a shoe with a point up to twenty-four inches in length, an ordinary gentleman was restricted to twelve inches. In Japan, the number of folds in one's fan was calculated even more precisely.[5] The spread of fashion did not progress unimpeded, because it implicitly challenged the static and hierarchical nature of traditional society. Nevertheless, from the fourteenth century on, in both the courts and cities of Europe, there was an inexorable movement toward fashion-oriented behavior.

From Italy, modern fashion spread to the court of Burgundy, which has been called "the cradle of fashion" and "the most voluptuous and splendid court in Europe, Italy included." French historians agree that the Burgun-

dian court "prefigure[d] that of Versailles"—both in the elegance of its dress and in the elaboration of its court ceremonial, which created "a cult devoted to a monarch set up as an idol."[6] Luxury and fashion were symbols of power, brilliantly exploited by rulers and avidly pursued by the nobility.

In the fifteenth century, the dukes of Burgundy were far wealthier and more powerful than the kings of France—and this was reflected in their dress. When Philip the Good of Burgundy rode to Paris together with the Dauphin (later Louis XI), not only Philip's clothes but even his horse's trappings were so covered with rubies and diamonds "that beside it the clothes of the heir to the French throne looked almost pitiful." "More Parisian than *Dijonnais*," Duke John the Fearless of Burgundy was known as the "King of Paris," and when this "prince of violent and sombre character" appeared in the city in 1406—charged with murdering the real king's brother—"he wore a red velvet suit lined with grey fur and worked over with gold foliage. When he moved, his armour became visible under the wide sleeves."[7]

Red, like purple, was restricted to the ruling class, and it says much about the importance of symbols that, during the Peasants' Revolt in sixteenth-century Germany, the insurgents demanded the right to wear this color. Yet Philip the Good preferred to wear *black* velvet, because it served to distinguish him from his "peacock courtiers," creating a visually striking and symbolically ambiguous effect, one both "ascetic and satanic." The sombre magnificence of black was balanced against the perfectly fashionable cut of his short robe to create a sophisticated and dramatic look. This style of chic black was first worn by individual Burgundian and Italian dandies who were in the process of renouncing the gay colors of the late Middle Ages.[8]

If black was later to become uniform, nevertheless the first uniforms were brightly colored—and there was a highly developed language of colors that was heraldic in origin. The coat of arms was literally a coat, worn over the armour for battle or tournaments. Courtiers, servants, municipal officials, and soldiers all received gifts of clothing from their lords that amounted to livery. "On every possible occasion Philip [the Bold] liked to parade his whole court in costumes which showed the colours of his house [red and light green]. These were made of velvet and silk for the nobility and of satin and serge for the servants."[9]

The aesthetic and psychological effect of a group of people all dressing the same way is indisputable; this principle of unity lies behind the prestige of the uniform. For centuries, men dressed as magnificently as women (often more so)—but already at the very beginning of modern fashion, we find the first hints of the great division that later separated sober, very slowly changing male "uniforms" from bright and modish female fashions.

Ultimately, men's closer integration in the development of the modern state set them on the road to uniformity.

Fashion Follows Power

During the fourteenth and fifteenth centuries, the political fragmentation of medieval Europe led to the development of several regional fashion centers (principally the Italian city-states, but also the court of Burgundy) rather than a single fashion capital. Then, in 1492, Columbus discovered America, and Spain became politically, economically, and sartorially dominant. Spain increasingly influenced fashion even in Italy, where the city-states were beginning to weaken in relation to larger and more unified nation-states. At the beginning of the seventeenth century, political and economic power again began to shift, this time to France and Holland, launching the dual path of French and Dutch fashions—respectively courtly and bourgeois, ultimately feminine and masculine, modish and plain.

Male fashion reached new heights of splendor, however, before the "great renunciation." With the accession of Francis I, the Renaissance moved from Italy to France. A true Renaissance prince, Francis wore clothing of extraordinary richness, made of luxurious and colorful fabrics—doublets of cloth of gold, cloth of silver, velvet, satin, and taffeta in crimson, azure, violet, and every other color of the rainbow. His clothes and those of his courtiers were further ornamented with lace, gold braid, and embroidery, and precious jewels. Black velvet caps were decorated with white plumes and (wrote Rabelais) "dangling in a more sparking resplendency fair rubies, emeralds, and diamonds." As the Venetian ambassador reported in 1546, the king "likes a touch of elegance in his clothes."[10]

But the remainder of the sixteenth century was dominated by stiff, black Spanish fashions. The vertingale or farthingale (an underskirt distended by hoops) was worn by all but working-class and peasant women. Men's clothing was almost as rigid, and they, too, wore stiffened and padded armour-like garments of an increasingly sober and uniform cast.

It was the era of the Inquisition and the Counter-Reformation, and the black clothes and white ruffs of the Spanish aristocracy looked in some ways similar to the garb of Catholic priests and monks. The Italian Campanella (who was tortured seven times for defending Galileo against the Inquisition) wrote:

> Black robes befit our age. Once they were white;
> Next many-hued; now dark as Afric's Moor,
> Night-black, infernal, traitorous, obscure,
> Horrid with ignorance and sick with fright.
> For very shame we shun all colors bright,
> Who mourn our end—the tyrants we endure,

21

> The chains, the noose, the lead, the snares, the lure—
> Our dismal heroes, our souls sunk in the night.[11]

The black and sober Spanish fashion never entirely caught on in France, where (the poet Ronsard reports) "coxcombs" and "princes" alike were "silk-bedecked" and "rich in cloth of gold went glittering."[12] Nevertheless, black was still the dominant color, and even Spain's bitterest enemies—like the protestant English and the rebellious Dutch—wore Spanish fashions. In fact, the Dutch really carried the Spanish style into the next century—transforming this conformist black-and-white uniform from a Catholic, aristocratic, and courtly mode into a Protestant, bourgeois, and urban style.

Black clothing, simplified from Spanish courtly styles, must have seemed well suited to the Calvinist religious ideology of the Dutch bourgeoisie. With its emphasis on extreme conformity within the religious congregation and on the avoidance of any temptations of the flesh that might lead to sinful behavior, Calvinism placed a high value on sobriety of appearance and demeanor. Black clothing that underwent little stylistic change over a period of several decades served the social and religious needs of the community by allowing people conspicuously to avoid the "frivolity" and "temptation" of fashion, while at the same time permitting subtle manifestations of fashionable behavior. For, of course, even within the confines of a basic black-and-white style, fashion would appear in the fineness of cloth and cut and the quality of linen and lace.

Meanwhile, color—pale, glittering color—lay in wait, to reappear in the seventeenth-century French court.

The Court of the Sun King

Louis XIV is supposed to have said that "Fashion is the mirror of history." Certainly, the clothing of the Sun King was intended to represent unparalleled power and glory—an idea expressed most clearly in his official robes of state, which were emblazoned with gold fleurs-de-lys and completely lined with ermine. Many years later, Napoleon would consciously imitate him, adopting for his coronation a long red velvet robe with an ermine collar. But even on less exalted occasions, both of them remained aware of the symbolic value of clothing. From his elaborated curled periwig to his red high-heeled shoes, Louis XIV chose to present himself, not as a warrior-king (like some of his predecessors), but rather as the cynosure of the most magnificent court in the history of the western world.

When influence derived from proximity to the person of the monarch, when even the act of helping him into his shirt in the morning was a signal honor, what could be expected but that some of the same charisma should be associated with his style of dress.[13]

"Fashion is to France what the gold mines of Peru are to Spain." As early as 1665, the most important of Louis XIV's ministers, Jean-Baptiste Colbert, recognized the potential value of French fashion leadership. The gold that poured into the Spanish treasury from the South American colonies—and that formed the basis for Spanish fashion power—would be matched, and exceeded, by the money to be made in France from fashion. Then, as now, textiles were the foundation of the fashion industry. In a deliberate attempt to supplant Italy as the western world's greatest producer of luxury textiles, the French government initiated protective legislation designed to promote French silk weaving. In October 1687 *Le Mercure de France* described some of the finest textiles being produced in France:

> M. Charlier makes gold and silver fabrics, silk, gold cloth in the Persian style, and others in the Italian style. He makes velvets, satins, damasks, and all sorts of gold and silk cloth of the highest quality that one can buy directly in his Parisian shop. . . .

As fashion and textile historian Jean-Michel Tuchscherer points out, "Charlier's silks seem to have been destined mostly for the king." Colbert, however, was even "more sensitive to the wool economy than to the silk," wool being essential for army uniforms.[14]

State support was crucial to the rise of French fashion, but economics alone does not explain the shift from international Spanish black to modish French fashion. More important was the power and prestige of the French court. The marriage of Louis XIV of France and the Infanta Maria Theresa of Spain in 1660 symbolically opposed Spanish Grandees in black velvet and the French nobility in the baroque splendor of beautiful lace and gold and silver braid. Soon the colorful French style triumphed in courts and cities throughout Europe, while black-and-white was left to retrograde Spanish noblemen, Dutch burghers, and English puritans.

When the young king and queen made their triumphal entrance into Paris, Madame de Motteville wrote, enthusiastically: "The King was such as the poets paint for us these men that have been made divine. His clothing was of gold and silver embroidery, as beautiful as it should be in view of the dignity of the one who was wearing it." Of the new queen, she remarked elsewhere, "Her bosom appeared to us well formed and sufficiently plump, but her dress was horrible."[15]

Many years later, in 1697, when his grandson was to be married, Louis XIV "let it be known that he wished the Court to be very magnificent"; and although he himself had dressed simply for a long time past, on this occasion he would be clad in the most superb raiment. This was sufficient to launch a mad rush to attain the height of "richness and invention." "There was barely sufficient gold and silver," wrote Saint-Simon.

The shops of the merchants sold out in a very few days. In a word, the most delirious extravagance dominated court and city . . .

Things came to such a pass that the King regretted that he had allowed all this, and said that he had not realized that there were husbands so foolish as to ruin themselves on account of the dress of their women, and he might have added, on account of their own. But . . . I do not know whether, as a matter of fact, the King was not rather pleased, for it delighted him to look at all the wonderful dresses during the festivity. It was easy to see how this profusion of material and the exploitation of trade pleased him, with what satisfaction he praised the most magnificent and best apparelled, and how the little word 'discretion' had not been uttered by anybody, including himself.[16]

Yet although the king encouraged fashion by his splendid fêtes, he also constantly signed edicts *against* sartorial extravagance. Fashion was a question of etiquette, with Louis XIV as law-giver—and the inflexibility of ceremonial severely restricted vestimentary fantasy. Louis XIV desired the precise regulation of clothing according to minute distinctions of rank. Although he relaxed the laws restricting the use of lace—and imported hundreds of lace workers from Belgium and Italy—he was more possessive about woven material and trimmings of gold and silver. "He declared that the use of brocade belonged to himself, the princes of his family, and those of his subjects upon whom he might be pleased to bestow the privilege." Thus came into being the institution of *justacorps à brevet*—a blue coat lined with red (designed to look as much as possible like the clothing of the king himself) that could be worn only by virtue of an authorization signed by the king, and which carried with it the privilege of following the king in all his pleasure outings. If one wearer died, Saint-Simon reported, there was a scramble to see who would get to wear it next.

No doubt this was all very well, and the king frequently distributed among his courtiers gifts of textiles and various clothing "benefits" (such as the right to wear blue embroidery). Nevertheless, the courtiers were less and less free to dress as they pleased. Clothing at court was characterized by majesty and solemnity and, over time, the baroque splendor of the early years gave way to a look of rigid order, one even deliberately antiquated.

Women's fashions also changed only slowly during the reign of the Sun King, and they, too, were rather stiff and formal. Of course, they were luxurious, especially during the period when Madame de Montespan was the king's official mistress. As Madame de Sévigné wrote: "Her costume was a mass of French lace, her hair dressed in a thousand ringlets . . . her coiffure topped with black velvet ribbons and jeweled pins, her famous pearl necklace. . . . In short, a triumphant beauty to show off, to parade before all the Ambassadors." On one occasion, as a joke, Monsieur de Langlée (one of the king's friends and a known arbiter of fashion)

ordered the dressmaker first to present a gown that Madame de Montes-pan had ordered—but it was to be very badly fitted. Only after the lady had shown her extreme displeasure was the dressmaker allowed to suggest that perhaps another dress—a mysterious gift—would fit better. . . .

> Monsieur de Langlée has given Mme. de Montespan a golden gown, gold on gold, fitted over a golden brocade sheath, which was cross-woven with threads of various shades of gold—all of which adds up to the most heavenly fabric imaginable![17]

But however carefully planned the joke and however splendid the dress, it was not noticeably more *fashionable* than the court dress of earlier eras.

Yet more genuinely modern fashion was beginning to emerge—in Paris. Thousands of tailors, dressmakers, and milliners were actively engaged in the business of producing new fashions for the courtiers at Versailles, for wealthy bourgeois Parisians, and for an increasing number of foreign and provincial visitors.[18] During the end of the Sun King's reign, some of the younger princesses and ladies of the court "revolted against the ancient modes, and occasionally dressed after the new ones originated in Paris, but not on state occasions, when the rules of etiquette could not be trans-gressed in the smallest particular." In July 1715, the Duchess de Berry met with the "clever tailors" and "famous couturières" of Paris "to change the fashions." (Rose Bertin, *marchande de modes* for the stars of the Opéra, was already mentioned by name.) On the first of August, the Duchess d'Orléans and the Princess de Conti presented the latest novelties to Louis XIV. "The king said to them that they could dress as they pleased . . . that it was a matter of indifference to him." A month later, he died.[19]

Henceforth, to a far greater degree, fashion was to be a matter of indi-vidual choice, determined by a lady and her dressmaker (or a gentleman and his tailor), subject only to social opinion. The process rapidly acceler-ated when the new Regent left the gloomy old court at Versailles and returned to Paris.

Fashion in Paris

Foreigners were amazed at the Parisian mania for fashion: "They invent every Day new Modes of Dressing."[20]

> To be in Paris without seeing the fashions, you have to close your eyes. The scenes, streets, shops, carriages, clothing, people, everything presents only that. . . . A suit of forty days passes for very old among the distinguished people. They want new fabrics . . . modern systems. Whenever a fashion begins to dawn, the capital is infatuated with it, and no ones dares to show himself, unless he is done up in the new finery.[21]

Most historians have assumed that the court continued to dominate the mode (as it had under the Sun King). Thus, we read that Louis XV's mistresses, Madame de Pompadour and Madame Du Barry, set the fashion, to be followed in the next reign by Marie Antoinette. To some extent, this was true. The French court retained its prestige, and aristocrats throughout Europe wore French courtly dress, at least on formal occasions. Madame de Pompadour was, indeed, a leader in all the fine and decorative arts, including the art of dress. Yet everywhere, the baroque magnificence and status hierarchy of the old monarchical style were being transformed into the easy, flowing lines of an aristocratic and individualistic rococo. However influential individual aristocrats might be, they no longer represented the hierarchical authority of the court.

"Marie Antoinette preferred the title of Queen of Fashion to that of Queen of France," observed one court lady. But this showed her *loss* of influence; Louis XIV was no mere trendsetter, Marie Antoinette was—along with other, less exalted, Parisians. Thus, when Maria-Theresa of

An early form of the fashion plate, this illustration by Le Clerc for *La Gallerie des Modes et Costumes Français* (ca. 1779) shows a *robe à l'anglaise* in apple green silk.

Austria received a painting of her daughter, Marie Antoinette, she responded coldly: "this is not the portrait of the Queen of France; there is some mistake, it is the portrait of an actress."[22]

The year 1715 marks the real beginning of the eighteenth century—with a new reign in France (and in England), and a new sense of freedom and informality. The stifling rules of court etiquette were giving way to the development of a more open urban society, characterized by urban salons in which women and even individual commoners participated. Now fashions were not merely "trickling down" from the court to the city; they were emerging from within Parisian society itself. Yet the society was also animated by the old court belief in the importance of taste and art—of fashion as an expression of individuality. Ailene Ribeiro writes:

> The essence of 18th-century costume is the sophisticated urban dress—embroidered velvet coat and knee breeches, rustling silk taffeta dress over paniers, powdered hairstyles—that was France's great contribution to the world of fashion and civilized living.[23]

The geography of fashion in Paris centered around the rue Saint-Honoré and later the Palais Royal. "I met a foreigner who refused to believe in the *poupée de la rue Saint-Honoré*," recalled Mercier, who promptly took "the unbeliever" to see for himself the famous fashion dolls. In an era when fashion journalism was still somewhat rudimentary, large and perfectly dressed dolls were sent from Paris to dressmakers and private clients throughout the western world, and even to Constantinople.

Foreigners and Parisians also made pilgrimages to the source of Paris fashions. According to Mercier, the Palais Royal was unique: "They call it the capital of Paris. . . . It is like a tiny very rich town in the heart of a great city." The duc d'Orléans made a fortune from the shops and cafés that filled the arcades and gardens of the palace. Said Mercier, "A man might be imprisoned within its precincts for a year or two and never miss his liberty." Certainly, he would not be lonely, since it was one of the most popular promenades in Paris. According to the Baroness d'Oberkirch, it was the "resort of . . . idlers and the meeting place for court society and the Parisian *bon ton*."

The more humble Parisians, "all who must make their money go a long way, shopkeepers' wives and such," bought their clothing elsewhere, especially at the Fair of the Holy Ghost. In the Place des Grèves, every Monday there was a fair: "Skirts, paniers, loose gowns are there in piles from which you may choose. Here, a grand dress worn by the dead wife of a judge, for which the wife of his clerk is haggling; there, a prostitute tries on the lace cap of a great lady's lady-in-waiting." On other days, the place served as the public execution ground—a fact, as Mercier notes, that acted as little deterrent to the crowds of thieves and fences, some selling clothes they had recently seized from passers-by.[24]

London and Saint Petersburg were closer to Paris than many a small French town. The vast majority of people did not wear fashionable dress. Because the diffusion of fashion was still limited, the foreign and provincial nobility remained attached longer to the older vestimentary forms. Traditions long entrenched in particular regions carried more weight than innovations coming from faraway Paris. The provincial middle classes also drew their ideas of fine dress from the outmoded styles of local aristocrats, while the common people wore a mixture of long out-of-date high fashions allied with a basic functional costume that had existed for centuries. Just as "ceremonial and court dress had frozen into a kind of uniform," so also was regional dress a kind of antiquated "costume."[25]

As fashion journalism developed, in the course of the eighteenth century, provincials gained more access to Parisian fashions and began to try to imitate them. Even Jean-Jacques Rousseau, the apostle of natural living, wrote that

> Fashion dominates provincials, but Parisiennes dominate fashion, and knowing it, each bends it to her advantage. The former are like ignorant and servile copyists who copy everything down to the mistakes of orthography; the others are authors who copy authoritatively, and know how to restore the misreadings.[26]

It is worth noting that in 1761 Rousseau was already describing fashion in terms of the female inhabitants of Paris. Male modishness was beginning to be regarded as unnecessarily foppish.

Men's Clothing: The English Connection

At the beginning of the century, a pink silk suit, gold and silver embroidery, flowered and plain velvet, lace, jewelry, and powder were regarded as perfectly masculine. Dress was the visible sign of social standing—and the more elaborate the dress, the higher its wearer's apparent social status. The fashionable man wore a three-piece suit, composed of coat, waistcoat, and breeches, which were often but not always made of the same fabric. The style had none of the austerity of the reign of Louis XIV, and was far more graceful, slim, and *dégagé*. The quality of the material and decoration were the primary distinguishing characteristics, since tailoring as such was still rather crude.

Of course, not everyone could afford to follow the fashion and buy a multiplicity of fine suits. "With a black coat a man is well dressed," observed Mercier, "for you are believed to be in mourning . . . and can go anywhere thus clad. True, it shows you are but poorly off"—and for that reason, black was favored by people like "authors and retired folks," since a black coat "goes marvellously well with mud [and] economy" as well as

"the dislike for a lengthy toilet." Many men were reduced to buying sec-
ondhand clothes at the clothiers stalls, which were "ill-lit on purpose, that
the stains may be less noticeable and colors deceive the eye; thus, the suit
of solemn black, bought and paid for, is transformed before your eyes, by
the mere light of day, to purple or green, and spotted at that."[27]

There was, however, widespread imitation of aristocratic dress. One En-
glish visitor to Paris even suggested that this fashion competition might
ultimately lead to "the End of excessive Luxury, there being nothing that
can make Noble Personages so much despise Gold Trimming, than to see
it upon the Bodies of the lowest Men in the World."[28] Similar complaints
were also common in England, but there were significant differences be-
tween the mode of dress in the two countries.

The dichotomy between formal French dress and informal English dress
already existed before 1750, and was to become even more significant in
the second half of the century. As early as 1722, a visitor to England wrote:

> The dress of the English is like the French but not so gaudy; they generally
> go plain but in the best cloths and stuffs. . . . Not but they wear embroidery
> and laces on their cloathes on solemn days, but they don't make it their daily
> wear, as the French do.[29]

Furthermore, by the 1740s, some of the younger members of the English
nobility were affecting the clothes of the working class. They dressed, ob-
served Lord Chesterfield, like "grooms, stagecoach men, and country
bumpkins" in "brown frocks [and] leather breeches . . . their hats un-
cocked and their hair unpowdered."

The development of plainer male attire has often been described as a
reflection of the growing power of the bourgeoisie and of a general "de-
mocratization" of European society. Specifically, many fashion historians
have believed that plain male clothing was a product of the French Revo-
lution, when Mercier's black-coated bourgeoisie came to power. If, how-
ever, the plain style did not originate with the revolutionary bourgeoisie,
but rather several decades earlier in England, then its political and social
connotations are very different. Moreover, the simple style did not de-
velop solely among the "rising middle class," but also significantly derived
from the country and sporting clothing of the English aristocracy. By the
1780s, members of the French aristocracy also began to wear the English
style—and they would never have copied Mercier's humble authors.

The tension between the formal French style and the informal English
style caused difficulties in both countries—and had indirect repercussions
in America also. The term "Macaroni" is familiar to us today from one of
the oldest stanzas of "Yankee Doodle Dandy": "Yankee Doodle came to
town/Riding on a pony/Stuck a feather in his hat/And called it Macaroni!"
Although apparently nonsensical, this verse was originally used by the En-

glish to ridicule the poorly dressed American troops, by comparing them to a circle of notoriously modish Londoners, whose appearance was perceived by many of their contemporaries as odd and affected.

Macaroni appeared as "a new coterie word in 1764 for ultra-fashionable young men, Italianate and Frenchified." The original Macaronis were members of "the younger and gayer part of our nobility and gentry," who had made the Grand Tour and had founded a subscription table at Almack's Club, where they introduced the Italian dish from which they derived their name. But the Macaroni was more than a fop, and negative attention was focused primarily on members of the aristocratic oligarchy around the Court of St. James.[30]

What was Macaroni fashion? Why did some English aristocrats adopt it? And why did other Englishmen find it so offensive? Satirists described it as "extravagantly *outré*"—with "Five Pounds of Hair" towering "9 inches above the head" (in other words, the latest French hairstyle), often worn with a "little French hat" rather than the "manly Beaver" favored by less modish souls. Macaroni fashion included a coat whose tightness and shortness seemed almost obscene; that is it was a more formal and fitted garment than many Englishmen were accustomed to wear. Even the large buttons on Macaroni coats were copied from a style set by the Comte d'Artois, younger brother of Louis XVI. In fact, the Macaroni style "originated in France (possibly as a vain stemming of the flood of English outdoor fashions which were in the following decade to sweep all before them)."[31]

English aristocrats who wore ultra-French clothes did so, at least in part, to make a political statement: to differentiate themselves from wealthy merchants and lesser country gentlemen (who wore plain dark suits with excellent linen) at the same time that they associated themselves with their counterparts on the Continent. It is significant that Macaroni fashion appeared when the aristocratic oligarchy was at its most narrow and exclusive—and just as it was beginning to be challenged by liberal and popular movements.

A letter to *Town and Country Magazine* (November 1771)—a journal apparently read by merchants and country gentry—warned that Macaroni aristocrats were, in effect, the tools of foreign tyranny:

> Reflect upon the folly and extravagance of our present race of young noblemen . . . of the circle at St. James [that is, the Court]. . . . It was the policy of the ministers of Louis XIV to make their language universal, in order to pave the way to universal monarchy: to the same end were their fashions propagated throughout Europe; and every country that has adopted them has, in proportion, become effeminate and vicious. To our lot have they fallen most amply, as every macaroni daily evinces.[32]

The Macaroni was not merely "a minnikin, finicking French powder-puff." To the extent that an Englishman became effeminate and weak, he became unable to resist foreign threats and might even admire European tyranny. Thus, an article in *The London Magazine, or, Gentleman's Monthly Intelligencer* (April 1772) claimed that the Macaronis had brought home "only the vices and follies of a foreign country"; and the Macaroni Club was compared unfavorably with "the renowned *Beef-Stake Club* [sic] that took its denomination from Beef being the Englishman's great dish, and *Beef* and *Liberty* the objects of the institution."[33]

During the eighteenth century, a growing sense of cultural nationalism emerged as one aspect of British patriotism. Britishness and foreignness were viewed in moral terms. For many merchants and country gentlemen it seemed especially insidious that an important and visible segment of the English aristocracy—who should have set the model for the rest of the nation—so wholeheartedly embraced Continental culture. Their infatuation with foreign tastes was seen as indicative of their moral decline—expressed frequently in these satires in terms of effeminacy, occasionally as libertinism. The French, who were individually seen as being weak and effeminate, were conspiring to enslave the English by corrupting and weakening them.

A country led by a Macaroni elite and filled with would-be Macaronis was in no position to defend itself:

> Whither are the manly vigor and athletic appearance of our forefathers flown? Can these be their legitimate heirs? Surely, no; a race of effeminate, self-admiring, emaciated fribbles can never have descended in a direct line from the heros of Potiers and Agincourt. . . . [The author ends by lamenting] that this nation, in the most perilous of times is to be defended by such *things as these*.[34]

The Seven Years' War was a recent memory, and its conclusion did little to diminish the perceived French threat to the English colonies.

Thus, the existence of a fashionable, Frenchified aristocracy was no idle issue to the English patriot of 1772, who feared that corrupt courtiers surrounded and misled the King, endangering the Englishman's traditional liberties.

Robert Hitchcock's comedy, *The Macaroni*, combines many of the themes common to the literature attacking the Macaroni aristocrat. Epicene's servant, for example, tells him, "You seem de minished marqui— . . . von wou'd swear dere was not von drop of Englise blood in you." The Macaroni views himself as a cosmopolitan aristocrat, not a British patriot.

Lord Promise, the soon-to-be-reformed "Libertine," reprimands Epicene:

What a contemptible creature an Englishman dwindles into, when he adopts the follies and vices of other nations. . . . Think who you spring from, a race of hardy, virtuous, conquering Britons, and blush at your own degenerate exotic effeminacy—.

Even a libertine despises the Macaroni for his foreign vices and degeneracy, that threaten the character and liberty of his native land.

Indeed, it is the Macaroni's implicit threat to England's freedom that is most strongly emphasized in the Prologue:

> When *Britain* calls her valiant sons to arms,
> Their milky souls no martial ardour warms . . .
> And *fear's* the only passion they can feel;
> Save that, in which they every hour employ,
> (Narcissus-like)—the self-admiring joy. . . .

The Epilogue concludes by criticizing the elite for setting a bad example, and inspiring every "doctor," "soldier," and "barber" to imitate foolish foreign styles:

> In *English* garb, we know plain common sense
> To modish understanding gives offense;
> . . . Whilst fan-tailed folly, with *Parisian* air
> Commands that homage sense alone should share.[35]

The fashion in men's attire changed as more and more people came to perceive sober male dress as being a reflection of patriotism (versus aristocratic cosmopolitanism), liberty (versus tyranny), country and city (versus Court), Parliament and Constitution (versus royal prerogative and corruption), virtue (versus libertinism), enterprise (versus gambling, frivolity, and dissipation), and manliness (versus a fribbling, degenerate exotic effeminacy).

Ultimately, Macaroni fashion seems to have been doomed by its association with values that were in the process of being rejected by English society. The point is well made in a Gillray print of 1779 entitled *Politeness*, in which John Bull and a frog-eating Frenchman exchange insults. The Frenchman—delicate, richly dressed, and bewigged—can be read as a symbol of what the Macaronis stood for and identified with. He is rejected by British patriotism personified. John Bull, stuffed with beef and porter, plainly dressed, and proud of his liberties, was embraced by his countrymen as a symbol of themselves. The Macaroni was not merely a *petit-maître;* he was part of a rear-guard defense of continental and courtly styles and values, destined to be routed by plain-dressing John Bull.

The phenomenon of plainer male dress spread from England to France in the 1770s and 1780s, as part of a wave of Anglomania that sometimes

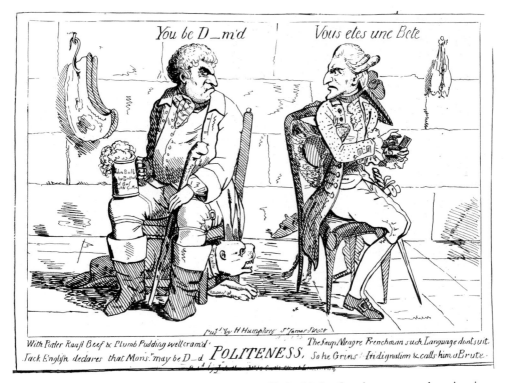

You be D__m'd *Vous etes une Bete*

With Porter Roaft Beef & Plumb Pudding well cram'd
Jack Englifh declares that Mons.r may be D__d **POLITENESS**, The Saup/Meagre Frenchman such Language dont suit.
So he Grins Indignation & calls him a Brute.

This Gillray print of 1779 shows John Bull, stuffed with beef and porter, exchanging insults with a frog-eating Frenchman, whose elaborate dress and high powdered wig give him a close resemblance to caricatures of the Macaronis. Courtesy of the Trustees of the British Museum.

(but not always) implied an appreciation of English political liberties. The French *philosophes* had admired the liberal politics of England and the supposed virtuous simplicity of country life—both elements of which were at least implied by the English style of informal country dress. The portrait of Sir Brooke Boothby (1781) by Joseph Wright epitomizes the influences that flowed back and forth across the Channel. Frequently reproduced in fashion histories, it is best described by Quentin Bell:

> The young man has thrown himself upon the ground and this for the excellent reason that he wants to return to Nature. Above him the freely growing trees of the forest; by his side the running brook; beneath his hand a MS copy of *La Nouvelle Heloïse*. He wears the mildly amiable look of a virtuous philosopher; he also wears a suit cut by a first-rate tailor. It is a suit carefully designed for a Natural Man who is also the eldest son of a baronet; it is no way gaudy or ostentatious, it has an air of high luxury (a quality so evident

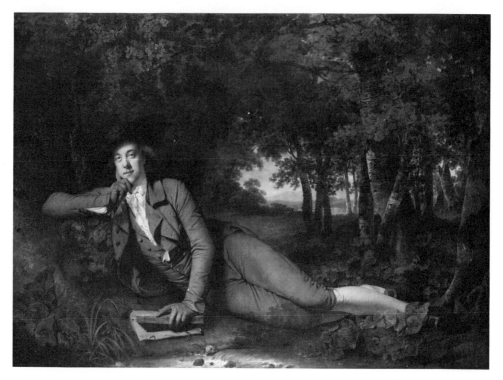

Contrary to popular belief, the development of the modern male suit was not simply a reflection of the growing power of the bourgeoisie. Darker, plainer male attire originated several decades *before* the French Revolution, and derived in part from the country clothing of the English aristocracy. The portrait of *Sir Brooke Boothby* (1781) by Joseph Wright of Derby displays the clothing of the future. As Quentin Bell wrote: "It is a suit carefully designed for a Natural Man who is also the eldest son of a baronet." Although "in no way gaudy or ostentatious, it has an air of high luxury." Courtesy of the Tate Gallery, London.

that we cannot but wonder anxiously whether, when the young man gets up, he will not discover that he has been lying on a cow pat) and this derives entirely from its beautifully discreet cut. These are the clothes of the future. . . .[36]

The *habit à la française* and the *habit à l'anglaise* existed side by side in the Paris of the 1770s and 1780s. They even merged to some extent, as the informal frock coat was produced in both its plain English version and in a more highly decorated and form-fitting French style. The English riding coat was also adopted as *la redingote,* along with a host of other horsey customs and accoutrements, such as buff breeches, greatcoats with three capes like those worn by English coachmen, jockey caps, jockey boots— and, for that matter, jockeys, horse-racing, and driving one's own carriage.

But how did Frenchmen react to the invasion of this English style? Mercier described in detail how "this English folly" was all the rage in the 1780s. In his view, it implied no real appreciation of English liberties, and he patriotically argued for a return of the French style.

> Rich man's son, sprig of nobility, counter-jumper—you see them dressed all alike in the long coat, thick stockings, puffed stock; with hats on their heads and a riding-switch in their hands. . . . This is well enough; the dress is neat and implies a most exact cleanliness of person. But at the first sentence exchanged, the familiar Parisian ignoramus peeps out from under the islander's hat. . . . And though he dresses like a citizen of London, head high, Republican air and so on, you need expect from him no proper appreciation of serious questions.
>
> No, no, my young friend. Dress French again, wear your laces, your embroidered waistcoats . . . powder your hair . . . keep your hat under your arm, in that place which nature, in Paris at any rate, designed for it . . . wear your two watches at once. Character is something more than dress. . . . Keep your National frippery, and in that silly livery talk your fill of nothing. . . . Have we nothing to learn from Englishmen other than the tailor?[37]

Looking back on the decade before the Revolution from the perspective of the Napoleonic years, De Segur recalled how aristocrats began to dress like their valets. "By ceasing to respect the public," he believed, they had ended by forgetting "all the nuances in society." Similarly, Charles James Fox came to think that "The neglect of dress in people of fashion had contributed much to remove the barriers between them and the vulgar, and to propagate levelling and equalizing tendencies."[38] Yet, in dressing like valets and coachmen, had they originally intended to assert any such democratic (or quasi-democratic) ideas? Probably only in a limited sense, going little further than the idea of a constitutional monarcy and "republican virtue."

Much of the imitation of the English style was undoubtedly "merely" fashionable, and much of the contemporary response proves that John Bull was not the only cultural nationalist. The *Petit Dictionnaire de la Cour et de la Ville* (1788), for example, commented sourly:

> Soon Paris will be completely English. Dress, carriages, hair, jewelry, drinks, entertainments, gardens, and morals, everything is in the English style. We have taken from this wretched people le vauxhall, le club, les jocqueis, les fracs, le vishk, le punch, le spleen, & la fureur du suicide.[39]

Some French fashion magazines earnestly advised men not to adopt "the silly manner of the young Englishman . . . for [he] lacks that liberty and freedom which produces the grace that distinguishes the Frenchman."

Illustrations and news about the latest fashions had appeared sporadically since the sixteenth century, but only really became popular in the

second half of the eighteenth century when the French began exporting fashion illustrations. In 1786, there was even a unique exchange of engravings between England and France: *The Fashionable Magazine or Lady's and Gentleman's Monthly Recorder of New Fashions, being a compleat Universal Repository of Taste, Elegance, and Novelty for Both Sexes* appeared in London, including illustrations that reappeared several months later in the provocatively named French journal, *Le Magasin des Modes Nouvelles Françaises et Anglaises.*

There was, however, a slight difference in editorial policies, as *The Fashionable Magazine* insisted that "London now, generally speaking, gives Fashions to Paris, and, of course, to all Europe and not Paris to London." The French, however, referred to "robes Franco-Anglomanes" and said that fashion influences moved back and forth across the Channel. "The English copy in London the fashions of Paris; the French wear on the banks of the Seine English fashions."[40]

The Chemise Dress

Eighteenth-century women's fashions are extremely complex, so a much abbreviated synopsis will have to suffice. The formal *grand habit* was increasingly abandoned in favor of the *robe volante* or floating sack dress. The straitlaced found this negligée style to be the "equivalent of nudity," and wholly inappropriate for use outside the boudoir. Indeed, in England, tight formal dresses continued to be worn: "They are always laced, and 'tis rare to see a woman here without her Stays on, as it is to see one in Paris in a full Dress."[41]

The sack dress evolved into a form known throughout Europe as the *robe à la française* which became more fitted, at least in front, with Watteau pleats hanging loosely down the back. The little bustle characteristic of late seventeenth-century dress was abandoned in favor of hooped petticoats called paniers, which extended on either side. Increasingly, the skirt was open in front to reveal a decorative petticoat that was part of the garment, while the front of the bodice displayed a triangular stomacher. Court dress was stiff-bodied, highly decorated, and worn over enormous paniers. Even an "ordinary" *robe à la française* was highly decorated, made of patterned silks covered in ribbons, ruffles, furbelows, and lace.

Les modes à l'anglaise initially entered France under the guise of sporting clothes, especially in the form of the quasi-masculine riding habit, which was based on the man's habit. The English style was characterized by a close fit over the waist and a boned bodice; the fullness of the skirt was pushed toward the back over a false "rump." Another typically English style was a buttoned dress inspired by the man's redingote; still another was the large and elaborate hat. The real impact of English fashion, how-

ever, came in the 1770s and 1780s, when it merged with classical and colonial styles. After the French Revolution, when the English were allowed to visit France again, they usually failed to recognize their own influence on the Paris modes, so alien did the French and English appear to one another.

Before the rococo gave way to the classical style, the trimming of a dress was more important than its cut, since the shape of dresses changed only slowly. As a result, the couturières were less influential than *les marchandes de modes*—a term only very inadequately translated as milliners. Even wealthy and fashionable ladies might keep their dresses for a number of years, but they retrimmed them frequently, and that was where the milliner came in with her stock of ribbons and lace. At this time, the structure of the fashion industry was still arranged along the lines of the medieval guilds.

Until 1675, the tailors had made clothing for both men and women, but then the *maîtresses couturières* branched off to make various feminine garments. Meanwhile, the mercers' guild supplied the trimmings, and the milliners were an offshoot of this guild. Soon the more famous milliners began to encroach on the work of the couturière, or at least to reduce her to a purely subsidiary role. "Much of the credit for this take-over bid by the modiste was due to the greatest *marchande de modes* of all, Rose Bertin, whose flair for publicity and ability to catch the popular mood made her the Ministre de la Mode in Paris."[42]

Rose Bertin was the most famous milliner, in part due to her association with Marie Antoinette, whom she visited twice a week. Bertin's other clients had to come to her establishment on the rue Saint-Honoré, where they endured her boasting about her relationship with the Queen. The Baroness d'Oberkirch, for example, recalled that "Mademoiselle Bertin seemed to me an extraordinary person, full of her own importance and treating princesses as equals." Her "jargon" was "amusing," but it "came very near impertinence if one did not hold her at arm's length, and degenerated into insolence when one did not nail her to her place."

Bertin was not the only dealer in fashion and finery. Oberkirch also called at Baulard's, explaining that "he and Alexandrine used to be the most celebrated, but Bertin has dethroned them." One wonders if she was amused or annoyed when Baulard kept her "for more than an hour while he held forth against Mademoiselle Bertin, who put on the airs of a Duchess, and was not even a *bourgeoise*." Everyone seemed jealous: Once, at Versailles, Bertin spat in the face of another rival, a Mademoiselle Picot, who promptly sued her.

Lawsuits benefit the historian, as well as the attorney. How else would we know about mesdemoiselles Aymez and Degouste, who set up shop together in 1789 in gallery no. 199 of the Palais-Royal? They quarrelled, and Degouste opened a rival shop at no. 220. In 1791, Aymez "brought

proceedings against her for throwing ink at her shop and window display."[43]

Evidence for debts also survives: When Marie Antoinette exceeded her dress allowance of 120,000 livres—by an additional 138,000 livres—her Lady of the Wardrobe had to request a special grant. Thus, we know that in 1785, Rose Bertin was paid 27,597 livres as a dealer in fashions, plus 4,350 livres for lace. Hers was the largest share, but her competitors also profited: Dame Pompée received 5,527 livres, Demoiselle Mouillard (who did the children's clothes) 885, and Dame Noël 604. A tailor named Smith, who specialized in English riding habits, got 4,097 livres. Much of the rest went for jewelry.[44]

There were many milliners and dressmakers, although most have been forgotten today, unless they achieved fame in other fields. For example, one of the major players in the Affair of the Queen's Necklace—the self-styled "Countess de la Motte-Valois"—recalled being apprenticed as an adolescent to Mademoiselle Lamarche, "one of the most fashionable couturiers in Paris" but "also one of the busiest, and the heavy work was hardly appropriate for a person with a constitution as delicate as mine." After a breakdown, she "was sent back to work, to another modiste, a Madame de Boussol, at the stupendous salary of two hundred francs a year. The new situation being even more disagreeable than the last, I suffered a relapse." Working her way down, she entered the employment of a Madame Coulon, lingerie maker: "Thimble and needle may well be the most suitable practice for my sex, but not for me, and certainly not at a wage of twelve sous a day!" But when she left Madame Coulon to become a kind of servant, she soon wished herself back: "How enviable the dressmaker's art now seemed to me!"

One can hardly blame her for turning to a life of crime. At one point, her con game involved hiring another milliner and part-time prostitute called Oliva to impersonate the Queen at a midnight tryst in the so-called Grove of Venus. Oliva testified that, on this occasion, "The self-styled Countess de Valois personally took charge of my costume. She . . . attired me in a dress of finest white *linon mouchete* [lawn] made, as best I can remember, *en gaule,* a popular style more frequently referred to now as a chemise."[45] This bizarre account is highly revealing, for why should Marie Antoinette's impersonator wear a simple white chemise, instead of an elaborate brocade dress?

After all, fashion historians have told us that the chemise dress only came into fashion during the course of the French Revolution, as the expression of an entirely new way of thinking:

> The aristocratic stiffness of the old regime in France is completely mirrored in the brocaded gowns of the eighteenth century. The republican yet licen-

tious notions of the Directoire find their echo in the plain transparent dresses of the time.[46]

Moreover, the clothes worn before and after the Revolution are so different that we seem justified in assuming that the Revolution somehow *caused* this profound sartorial change. And yet here we have criminals at work before the Revolution, dressing the "Queen" in a chemise dress—and successfully duping a Cardinal of the highest blood, who continued to insist to the end of his days that he *had* met Marie Antoinette that night. And why not, since the real Queen did wear dresses *en gaule*—at least sometimes.

Elizabeth Vigée-Lebrun's portrait *Marie Antoinette Wearing a "Gaulle"* (c. 1783) provides visual proof that sartorial revolutions were occurring even before the fall of the Bastille. Certainly, this simple frock was in startling contrast to the stiff and highly decorated dresses shown in Boucher's famous paintings of Madame de Pompadour or in Drouais's portrait of the Marquise d'Aiguirandes (1759). In fact, the picture of Marie Antoinette caused such a scandal that it had to be withdrawn from the Salon. According to one critic, "Many people have found it offensive to see these august persons revealed to the public wearing clothes reserved for the privacy of their palace."[47] Others attacked the Queen for damaging the silk industry of Lyons by favoring simple "foreign" fabrics.

Madame Vigée-Lebrun described the incident in her memoirs, emphasizing, however, the charm of the Queen's dress and her own *succès de scandale:*

> I painted several . . . portraits of the Queen . . . I preferred to paint her without grand attire. . . . One of them shows her wearing a straw hat and dressed in a white muslin robe, the sleeves of which were crimpled crosswise but fairly tight. When this portrait was exhibited at the Salon, the evil-minded did not fail to say that the Queen had had herself painted *en chemise;* for . . . slander had already begun to make her its butt.
>
> Nevertheless, this portrait had great success. Towards the end of the exhibition, a little play called . . . La Réunion des Arts, was performed at the Vaudeville. . . . When the turn came to Painting . . . I saw the actress copy me . . . in the act of painting the Queen's portrait. At the same moment everybody in the boxes and parterre turned towards me and applauded me tumultuously. And I do not believe it is possible for anyone to be so moved and grateful as I was that evening.[48]

The royal family commissioned another painting of the Queen, but this one showing her in formal court dress and together with her children—an obvious attempt to emphasize her position and social function.

The artist herself was rather an interesting figure with avant-garde taste in clothes. She recalled that in the 1780s, she "spent very little on clothes.

In this respect, I was even accused of being too careless, for I always wore white dresses of muslin or linen, and never had any ornamental dresses made except for my sittings at Versailles." In other words, when she went to court to paint Marie Antoinette, she had to wear court dress, but otherwise she wore the simplest Parisian styles. This was certainly not for lack of money, since at this time she made as much as 70,000 livres ($210,000) a year. Rather, as she explained, "I had a horror of the costume that women wore then." And in her paintings, she often "made great efforts to give them a more picturesque look." Apart from winding vaguely classical scarves around her sitters, she also sometimes persuaded them not to use powder and wigs which she "loathed." In fact, she even claimed credit for helping to popularize the new look: After her sitting, "the Duchess [de Gramont-Caderousse] retained her coiffure and went in it to the theatre. Such a pretty woman was sure to set the tone, and indeed the fashion grew greatly, until at last it became general."

Pretty, rich, and fashionable herself, Vigée-Lebrun gained celebrity for her parties as well—especially for one in which all the guests wore Grecian costume. Since her "atelier was full of draperies used for [her] models," the guests were "transformed into perfect Athenians" as soon as they arrived. Men had their powdered wigs taken from them—assuming they had worn them when visiting a hostess who "detested them, so much so that I once refused a rich suitor because he wore a wig." Their own "tresses were undone at the side" and they were crowned with laurels. Since the hostess "always wore a white dress like a tunic," she "needed only to put a veil and a chaplet of flowers on [her] head."[49]

Clearly, the development of the chemise dress was related to a more widespread classical trend that affected all the decorative and fine arts. Vigée-Lebrun's "perfect Athenians" ate off "Etruscan" plates, and at least some of them shared the Enlightenment enthusiasm for the philosophy (and politics) of the ancient Greeks and Romans. Yet when my first book, *Fashion and Eroticism,* was published, some reviewers misunderstood me to believe "that political and social revolutions have little influence on dress fashions." In fact, I made the significantly different point that "Whatever connections they might have with the wider culture and with social change, styles of dress are clearly and more directly related to earlier styles and to the internal process of fashion change." Moreover, it cannot be emphasized too often that world historical events—like the French Revolution—do not themselves precipitate dramatic changes in fashion—such as the Empire style. Rather, the roots of the change in fashion *precede* the great event.[50]

After the fall of the monarchy in 1792, women's dress became progressively more "undress" and pseudo-classical, especially in Paris. Under the Directory (1795–1799), the Consulate (1799–1804), and the Empire (1804–

1815), these trends were further accentuated, but they did not originate either during the radical phase of the Revolution or during the reaction that followed the reign of terror. Although we call the chemise dress "the Empire style," in fact "the world of the first Empire . . . only prolonged the last period of a fashion born before 1789, a fashion which, lasting almost a third of a century, was inspired by . . . that of the Antique."[51]

The influence of the Enlightenment provided the context within which French ladies began to favor a simple, "undress" style, at least for informal occasions. The English sporting style merged with another "virtuous" and "natural" style, that of neoclassical dress. Indeed, in all the arts, there was a movement away from the three-dimensional rococo and toward the "pure" straight lines of classicism. Furthermore, there is some evidence that the chemise dress had colonial, as well as classical and English antecedents. Much of French eighteenth-century wealth was based on Caribbean sugar—and Creole ladies understandably favored cool, light, white fashions. Both the material and the indigo that (with bleaching) tinted it to a striking bluish white came from the tropics, however much they were popularly associated with the pellucid atmosphere of Mediterranean Greece and Rome.

The chemise dress developed within a fashion tradition in which informal, negligée styles repeatedly emerged. The seventeenth-century mantua, the early eighteenth-century *robe volante*, the English sporting style, the chemise dress—all originated as informal or semiprivate dress, but made their way into a more public and formal realm, in the process becoming themselves somewhat more formal. But there is a trend over time toward increasing public acceptance of informality—or, rather, a constant redefinition of "formality." A little more than a decade after Vigée-Lebrun's private party, women would stroll through the gardens of Paris looking more or less Athenian.

3
The Revolution: Liberty, Equality, and Antiquity

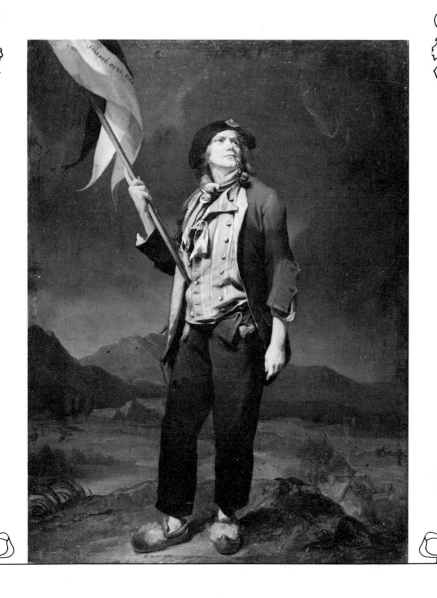

Boilly's *Portrait of the Actor Chenard in the Costume of a Sans Culotte* shows the clothing associated with the most radical phase of the French Revolution. It must be emphasized, however, that Robespierre and most other revolutionaries did *not* wear *sans-culotte* clothing. In terms of the history of fashion, the most significant feature of Revolutionary dress was the replacement of aristocratic knee-breeches by working-class trousers. Hence, of course, the name *sans-culotte* (without breeches). Musée Carnavalet; photograph courtesy of the Musées de la Ville de Paris, © SPADEM 1987.

Le costume étant le plus énergique de tous les symboles, la
Révolution fut aussi . . . un débat entre le soie et le drap.

Balzac, *Traité de la vie élégante*, 1830

I walk in Paris," wrote Mercier, "but what a change has come over
it!"[1] Almost ten years after the fall of the Bastille, seven years after the
royal family was arrested, five years after Robespierre was guillotined—
the revolution continued. These were the years of the "white terror," so
called to distinguish it from the radical phase of the revolution. Now the *sans-
culottes* and Jacobins were hunted down, arrested, and murdered by the
conservative Thermidorian government. Napoleon's star was just begin-
ning to rise, and the return of the Bourbons was still more than fifteen
years away. Throughout the years of revolution and counterrevolution,
fashion was very much a political issue.

As historian Lynn Hunt has shown, "Politics were not confined to verbal
expression." Symbolic forms of political practice were also significant.
"Different costumes indicated different politics, and a color, the wearing
of a certain length of trousers, certain shoe styles, or the wrong hat might
touch off a quarrel, a fistfight, or a general street brawl." In her recent
book, Hunt quotes from a "typical" proclamation of 1797:

> It is a contravention of the constitutional charter . . . to insult, provoke, or
> threaten citizens because of their choice of clothing. Let taste and propriety
> preside over your dress; never turn away from agreeable simplicity. . . .
> RENOUNCE THESE SIGNS OF RALLYING, THESE COSTUMES OF
> REVOLT, WHICH ARE THE UNIFORM OF AN ENEMY ARMY.

In 1797, the "costumes of revolt" referred to the clothing of "ROYALIST
CONSPIRATORS." But Hunt found that by 1798, an illustrated political
brochure was stressing the sartorial differences between good republicans,
called "the independents," and militant *sans-culottes*, "the exclusives." The
clothing of middle-class "independents" was a sign of their political virtue
and moderation. It was clean and respectable, but not luxuriously aristo-
cratic; they wore "close-fitting pants of fine cloth, ankle boots, morning
coats, and round hats." By contrast, the plebian "exclusives" wore dirty
and slovenly clothing, short jackets, coarse woolen trousers, and "out-

landish hats." Other categories included the "sell-outs" *(les achetés)* who "never had their own look," the "systematics" who changed their costume with the prevailing political winds, and the "fat cats" *(les enrichis)* who wore luxurious and counterrevolutionary dress.[2]

The Revolution marked the end of the vestimentary *ancien régime*, and the beginnings of a new liberty of dress. But this liberty was always constrained by the politics of the day. When the Estates General were convened in 1789, the members dressed in the costumes appropriate to their respective estates. The First Estate (the hereditary nobility) wore gold-trimmed cloaks and hats with white plumes; the clergy wore religious costumes; and the Third Estate (the commoners) had to wear magistrates' caps without braids or buttons and black knee-breeches with short black capes. In effect, this was the formal black uniform decreed for legal officials, but black already carried more general bourgeois connotations.

The significance of these sartorial distinctions was not lost on the Parisian public, who protested both the vestimentary discrimination and the tripartite division of the "Congress." Soon, the more radical members of the Third Estate declared that they represented the people of France, and they regrouped to form a new unitary legislative body, the National Assembly, which they invited the others to join. From being a humiliating caste mark, the dark suit now became a symbol of political virtue, at least in contrast to formal Court dress.

The political meaning of clothing was apparent to everyone when, in 1792, the revolutionary official, Roland, went to a meeting of the king's cabinet dressed in an ordinary suit, shoes without buckles, and only lightly powdered hair. By ignoring the minute regulations that governed court etiquette, he was making an obvious and radical statement about their essential irrelevance.

Chateaubriand recalled the early years of the Revolution—1789 and 1790—as a whirlwind of political, literary, and theatrical events, and of stylistic variety:

> Walking beside a man in a French coat, with powdered hair, a sword at his side, a hat under his arms, pumps and silk stockings, one could see a man wearing his hair short and without powder, an English dress-coat and an American cravat.

The ragamuffin *sans-culottes* cheered revolutionary actors, "and the beautiful Mme. de Buffon could be seen sitting by herself in a phaeton belonging to the Duc d'Orleans, waiting at the door of some club." More ominously, from Chateaubriand's point of view, the National Assembly was divided between royalists, liberals, and radicals, and was even invaded by "the ladies of the Market, knitting in the galleries." At one stormy evening session, Chateaubriand noticed "a common-looking deputy mount the tri-

bune, a man with . . . neatly dressed hair, decently clad like the steward of a good house or a village notary who was careful of his appearance. He read out a long and boring report, and nobody listened to him; I asked his name: it was Robespierre." Using the language of clothes and with the advantage of hindsight, Chateaubriand concluded, "The men who wore shoes were ready to leave the drawing-rooms, and already the clogs were kicking at the door."[3]

The men without shoes were usually referred to as the *sans-culottes*, because instead of wearing upper-class knee-breeches, they wore long loose trousers. Instead of a coat, they wore a short jacket called a *carmagnole*. Instead of an aristocratic three-cornered hat or a more "patriotic" round hat, they generally wore some type of cap, perhaps even the infamous *bonnet rouge*. At first *sans-culotte* clothing was only worn in the popular quarters of the city and in the working-class suburbs. But after the fall of the monarchy in 1792, a popular commune was formed in Paris, and workers' clothing temporarily assumed a certain status among some revolutionaries. The actor Chenard wore *sans-culotte* costume on the occasion of the Fête de la Féderation of 1792.

Sans-culotte clothing was not worn, however, by many of the most important revolutionaries. Robespierre, for example, attended the Festival of the Supreme Being (8 June 1792) clad in a cornflower-blue suit, nankeen breeches, a tricolor sash, and a hat with a tricolor cockade. In a portrait from about the same time, he is shown in a striped vest and coat, a ruffled cravat, and powdered hair.

It is likely that the perceived unsuitability of popular dress contributed to the attempts to design a new costume for French citizens. Thus in 1793 or 1794, the artist David designed a Greco-Roman costume with a tunic and large cape. It was probably never worn, although a later version, intended as the official uniform of the leaders of the Directory, had at least ceremonial use. The failure of these official togas is unsurprising, and ultimately less significant than the fact they were introduced at all. Clearly, middle-class revolutionaries (whether radical Jacobins like Robespierre or moderate to conservative Thermidorians) were unhappy with the downward leveling implied by *sans-culotte* dress.

The most controversial element in *sans-culotte* costume was the red cap of liberty. Resembling the phrygian caps worn by freed slaves and convicts, it was intended to remind wearer and viewer of the people's newfound liberty. While *sans-culotte* patriots argued about whether all citizens should be "allowed" to wear the liberty cap, more establishment politicians, such as the members of the Convention, had a profound aversion to the red bonnet.[4]

Unlike the *bonnet rouge*, the tricolor was a symbol that all republicans could support. In 1789, red and blue were chosen as the revolutionary

colors of Paris, and Lafayette later persuaded the revolutionaries to include white also, as a symbol of unity with the king. Such symbolic colors had previously been the prerogative of princes. Indeed, diehard royalists continued to flaunt the white cockade (for the Bourbons) or the green cockade (for the Comte d'Artois). The very concept of "national colors" symbolized the triumph of popular sovereignty. In the early stages of the revolution, even the king wore "an enormous tricolor cockade in his hat" and was hailed as "Father of the French and King of a free people," although, as Chateaubriand noted sarcastically, the people would soon cut off his head. It is clear, however, that Louis XVI never accepted the idea of a constitutional monarchy, and he wore the tricolor only reluctantly and under pressure.[5]

The tricolor was incorporated into numerous "revolutionary" fashions. Some of the early fashions *à la Bastille* were quite elaborate, such as a locket worn by Mademoiselle de Genlis that was "made from a stone of the Bastille, cut and polished, and bearing the word 'Liberté' in brilliants." Encircling the stone was a laurel wreath (in emeralds) fastened by a national cockade in blue, red, and white precious stones. There were also jewels, fans, and dresses *à la Constitution* and later *à la Federation.* All this was within the tradition of fashions and hairstyles commemorating public events from naval victories to the American War of Independence. Nevertheless, as the political situation changed, so did the dominant style of dress, which became increasingly sombre.

Fashion did not disappear entirely, but was increasingly governed by the principles of liberty, equality, and fraternity. The *Journal de la Mode et du Goût* (August 1790) presented a fashion plate of a "patriotic woman" wearing "the new uniform": a mannish black hat decorated with a cockade "in the colors of the nation," "hair without powder," a bodice designed to look like a jacket over a waistcoat, and a matching dark skirt. Other illustrations show women in simple, modest, vaguely "English" dresses, with rather high waists and the fullness of the skirt pushed in back. Powder and heavy cosmetics fell into disfavor as "aristocratic," as did high heels (much to the dismay of novelist and "foot fetishist" Restif de la Bretonne). According to the *Cabinet des Modes* (5 November, 1790): "Our way of living is becoming purified; extravagance and luxury are diminishing."[6]

Chateaubriand married in March 1792 and set out for Paris the next month with his wife and sisters:

> Paris in 1792 no longer looked the same as in 1789 and 1790; this was no longer the Revolution in its infancy. . . . The appearance of the people was no longer excited, curious, eager: it was threatening. . . . Variety in dress was a thing of the past; the old world was slipping into the background; men had donned the uniform cloak of the new world which as yet was merely the last garment of the victims to come. . . . One could sense the approach of a

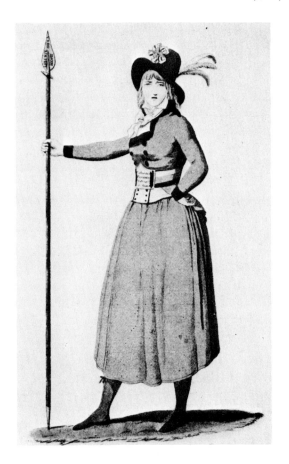

The fashions of the Revolution emphasized an egalitarian and austere style. An extreme example of *sans-culotte* dress is depicted in the print *Frenchwomen become free*. Note both her short skirt and the pike bearing the words "Liberty or Death." Reproduced from *Musée Rétrospectif* (Paris, 1900). Courtesy of the Fashion Institute of Technology Library.

plebian tyranny. . . . With the Parisian populace there was mingled an alien population of cut-throats from the south; the vanguard of the Marsaillais . . . could be recognized by their rags [and] their bronzed complexions.[7]

The upper-class fear of plebians, the northerner's fear of swarthy southerners, their tendency to regard the "other" as people of another race, even another species—all this must be taken into account when we read Chateaubriand's vivid picture. But it is probable that many middle-class Parisians also viewed the *sans-culottes* as a kind of slovenly and menacing rabble, with a considerable admixture of "foreigners" from southern French ports. From the vantage point of today's social historians, the *sans-culottes* appear as small Parisian shopkeepers, artisans, and apprentices, not the rabble but the people. As the Revolution entered a more radical phase, the *sans-culottes* tended to regard middle-class liberals as lukewarm patriots, at best, and at worst as counterrevolutionaries. It was wise to look like a citizen.

Rose Bertin fled to England, along with many of her clients, but other

dressmakers swam with the revolutionary tide. One dressmaker dropped the title madame and called herself citizenness, while renaming her shop the Maison Egalité. The *Journal de la Mode* gave its dresses names such as the *negligé à la patriote, redingote nationale,* and *déshabillé à la democrate.* The *"caraco* of the people" (a simple jacket and skirt) was popular in the early 1790s. But the editor of the *Journal de la Mode et du Goût* attempted to promote a dress with a "white gauze pouf *à la contrerevolution"* (in the issue of 25 May 1791)—an imprudence which may have contributed to the demise of his magazine. From 1794 through 1796, fashion magazines ceased to exist in France.[8]

Simplicity of dress might be a political statement, a matter of economic necessity, or a form of protective camouflage. Thus, in 1793, a middle-class acquaintance of Madame de la Tour du Pin pretended to be a "fervent demagogue" while hiding aristocrats in his home. He was disguised in "the rough frieze jacket known as the 'carmagnole,' sabots, and a saber."[9] Chateaubriand himself escaped from France wearing the uniform of a member of the National Guard. Yet when he joined the Army of the Princes, he disapproved of its clothing distinctions:

> The nobles of my province had provided seven companies; to these was added an eighth consisting of young men of the Third Estate: the steel-grey uniform of this last company differed from that of the seven others, which was royal blue with ermine facings. Men attached to the same cause and exposed to the same dangers perpetuated their political inequalities by these odious distinctions.[10]

And he was aware of the irony when Austrian troops "insulted the colors [of the National Guard] in which France was soon to dress a subjugated Europe."

Liberty of costume and equality of dress were fundamental to the French Revolution, in its early as well as its radical phases. The constitutional monarchist, Mirabeau, had thundered against inequality of dress in one of his more popular speeches. An early decree of the National Assembly abolished distinctions of dress, abrogating earlier sumptuary laws. Later, by a decree of the 8th Brumaire of the Year II (29 October 1793), the Convention declared that

> No person of either sex can force any citizen or citizenness to dress in a particular fashion, under pain of being considered and treated as a suspect [i.e., a counterrevolutionary]. . . . Each is free to wear such clothing or attire of his sex that he chooses.[11]

Initially, the concept of "liberty of costume" meant an end to clothing distinctions based on differences between aristocrats and commoners. It was the reestablishment of these distinctions within the Army of the Princes

that appalled Chateaubriand. As the Revolution became more radical, however, there was an additional attempt to suppress sartorial differences based on socioeconomic class. For several years, the fear of being considered and treated as a counterrevolutionary considerably limited the individual's theoretical freedom of dress.

The Directory: Incroyables and Merveilleuses?

Under the Jacobin Reign of Terror, the *sans-culotte* was praised as a patriot (although controlled as an independent political actor); the quasi-fashionable bourgeois was in danger of being denounced as a *muscadin,* or counterrevolutionary dandy. For women, the white muslin chemise dress was frowned on, "as recalling too vividly the attire of the Ancien Regime."[12] Thus, the chemise was seldom portrayed in illustrations of revolutionary Paris—except in depictions of civic festivals when selected women were dressed in classical garb to represent the Goddess of Reason. The style did not disappear entirely: Vigée-Lebrun's *Portrait of the Comptesse de Buquoi* (1793) shows her in revealing Grecian attire. And even during the height of the Terror, there are references to Parisian dandies. But it was really only after the Ninth of Thermidor—and the execution of Robespierre—that there was a genuine revival of fashion.

Most fashion histories describe the Directory period in lurid terms: "Fashion reverts to the Greek and Roman period—classical dresses—transparent draperies—The 'Merveilleuses'—Indelicacy of their costume—Seminude women in the Champs-Elysées." In the annals of masculine fashion, it was the period of the *incroyable,* the *muscadin,* and the *jeuness dorée:* "The Incroyables wore their collars so high that they almost covered their gold-ringed ears, and the tails of their frock coats trailed on the ground. Further exaggerations included indecently tight trousers hiked to northerly waistlines just beneath the armpits. . . . The Merveilleuses and Incroyables were parvenues . .. [and] Royalists. In the manner of their spiritual descendants, the zoot suiters of the 1940s, the Teddy Boys of the 1950s and . . . the . . . Mods, they spent an inordinate amount of money on their clothes." It was a time of luxury and license.[13]

According to Mercier, the Incroyables looked "so like the recent and amusing print which bears their names that truly I cannot look on it as caricature." Female fashions were even more outrageous:

> The women . . . all go in white. The bosom is bare, the arms are bare. . . . The bodice is cut away and beneath the painted gause rise and fall the reservoirs of maternity. A chemise of transparent linen gives a view of legs and thighs encircled with gold and diamond bangles. . . . It is yet another impudence of the *Merveilleuse.* The flesh-colored tights . . . excite the imagi-

nation and expose the shape and allurement without any reservation. And such is the day that follows the yesterday of Robespierre.[14]

Were men walking caricatures? Did women really go topless in transparent dresses?

The stereotyped picture of royalist fops in ludicrous clothes is seriously misleading. For the poor, this was an exceptionally harsh and disheartening period. By any definition, only a handful of people qualified as the incredible, perfumed, and gilded youth. At the very least, we must recognize that the Merveilleuses and Incroyables can hardly have been typical of their period, but rather represented an extreme version of modish behavior, and were perceived as even more outrageous than they were.

After the fall of Robespierre, there was a 180-degree change in the political connotations of dress. In its effort to stamp out Jacobin and popular opinion, the Thermidorian government "organized the *jeuness dorée* into armed bands filled with draft dodgers, deserters, shop boys, and law clerks encouraged by their employers."[15] They wore an exaggerated version of English coats and cravats, not because they were royalist emigrés who had just returned from England—they were mostly young bourgeois and riff-raff—but because this was a development of prerevolutionary high fashion. Not only were they unleashed politically by the conservative (but still republican) regime, but they were also released from popular pressure to conform to anti-fashionable dress. On the other hand, *sans-culottism* in dress, speech, and behavior was now proscribed.

By 1797—the year that fashion magazines reappeared in France—the chemise dress returned to the Paris scene. This, too, represented a continuation of prerevolutionary fashion, after a hiatus of several years. The style did become more physically revealing than when Marie Antoinette had appeared *en gaule*—but existing dresses from the period are by no means as "transparent" and obscene as Mercier indicates. The stories about Merveilleuses wetting their dresses to make them cling to their naked bodies seem to be based on nineteenth-century satires. It is primarily in comparison with previous styles that the chemise dress looked naked; muslin is relatively more fluid and transparent than heavy silk or wool, but the dresses were never see-through. Some women did abandon stays in favor of a kind of bust-bodice—but this hardly justified the pompous moralizing of later fashion historians, who claimed that "The disappearance of corsets is always accompanied by promiscuity."

Cultural histories of the Directory have been largely restricted to diatribes about the frivolity and immorality of Parisian society. We read that dissolute parvenus and tasteless *nouveaux riches* danced every night in provocative costumes at balls *à la victime*. In reality, a conservative bourgeoisie was fighting a war on two fronts—against popular left-wing forces and

against a royalist and religious right wing. The Directory style in fashion (and interior decor) developed out of this socioeconomic and political milieu.

There was a revival of high society and a veritable "war of symbols," in which the "egalitarian and austere . . . conception of the revolution" lost to an aggressive and ostentatious style. As historian Denis Wornoff puts it: The *bonnets rouges* and the *sans-culotte* style were replaced by the deliberately foppish style of the *jeunesse dorée*. "Poverty became a stigma, the hungry became 'starvelings' *('faméliques')*, the citizennesses of the people 'bitches'. . . . Everyone attempted to rise above their present status." And all of this was reflected in a self-conscious dedication to fashion.[16]

In his brilliant study, *Death in Paris, 1795–1801*, Richard Cobb describes the clothing of suicides and victims of sudden death who ended in the records of the Base-Geôle de la Seine, the predecessor of the Paris morgue. More than any other historian of the period, Cobb has unraveled "the language of clothing and livery"—and he has come up with a picture of Paris fashion that is very different from those in standard histories. Many of the women who drowned themselves in the Seine "first of all put on what must have been pretty well the whole of their existing wardrobe, filling themselves out with skirt after skirt, bodice after bodice." We don't know whether they attired themselves to die, or whether they habitually wore all their clothes to keep them from being stolen. Their clothes are repeatedly described in the records as poor or wretched *(mauvais):* poor skirt, poor stockings, poor vest in different colors, "everything very poor."

> But the monotony of such pathetic litanies is liable all at once to be broken with the description of some article or other of clothing that, even if it has seen better days, is still reminiscent of past luxury and of present timid pretension: a range of silks, some shot and shimmering, elaborate braiding, dulled, but still weighted in skilled craftsmanship, stuffs in complicated colours, immense handkerchiefs in bright, reassuring checks, canary-coloured waistcoats, with horn or moleskin buttons, even a few smart bottle-green *redingotes* with high collars at the back . . . a 36-year-old carpenter represents, no doubt intentionally, a symphony in blue: 'veste de drap *bleu*, un gilet de velours de coton *bleu* rayé en lozange, un pantalon de coutil *bleu*,' a brilliant blue, not the pale colour of charity.[17]

The range of liveries seen before the Revolution had become broken and scattered. Elements from military uniforms—like brass buttons engraved with *République Française* and the embroidered frogs of Hussar jackets—appeared on the bodies of civilians, women, and children. Did their original owners die, were they robbed, did they sell their clothing piece by piece? Clothing of the past and present were jumbled together, occupational clothing and regional costume—the only thing missing was a cock-

ade: neither a tricolor nor a white, green, or black royalist cockade appears in the records.

As Napoleon rose to power and French armies advanced across Europe, military uniforms increasingly influenced high fashion, "with young men prominent in the cowardly ranks of the class 'armies' of the *jeunesse dorée*, who have absolutely no intention of risking themselves on any battlefield further away than the Palais-Royal, affecting high military collars *à la hussarde* and tightly buttoned topcoats." But as Cobb points out, "the poor and the very poor were certainly not concerned with such collective manifestations of political conformism and creeping militarism that . . . had begun to infect Paris from the Year III onwards." Indeed, he emphasizes that "their clothing had at no time reflected the passing modes affected by that minority of the population that lived at a disputatious political level." Even when *sans-culotte* fashion dominated, it was really only "sedulously followed by small and vociferous groups of middle-class demagogues." The majority of *sans-culottes* themselves had simply continued to dress as they always had, and didn't trouble themselves to adopt the carmagnole unless it was already part of their customary dress.[18]

Meanwhile, at the pinnacle of society, Napoleon crowned himself Emperor and reestablished Court dress, thus in a sense ending both political and sartorial efforts at liberty and equality. Court dress for women was still classical in form; for men it combined military stiffness with aristocratic luxury. Napoleon's own clothes tended toward uniforms, both civil and military. For ceremonial occasions, he had recourse to imperial robes that recalled the "Grand Costume de France" worn by the Renaissance king, Henri IV.

Then Napoleon fell from power and the Bourbons returned. Many of the emigrés came back wearing English clothes, but they were soon being dressed by people like the celebrated Leroy of Paris, former dressmaker to the Imperial court. Boucher suggests that Leroy may have modified the Empire style in deference to his new clients' preference for fuller English skirts and longer waists. Although entirely possible, such occasional modifications were ultimately irrelevant: Fashion, and the decorative arts in general, were in the process of shifting from the now old-fashioned classical style to the romantic and historicizing neo-gothic. The fashions of both the *ancien régime* and the Republic were rapidly disappearing, however much certain aristocrats might want to turn the clock back to the feudal past. According to Uzanne, under the Restoration (1815–1830):

> Every one in the royal assembly did his best to present transcendent ideas for a vestarian counter-revolution. . . . People spoke of abolishing the long redingotes . . . and the long breeches. Nobody, however, came forward to present a reasonable solution capable of rallying all suffrages, and Louis

XVIII, fatigued with so much vain chatter, put an end to the discussion by writing . . . "What would you think, my dear Dreux-Breze, if we returned to the ruffs of our great-great-grandmothers?"[19]

4
Parisian Types

The elegant, coquettish Parisienne is preferable to the Venus de Milo any day, declared Balzac. And although his fictional heros usually had flashier mistresses (such as actresses or duchesses), other writers maintained that the "most incontestibly Parisian" woman was the *grisette,* a figure who held a special place in the pantheon of Parisian types. She was usually described as being a seamstress, milliner, or dressmaker. The word *grisette* referred to her grey wool dress, but contemporary accounts insist that despite her "humble" and "cheap" clothes, she was nevertheless "pretty" and "smart." In Gavarni's illustration for *Les Français peints par eux-mêmes* (1840–1842), the grisette is shown delivering a package.

La toilette est l'expression de la société.

Balzac, *Traité de la vie élégante*, 1830

Honoré de Balzac was born at Tours in 1799, the year of Napoleon's coup d'état. He came to Paris when he was twenty; like so many of his characters, he arrived wearing the provincial clothes that his mother had given him. Within a few years, however, he met several fashionable ladies and began ordering his clothes from Buisson, a well-known tailor on the rue de Richelieu: One month a walnut-colored redingote, a black waist-coat, steel-grey pantaloons; the next month black cashmere trousers and two white quilted waistcoats; later thirty-one waistcoats bought in a single month, part of a plan to buy three hundred and sixty-five in a year. By the end of 1830, he owed his tailor 904 francs and his bootmaker almost 200—twice the sum he had budgeted for a year's food and rent. But he believed that good clothes were a necessity for an ambitious young man from the provinces out to conquer Paris.

Eighteen-thirty was also the year he wrote his "Treatise on the Elegant Life," which first appeared in the literary and fashion magazine *La Mode*. Balzac was becoming a successful writer—even a theorist of dandyism. But for all the money he spent, and for all his interest in clothes, Balzac's contemporaries agree that he was appallingly poorly dressed. According to the Baronne de Pommereul, Balzac was a fat man whose badly made clothes made him look even fatter. The painter Delacroix criticized Balzac's sense of color, the way he wore a black vest with a blue coat. Madame Ancelot said that when Balzac was working on a book, his clothes were neglected and even dirty, and when he went into society he adopted an elaborate and bizarre style "which astonished his friends and which he laughingly called an *advertisement.*" He was famous for working in a slovenly dressing-gown, and strolling along the boulevards carrying a magnificently eccentric jewelled cane.[1]

Captain Gronow was surprised and disappointed at Balzac's appearance:

Balzac had nothing in his outward man that could in any way respond to the ideal his readers were likely to form of the enthusiastic admirer of beauty

and elegance in all its forms and phases . . . The great enchanter was one
of the oiliest and commonest looking mortals I ever beheld; being short and
corpulent, with a broad florid face, a cascade of double chins, and straight
greasy hair . . . Balzac had that unwashed appearance which seems gener-
ally to belong to French *litterati*, and dressed in the worst possible taste, wore
sparking jewels on a dirty shirt front, and diamond rings on unwashed fin-
gers . . .[2]

Gronow was the biographer of the notorious Regency dandy, Beau Brum-
mel, the idol of all French dandies. Unfortunately, many of them (like
Balzac) completely misinterpreted the austere English dandyism that they
were ostensibly copying. One of Brummell's cardinal rules was "clean linen—
and plenty of it" and he abhorred the ostentatious use of jewelry. In fact,
there was something distinctly vulgar about Balzac's brand of fashionable
self-promotion—or at least something more enthusiastic, self-consciously
artistic and Bohemian than strictly dandiacal.

Balzac might have been fat, slovenly, and vulgar in real life, but he knew
what the elegant young man was supposed to look like. And he created a
host of dandy characters, from Charles Grandet to Eugène de Rastignac
and Lucien de Rubempré. When we think of his characters, we see them
in the clothing of the Romantic era. This takes no leap of the imagination:
Balzac created more than two thousand characters, and he described the
clothing of almost every one of them in minute detail.

Balzac shows his characters' vanity, their embarrassment, their self-
consciousness, and their obliviousness to their clothed appearance, but he
never once implies that they should concern themselves with more "im-
portant" things. Clothes *are* important to Balzac. Not only do they place a
character within a particular social, spacial, and temporal setting, but they
also express his (or her) personality, character, ambitions, inner emo-
tions—even destiny. "The question of costume," argues Balzac, "is one of
enormous importance for those who wish to appear to have what they do
not have, because that is often the best way of getting it later on."[3]

From the Provinces to Paris

Lucien Chardon was a handsome young man, by the standards of 1820.
He was of average height, slender, young, and graceful. His facial features
were Grecian; his complexion had "the smooth whiteness of a woman's
skin"; his hair was wavy and fair; he had an angelic mouth with coral lips
and impeccably white teeth; he had the elegant hands "of a well-born man."
If this doesn't sound feminine enough, we also learn that "Any man look-
ing at his feet would have been tempted to take him for a girl in disguise,
the more so because, like most men of subtle . . . mind, he had a woman's
shapely hips." In short, although he was only a poor provincial, he had

precisely the right type of body to wear the latest fashions. The fashionable silhouette—for men as well as women—was shaped like an hourglass, with a padded chest, cinched waist, and flared hips. Small hands and feet and delicate facial features were regarded as signs of refinement and aristocratic blood. As his friend David observed, "you look like a gentleman."[4]

Standards of appearance in the provinces were not very strict: In his blue coat with yellow buttons, plain nankeen trousers, the shirts and cravats made by his adoring sister, Lucien is accepted in Madame de Bargeton's salon. It also helps that he has adopted the aristocratic name "de Rubempré," to which he was only distantly entitled. (This was not the kind of thing to bother Balzac, who adopted the particle "de" without having any right to it at all.) Of course, Lucien is not *well* dressed; he is guilty of wearing boots instead of shoes, but his sister soon saves the money to buy him elegant shoes from "the best shoemaker in Angoulême" and a suit from the best tailor. Nevertheless, he looks shabby in comparison with his rival, Monsieur du Châtelet, whose portly figure is clad in dazzlingly white trousers "with straps under the feet to keep the crease," and a black coat "commendable for its Parisian style and cut."

Madame de Bargeton, age thirty-six, had learned to dress in Paris and returned to Angoulême with the reputation of being both fashionable and artistic. Lucien is ravished by the sight of her in her medieval hairstyles, her oriental turbans and berets, her rather theatrical attire. The other provincial ladies were also "consumed with the desire to be taken for Parisians," but only succeeded in looking absurd in their "home-made dresses" in "incompatible color-schemes." (Their husbands looked even worse.) Although Madame de Bargeton shines in comparison with these ladies, there are already hints that she is trying too hard to look *artistic:* her turbans indicate literary pretensions, and her pink and white dresses are much too youthful. Precisely because she has no competitors, she has fallen into provincial bad taste.

When she and Lucien run off to Paris together, each begins to be more critical of the other's appearance: Lucien sees his mistress in a Paris salon where "[t]he proximity of several beautiful Parisian women, so elegantly and daintily attired, made him aware that Madame de Bargeton's *toilette,* though passibly ambitious, was behind the times: neither the material nor the way it was cut, nor the colours were in fashion. The hairstyle he had found so seductive in Angoulême struck him as being in deplorable taste." Of course, she is thinking much the same thing about Lucien: "The poor poet was singularly handsome, but he cut a sorry figure. His frock coat, too short in the sleeves, his cheap provincial gloves and his skimpy waistcoat gave him a prodigiously ridiculous appearance in comparison with the young men in the dress circle."[5]

Wandering through the Tuileries, watching the passersby, Lucien dis-

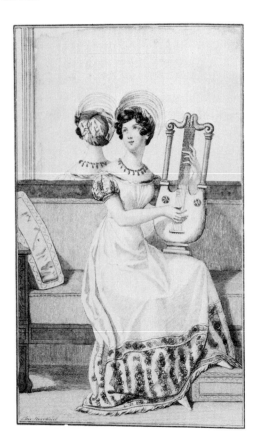

A fashion plate from the *Petit Courrier des Dames* (1822) shows the type of white cashmere dress and decorative, "exotic" turban that Madame de Bargeton admired. Notice also the format and iconography of the fashion plate, especially the mirror (so useful for showing the back of a hat or dress) and the suitably feminine musical accessory.

covers just how badly he looks: "In the first place, not one of these elegant young men was wearing a cut-away coat: if he saw one at all it was worn by some disreputable old man, or some poor down-at-heel, or a *rentier* from the Marais quarter." Even his good looks do not help him: "Would any young man have envied him his slender waist, concealed as it was by the blue sacking he had hitherto taken for a coat?" His waistcoat is so embarrassingly short and provincial that he buttons up his coat all the way, to hide it. Only now does he understand the difference between morning and evening wear—the crucial importance of being dressed appropriately for the time and place. Moreover, styles that were acceptable, even fashionable, in the provinces have in Paris trickled down to the working class—and been abandoned by anyone with pretensions to elegance: "only common people were wearing nankeen trousers." Elegant men wear white or patterned trousers that are stretched tight with foot-straps, not hanging loosely over their boots. Even his white cravat, which his sister had lovingly embroidered for him, turns out to be virtually identical to one worn by a grocer's errand-boy—and his poor sister had thought it the

height of fashion when she saw it worn by several gentlemen in Angoulême. Lucien realizes with horror that he looks like an uncouth shop assistant and, poor as he is, he rushes to the tailors of the Palais Royal, where he spends 300 francs "to re-equip himself from head to foot."[6]

But when he goes to the Opéra that evening, the attendant sizes up Lucien's "borrowed elegance" and refuses to let him enter. Nor does he favorably impress Madame de Bargeton when she finally escorts him in. In comparison with the dandy, Monsieur de Marsay, Lucien looks "starched, stilted, stiff, and raw." De Marsay thought that Lucien was "dressed like a tailor's dummy"—and, indeed, in clothes tighter than he had ever worn, poor Lucien felt rather like "a mummy in its case." They all wore their clothes with such easy elegance, thought Lucien, whereas he felt as though he were dressing up for the first time in his life. Bitterly, he realized that his coat was too exaggerated, his waistcoat in bad taste—that he would have to go to a first-rate tailor.

So the very next day, he goes to the German tailor Staub, to a new linen-draper, another shoemaker. Out of the 2,000 francs he brought to Paris a week before, 360 remain. As he writes to his sister, you can get waistcoats and trousers here for 40 francs (already far more expensive than in the provinces), but a good tailor charges at least 100.

It is typical of Balzac to mention names and prices; indeed, there is some evidence that he deliberately promoted the shops he patronized—as a way of partially making up for the fact that he was always years behind in paying his bills: Charles Grandet, for example, came back from Paris with two suits by Buisson. But, beyond that, Balzac believed in the importance of tailors and their colleagues: "Rastignac understood the influence that tailors exercise on the lives of young men." In Balzac's novels, a change in appearance heralds a change in personality—and thus a change in destiny. Lucien's sartorial metamorphosis is presented as a necessary stage in his social ascent; only now is he ceasing to be a provincial and becoming a real Parisian.

De Marsay's role is significant, because he shows how Lucien's personality also must change. Lucien is a poet and thus sensitive and passionate. De Marsay is cold, egotistical—and elegant. Moreover, as De Marsay explains, "women love fops," because fops love themselves. In other words, Balzac is implying that *Lucien can only be a successful dandy when he is less of a poet.* Here is Balzac's explanation for his own sartorial failure. He is an artist, attracted to jewels and bright colors, and without the steely self-control necessary to restrict himself to severe, understated elegance. Similarly, Madame de Bargeton only becomes truly elegant when she renounces her own artistic tastes and "dresses like any other leader of society."[7]

Balzac was ambivalent about dandyism, even as he praised it in the pages

of *La Mode*. According to his "Treatise on the Elegant Life," there were three classes of modern beings:

> The man who works;
> The man who thinks:
> The man who does nothing.

They have, respectively, three forms of existence:

> The busy life;
> The artistic life;
> The elegant life.[8]

Much as he admired "the sentiment of fashion," Balzac was personally too busy for the elegant life. But, then, he was such a single-minded artist that he is reported to have said once, after sex, "There goes another book."

Within the context of Balzac's novels, Lucien's sartorial transformation functions primarily to show how "the great man from the provinces" is becoming a true Parisian. Madame de Bargeton's goal is also *se désangoulêmer,* to shed all her provincial modes and manners, and to become a Parisienne.

Dandyism Goes to France

But to be an elegant Parisian dandy was to be an imitation Englishman. *Dandysme* and *anglomania* dominated Parisian society from the Restoration through the July Monarchy. Many French aristocrats (like Chateaubriand) returned from exile, partly English in manner and tastes. Also influential were the thousands of English officers and tourists who flooded into Paris in the years after 1815. "The English dandies took Paris much as Wellington had taken Waterloo," writes Ellen Moers. Yet, as she points out, the French were confused about precisely what they were copying.

Was the dandy an understated gentleman who sprang from nowhere and established himself as the social equal of princes—like Beau Brummell? Balzac enthusiastically approved of "BRUMMEL!" (even if he misspelled his name). Or was he the aristocratic, horsey sportsman (or "centaur"), as Balzac also indicated in his "Treatise on the Elegant Life"? Was he the "fatal man" of English Romanticism? As Moers points out, "Anglomania made the dandy and the romantic one and the same, though the two had scarcely met at home. It was not unusual for an *anglomane* to show his enthusiasm for the defeat of Napoleon by dressing one week as a dandy, and the next as a *chevalier* out of *Valtre-Scott*."

Now there was a style for every position. There were *ultras* in knee-breeches . . .; liberals flourishing in their grey hats; bonapartists wearing the imperial frock coat with large gold buttons. There were feminists in men's clothes, *à*

la George Sand; blues in turbans, *à la* Mme de Stael. There were followers of Byron with artificially pale faces and wild hair. There were followers of Scott who wore tartans. . . . There were followers of Dumas with velvet capes and swords, *genre moyen-âge;* followers of Gautier and Hugo with *pourpoints à la Van Dyck, polonaises à brandebourg, redingotes hongroises, genre pittoresque.* The impetuous *Jeune France* could be distinguished from his more subdued opponent, the classicist, by the famous *gilet rouge:* it was the *flamboyants* against the *grisatres.*[9]

The Romantic dandy copied his clothes from historic personages. Although he favored the Middle Ages especially, he occasionally wore fashions from the first great French Revolution. The horsey English dandy was perhaps the most popular, although the style had little to do with Beau Brummell's codification of the plain masculine uniform and his redefinition of what it meant to be a gentleman. In 1823, the year that Lucien conquered Paris society, the magazine *La Pandore* complained about the mania for English fashions: *"Le fashionable . . .* has made of his valet de chambre a *groom,* and a *djaky* of his coachman. *Boy* is the term he always uses with a garçon de cafe." He drinks tea even though it irritates his nerves, because he must imitate the *"gentlemen* of London." Naturally, he must employ only an English tailor to make his redingote.[10]

De Marsay imitated the Beau's cold personality and his severely correct style of dress. His name, however, is clearly derived from the real "butterfly dandy," the Anglo-French Count d'Orsay, whose taste in dress tended toward pastel silks, jewelry, and perfume. Lucien also observed de Marsay and Rastignac on horseback, escorting Madame de Bargeton's carriage to the Bois de Boulogne, thus introducing the theme of houseback riding. Out of the range of anglomaniac options available, Balzac chose colorful flamboyance for himself and monochromatic elegance for Lucien.

Men had not yet abandoned fashion, color, and luxury, although their clothing was inexorably moving toward sobriety. In the 1820s, the all-black uniform was worn mostly for formal evening functions, where it carried romantic and dandiacal associations, very far from the respectable daytime black of the later nineteenth century.The revolutionary replacement of knee-breeches by trousers was only partially complete: Tight-fitting pantaloons were visually closer to knee-breeches than to the loose trousers of the working class. Near the end of *Lost Illusions,* Balzac describes Lucien in the evening fashions of 1823:

> Lucien was now being lionized; he was said to be so handsome. In conformity with the fashion reigning during this period, to which we owe the transition from the former ballroom breeches to the ignoble trousers of our day, he had put on black, tight-fitting trousers. Men's clothes were still cut close to the figure, to the great despair of skinny or misshapen people: Lucien's proportions were those of a Phoebus Apollo. His grey open-work stockings, his

In 1823, the year that Lucien conquered Paris society, *le lion* was the term used to describe the masculine leaders of fashion. "Men's clothes were still cut close to the figure," wrote Balzac. From Lucien's "black, tight-fitting trousers" and open-work stockings to his "black satin waistcoat, everything was fitted, one might say moulded to his person." The fashion plate from *Costume Parisien* (1823)—featuring a coiffure in the style of Monsieur Plaisir, black broadcloth coat, silk vest, cashmere trousers, and open-work stockings—verifies Balzac's accuracy as a fashion historian.

elegant shoes, his black satin waistcoat, his cravat, everything in fact was scrupulously fitted, one might say moulded to his person. His fair, abundant, wavy hair enhanced the beauty of his white forehead, round which the curls rose with elaborate gracefulness. . . . The beauty of his small, feminine hands was so enhanced by his gloves that one might have thought that they should never be seen bare. He modelled his deportment on the famous Parisian dandy de Marsay, holding in one hand his cane and hat.[11]

The Physiology of Fashion

By the time Balzac wrote about Lucien being "lionized," *le lion* was the term used to describe the masculine leaders of fashion. In the annals of slang, it succeeded *le fashionable* and alternated with *le dandy*. There was, in fact, a mania for using zoological terms: "A dandy would call his mistress *ma tigress*, if she were a well-born woman, and *mon rat*, if she was a

dancer. His groom was *mon tigre.*" One of the novels of the July Monarchy opened with the words: *"Le lion avait envoyé son tigre chez son rat."*[12]

According to the scientific theories of the early nineteenth century, human society could be analyzed according to a biological model: There were virtually different "species" of people, whose outward appearance corresponded to their inner character, just as the lion's teeth showed his carnivorous nature. Balzac wrote within the same tradition that produced the myriad little books known as *physiognomies* and *physiologies* that characterized the various social types of the great city. Indeed, in addition to his novels, Balzac wrote physiologies—such as the *Physiologie de la toilette*, subtitled "On the Cravat, considered in itself and in its connections to society." He also contributed to veritable encyclopedias, such as *The French Painted by Themselves* (1840–42) and *The Big City: A New "Tableau de Paris"* (1844), which included images and descriptions of the most Parisian types.

The characters in Balzac's novels, like the personages in his physiologies, were intended to correspond to the new urban types that flourished in the growing capital: the *lion*, the poet, the notary, the politician, the employee, the *rentier*, the military man, the actress, the *grisette*, the lady. Naturally, these people existed and, to a considerable extent, did wear distinctive styles of dress. But we must recognize that authors and illustrators alike preferred some of the characters of modern life to others, and their picture of the Parisian population is skewed, as well as being subject to a degree of satiric exaggeration.

No doubt, many notaries did wear their traditional black suits, but were young notaries really dandies who gradually shed their "butterfly" glamour for a drab chrysalis? Was it as easy to identify an employee then as it is to spot an office worker today? In the human *genus,* there were "a thousand species created by the social order," wrote Balzac. And one of his collaborators noted that there were "innumerable varieties" of employees alone. But they insisted that a glance at his badly tailored suit and baggy trousers was sufficient to say, "Voilà un employé."[13]

The appearance and habitat of each species were duly noted:

> The *rentier* stands between five and six feet in height, his movements are generally slow; but Nature, attentive to the conservation of weak species, has provided the omnibus by the aid of which the majority of *rentiers* transport themselves from one point to another in the Parisian atmosphere, outside of which they cannot live. Transplanted beyond the banlieue, the *rentier* wastes away and dies.

His clothing receives the same treatment:

> His large feet are covered with shoes that lace up, his legs are endowed with trousers in brown or in a reddish color; he wears checked vests of mediocre value. At home, he terminates in umbelliform caps; outside, he is covered by

hats costing twelve francs. He is cravated in white muslin. Almost all these individuals are armed with canes.[14]

Of course, Balzac himself was always armed with a cane—although a rentier who spent only twelve francs for a hat would never have carried a cane with a golden head studded with turquoise.

If workers wore caps, the hat was quintessentially bourgeois; but there were hats and hats. According to Balzac, a bohemian appointed to political office (under the July Monarchy) immediately changed his low, wide-brimmed hat in favor of a new hat whose design was "truly *juste-milieu.*" Retired imperial soldiers "took care to have their new hats made in the old military style," reported another writer. Even without his hat, the Baron Hector Hulot was immediately recognizable as a veteran of the Napoleonic army: He stands with "military erectness . . . his figure, controlled by a belt," wearing a blue coat with gold buttons, "buttoned high." Dominated by his erotic obsession with Valérie Marneffe, Hulot is lured into abandoning all personal and sartorial self-respect, and ends up in filthy rags, wearing, perhaps, one of those shabby old hats worn by rag-pickers and sold on the street by the old-clothes man.[15]

Despite his interest in fashion, Balzac apparently looked less like a fashion plate—and more like the *rentier* (another "Parisian type," here portrayed in an illustration by Grandville from *Les Français peits par eux-mêmes*). "His large feet are covered with shoes that lace up . . . he wears checked vests of mediocre value . . . he is covered by hats costing twelve francs. . . . Almost all these individuals are armed with canes."

Clearly, the audience for Balzac's novels was able to recognize the types portrayed and to appreciate (better than we can today) the nuances of their dress. We may recognize, for example, that Cousin Bette dressed like a prototypical "poor relation" and "old maid" in a hodge-podge of cast-off garments and vestimentary bribes. We may even sympathize when she gives up hope of marrying—and stops wearing corsets. But does the modern reader (especially the foreigner) fully appreciate the significance of Bette's expensive yellow cashmere shawl, her sallow skin, and her black velvet hood lined in yellow satin? Many of us have forgotten that yellow was traditionally the color of treason and envy. For Balzac's readers, both her dress and her physical appearance provided important clues to her inner character.

Yet, great as he was, Balzac could also be grossly oversimplistic in his use of clothing symbolism. Lucien's mistress, the actress Coralie, openly proclaims her sexual passion when she first appears wearing *red* stockings. Conversely, Hulot's virtuous and long-suffering wife habitually wears the *white* of purity. And the saintly prostitute, Esther Gobseck, dresses for her meeting with the banker, Nucingen, in bridal white—even wearing white camellias in her hair. Real people do not utilize such a transparent and unidimensional language of clothes, any more than bad guys wear black hats.

But if he ignored many subtleties, Balzac did know that clothing can lie. Indeed, he was highly conscious that fashion could subvert the theoretical connection between physiognomy and character—thus making of social intercourse a perpetual masquerade. Consequently, he pays particular attention to the clothing of people who are not what they seem to be. Valérie Marneffe has four lovers, but she usually dresses like a respectable married woman, in simple, tasteful fashions. According to Balzac, "These Machiavellis in petticoats are the most dangerous women"—far more to be feared than honest *demi-mondaines*.[16]

Balzac pays more attention to the clothing of wicked characters than of virtuous ones, and the worst villains frequently resort to disguises, the better to conceal their true character. In *Lost Illusions*, the master criminal Vautrin is dressed as a Spanish priest: His hair was "powdered in the Talleyrand style. . . . His black silk stockings set off the curve of his athlete's legs." In *César Birotteau*, the repulsive scoundrel Claporan normally wears "a dirty dressing gown, opening to show his undergarment," but when he goes into society he wears elegant clothes, perfume, and a new wig. Like criminals, police spies adopt innumerable disguises: In *The Chouans*, Coretin dresses as an Incroyable; and in *A Harlot High and Low*, we learn that Contenson also "could turn himself out stylishly when there was need," although "he cared as little about his everyday dress as actors do about theirs." He first appears to us in a repulsive and absurd costume, consist-

ing of "a bailiff's breeches, black and shiny . . . a waistcoat bought in the Temple, but embroidered and with lapels! . . . a coat of black turning red! . . . The silk hat shown like satin, but its lining would have yielded oil for two small lamps . . . an observer might have said to himself: 'There goes a squalid person' "—but beyond that, Contenson was "indefinable."[17]

This is great stuff—we can see, feel, and smell these disgusting clothes—but the overall picture is, of course, unduly melodramatic.

Balzac's images need to be seen in conjunction with other descriptions of contemporary dress. Thus, for example, the famous dandy Barbey d'Aurevilly argued in 1836 that what characterized the *lions* was their ferocious hatred for the upstart bourgeoisie. The date is significant, because in 1830 there was another revolution that ousted the reactionary Charles X in favor of the Orleanist prince, Louis Philippe. "It is difficult to avoid a cynical assessment of '1830'," writes historian Robert Magraw. "Despotism shifted from chateau to Stock Exchange." Louis Philippe became known as the Bourgeois King, his scepter the *umbrella,* traditionally the sign of a prudent nature and the lack of a carriage. In terms of high fashion, dandyism entered a new phase, and there was a resurgence of aggessively aristocratic symbolism: The *lions'* extremely fashionable dress was intended to distinguish them from the increasingly powerful protocapitalist bourgeoisie.

If the dandy went to France under the Restoration, than under the July Monarchy he went to press. For, although elegance might be partly a symbol of aristocratic reaction, it is also true that much of the dandy literature of the time was directed toward a mass audience. In fact, between about 1820 and 1860, there was a genuine "media explosion" that featured a wide variety of Parisian types and catered to an enormously expanded public, ready to consume words, images, and goods.[18]

The Working Woman as Artist, Aristocrat, and Erotic Fantasy

Although Balzac's heros usually had flashier mistresses—like actresses and duchesses—other writers contended that the "most incontestable Parisian" woman was the *grisette,* a figure who held a special place in the pantheon of Parisian types, and in the history of Paris fashion. She did not exist in other countries, claimed Jules Janin, nor even elsewhere in France. In his *Physiology of the Grisette,* Louis Huart defined her as "a young girl sixteen to thirty years old who works all week and has fun on Sundays. Her job: she would be a seamstress, a flower-maker, a glove-maker, a milliner."[19]

The term was eighteenth-century, and referred to her coarse grey dress, but although Mercier spoke of her, the grisette really only entered Parisian folklore during the 1820s and 1830s, when she appeared with her student lover in Murger's *Scenes of Bohemian Life* and in erotic prints like

Milliners Rising and *Student Days*. According to Huart and Janin, her trademark was not the grey wool dress, but rather the little pink hat with ribbons "and other such cheap charms." Despite her poverty, her "humble" and "cheap" clothes, she was nevertheless "pretty" and "smart." In the mythology of loose women, the grisette was the predecessor of the more mercenary *lorette* of the July Monarcy and the notoriously extravagant *grande cocotte* of the Second Empire. Unlike her successors, the grisette was not a kept woman or a courtesan, but a working woman. This was a crucial element in the stereotype.

In real life, dressmakers and seamstresses worked from nine in the morning until eleven or twelve at night and occasionally on Sunday. Alternating with this crushing work schedule were long periods of unemployment.[20] Except for the most skilled workers, wages were very low. Writing at the end of the nineteenth century. Octave Uzanne estimated that a good dressmaker's assistant might make 3.7 francs a day and, taking into account the slack season, perhaps 1,350 francs a year. Flower-makers might make 5 or 6 francs a day, but worked only four or five months of the year. Makers of fine underclothing, who tended to work on a piece basis, might make anywhere from 80 centimes per day during the off-season to 3 or 4 francs a day. Apprentices might make only 20 or 25 sous per day. As Uzanne notes drily, "These facts speak for themselves."[21]

Many working-class women sporadically turned to prostitution to survive. Meanwhile, middle-class men tended to regard poor women as legitimate sexual prey. At the same time, there is evidence that their feeling of guilt (or uneasiness about vice) contributed to the development of certain beliefs about the "morality" of grisettes. Thus, in the early part of the nineteenth century, we find a noticeable romanticization of the poor grisette: She is of easy virtue, but with a heart of gold. Later in the century, there is more of an emphasis on her supposedly mercenary and lascivious character. All this lends a rather unpleasant quality to the literature on the grisette.

Thus, in *The French Painted by Themselves*, Jules Janin dwelt at length on the grisette's poverty: She was "poor (Heaven knows *how* poor)" but also "touching and respectable," "ever laboring and busy"—and *happy* to perform her task: "to clothe the fairest portion of the human race." An "idle" grisette would no longer be "in the department of honest grisettes." She would pass "the slight boundary which separates her from Parisian vice." But: "Let's not speak of her—she will spoil our subject." Far better to dwell on the idea that

> these little girls, children of the poor, who will die as poor as their mothers
> . . . become the all-powerful interpreters of fashion throughout the entire
> universe.

The "romance" and "poetry" of female labor were favorite themes in the nineteenth-century literature, the more so when the women worked in a "luxurious" and "artistic" trade like fashion: "What more agreeable work than to have, without cease, between your hands, under your eyes, velvet, silk, flowers, feathers." In fact, despite the very large numbers of women in the sewing trades, probably at least as many women worked as domestic servants—but this job was harder to romanticize, more obviously drudgery. Factory workers, laundresses, tradeswomen, and shopkeepers also received less attention than "the workers of elegance," whose poverty and hard work could be given a spurious gloss by virtue of the glamour of their profession.

This was a portrait of the working woman as artist and as erotic fantasy, and even as a kind of natural "aristocrat." The ubiquity of the concept was such that Janin was only slightly hyperbolic in praising the grisettes as

> our elegant duchesses of the street—our countesses who walk on foot—our fine marchionesses who live on the labor of their little fingers—our gallant aristocracy of the workshop and counter . . . all who are poor, and fair, and young!

The grisette was "content with little—content with nothing." She wanted only "a little love." In Janin's view, it was natural that "these pretty little countesses of the rue Vivienne" should be attracted to the law and medical students who flocked to Paris to study and revel. It was equally natural (though sad) that, having graduated, the middle-class student should abandon his "little friend" for "a few acres of land or a few bags of money, that his provincial bride brings him as her dowry." In most cases, the grisette would eventually marry within her own class:

> Thus, she passes from an amorous poet to a brutal husband, from laughter to tears, from merry poverty to harsh indigence. All is finished for her. . . . She does not die, luckily, without leaving a good provision of grisettes to succeed her.

Rather implausibly, he added that, occasionally, a "virtuous" grisette might marry "a great lord," and exchange "her humble garments, her simple neckerchief, and worn shawl, for diamonds, cashmeres, and embroidered dresses."[22]

The milliner was even more fascinating than the ordinary grisette. In another chapter of *The French Painted by Themselves*, Maria d'Anspach maintained that "The grisette is only a worker, the milliner is an artist." Unlike Janin, d'Anspach dismissed the average grisette as a mere seamstress, whose "coarse and purely manual labor" bore little resemblance to "the elegant works that escape from the imagination and the industrious hand of the milliner." A true creative artist, the milliner was frequently "author" of "a masterpiece." She constantly invented new models of hats

and revived earlier styles; and even when the basic substructure of the hat was simple, she decorated it artistically with ribbons, flowers, and feathers, creating a "harmonious ensemble." Although poor, "she loves all that is beautiful and distinguished. The *comme il faut* is her religion . . . to which she clings like a Rohan to his coat of arms."[23]

This comparison with one of the greatest noble families of Europe was intentional, for milliners were perceived as the ultimate aristocrats of the working class. As Uzanne wrote in his sympathetic study of Parisian women:

> The milliners are the aristocracy of the workwomen of Paris, the most elegant and distinguished. They are artists. . . . Their ingenuity in design seems limitless.[24]

Clearly, the word aristocracy is being used in a special way, indicating both the milliner's relatively higher pay and standing within the working class and her status as an *artist*—that is, a member of what might be called the "new aristocracy of art."

According to d'Anspach, the milliner was "a poor girl," perhaps "an

According to *Les Français peints par eux-mêmes* (1840–1842), "the grisette is only a worker, the milliner is an artist." The "romance" and "poetry" of female labor was a favorite theme in nineteenth-century literature. The milliner, especially, was frequently described as an "artist" and "aristocrat." "The *comme il faut* is her religion . . . to which she clings like a Rohan to his coat of arms." For maximum effect, this image of *The Milliner* by Eugene Lami should be compared with paintings on the same subject by Degas, Manet, and Eva Gonzales.

orphan too well raised to be a simple worker and too little instructed to be a teacher, or . . . the daughter of an artisan" who was alienated from the "coarseness" of her class, which was in such contrast to the "elegance and *politesse*" of those with whom she comes in contact at the millinery shop. Indeed, from d'Anspach's point of view, the "mere" middle-class student from the Latin Quarter—with his pipe in his mouth and his lack of gloves—was himself too humble a lover for the Right Bank milliner. Thus, one of her milliners is made to say:

> Oh! why do we no longer live at the time when lords loved milliners so much, they were pleased to make them great ladies? They married them. Our seigneurs are the *dandys* who come to look at us through the shop windows, write us very beautiful letters, but do not marry us. . . . [Yet] bankers, Russian princes, and *my lords* sometimes visit fashion workshops as well as artists' studios, and if they buy a picture in one, they sometimes choose a pretty woman in the other.[25]

Such Cinderella fantasies obviously bore little relation to reality, although the lucky milliner might find a patron who would set her up in business for herself—as happened much much later to the great Coco Chanel.

Although hats were an important element in fashion, only an occasional milliner achieved real financial success. For example, later in the nineteenth century, Caroline Reboux, the fourth child of an impoverished noblewoman and a man of letters, was orphaned and came to Paris to work and marry. Eventually, she opened a millinery shop of her own on the rue Richelieu, serving a bourgeois clientele. Most milliners, however, worked as paid employees in such shops. A milliner's assistant might make 3 francs a day. The premières might make 2,000 and 3,000 francs a year, sometimes more. But only a clever and lucky milliner was able to open a shop of her own, and marriage to a man of higher class was most unlikely.[26]

Perceived by middle-class observers as "the industrious bees of fashion" or "the legion of laborious ants," how did the thousands of women in the Paris clothing industries regard themselves? According to Uzanne, there was at least one "not very successful strike" by late nineteenth-century dressmakers. But he observed that "The poor girls were soon obliged to return to their work . . . No deputy came to their assistance . . . Our democracy, based as it is on the suffrage, could not trouble itself about the fate of women who did not have the vote, and from whom there was nothing to fear."[27]

How different this sounds from d'Anspach's bland assertion that milliners rejoice at the "dead season" since this was their "vacation" time, when they left for the provinces, visited their families, or even wandered "to London, Vienna, St. Peterburg."[28] Lazy peregrinations were made by another group of people entirely.

The image of the grisette owed a great deal to the popular illustrators and journalists who first presented in the mass media a portrait of contemporary Parisian life. To be accepted by readers, she had to conform to the sterotypes associated with poor people, women, and Parisians. If the grisette was poor (even "very poor"), she was not supposed to resent this or try to escape her position in society. Thus, she was not supposed to use clothing to appear to be "better" than she was, nor was she to turn to prostitution. She *worked*—and then *gave* her sexual favors to young men of a "better" and more "elegant" class. Since middle-class people deplored and exploited female labor, it was not surprising that popular writers should emphasize a "nice" trade like making hats, which seemed both artistic and fashionable.

Since Paris was, by definition, elegant, and since elegance was associated with female erotic beauty, even the poorest woman had to be presented as elegant: Her clothing, though "humble," indeed "cheap," was nevertheless "pretty" and "smart." And yet, the working-class woman in Paris probably *was* often far more elegant than her counterparts in other cities. The industries of fashion were so ubiquitous and had reached such a high degree of quality that even Parisian ribbons were prettier than those elsewhere.

Fashion and the Modern Parisian Woman

The elegant, coquettish Parisienne is preferable to the Venus de Milo any day, declared Balzac. Nor was he the only one for whom feminine sexual beauty was closely associated with Paris fashion. The image of *la femme Parisienne* preoccupied French artists and writers from the Romantic period through the Belle Epoque. As envisioned by her contemporaries, she was not merely a female inhabitant of Paris, but rather the symbol of a particular type of woman. Indeed, according to the *Physiology of the Parisienne*, fully five-sixths of the women in Paris were "provincial in spirit and manners." Conversely, there might exist "graceful and spirited" provincials—"provided only that they do not live in the provinces." Uzanne, however, argued that "A woman may be Parisian by taste and instinct . . . in any town or country in the world." But he added that "In every class of society, a woman is *plus femme* in Paris than in any other city in the universe." "It is not that Parisian women are faultlessly beautiful," he wrote, "but that they have something better then perfect beauty." Perfect art.[29]

Long before Worth, fashion was already associated with recognized "names." It was enough to say: "The Parisienne is dressed by Palmyre. . . . She orders her hats from Herbeaux." Certainly, the great couturières of the July Monarchy—Mesdames Vignon, Palmyre, and Victorine—dressed many of Balzac's female characters, just as real tailors like Staub and Buis-

son dressed his heros. But both Balzac and the physiologists made it clear that clothes alone did not create the Parisienne (or her male counterpart). "Provincials put on clothes, the Parisienne dresses." The Parisenne's distinguishing characteristics were "taste and grace"—"those two nothings whose mixture is the most dangerous . . . of potions. The *je ne sais quoi!* that is to say, what captivates and subjugates men, pushes them to marriage, to suicide, to madness."[30]

In the mythology of Paris, there have been two somewhat contradictory themes. On the one hand, Paris was perceived (with some justification) as the ultimate cosmopolitan capital. According to *Paris and the Parisians:* "Paris belongs to all the world. . . . Each can come with his baggage of intelligence, industry, or talent." More especially, it was the symbol of France: "What is the Parisian? It is *le Français par excellence,* to the superlative." The Parisienne, argued Uzanne, was "every Frenchwoman." But, on the other hand, as we have seen, there was a rigid dichotomy between Paris and everywhere else. There were Parisians, and then there were "barbarians and provincials." Just as there was no room for "the slow pronunciation of France-Comte [or] the dragging endings of Normandy," the language of clothes was also restricted to the great tradition of the capital, and eschewed the little traditions of the provinces.[31]

Although Parisians regarded the provinces as backward appendages of the metropolis, dressmakers did occasionally incorporate into high fashion certain elements of traditional regional costume. Provinces such as Brittany seemed especially picturesque. More significant for fashion, however, were the "exotic" costumes of foreign lands. Indeed, as the French colonial empire expanded, Orientalism became a recurrent theme in Parisian fashion. The writer Théophile Gautier was only one of many Parisians to be fascinated by Algerian costume:

> It is strange [he wrote], we believe we have conquered Algeria, and Algeria has conquered us. Our women already wear scarves interwoven with thread of gold, streaked with a thousand colours, which have served the harem slaves, our young men are adapting the camelhair burnous. The tarbouch has replaced the classic cashmere skull-cap, everyone is smoking a nargileh, hashish is taking the place of champagne; our Spahi officers look so Arab one would think they had captured themselves with a smala; they have adopted all the Oriental habits, so superior is primitive life to our so-called civilization.
>
> If this goes on, France will soon be Mahometan and we shall see the white domes of mosques rounding themselves on our horizons, and minarets mingling with steeples, as in Spain at the time of the Moors. We should indeed like to live to see the day.[32]

As an arch-romantic, Gautier naturally despised the bourgeois top hat and other unpicturesque modern attire. At home, he often wore elements of Middle Eastern dress. Indeed, many perfectly conventional men favored

vaguely Oriental dressing-gowns, slippers, and caps (in the privacy of their homes).

The fashions of the Restoration (1815–1830) and the July Monarchy (1830–1848) began on a wave of aristocratic reaction and went out with another republican revolution, but the dominant theme throughout was the triumph of the bourgeoisie. As Marx said, the ruling ideas of any epoch are those of the ruling class, and this is no less true of fashion ideas. The fashions of the eighteenth century were essentially aristocratic, those of the nineteenth century bourgeois—but (and this is a very large *but*) nineteenth-century fashions continued to be very strongly influenced by aristocratic standards of taste. The "great notables" of early and mid-nineteenth century France were a combination of the old aristocracy, the Napoleonic nobility, and a high-financial oligarchy.

The slogan of the era was *"Enrichissez-vous"*— Get rich! For Parisians of both sexes, the question of elegance was inextricably connected to the redefinition of class and status in the wake of the French Revolution. According to Balzac, the "Parisian Lady" was "essentially a modern creation," and a product of the revolution. The "Great Lady" of the past no longer existed. *"La femme comme il faut*—this woman proceeding from the ranks of the nobility, or put forward from the bourgeoisie, coming indifferently from all parts, capital or province, is the type of the present time." Now, the Lady was for the fair sex what the Gentleman was for men, first in England, and then in France. Her clothing, like the clothing of the gentleman, emphasized good taste rather than the blatant luxury of the prerevolutionary elite.[33]

The modern Parisienne was a representative of both Society and modern society. But while the fashions of the Parisienne were decorative and everchanging, still partly aristocratic in the old sense, male elegance was slowly but surely being restricted to minute details of dress within the context of increasing blackness and uniformity. Furthermore, whereas the ideal of the Parisienne potentially embraced women across the social spectrum (from the lady to the milliner), the male ideal was much narrower socially. We find no apotheosis of the tailor comparable to that of the grisette; the tailor appears in physiologies more as a humorous type that as a hero in his own right. Instead, we see an increased focus on the idea that the gentleman dandy was the new "aristocrat" in a bourgeois capitalist world.

5
The Black Prince
of Elegance

Emile Duroy's *Portrait of Charles Baudelaire* (ca. 1844) shows the poet when he was a young, elegant figure clad in velvety black—"like a Titian portrait come to life," recalled his friends, and with the face of a "young god, a truly divine countenance uniting all elegances, all strengths, and the most irresistible seductions." According to Baudelaire, the dandy's "solitary profession is elegance," and black was the only acceptable color to wear. Musée de Versailles; photograph courtesy of the Musées Nationaux de France, Paris, © SPADEM 1987.

Eternelle superiorité du Dandy.
Qu'est-ce que le Dandy?

Baudelaire, *Mon coeur mis à nu*, n.d.

Whe we think of Charles Baudelaire, we imagine him as he looked in the Carjat and Nadar photographs of the 1860s—with deep lines etched in his face, with thinning and disheveled hair, and grim staring eyes. His clothes are unremarkable; usually we see little more than a voluminous black coat with a velvet collar, like a banker's coat, a glimpse of shirt, and a black satin cravat tied in the large loose bow of the literary man. This was the decade in which he wrote his famous essay, "The Painter of Modern Life," in which he argued that "Dandyism is the last burst of heroism in the midst of decadence." But the legend of Baudelaire the Dandy began long before, when he was a young poet in the early 1840s.

The portrait by Emile Deroy shows an entirely different Baudelaire: young, handsome, rich, and happy—a slender, elegant figure clad in velvety black with a white cravat like a necklace. He wears long, dark wavy hair down to his shoulders in romantic fashion. His slight pointed beard makes him look vaguely Christlike, but his sardonic look gives a strange, even satanic impression. He had the face of a "young god," said Theodore de Banville, "a truly divine countenance uniting all elegances, all strengths, and the most irresistible seductions." He sometimes looked "like a Titian portrait come to life, in his black velvet tunic, pinched in at the waist by a golden belt," remembered Hignard. At other times he wore plain black broadcloth, in suits of his own design, the products of innumerable fittings with his harried tailor. He dressed in coats with long narrow tails, open at the neck to show an expanse of shirt front; in tight trousers fastened under patent-leather shoes; in pale pink gloves. He looked, said LaVavasseur, like *"Byron dressed by Beau Brummell."* [1]

Charles Cousin, another old school friend, remembered "Baudelaire at twenty":

> . . . crazy about old sonnets and the newest painting, with his polished manners and conversation full of paradoxes, leading a bohemian life and a dandy to boot, a dandy above all, with the whole theory of elegance at his fingertips. Every fold of his jacket was the subject of earnest study.

Baudelaire's insistence on *black* clothing impressed Cousin, as it did all the poet's friends:

> What a miracle that black suit was, always the same, no matter what the season or the time of day! The dress coat, so gracefully and generously cut, its lapels constantly fingered by a beautifully manicured hand; the beautifully knotted cravat; the long waistcoat, fastened very high by the top button of the twelve and negligently gaping lower down to reveal a fine white shirt with pleated cuffs, and the corkscrew trousers fitting into a pair of immaculately polished shoes. I shall never forget how many cab fares their varnish cost me![2]

The ideal dandy, wrote Baudelaire, is "rich and idle"; his "solitary profession is elegance." When he came of age in 1842, Baudelaire established himself in a stylish apartment at the Hôtel Lauzun on the Ile-Saint-Louis. One of his neighbors was the young painter Boissard, in whose rooms Baudelaire smoked opium and hashish, and talked about art. Also in the same building lived Roger de Beauvoir, one of the best-known dandies of the 1840s, whose dress and lavish apartment were featured in *La Mode*. With an inherited income one-tenth that of Beauvoir's, Baudelaire strove to emulate his style of life. But he quickly ran through all his income and part of his capital. In 1844, horrified at his mounting debts, Baudelaire's family had him declared financially incompetent, thus bringing to a close his period as a rich dandy.[3]

Thus, it was only between 1842 and 1844 that Baudelaire could afford to devote considerable time and money to his appearance. During that period, he specifically rejected both the foppish style of the fashionable Right Bank *lions* and the flamboyance of the Left Bank bohemians. Dandyism in its Right Bank manifestation had definite social and political connotations, being in part a statement of aristocratic superiority. In practice, most *lions* adulterated pure Brummellian simplicity in the English style with doses of old-fashioned French aristocratic display. Meanwhile, on the Left Bank, the bohemians mounted a different sort of revolt against the bourgeoisie. Their clothing was often more or less deliberately slovenly and self-consciously artistic. If spotless white linen was the sign of bourgeois respectability, the bohemians would wear dirty shirts—or no shirts at all. In place of the top hat, they wore broad-brimmed Quakerish hats, plumed hats, berets, or caps. Their medievalism expressed itself in unorthodox dress, their frequent poverty in motley clothes—all of it, perhaps, epitomized in the outrageous costumes worn to Carnival balls.

Living on an island in the middle of the Seine, Baudelaire was also symbolically situated halfway between Left Bank bohemia and the fashionable Right Bank neighborhoods. In many respects himself a bohemian, a member of the intellectual and artistic subculture of Paris, Baudelaire never-

theless rejected much of the bohemian way of life, including its style of dress. Yet neither in dress nor in attitudes did he resemble the Jockey Club dandies of the Right Bank, whom he regarded as barbarians. In fact, his clothing was designed to set him apart from the bourgeoisie, the bohemians, *and* the conventionally elegant aristocrats.

At this time, despite the gradually darkening sartorial palette, black was far from being the only color men wore. Both *lions* and bohemians retained a fondness for color, even if only in the form of a bright waistcoat. According to the magazine *Le Dandy* (1838): "English black is the shade most worn, followed by blue, court green and dragon green; acorn and dark olive are reserved for demi-toilette. Riding or morning suits are in a very bright green color." And again, the same year, we read that "Dark blue is the color adopted this winter for dinners and visits. . . . For evenings and balls, black and brown are always exclusively adopted." In the daytime, cashmere vests "of various colors" are correct, as is tartan; for evening, "white satin lamé" is a good choice. For that matter, although "The black English suit with silk buttons is always required for *grande tenue* . . . one also permits, at a ball, fantasy suits [in] burned chestnut, golden bronze, [and] cornflower blue, with metallic buttons that are an agreeable diversion from the severity and monotony of black."[4]

Clearly, Baudelaire did not rely for advice on *Le Dandy. Journal special de la coupe pour messieurs les Tailleurs.* Baudelaire insisted on black: "always the same, at every hour, in every season." At the beginning, he occasionally used an accent of color, like the pale pink gloves and the cravat of red (*sang de boeuf*) that Nadar recalled. He may even have had one blue suit. Later, however, according to LaVavasseur, he wore all black, including a black cravat and a black waistcoat. He felt that black looked more *grave,* more serious and severe, and that it was more appropriate to "an age in mourning." Others, like Alfred de Musset, also regarded the nineteenth century as a period not of progress but of decline, and interpreted its color symbolism in the same way: "This black clothing that the men of our time wear is a terrible symbol . . . of mourning."[5] Rather than rejecting this doleful style, Baudelaire embraced and exaggerated it.

In addition, he designed all his clothes himself and insisted on the same meticulous attention to details that later almost drove his publishers mad. Even in an era when clothes were made to measure, he was known for demanding fitting after fitting. "Costume played a large role in Baudelaire's life," wrote Champfleury. He "wore his tailor out" trying to get coats "full of pleats," since "regularity horrified this nature full of irregularities." When he was finally satisfied, he would tell the tailor, "Make me a dozen suits like this!" Another anecdote states that he "glass-papered his suits so that they should not look too new."[6]

"I knew him when he was very rich and relatively poor," wrote Banville,

"and I always saw him, in the one and the other situation, as detached from material things, and superior to the caprice of circumstance. . . . His toilette, like his manners, were always those of a perfect dandy." But other witnesses of the late 1840s saw the evidence of poverty, although they also observed his spotless linen and clean boots. Toubin remembered him as wearing "a red cravat—though he was not a republican—rather loosely tied, and one of those sack overcoats that had been in fashion some while back, which he found useful to dissemble the gauntness of his frame." Sometimes Baudelaire was reduced to wearing a worker's overall on top of still elegant black trousers: "artisan above, dandy below," as one unsympathetic wit put it.[7]

In the years when utopian socialism was popular among intellectuals, Baudelaire delighted in scandalizing others with his reactionary opinions. But if his red cravat was not then a symbol of republican sympathies, he would later show a surprising affinity for revolutionary street fighting. Moreover, after he lost control of his finances, Baudelaire became not simply *déclassé,* but truly poor. Always slender, he was now gaunt, and frequently without the money for food or clothing. As he wrote to his mother during the winter of 1853–54, "I am so used to wearing two shirts under a pair of torn trousers and a jacket too threadbare to keep out the wind, I have got so clever at stuffing straw or even paper into my shoes to keep the wet coming through the holes, that I am scarcely conscious of anything but my moral distress." Many of his clothes disappeared permanently into the pawnbroker's. He sent his one overcoat to be mended but was unable to pay the derisory repair bill.[8]

Not only his clothes, but even his hair changed. At first, "his hair waved over his collar in elegant and perfumed locks," (as Champfleury put it). In his autobiographical novelette *La Fanfarlo,* Baudelaire described it as "hair pretentiously arranged in a Raphaelesque manner." But by the time the novel appeared in 1844–45, he cut his beautiful long hair and shaved his moustache and beard, explaining to Théophile Gautier that "it was puerile and bourgeois" to retain such "picturesque" elements of appearance. Wrote Champfleury: "His naked skull had a bluish tint due to his barber's razor."[9]

There was an element of posing in this: Hair cropped short was in the English fashion, and demonstrated his disdain for the self-consciously artistic look. But beyond that, it appears that Baudelaire was suffering from the onset of alopecia, a side effect of syphilis that causes the hair to fall out. A shaved skull concealed the ravages of the disease.

If many bohemians continued to regard him as something of a dandy, upper-class writers like the Goncourt brothers characterized Baudelaire as a "sadistic Bohemian," with a "correct and sinister" appearance. In a diary entry of October 1857, they wrote:

> Baudelaire had supper at the next table to ours. He was without a cravat, his shirt open at the neck and his head shaved, just as if he were going to be guillotined. A single affectation: his little hands washed and cared for, the nails kept scrupulously clean. The face of a maniac, a voice that cuts like a knife, and a precise elocution that tries to copy Saint-Just and succeeds.[10]

This hostile picture is nonetheless revealing. It is entirely possible that the poet who wrote, "I am the wound and the knife . . . the victim and the executioner," intended, in part, to appear simultaneously as a victim of the guillotine and as Robespierre's fanatical associate, Saint-Just (known as the Angel of Death). Baudelaire wore no cravat—in today's terms, no tie— but unlike other Left Bank figures who might also eschew such formality, his hands were perfectly manicured. To be a poet, it was not necessary to have ink-stained fingers; all that was merely the affectation of artiness. His precise elocution, like his exaggerated politeness, was both distinguished and ironical.

Far more than Balzac, Baudelaire succeeded in developing a personal ideal of dandyism. Balzac worked in an old monk's robe. He normally looked utterly dishevelled; and his sporadic dandyism was dependent both on wealth (or credit) and on a fashionable setting, such as a duchess's salon. Baudelaire required neither, since he never attempted to pose as a dandy for the fashionable world. If poverty forced him to dress simply, he had already begun to adopt a deliberately austere style. Photographs of Baudelaire from the 1850s (when he was in his thirties) still show the figure of a dandy: A picture of 1854, for example, reveals him in a handsome topcoat with a high, loose, stylish collar. His hand thrust inside the coat, in Napoleon's famous gesture, he was not beaten yet.

What Is the Dandy?

There are no dandies, as such, in Baudelaire's poetry, but he dealt with the subject sporadically in his intimate journals, where he wrote the cryptic lines, "The eternal superiority of the Dandy. What is the Dandy?"[11] He never fully answered the question, although dandyism plays an important role in two of his most famous essays: "On the Heroism of Modern Life" (a section of his *Salon of 1846*), and "The Painter of Modern Life" (1863).

Dandyism, he insisted, "is a modern thing, resulting from causes entirely new." It appears "when democracy is not yet all-powerful, and aristocracy is just beginning to fall." In other words, it was a phenomenon of the years in which he was writing. Baudelaire's attitudes toward the modern age were complex, however. On the one hand, he regarded it as a vulgar and materialistic age of "decadence," dominated by a philistine bourgeoisie. But he also insisted (perhaps partly ironically) that there was "an epic side" to modern life, and he vastly perfered "the garb . . . of the

modern hero" to the sight of some "little artist dressed up as a grand panjandrum"—pretending, in other words, to live in some other, greater, era.

He describes the modern clothing of the bourgeois male in ambiguous terms: "A uniform livery of affliction bears witness to equality." The "symbol of a perpetual mourning" is the "necessary garb of our suffering age." Any other type of clothing would be a vain denial of the realities of modern life. Even "eccentrics" have reluctantly abandoned their "violent and contrasting colors" for "slight nuances" in design and color. In this respect, Baudelaire firmly believed that *il faut être de son temps*.

"But all the same," asks Baudelaire, "has not this much-abused garb its own beauty?" Perhaps the fact that it *was* abused made it appeal to him more; it was not merely inevitable, but also oddly poetic: "The dress-coat and the frock-coat not only possess their political beauty, which is an expression of universal equality, but also their poetic beauty, which is an expression of the public soul—an immense cortege of undertaker's mutes (mutes in love, political mutes, bourgeois mutes . . .). We are each of us celebrating some funeral."[12]

What does he mean by this? Baudelaire's politics have always seemed confusing. Why in 1846 (during the July Monarchy) should he celebrate the frock-coat as a symbol of political equality and political silence? Was the bourgeois the hero of modern life? Two years later he took part in the Revolution of 1848, on the side of the revolutionaries: not just in February, against the monarchy—many bourgeois did that—but also in June, when the populace of Paris fought against the bourgeoisie.

Tocqueville called the June Days "a class battle, a sort of slave war." So did Marx; with some reservations, modern historians have followed suit. It is all the more surprising, therefore, that the poet of dandyism "chose to fight *with* the insurgents in the June Days" when "all respectable Paris, all fashionable society, all the intelligentsia of the Left Bank, stood against him on the side of Order."

As T. J. Clark writes, "Does a dandy fight, or talk politics, or believe? Baudelaire in 1848 did all these things. The dandy became Baudelaire's opponent." Clark points out that sometime after 1851, Baudelaire described one of Daumier's cartoons, now lost, which showed the corpse of a worker

> riddled with bullets; behind it are assembled all the town bigwigs, in uniform . . . well turned out, their moustaches *en croc*, and bursting with arrogance; and also present, necessarily, some bourgeois dandies who are off to mount guard or to take a hand in quelling the riot with a bunch of violets in the button-hole of their tunics—in other words, the ideal image of the *garde bourgeoise*.

Meanwhile, a shark in judge's robes passes "his claws over the corpse's flesh," saying, "Ah! That Norman! . . . He's only shamming dead so as to avoid answering to justice."[13]

There could hardly be a more devastating picture of the "bourgeois dandy," and it is clear that Baudelaire agreed with Daumier's leftist interpretation of the June Days. Years later, Baudelaire dismissed his participation in the June Days as an "intoxication," motivated by a desire for vengeance and destruction. "Can you imagine a Dandy speaking to the people," he asked himself, "except to mock them?" And yet he clearly remained politicized even after the bourgeoisie put down the workers, and even after Napoleon III came to power. Indeed, he may even have resisted Napoleon's coup: "My rage at the coup d'état. How many bullets I exposed myself to! Another Bonaparte! What a disgrace!"[14]

It would seem that while the bourgeois in his frock-coat had once been a kind of modern hero, he was no longer—at least not in the same way. Henceforth, neither bourgeois dandies nor Jockey Club dandies would qualify for the title.

Baudelaire's last and fullest explication of the dandy ideal appeared in *Le Figaro* in 1863, in an essay on "The Painter of Modern Life." He again asserts that dandyism is modern; it appears "in periods of transition."

> In the disorder of these times, certain men . . . may conceive the idea of establishing a new kind of aristocracy . . . based . . . on the divine gifts which work and money are unable to bestow. Dandyism is the last spark of heroism amid decadence.

The dandy is no longer the necessary and inevitable hero who expresses modern times; he is the hero who rejects and struggles against the decadence of modern life. In place of putative equality, Baudelaire proposes a new kind of aristocracy—but not, of course, the old sartorial paraphernalia of aristocracy.

> Dandyism does not . . . consist, as many thoughtless people seem to believe, in an immoderate taste for the toilet and material elegance. For the perfect dandy these things are no more than symbols of his aristocratic superiority of mind. Furthermore, to his eyes, which are in love with *distinction* above all things, the perfection of his toilet will consist in absolute simplicity. It is a kind of cult of the self . . . a kind of religion.[15]

Although the word *le dandy* was adopted from the English language, its meaning underwent a sea change when it crossed the Channel, becoming less social and sartorial, and more literary and symbolic. One could hardly get more metaphysical than this idea of dandyism as a religion.

But what exactly did it mean when Baudelaire described dandyism as "a kind of religion," a "doctrine of elegance and originality"—in short, "a cult

of the self"? When he wrote that the "passion" for dandyism "is first and foremost the burning need *to make of oneself something original*," he did *not* mean that the dandy's goal was "to be original." That would be "a naive, Romantic, and Bohemian ideal" (as Ellen Moers, the preeminent historian of dandyism, correctly emphasizes). Indeed, that had been Baudelaire's initial mistake when he first began to experiment with sartorial innovations. Rather, out of his own being the dandy created an original work of art—not through self-indulgent artistry but by stoically emphasizing the uniquely modern elements of style. The perfect dandy was a kind of artist who created—himself.[16]

It is in this light that we need to see Baudelaire's chilling injunction: "Woman is the opposite of the Dandy," because she is "natural" and "vulgar." Only to the extent that she creates an *artificial* persona (through dress and cosmetics) is she, in Baudelaire's view, at all admirable. For all his perceptiveness about fashion and elegance, Baudelaire's ideas about women remained hackneyed. His hostility keeps breaking through the surface, as when he writes that "Woman . . . is a divinity . . . the object of the keenest admiration. . . . She is a kind of idol, stupid perhaps, but dazzling." Because of this, his piece, "In Praise of Cosmetics" is only superficially radical, since although he goes against the grain in his attack on naturalness, he still insists that women have a "duty" to be beautiful.

However, I would argue that, contrary to popular belief, the idea of looking "natural" is not favorable to women either, since the concept of "women's natural role" implies that she can never escape the bondage of anatomy. Real freedom for women as well as men lies in self-creation. But in Baudelaire's view, the self-creation of the (male) dandy was entirely different from the injunction that woman should make of herself an "idol" to be worshipped. It is likely that Baudelaire's ideas on gender derived in part from what anthropologists say is a nearly universal view that women's work is primarily physical and natural—making love and making babies. *Cultural* work has been primarily associated with the male domain. Moreover, the deeply engrained idea that leisure and culture went together also worked against women.

In striking contrast to today's stereotype of the nineteenth century, which insists that women's dress reflected their leisure and men's clothing was suited to a life of constant work, French writers were more likely to downplay men's role as workers. Naturally, the Parisian lady did not work for pay either; and she, too, devoted much attention to her toilette. But she had familial and erotic responsibilities: She worked at home. The person with "nothing" to do was more likely to be a man than a woman.

In his *Treatise on the Elegant Life*, Balzac argued strenuously that a man who worked could not be truly elegant, and that by the time such a man

retired, "the sentiment of *fashion* has been obliterated, the time of elegance has flown." Baudelaire, too, maintained that "A dandy does nothing." He is a "man of leisure and . . . education. The rich man who loves to work"— but presumably, work not for money, but at some kind of artistic creation.[17] Both dandyism and creative idleness appeared as elements in Baudelaire's portrait of the painter of modern life.

Fashion and the Painter of Modern Life

As early as the eighteenth century, Diderot suggested that "When a society's clothes are mean, art should disregard costume." This became even more of an issue in the next century, when contemporary fashion was widely regarded as artistically inferior to the clothing of the past, both in its feminine changeability and its masculine sobriety. Already in the 1840s, while still a student, Edouard Manet denounced Diderot's position as "quite stupid," and argued that "We must accept our own times and paint what we see." The Realist critic Champfleury also called for paintings of "present-day personalities, the derbies, the black dress-coats, the polished shoes or the peasants' sabots."[18]

But Baudelaire carried the search for modernity a step further, in his insistence that "the heroism of modern life" was to be found, above all, in Paris, the first truly modern metropolis. The relationship between modern Paris—"the capital of the nineteenth century"—and the development of artistic modernism has subsequently been explored in studies of the city as symbol and spectacle for the male artist. Yet Baudelaire's emphasis on fashion has received very little critical attention, despite the fact that he presented fashion as the single most striking *sign* of modernity. "The painter of modern life," he wrote,

> has an aim loftier than that of the mere *flâneur*, . . . something other than the fugitive pleasure of circumstance. He is looking for that quality which you must allow me to call "modernity"; for I know of no better word to express the idea I have in mind. He makes it his business to extract from fashion whatever element it may contain of poetry within history, to distill the eternal from the transitory.[19]

Flâneur is a term only very inadequately translated as "stroller," "lounger," or "loafer." This idle and dandified *boulevardier* appeared in physiologies as the "native and inhabitant of a metropolis, of Paris," for "only a big city can serve as the theatre for his incessant explorations." In fact, according to Auguste de Lacroix's chapter in *The French Painted by Themselves*, "We do not even admit the existence of the flâneur anywhere than in Paris." Just like the grisette, he was a quintessentially Parisian character.

No mere tourist, the flâneur stood in relation to the *badaud* ["rubber-neck"] as the gourmet did to the gourmand, or as Balzac in comparison with the "peasant arrived yesterday in Paris."

The flâneur was also a kind of artist—"a *dilettante*, painter, poet, antiquarian, bibliophile, . . . a connoisseur of the opera," and admirer of actresses like Rachel. In fact, he might even have a profession: "Who discovered Mademoiselle Rachel . . . ? A director-flâneur." And "the author of the *Tableau de Paris* had to idle away his time enormously." Ultimately, the flâneur was supposed to be the observer of the Parisian scene—a girl-watcher, naturally, but much more than that; as much a symbolic figure as the dandy. De Lacroix ends with the rhetorical question: "Who are you finally, you who read these lines, and who am I who writes them? A flâneur."[20]

For Baudelaire, the painter of modern life had to be a wanderer in the big city—"the perfect flâneur," "the passionate spectator," whom "we might liken . . . to a mirror as vast as the crowd itself; or to a kaleidoscope gifted with consciousness." "The spectator is a prince who everywhere rejoices in his incognito." Moreover, the artist-flâneur had to be attuned to every shift of fashion:

> If a fashion or the cut of a garment has been slightly modified, if bows and curls have been supplanted by cockades, if *bavolets* have been enlarged and *chignons* have dropped a fraction towards the nape of the neck, if waists have been raised and skirts have become fuller, be very sure that his eagle eye will already have spotted it.

The painter of modern life recognized that contemporary fashion, pose, and gesture distinguished the modern urban subject from the people of other times and places.

Fashion was the key to modernity: Baudelaire argued that it was simply "laziness" that led artists to "dress all their subjects in the garments of the past . . . the costumes of the Middle Ages, the Renaissance, or the Orient."

> The draperies of Rubens or Veronese will in no way teach you how to depict *moire antique, satin à la reine,* or any other fabric of modern manufacture, which we see supported and hung over crinoline or starched muslin petticoat. In texture and weave these are quite different from the fabrics of ancient Venice or those worn at the court of Catherine. Furthermore the cut of skirt and bodice is by no means similar: the pleats are arranged according to a new system. Finally, the gesture and bearing of the woman of today give to her dress a life and a special character which are not those of the woman of the past.[21]

You simply could not paint modern individuals if you did not have an intimate understanding of their dress.

Some art historians have criticized Baudelaire for choosing the minor artist Constantine Guys as the painter of modern life, rather than someone like Manet. But Baudelaire was not trying to identify the next genius. Rather, he was continuing an exploration begun in his "Salon of 1846," in which he asked artists to "look at" the "mysterious grace" of modern fashion. If modern man had abandoned the fabulous costumes of earlier eras in favor of a black uniform, then (Baudelaire argued) artists must learn "to create color with a black coat, a white cravat, and a grey background."

> Although M. Eugène Lami and M. Gavarni are not geniuses of the highest order, they have understood all this very well—the former, the poet of official dandyism, the latter the poet of a raffish and hand-me-down dandyism![22]

Artists like Gavarni, Devèria, and Lami were "historians"; Guys' sketches were "valuable records of civilized life." If they were not "great" artists, that did not matter. Baudelaire repeatedly took the tone of an art critic who has provocatively chosen to emphasize, not the great paintings of the past by artists like Titian and Raphael, but rather the work of admittedly lesser artists, work which was, however, valuable for its portrayal of modern life.

One of the reasons Baudelaire praised Guys so strongly was because he regarded him as being simultaneously a dandy, a flâneur, and an artist—a participant, an observer, and a creator of the world of fashion. He described Guys as a "dandy-flâneur," albeit one who lacked the dandy quality of being (or appearing to be) totally blasé. "When Monsieur G sketches one of his dandies . . . nothing is missed." Who but a dandy could fully appreciate "his way of wearing a coat or riding a horse"?[23]

In the language of fashion, X does not simply equal Y. Rather, the context determines the meaning of any given clothing sign. Dandyism could be a sign of membership in a socially prestigious group, *or* it could be a badge of membership in some other, less easily defined group of self-proclaimed "aristocrats," such as artist-flâneurs.

Baudelaire's attack on the wealthy Anglophile Jockey Club dandies makes this distinction very clear: When Wagner's *Tannhauser* was staged in Paris, the socially prominent dandies loudly objected to the introduction of opera without ballet (that is, without their mistresses appearing, semi-clad, on stage). "Keep your harem," wrote Baudelaire, "but let us be allowed to have a theatre. . . . *Thus we shall be rid of you, and you of us.*" Baudelaire played the dandy to an audience composed primarily of other *déclassé* artists and intellectuals, not aristocrats or social-climbing bourgeois. This is crucial to any understanding of his theory of dandyism. As Gautier testified: "He was a dandy lost in Bohemia, but preserving his rank and manners and that cult of the self."[24]

In his book *Bohemian Paris*, historian Jerrold Seigel describes the phenomenon well: In the nineteenth century, "the boundary between art and the life of art could no longer be maintained." And if "the principle of modern life and art was individualism," then both the dandy's cult of the self and the flâneur's "self-diffusion" were esential. Or as Baudelaire put it: The painter of modern life was "an I with the insatiable appetite for the 'non-I'."[25]

The Triumph of Black

Baudelaire was, at one and the same time, both highly original and very much a product of his own time. He believed that the dandy was a member of "a new aristocracy" of artists and intellectuals, for whom an elegant simplicity of dress symbolized their personal superiority and distinction. It was not something that money could buy. However, for many other middle-class Frenchmen, "distinction" was also important as a way of emphasizing *their* superior position in the hierarchy of modern society.

The *triumph of black*—the cornerstone of Baudelaire's personal dandyism—was the primary characteristic of bourgeois male clothing in the nineteenth century, which also moved toward "absolute simplicity." The idea of the gentleman-dandy was important for the society as a whole, because it bridged the gap between the old categories of aristocrat and bourgeois, thus contributing to the legitimation of a new social elite, to be based neither exclusively on birth nor on wealth, but rather on *savoir-vivre* and elegance.

Taste became a social and political issue. Of course, what we might call the upper-middle class interpretation of elegance was not quite what Baudelaire had in mind with his "mixing together of the aristocratic and bohemian versions of outsiderness, distinction, and rejection." But there were many *juste-milieu* bourgeois who also attempted to establish "social differentiation through refinement, subtlety, renunciation, and in-groupness of taste, when taste [was] no longer simply the inherited, bone-bred prerogative of a small, hereditary aristocracy." Anyone could appreciate rich, elaborate dress, "that is, any old nouveau-riche industrialist or nouveau-middle-class greengrocer," but only a self-conscious and sophisticated elite would feel that "less is *truly* more."[26]

In fact, "the eternal black suit" became so dominant in mid-century that the tailors' magazine *Fashion-Théorie* began to moan:

> When will we be delivered . . . from this costume which says nothing and can say nothing, which only lends itself to insignificant modifications . . . incapable of animating the genius of our art. Each time that a new season arrives, we hope for the fall of this sombre tyrant of the salons, but it is always victorious and seems to come out of these struggles more powerful

than ever. However, insurrections are not lacking, and strong good spirits fought against it with real courage last winter. They were young, they were rich, two conditions of success on the battlefield of fashion.

In their "taste and true elegance," they were not like "those ridiculous innovators who . . . search for change only for the sake of change." But nevertheless they failed. And the tailors hypothesized that they had been "vanquished" by the prejudice of women, who judge and decide what men are to wear:

> Women admit us to their receptions . . . only in the black suit, because rigged out this way, we are frankly ugly, and we serve as a foil to set off their beauty.[27]

Fascinating as this theory is, it is more likely that class competition—not the battle between the sexes—was responsible.

"Men are not equal, and women still less so." Thus began one of the innumerable nineteenth-century guidebooks dedicated to teaching the postrevolutionary reader how to be elegant by applying "the old traditions of French *politesse* . . . to modern practices." As the author saw it:

> The distinctive character of our age is . . . the combat between . . . the need for equality which devours all pride . . . and the need of luxury which overturns all classes.[28]

Neither "ludicrous" and "anachronistic" luxury nor middle-class "shabbiness" and "vulgarity" were acceptable, however; so *savoir-vivre*, the knowlege of the world of manners, language, and dress, became an artificial dividing-line, separating the Ins from the Outs. "*Savoir-vivre* is the masculine *je ne sais quoi*." Faced with social and political *embourgeoisement*, the old and new elites combined and created new categories of society: "Formerly one said the court and the town, now one says the great world and the bourgeoisie."[29]

The Anglophile cultural ideal of *le gentleman* (and *le dandy*) assumed a growing significance that was expressed by the rapid adoption of the modern man's dark suit. "A beautiful suit well worn inspires confidence. Why? Because it speaks of money, of credit, and of taste." For middle- and upper-class Frenchmen, the suit represented not the triumph of democracy or equality, but class distinction, as this had been redefined in the aftermath of the Revolution. In the past, elegance had been "relative." It applied to the upper class as a whole, more than to any given individuals. But with the "confusion of our modern times," and the (perhaps necessary) "mixing of classes," elegance had become "absolute" and "individual." Thus, some individuals attained true elegance, while others only purchased an "absurd" and "garish" ostentation: Although "the bourgeoisie is none other than the people—who have worked in order to buy a private

income and a black suit," the true gentleman alone knew how "to wear the suit correctly."[30]

A man unused to hunting would look "stupid" in riding clothes, because he was no real *chevalier*. Even physical qualities supposedly conformed to the "laws of elegance." Just as a "fine, elegant horse" looked different from a "thick, peasant horse," so also would the elegant man show the signs of nobility—a torso that was relatively short in relation to the legs (indicating that his ancestors had ridden horses, not walked), small feet and "frail" hands (hard labor enlarging these appendages), and high arches (only peasants had flat feet). Although you might not be able to improve a fat and inelegant nose, you could act on the knowledge that, while poverty and thinness were related, excessive weight did not demonstrate high status: "A fat man or woman can, perhaps, be magnificent, superb, imposing, etc. . . . They are not elegant." Fatness indicated a coarse and sensual character, contrary to elegance. Conversely, children and animals might be "graceful," but they were never elegant, since elegance was, above all, an *acquired and disciplined characteristic*.[31]

Thus we see again how the significance of elegance was inextricably connected with questions of class. But definitions of class were themselves in a period of flux, which may help explain why London was the capital of men's fashion, and Paris of women's fashion. Great Britain, not France, had the world's most advanced capitalist economy, as well as a tightly unified political state at the nucleus of an expanding empire, all of it under the direction of a ruling class that combined elements of the landed aristocracy with elements of the commercial and industrial elite. The gentleman ideal was elitist, but less so than the idea that aristocrats were *by blood* different and superior to commoners. A person could, after all, *become* a gentleman—or at least his son could. As French society followed suit, the clothing of French men increasingly reflected the new social ideal. It would be an overstatement to frame this change in terms of the triumph of a "bourgeois" over an "aristocratic" ideal of dress, but there is an element of truth in that characterization.

Another tailors' publication, the *Journal des Modes d'Hommes*, suggested in 1867 that the revolutions of

> 1830 and 1848 have both had a very great influence on the tendency to equality by means of a relative uniformity of costume. [But] in a nation that exits from these crises to enter a phase of order, of liberal and regular [progress] . . . general culture brings [a sense of] proportion and good taste in costume. . . .
>
> From the corporate [and] functional, costume becomes individual. . . . There is neither the uniformity [of revolution] nor caste-like distinctions. *It is no longer the personage who dresses, it is the man.*[32]

This analysis sums up well what might be called the bourgeois individualist character of modern clothing, and is as applicable today as in the nineteenth century. During the various French Revolutions, clothing became temporarily more sober and "egalitarian," but this tendency was qualitatively different from the ordinary soberness of modern bourgeois male dress, which depends on subtle small differences to establish social distinctions.

Still, the extent to which people *complained* about the black suit is remarkable. Of course, it is true that the language of clothes is constructed according to the association of ideas:

> Thus it is that *black* for us has become the symbol of sadness and mourning. It matters little whether those associations of ideas be purely conventional, or that they result from a spontaneous and general sentiment among men; it is sufficient that they be accepted.[33]

In Stendhal's novel, *The Red and the Black* (1830), the red referred to the uniform of Napoleon's soldiers, and the black to clerical costume—which for Stendhal symbolized glory versus black reaction. But black is also the color of the frock coat given to the clever young peasant Julien Sorel when he becomes tutor to Monsieur de Rênal's children. "I've never worn anything except a jacket before," says Julien, feeling both proud and awkward. Later, however, the Marquis de La Mole gives Julien a blue coat, which marks another step upward, for when Julien wears the blue coat, "the marquis treated him as an equal."[34]

If dressing in black could be a sign of bourgeois respectability, it could also be a badge of mediocrity. Thus, a tailors' magazine derided the black suit:

> The poverty of this costume next to the brilliance, richness, and simplicity of women's dress, becomes more and more shocking. . . . The black suit—the suit of the officer of funereal pomps, of the *maître d'hôtel*, of the cook in his Sunday best—will no longer be worn for serious ceremonies or for mourning. This will be, with a few fantasy exceptions, the suit of the humble soliciter and the livery of the underling.[35]

Gradually, fashion writers began to emphasize the importance of detail and of occasion-specific clothing behavior. In *La Comédie de notre temps* (1874), Bertall wrote a large section on men's clothing, in which he noted that the black suit was "par excellence, the clothing of evening. The same suit, the black trousers, the same white cravat, which are the supreme and inevitable elegance under gaslight, are burlesque and ridiculous in the daytime." Only notaries, businessmen, and other such employees persisted in wearing a black suit and white cravat before dinner. Moreover, he suggested (unreliably) that in the evening, *those* people wore blue coats and yellow

trousers. His main point, however, was that the dark suit which was fashionable in the daytime must look noticeably different in cut and shade from stark black evening wear. In fact, ideally, a man would wear several different outfits in the course of a day. (Vestiges of this practice remain even today, although what was once a relatively informal costume—the morning coat—has become, for a more casual age, an extremely formal ensemble.)

Bertall, indeed, devised a kind of modern physiology of the man's suit, distinguishing between those associated with different occupations, status groups, and personality types. A successful merchant, an old employee, a serious politician, and a young rich "swell" took what was basically the same suit and created with it a variety of different looks. The individual's age also had an effect, as he moved from boyhood skirts to school clothes, reaching the peak of fashionability in young manhood, and then declining into ever baggier and more démodé clothing.

Attitudes toward dandyism, as such, varied. Bertall poked mild fun at *les gommeux*, "the young men who play the comedy of chic," but he also gave them a distinguished history. Only their names changed over the years: *roués* during the Regency, *les merveilleux* under Louis XV, *les incroyables* during the Directory, *les fashionables* during the epoch of the Allies, *les dandies* under the Restoration, *les lions* or *les gants jaunes* under Louis-Philippe, then *daims* (bucks), *gandins* (mashers), *cocodes* (the masculine equivalent of *cocottes*.) Known for a while as *les petits crevés* (those who were used up), they were now called *gommeux* (swells). The term itself was thought to have originated within the elite gentlemen's clubs, from which it spread to the pages of *La Vie Parisienne*.[36]

But the dandy was also disliked. The members of elegant society, like the bourgeoisie in general, found it uncomfortable to cope with what might be hostile or ironical parodies of their own pretensions—or simply an entirely different interpretation of the meaning of dress. Not everyone agreed that the dandy was, himself, a gentleman. Individuality had its dangers. According to another etiquette book, the dandy "exaggerates the rules, makes them ridiculous; what he wants is the triumph of the bizarre, of the conspicuous [*singulier*] over the natural."[37] It reminds us of the Goncourts' reaction to Baudelaire: He looked correct, but also bizarre. At the time when Baudelaire was praising the dandy, others were attacking him:

> [The dandy is] the Black Prince of elegance, the demi-god of ennui, looking at the world with a glassy eye. . . . Indifferent to the horse that he mounts, to the woman that he greets, to the man that he approaches and at whom he stares for a moment before acknowledging him, and wearing written on his forehead—in English—this insolent inscription: *What is there in common between you and me?*[38]

6
Art and Fashion

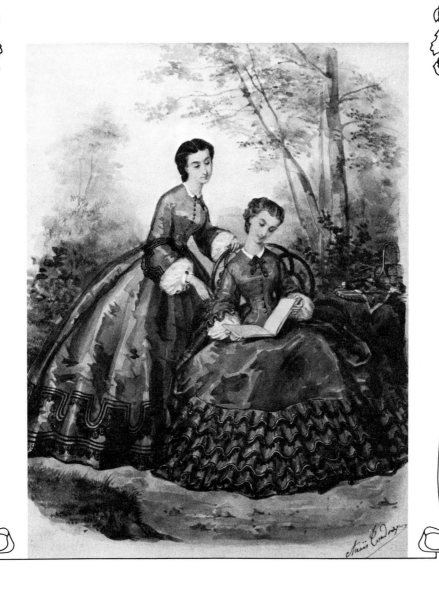

In this original watercolor (from which a fashion plate was made), Anaïs Colin Toudouze chose to display two fashions of the early 1860s on ladies safely secluded in a garden. Yet her own career demonstrates that, far from being restricted to a life of domesticity, many women were active participants in both the fashion industry and the world of art. Moreover, there are a number of striking similarities between fashion illustration and the work of even the most advanced artists. A painting such as Monet's *Femmes au Jardin,* for example, was influenced by fashion-plate art. Courtesy of the Coleman Collection.

J'ai sous les yeux une série de gravures de mode. . . . Ces costumes . . . presentent un charme d'une nature double, artistique et historique.

Baudelaire, *Le peintre de la vie moderne*, 1863

The fashion plate is a minor art form. A recent history of print-making described it as "this pleasant genre in which the French are particularly distinguished."[1] Fashion itself is widely perceived in the United States today as a frivolity, of less and less importance to serious people. The fashion plate is also generally regarded as being of limited value as a historical source, if not actually misleading. After all, fashion plates are obviously idealized images—but it is precisely for that reason that Baudelaire admired them.

The first section "The Painter of Modern Life" is strangely entitled "Beauty, Fashion and Happiness." In it, Baudelaire begins by describing the experience of looking at a set of fashion plates from the late eighteenth and early nineteenth centuries:

> I have before me a series of fashion plates . . . which have a double-natured charm, one both artistic and historical. They are often very beautiful and drawn with wit; but what to me is every bit as important, and what I am happy to find in all, or almost all of them, is the moral and aesthetic feeling of their time. The idea of beauty which man creates for himself imprints itself on his whole attire, crumples or stiffens his dress, rounds off or squares his gesture, and in the long run even ends by subtly penetrating the very features of his face. Man ends by looking like his ideal self.[2]

According to Baudelaire, a series of fashion plates reveals how our idea of beauty changes over time. Through our choice of clothing, gesture, and expression, we try to approximate our ideal self. Fashion is a mode of self-creation, but it is not an endeavor that each individual undertakes alone. Rather, it is a process of collective definition. *To look the part* is as important as it always was, even when we model ourselves after the antifashion stars of music video or the uniform stereotypes of successful executives instead of the figures in fashion plates. Baudelaire's concept of the dandy and his

emphasis on the role of fashion in the painting of modern life remain valuable. Equally important in his philosophy of fashion is the concept that every style is beautiful *in its own time*.

Baudelaire recognized that fashion is never "natural." It is always and necessarily artificial. The popular belief that fashion is (or should be) progressing toward greater naturalness is antithetical to the phenomenon. Nor is fashion merely concerned with the outer clothing of human beings—fur for the "naked ape." Fashions in clothes change, and so do fashions in bodies and faces. It is apparently a difficult concept for people to grasp, but there is no authentic, natural *you* underneath all the artifice of civilization. Just as the individual cannot exist apart from society, so also is the body itself a product of "the glass of fashion and the mould of form."

In Baudelaire's liberating theory of Beauty, the idea of an abstract and "ideal" beauty is rejected, in favor of an emphasis on the dual character of beauty—half "eternal," but also half "ephemeral," "fugitive," and "contingent." He presented fashion as the prime example of the "transitory" element in beauty. Fashion was best explained by reference to changing ideals of beauty and the "ideal self"—ideals that people themselves create. However "ugly" modern garb might initially appear, it was the artist's duty to find the "mysterious element of beauty" that was all its own.

No one was more dedicated to this task than the fashion illustrator, but many other artists also depicted the world of fashion and were influenced by the imagery of the fashion plate. The rise of the Parisienne as a genre subject for popular art and modern literature was related to the development of fashion studies and caricatures, art forms that emphasize the salient characteristics of the new look. Fashion plates act as a kind of propaganda for the latest style, whereas caricatures satirize its exaggerations; but both focus on images of modernity. All such popular images of the modern Parisian woman helped to define and create new and contemporary ideals of feminine beauty as part of a chronicle of modern urban life.

One artist, in particular, was noted both for his images of the Parisienne and for his fashion plates, and was a predecessor of the later painters of modern life. I mean, of course, Gavarni, whose real name was Sulpice-Guillaume Chevalier (1804–1866). Gavarni created fashion illustrations for *La Mode* (in which Balzac also published), as well as for the *Journal des Dames et des Modes, Petit Courrier des Dames, Fashionable, Sylphide, La Vogue,* and many other magazines. He was not primarily known for his fashion work, but rather for his illustrations of modern Parisian life. The *grisettes, lorettes,* and Opera Balls of Gavarni were and remain more famous than his fashion plates. As the Goncourts wrote:

> Paris! l'amour! Paris! la femme! Paris! la Parisienne! . . . tous les Paris!—c'est l'oeuvre de Gavarni.

Yet Gavarni's other work bore the continuing "trace" of his fashion drawings, although only a few viewers (like Baudelaire) regarded that as a beneficial influence, or at least not necessarily a defect.

According to Baudelaire, Gavarni's prints formed the visual complement to Balzac's *Comédie Humaine*. As he put it, "The veritable glory and true mission of Gavarni and Daumier were to complete Balzac, who . . . reckoned them his auxiliaries and commentators." And if Daumier was, perhaps, the greater, nevertheless Gavarni was also a historian of his time. Moreover, *imagiers* like Gavarni represented a new type of artist. The multiple images they produced were not high art, nor were they examples of the crude and anonymous popular imagery that had existed for centuries. Technological innovations made "good images cheap, and cheap images good," while socioeconomic changes created a mass market for images, words, and fashions.[3]

We recognize Gavarni as an historian of fashion and a poet of dandyism. But there were many other fashion illustrators, both male and female.

Imagiers like Gavarni represented a new type of artist, whose popular illustrations focused on modern Parisian life. One of his humorous drawings showed a husband unlacing his wife's corset while murmuring to himself: "How strange! This morning I tied a knot, and now it's a bow." In addition to pictures like *"The Grisette"* (see Chapter 4), Gavarni also did straightforward fashion illustrations, like this one of ball dress for *La Mode* (ca. 1830).

Some five hundred have been catalogued in France from the eighteenth to the early twentieth centuries. Unfortunately, it is difficult to find information about particular individuals. Often only their names are known, or even less, as in the case of the talented B. C., who did some fine plates for the *Journal des Demoiselles*. There is, however, some information on one family of fashion illustrators—the Colin sisters—who were collectively "responsible for many of the most charming fashion plates of the mid-nineteenth century," and whose careers extended from the July Monarchy well into the Third Republic.[4]

The Colin Sisters

Historically, relatively few women have become artists, and those who did were often the children of artists. Yet as Julie de Marguerittes observed in 1855, any visitor to the Louvre would see that "girls are regularly educated for artists in France." Moreover, the trend seemed to be accelerating, since although there were "many distinguished [female] painters," there were even more novices under the age of twenty.

> These girls belong, by their education, to the higher middle classes. . . . They are the daughters of government employees with small salaries—of professional men—often of artists—for talent is frequently hereditary.

(More to the point, such girls had access to training at home, at a time when art schools were closed to female students.)

"Their ability does not frighten away suitors," added Marguerittes. There is "nothing masculine" about drawing and painting, and their chosen occupation need never interfere with housewifely duties. Girl artists were "fond of dress and amusement." They were "neatly dressed, not a stain on the white manchette, or the simple muslin dresses." Indeed, "some of these young girls . . . will perhaps marry artists," and might continue to paint in their spare time.[5]

This general description applied remarkably well to the Colin sisters—Héloïse, Anaïs, Laure, and Isabelle. Their father, Alexandre-Marie Colin (1798–1875), was a distinguished painter and lithographer, whose brother Hubert was a sculptor and whose sister Virginie was a painter of miniatures. Even Alexandre Colin's first wife (the girls' mother) was a painter. Many of their ancestors were also artists, the most famous being Jean-Baptiste Greuze (1725–1805), whose uplifting genre scenes were ardently admired by Denis Diderot.

Père Colin's studio was a center of artistic activity in Paris. A supporter of the Romantic movement, he was a close friend of Delacroix, Gericault, Gavarni, Gautier, de Musset, and Devéria, many of whom visited his atelier—which, (in proper Romantic fashion) was filled with interesting bibel-

The Colin Family (1834–1835) is a watercolor by the two sisters, Héloïse Colin [Leloir] and Anaïs Colin [Toudouze]. From left to right: Anaïs, Isabelle, Mme A. Colin, Héloïse, and Laure; behind them stand Aunt Virginie, Uncle Paul-Hubert, and the girls' father Alexandre Colin. Virtually every member of the family was an artist. Courtesy of the Musée de la Mode et du Costume, Paris; photograph courtesy of Chantal Fribourg.

ots and, significantly, an excellent collection of antique costumes suitable for use in historical paintings. According to his great-grandson, Georges Gustave Toudouze, Alexandre Colin favored all the most exaggerated historical fashions of the Romantic style. He and his friends draped themselves in damask and brocades, wore seventeenth-century ribbons and Cavalier hats over hair cut *à la Charles VI*.

Growing up in such a milieu, it is not surprising that the Colin girls, along with their half-brother Paul (the child of Alexandre's second wife), should all become not merely interested in costume but also proficient painters and engravers by the time they reached adolescence. Indeed, be-

tween the ages of fourteen and twenty, all four girls had received medals at the Salon, and their paintings were favorably reviewed.

The *Album of the Salon of 1842*, for example, includes reproductions of pictures by Héloïse and Anaïs Colin. Héloïse entered a historical painting set during the Renaissance, called *Intérieur de famille*. It shows a man with a woman on his lap, another at his feet, and a greyhound sitting by the fireplace. Anaïs showed a picture of Joseph and Mary putting the baby Jesus to bed in a room with classical pillars and drapery. *Une sainte famille* was, actually, not much of a picture either, although the accompanying description was charitable: After mentioning two "ravishing pictures" by Alexandre Colin, the anonymous author gallantly declared that "To the name of this artist, we can now add those of *mesdemoiselles* Anaïs and Héloïse Colin, whose pictures are notable for their distinction and grace, and from whom we ask a little more truthfullness in coloring, and a little more light. Here's a whole family of artists."[6]

Even within a family of artists, however, there were distinctions between the kinds of art undertaken by men and women. Despite the occasional religious or historical painting, on the whole the Colin sisters did not attempt the great religious or historical themes that were still regarded as the highest form of art. Nor did they receive the kind of professional academic training that male artists commonly received. *Père* Colin, for example, made frequent trips to England and Italy, and eventually became Director of the French Academy at Rome. Presumably, the training his daughters received was obtained at home, or possibly in the atelier of a family friend. Nevertheless, the girls were permitted, even encouraged, to work, to exhibit, and to sell. While still in their teens, they also began to produce illustrations for the burgeoning fashion press.

Fashion journals multiplied rapidly from 1830 to 1870, and there was a constant need for fashion illustrations, so it was probably easy for the girls to find work. In addition to the magazines about fashion for a general audience, there were also specialized journals, intended for dressmakers, tailors, and milliners. The money from subscriptions was increasingly supplemented by that obtained from advertisers, who inevitably came to exert an influence on the content of magazine articles. Indeed, many articles were little more than "puffery" (or unacknowledged advertising). Almost certainly, the fashion plates also reflected bribery on the part of certain dressmakers, who saw to it that *their* dresses were portrayed in full color. Eventually, many fashion magazines also included a number of black and white illustrations, but the color print (or prints) were more important.

There were, of course, other kinds of magazines that needed illustrators—humor magazines like *Le Charivari* and journals of fashionable life (as opposed to fashion, per se) such as *La Vie Parisienne*. But these tended to have a predominantly masculine readership and perhaps also an audi-

ence of demi-mondaines. Thus, they tended not to be a suitable forum for young ladies, who could hardly be expected to produce risqué illustrations of actresses or dancers meeting their lovers backstage.

The eldest of the Colin sisters was Héloïse (1820–1875), who married the religious painter, Auguste Leloir. Leloir was a student of Picot (a disciple of the great classicist David); he did works like *Coronation of the Virgin* for the famous Church of Notre-Dame-de-Lorette in Paris. Their first son, Louis, also became an artist and won the Premier Second Grand Prix de Rome with a work entitled *The Death of Priam, Killed by Achilles,* and went on to study at the School of Fine Arts. This was precisely the kind of academic training from which women were excluded. On the other hand, such classical themes were gradually becoming *démodé* by the middle of the nineteenth century, to be replaced by an eclectic mixture of genre scenes prefered by bourgeois clients.

Héloïse found her niche in the world of popular illustration. She did a series on *Celebrated Novels* (which showed characters from such novels as *The Count of Monte Cristo* and *The Three Musketeers*), as well as illustrating new thrillers like *The Mysteries of London.* The bulk of her work, however, was done for the fashion press, and most of it appeared under the auspices of the House of Mariton.

Louis-Joseph Mariton was a hairdresser who, in 1834, launched the fashion magazine *Le Bon Ton,* which became very successful; within a dozen years Mariton had become the proprietor of nine fashion magazines. Héloïse's prints were thus distributed to many French magazines, such as *Le Follet, La Sylphide, Le Journal des Demoiselles, Le Magasin des Familles, La France Élégante, Le Petit Messager des Modes, La Mode Illustrée,* and others, as well as the English magazine, *La Belle Assemblée.*

It was a common practice for foreign fashion magazines to enter into an agreement with a French publisher to purchase the right to reproduce the French fashion plates (which tended to be of higher quality than those in other countries). With copyright laws little enforced, some prints were simply pirated by foreign journals. In neither case, of course, did the artist-illustrator receive additional payment. However, there is indirect evidence that Héloïse Leloir may have done work on her own for the fabulously successful Berlin publication, *Die Modenwelt,* which had more than a dozen foreign editions. In these cases, her signature reads "Héloïse Colin," presumably to ward off objections from her usual publisher.

Héloïse was very close to her sister, Adèle Anaïs Colin (1822–1899). The two frequently worked together and have styles so similar that, without seeing the signature, it is difficult to distinguish their pictures. Indeed, the whole family seems to have been close-knit. The very fact that we know something about these women is due to the family pride of Héloïse's second son, Maurice Leloir (1853–1940), a painter, historian, and author

of the *Dictionnaire du costume*. He, in turn, was the father of the painter Susan Leloir. Moreover, Anaïs's grandson, Georges Gustave Toudouze, also inherited an interest in both fashion and family history; and he wrote a book on *Le Costume français*.

If Anaïs is more famous than Héloïse, it is partly because she lived longer and had a larger *oeuvre* than her elder sister. In 1845, Anaïs married the architect and aquafortist engraver Gabriel Toudouze, a native of Brittany (where his grandfather had been the Prince of Condé's lieutenant of the hunt). Although Gabriel was only eleven years her senior, he died in 1854, leaving Anaïs with three small children to support. It was therefore largely economic necessity that made the young widow the most industrious of the Colin sisters, working nonstop through the 1870s, sometimes collaborating with Héloïse, and continuing regularly to produce fashion plates up to the time of her death.

But her fame reflects the high quality as well as the stupendous quantity of her work. According to Vyvyan Holland's classic study, *Hand Coloured Fashion Plates 1770 to 1899*, the illustrations of Anaïs Toudouze merit attention, because she was "one of the most prolific and certainly the most popular of all the later fashion-plate artists." The most authoritative modern source, *La Gravure de la mode féminine en France*, also states that Anaïs Toudouze produced "drawings, watercolors, and fashion engravings" for "almost all the fashion journals of her time," and lists twenty-seven journals to which she made significant contributions.[7]

Her only real competitor was Jules David (1808–1892), a painter and lithographer, who collaborated with the publisher Adolphe Goubaud on *Le Moniteur de la Mode* from its beginning in 1843 until David's death in 1892. Goubaud and his son were even more successful than Mariton in producing fashion magazines, owning several in France as well as publishing eight foreign editions (German, English, Belgian, Russian, American, Italian, Spanish, and Portuguese) of *Le Moniteur de la Mode*, and five foreign editions (German, English, Hungarian, Polish, and Czech) of *Paris-Mode*, which was aimed at professional dressmakers. David drew all the fashion plates for *Le Moniteur de la Mode*— some 2,600 of them.

He also did moralistic genre scenes and lithographic series on themes like "Vice and Virtue" which were rather popular. They made a bad impression on Baudelaire, however, who described them as "virtuous asininities and ineptitudes." Baudelaire also dismissed the work of another part-time fashion illustrator, Compte Calix, as "a metaphysic within reach of the simple."[8] He did not even mention the occasional Salon paintings by members of the Colin family, but we may assume that he would not have thought much of them, either.

Yet Baudelaire might have liked Anaïs's special collection of pictures, *Le Maitre à danser* (Paris and London, 1844), for which she did more than a

In addition to her fashion work, Anaïs Colin [Toudouze] also did illustrations for books such as *Le Maitre à danser* (1844). Indeed, the dance was a favorite theme for illustrators from Gavarni to Sem. Not surprisingly, Anaïs focused on the elegant aspects of the dance, rather than on its comic or seductive side. Courtesy of the Bibliothèque Nationale, Paris.

dozen prints of men and women dancing the polka, the waltz, and the mazurka.

These dances were relatively new—indeed, one of Anaïs's main concerns was apparently to show the precise steps to be executed—although they were no longer widely regarded as shocking. Back in the 1830s, when Gavarni and Devéria did pictures of the waltz, moralists were still decrying the "lascivious flight" of *la valse impure*. And even at mid-century, people felt a "thrill" as "the couples dance pressed against each other." And when they drew apart, it was to look at one another for a moment, before plunging back into the fray. A man might fulfill his social obligations dancing the staid quadrille, but he "reserved for the favorite of the moment" a dance like the polka or the waltz.[9]

The mania for dancing that emerged during the Directory continued throughout the nineteenth century, and Anaïs's pictures of dancers have a place in the imagery of modern Parisian life. Not sup, isingly, she eschewed what Baudelaire called the "sweetly sensual" aspects of Devéria's prints; and she certainly never did scenes of the riotous Opéra balls, when loose women donned short skirts and even trousers. Nor was she concerned here with the depiction of upper-class social life, which Gavarni portrayed in his *Ball at the Chausée-d'Antin*. But the fashion-plate prettiness of her figures (both male and female), their combination of elegance and

Jules David was the Colin sisters' main competitor. In this fashion plate for *La Moniteur de la Mode* (ca. 1850), he depicted two of the most popular fancy-dress costumes, "Juive et Espagnole." The Middle Eastern costume (here that of a Jewish woman, probably from Algeria) included trousers. The fancy-dress party provided one of the few legitimate occasions for European women to wear trousers or short skirts.

romance, is very similar to the style of *La Valse* as portrayed by artists like Gavarni and Gustave Janet.

Foreign costumes, of course, were a natural theme for a fashion illustrator. Another series of prints, *Les Filles de l'empire céleste* (1850), featured the charms of the "exotic" East, and Anaïs did dozens of other pictures on costumes of different countries: Spanish, Swiss, and Italian folk dresses, Turkish, Syrian, and Persian costume, a hopelessly inaccurate version of an Indian sari, one fairly accurate version of a Japanese kimono and another that combined Chinese and Japanese clothing elements into something that would have been unrecognizable to a person of either country. Héloïse did similar series, in which, for example, flowers provided the motif: linking Chinese girls with camelias, Indians (their saris are better) with dahlias, Middle Eastern women with roses, medieval women with marguerites, and so on.

Catering to the Romantic enthusiasm for the past, Anaïs did scenes of leisure and romance in earlier centuries: a medieval lady playing a harp, an eighteenth-century maid pouring tea for her mistress, a woman of the Renaissance looking out from a window. There are strange juxtapositions: a Middle Eastern *peri* next to an English lady from the reign of Henry VIII, an Arlesienne next to a Japanese, a courtier of Louis XIV's time next to a Breton peasant. Anything picturesque would do.

Religious and charitable themes were also popular: two peasant women in laced bodices offering grapes and flowers to a statue of the Virgin Mary; a modern mother teaching her little boy to give bread and drink to a beggar outside their home. Indeed, anecdotes of maternal love appear as often as scenes of romantic love. Baudelaire would probably not have liked these historicizing and moralistic pictures, which expressed a widespread desire to get away from modern urban life.

Scenes of long ago and far away were often similar in style to fashion plates. (Indeed, the silhouettes of earlier dresses were usually subtly altered to conform to the current physical and sartorial ideal.) But the purpose of historical illustrations was different from that of the fashion plate, as such, which was intended to express the look of the moment in all its ephemeral beauty. Both a nostalgia for the past and an appetite for modern life exerted an attraction on the people of the nineteenth century. Innumerable historicizing and exotic details found their way into modern dress, architecture, and design.

This was most strikingly apparent in fancy dress for costume balls, which were immensely popular throughout the century. Baudelaire referred to such fancy-dress costumes when he warned the painter of modern life:

> By neglecting it [the element of transitory beauty] you . . . tumble into the abyss of an abstract and indeterminate beauty. . . . If for the necessary costume of the age you substitute another, you will be guilty of a mistranslation only to be excused in the case of a masquerade prescribed by fashion.[10]

If Anaïs and Héloïse "mistranslated" the clothing of the past (and of other countries), nevertheless from the perspective of their *own time,* they were as dedicated as Constantin Guys to capturing the look of the moment. And even their images of long ago and far away should probably be seen, in large part, as a kind of imaginary "masquerade prescribed by fashion."

We know less about the third Colin sister, Laure (1827–1878), who did fashion illustrations for a dozen magazines—to say nothing of those like *Godey's* that stole her images. She also married a painter, Gustave Noël, and had a daughter, Alice, who became a ceramic painter and miniaturist.

Alone among the four sisters, Isabelle Colin gave up painting, when she married an engineer named Hippolyte Malibran. Perhaps the fact that he was not an artist influenced her decision. But her namesake (Anaïs's daughter) continued the family tradition.

We have said that Anaïs had three children to support: Gustave, who became a novelist and whose son wrote *Le Costume français;* Edouard, who became a painter and won the Premier Grand Prix de Rome; and Isabelle, the youngest. Isabelle Toudouze (1850–1907) became a talented painter of fashion illustrations and of flowers—the latter being another typically "feminine" art form. Isabelle married Leon Desgrange, and had a daugh-

ter, Jeanne, who married first the architect and decorator Selmersheim, and then the painter Signac.

We may assume that Anaïs taught Isabelle and introduced her to fashion editors. By the time Isabelle began to paint, the fashion plate ideal had moved far from the fairylike imagery of Romanticism to the opulent charms admired during the Empire and the Third Republic. Although she sometimes portrayed women picking fruit in Arcadia (or drifting in a rowboat with neither oars nor oarlocks),[11] real women were moving into a wider world—changes indirectly expressed in other fashion plates she did.

Meanwhile, the Colin sisters' younger half-brother, Paul Colin, became a marine painter and engraver. He married Sarah Devéria, daughter and niece respectively of the painters Achille and Eugène Devéria, whose scenes of modern life pleased Baudelaire. Like Anaïs, Achille Devéria did various series of costume illustrations, such as his *Costumes historiques de ville* (Paris, 1831), which included foreign and folk costumes, as well as the ballerina Marie Taglioni in a short gauze skirt, and the actress Rachel playing the part of Roxanne in *Bajazet*—wearing Turkish trousers. With Paul's marriage to Madamoiselle Devéria, we circle back to the group of popular illus-

While Anaïs's daughter Isabelle Toudouze Desgranges became a fashion illustrator, her son Edouard Toudouze did "high art" paintings such as this, *Salomé triomphante,* which was exhibited at the Paris Salon of 1884.

trators whom Baudelaire praised so highly, and whom modern art historians regard as important precursors of the Realists and the Impressionists.

Even these sketchy biographical details tell us something about the lives of several ordinary Parisian women. Far from being restricted to home and family, they were active participants in both the fashion industry and the world of art. Their careers indicate, however, the ways in which women artists were pushed in different directions from those followed by their fathers, brothers, and sons. Whatever its flaws, the *Salome* by Anaïs's son, Edouard, is "fine art," whereas the watercolors by Anaïs, however charming, are "applied art"—in the service of the Parisan fashion industry. The career of the fashion illustrator can thus be seen either as part of the history of fashion or as neglected chapter in the history of art.

The Fashion Plate

Perhaps our analysis should begin with the fashion plate itself, which is at one and the same time so obvious and so mysterious. The goal of promoting and selling the current fashions involved the use of a particular art form with its own conventions and history. Arnold Bennett's gentle spoof of the genre (in his story *The Old Wives' Tale*) indicates how its purpose was expressed visually:

> The print represented fifteen sisters, all of the same height and slimness of figure, all of the same age. . . . and all with exactly the same haughty and bored beauty. . . . One was in a riding habit, another in evening attire, another dressed for tea, another for the theatre; another seemed to be ready to go to bed. One held a little girl by the hand. . . . Where had she obtained the little girl? Why was one sister going to the theatre, another to tea, another to the stable, and another to bed . . . ? The picture was drenched in mystery.[12]

We find this description amusing, in part because Bennett appears to be taking the fashion plate more seriously than it deserves. After all, we think, the figures shown are not really sisters, the little girl is no one's daughter. They are not intended to represent real people. Rather, they are mannequins, whose function is limited to wearing clothes, whether evening dresses, riding habits, or tea-gowns.

To "read" a fashion plate, we might usefully compare it with drawings of automobiles, particularly those of the 1950s and early 1960s when design elements were extremely important and features like fins were stressed. An engineer's drawing of a particular car would differ from that produced by an advertising artist. The engineer would provide exact measurements and details; the artist would emphasize and even exaggerate

elements such as streamlining, fins, or boxy "hips." The work of the fashion artist-illustrator lies somewhere between these two types, with additional allusions to high or academic art.

Anaïs must have been proud of her fashion illustrations, because she kept many of the originals—and after her death, her grandson donated them to the Musée de la Mode et du Costume. She even kept the original sketches, with neatly pencilled annotations indicating which colors were to be used for each article of clothing. This evidence indicates that the editors of the magazine would ask some more or less well known couturière to send the clothes to the artist's house to be copied.

The fashion plate still retained its essentially artisanal character, and involved a process of several stages. After preliminary pencil sketches, in which Anaïs decided on the composition and theme, and determined the best way to present the clothes, she produced a sketch in graphite and watercolor with touches of white highlights. Anaïs's draftsmanship was noticeably better than that of most of her contemporaries, but her pictures were still drawn to a predetermined plan, using a vocabulary of stereotyped elements: Certain details of dress were exaggerated for effect (such as the narrow waistline or the triumphant mass of the skirt), while other aspects (such as the trimmings) were precise and highly detailed.

The translation of the drawing into print form brought its own characteristics, as her light, even tentative, lines drawn in graphite were replaced by the darker, heavier lines of the engraving. The shading and tone of her watercolor also had to be given black-and-white equivalents in the form of tiny lines and dots. Occasionally, the artists themselves would make the engravings, but, although she knew how, Anaïs delegated this task to one of several professional engravers. In the next stage, the original color wash was replaced by colored ink, which was applied onto the prints by teams of young women. Probably each of them added only one color, before passing the print along to a fellow worker. Each worker applied solid blocks of color without tonal variation. Although the amount of labor involved in hand-coloring fashion plates seems prodigious by today's standards, at the time it represented a leveling effect necessary for mass production. We can also see here the extent to which the Colins were highly skilled workers, in comparison especially to these teams of colorists. But even with the better fashion plates, something of their exquisite miniature quality was inevitably lost when the original watercolor was reproduced in the harder, crisper print medium.

It was only in the last quarter of the nineteenth century that fashion journals began tentatively to use fashion photography or photoengraving. A few fashion illustrators, like August Sandoz, occasionally worked from photographs (for example, of Worth dresses). Some of his sketches are also in the Musée de la Mode, including one with pencilled-in editorial

comments instructing Sandoz to eliminate the cleavage he had daringly sketched in! It was still uncommon for photographs actually to replace fashion prints, presumably because photographs were regarded as insufficiently flattering or stylized. Yet by this time, with a few exceptions, the quality of fashion plates was progressively deteriorating, due to ever cheaper methods of reproduction.

For the modern viewer, the conventions of fashion-plate imagery may seem artificial and incongruous. This was not necessarily due to the incompetence of the artist. The purpose of the fashion plate necessarily influenced the composition and the use of space, the setting, and the position and type of figures. Every element was subordinate to the goal of showing off the clothes to the best advantage and creating an image of fashionable beauty.

The dominant characteristic of fashion-plate art was—not surprisingly—the presentation of fashion. It was, therefore, axiomatic that the figures should be arrested in poses that would show as much of the dress as possible, even if this necessitated some rather awkward positions. The presen-

Just as automobile advertisements from the late 1950s stressed design elements like "fins," so also did fashion plate art emphasize and exaggerate the novelties that made the particular dresses *à la mode*. A fashion plate for the *Journal des Demoiselles* by the illustrator known only as B. C. shows reception and visiting dresses. Certain details (such as the long, slender waist and the triumphant mass of the skirt, swept up over the new, high bustle) were exaggerated for effect, while other aspects (such as the trimmings) were rendered in precise detail.

An illustration from *La Vie Élégant* (1882) also features the fashionable silhouette. But the caricaturist Mars has emphasized the seductiveness of the body and dress in a way uncharacteristic of the rather stiff figures in fashion-plate art.

tation entailed a standard formula of full-length figures in contemporary dress. The number of figures in any given fashion plate varied from one to eight or more, but usually two or three. When there are several figures, they tend to be at medium distance from one another, so that none of them obliterates the costumes of her companions. Thus, the figures themselves were not primarily intended to interact with one another, but simply to be in proximity. There is an overwhelming emphasis on arrangements that not only displayed as much as possible of the costumes, but that also stressed their salient points: the overall silhouette and the novelties of design and decoration that made these particular dresses *à la mode*. The construction of the dress and the characteristics of the fabric also had to receive due attention, since the fashion plate was designed to be informative as well as attractive.

If drawing as imagination or "thinking on paper" was the privilege of fine artists, the work of fashion artists used drawing as a means of explain-

ing what a completed work in another medium would look like. As a technical aid and a promotional device, it was necessarily drawn to a predetermined plan. Yet fashion plates portrayed many of the same conventional poses that were typical of fashionable figure paintings, and that were also characteristic of the majority of nineteenth-century photographs. Just as the photographer's sitters were advised to hold a particular, graceful pose, so also did the fashion mannequins avoid informal positions and casual groupings. Fashion illustrators shunned the awkward and humorous poses often found in caricatures and other popular prints, nor did they employ unorthodox viewpoints or cropping, nor even the light sketching line so characteristic of *La Vie Parisienne,* which seemed to emphasize the undulating movement of the figures. Instead, the mannequins stand or sit stiffly in the center of the frame, facing forward or turned slightly to one side; mannequins taken from behind often look backwards over one shoulder. When there is more than one figure, they tend to form a composition in the shape of a pyramid—a natural format for much of the century, considering the bulk of the ladies' skirts.

In the 1830s, *Le Petit Courrier des Dames* adopted a format showing one primary female figure, facing forward, and another secondary female figure somewhat further back, facing away—her double, as it were, displaying the reverse side of the dress. Sometimes a mirror was added, to show the back of the dresses and hairstyles. By the 1840s, however, it became more customary to show two women side by side, perhaps standing somewhat apart from each other. Or else one stands while the other sits. Later, in the 1870s and 1880s, when back-fullness was fashionable (in the form of bustles and trains), fashion plate figures posed to emphasize this feature, and were frequently shown from the side.

Sexual segregation was the rule. Fashion plates from the first decades of the nineteenth century often show a man and a woman together, a convention to some extent retained thereafter in France although becoming less common, but tending to disappear in English and American plates. Whether this is an indication that men and women lived largely separate lives is unclear; it was probably simply a method of showing as many female costumes together as possible. A typical plate might show two women and a girl, while the less common men's plates might show three men, or two men and a boy. Since men's clothing took up less space, the artist could fit more male figures onto a single page.

Contrary to popular belief, the fashionable stylization of the body applied to both sexes. Fashion plate men of the 1830s—like their female counterparts—have huge eyes, delicate features, and figures resembling an hourglass. A typical example from *Le Petit Courrier des Dames* (31 December 1838) shows three such men standing by a fireplace. Notice that this is a man's fashion plate in a predominantly feminine magazine. In the

1830s, fashion magazines were still *relatively* directed toward both sexes. By the middle of the century, fashion magazines were much more exclusively for women, with the exception of the tailors' magazines. By mid-century, the hourglass look was becoming modified, and more of the male body was effectively concealed by longer coats that reached mid-thigh, and by wider trousers. A typical arrangement shows one man in formal day dress and another in formal "aristocratic" evening dress—with knee-breeches instead of trousers.

There were, however, many more fashion plates for women than for men—and those for men were often intended specifically for tailors. We are justified, therefore, in paying far more attention to women's than to men's fashion plates. Men seemed to have gotten their fashion information from other sources—perhaps secondhand from their tailors.

The size of fashion plates also influenced the number and arrangement of the figures. Although some of the deluxe plates of the late eighteenth and early nineteenth centuries were fairly large, most from the first half of the nineteenth century were small, which to some extent limited the "action" that could be portrayed. As larger plates became more common, there tended to be more figures and more of an emphasis on their interaction within an identifiable setting. There is not necessarily a connection, however, between size and activity: Some of the largest plates from the 1880s and 1890s show only a single female figure standing face forward, in the middle of nowhere; in contrast, a small print from *Le Beau Monde* (London, 1807) shows a man and a woman playing cards, while another woman watches.

La Mode Illustrée led the way with larger plates and topical settings. From its first publication in 1860 "dates the transformation of fashion journals." A weekly journal, its stated goal was "to teach mothers and young people, by means of prints and descriptions of a rigorous exactitude, how to make all the useful objects that they need." The editor Firmin Didot introduced multiple editions, having either 12, 26, or 52 colored fashion plates per year. Moreover, the magazine adopted a much larger format (370 × 260 mm), which gave a new prominence to the fashion plates, most of which were the creations of Anaïs, her sisters, and her daughter.

Much of the text of *La Mode Illustrée* was a straightforward response to the readers' questions about the styles that were coming in, the fabrics that were fashionable, problems with home dressmaking, and the gowns recently worn by noted personalities: "Some of our subscribers who live in the country, but in proximity to a city, have asked me to indicate to them which dresses can be worn in the country without inconvenience, and in the city without oddness." *La Mode Illustrée* would never have said, as *La Vie Parisienne* did, that "the recipe for making the new fashions" is to "take

a woman [and] wrap her once in a length of satin, twice obliquely in gauze, three times in a veil of muslin. Add 20 metres of flower garlands." When the poet Stephane Mallarmé wrote and edited *La Dernière Mode* for part of 1874, he failed to adopt the proper, serious tone. For example, when a reader asked whether a female bicyclist should wear trousers or a skirt, Mallarmé replied:

> Faced with your question, I feel like a pedestrian in front of a steel-horse, trying to get out of the way, who is bowled over, pierced by the dazzle. However, if your purpose is to show legs, then I prefer a slightly raised skirt, vestige of the feminine, rather than mannish trousers.[13]

No wonder he was fired!

The fashion-plate setting (like the description) was supposed to give some indication both of the circumstances for which the clothes were designed, and, indirectly, of the places where women were supposed to be. The setting is often vague—an interior or garden of some sort, barely indicated by faintly traced in objects like a bench or a mirror. When there is more detail, the interiors hint at luxury and status, through the inclusion of sketchy elements such a chandeliers, pillars, curtains, and portraits of presumably illustrious male ancestors in the dress of the *ancien régime.* Similarly, the gardens show not only trees, but plants in urns, a distant chateau, and statuary (such as stone cherubs).

Since each print usually shows at least two complete costumes, there is not always a close correspondence between setting and clothes. For example, if one costume is a visiting (day) dress and the other is a ball gown (evening wear), only one of the two figures is really in correspondence with her setting. The example that Arnold Bennett gave, with figures in sporting, evening, at-home, theatre, and night dress is a rather unusual instance of such incongruity, and probably refered to an extra-large fashion plate. Often there is at least a pretext for the portrayal of different occasion-specific dress in proximity: For example, a woman comes to visit a friend in her home, thus enabling the artist to show both outdoor and indoor dresses.

For the most part, women were supposed to be at home or in the safely enclosed garden, an obvious extension of the domestic sphere. They are shown in the parlor—receiving guests, having tea, sewing, showing off new jewelry or the new baby. They might be engaged in some suitably genteel and artistic activity, such as painting or playing the piano or the harp. They not only embroider, but use a sewing machine to make clothes for the whole family.

By mid-century, however, they were increasingly shown outside the home, perhaps in the park, either riding horseback or walking with a female

In this fashion plate from *La Mode Illustrée* (1881), Anaïs Colin Toudouze juxtaposes a visiting dress and a hunting costume. Clothing for *le sport* often featured skirts that were shorter than usual—at least when there were likely to be few spectators. Hunting took place in the countryside, among one's peers; gymnastics and later fencing were private indoor exercises, and so on. We cannot, however, simply assume that sports clothing was designed to be functional. The nineteenth-century person was more likely to think in terms of propriety and prestige. Because hunting was regarded as an aristocratic sport, hunting costumes (and riding habits) were often featured in fashion-plate art.

companion and a child. Two women together might be shown window-shopping, walking in the country, at the seaside, at church, or in an art museum. Social settings include the evening reception, the fancy dress party, the theatre or the opera, a fox hunt or the horse races. But the women are usually shown away from any crowd. At the opera, for example, they are in a little group safely together in their private box, rather than mingling with the crowd in the foyer. Nevertheless, their world was expanding, and sometimes they went so far from home as to enter a first-class railway carriage.

In personality, they were affectionate: They loved animals and children, and pitied the poor. One woman feeds her pet macaw, others look at the birds in an aviary or dovecote. They are charitable, dispensing aid and money to the poor, and teaching their little girls to do the same. In fact, they often appear with a child—although groups of children also had their own, separate fashion plates.

In the mid-eighteenth century, men dressed as elaborately and modishly as women. A pink silk suit, gold and silver embroidery, lace, jewelry, and powder were regarded as perfectly masculine. This early fashion plate by Le Clerc for *La Gallerie des Modes et Costumes Français* (ca. 1779) shows an elegant three-piece spring suit. The hat was intended to be carried, not worn.

Just as an engineer's drawing of an automobile differs from the illustration used in an advertisement, so also are there different types of fashion illustration, This eighteenth-century watercolor indicates the design to be embroidered on a man's waistcoat.

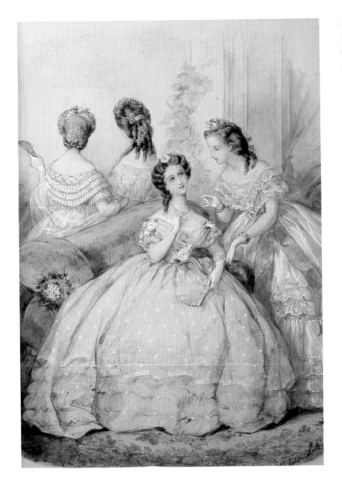

Even in the best quality fashion plates, something of the exquisite miniature quality that characterized the original drawing was inevitably lost when the watercolor was reproduced in the harder, crisper print medium. The difference is clear when we compare this watercolor drawing by Héloïse Colin Leloir with the fashion plate made from it that appeared in *The Paris Élégante and Journal of Fashion* (1862). Courtesy of the Coleman Collection.

The translation of the original into print form meant that the shading and tone of the watercolor had to be given black-and-white equivalents in the form of tiny lines and dots. In the next stage, the original color wash was replaced by blocks of colored ink. Teams of young women were organized in assembly-line fashion, each worker applying one color. Courtesy of the Coleman Collection.

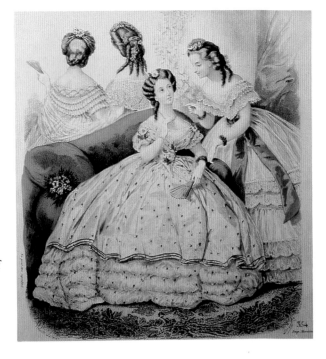

The differences between traditional fashion illustration and the Art Deco
fashion plate are clear if we compare a picture by one of the Colin sisters with
this fashion plate by Georges Barbier from *Le Journal des Dames et des Modes*
(1913). The complexity, delicacy, and detail of nineteenth-century fashion
give way to an emphasis on the dominant line and color of a dress.

In 1911, the year that Paul Iribe produced *Les Robes de Paul Poiret*, Paquin commissioned a deluxe album entitled *L'Eventail et la fourrure chez Paquin*, by Iribe, in collaboration with Georges Barbier and Georges Lepape. In this masterpiece of fashion illustration, Iribe portrays Paquin's dress in flaming colors and on a figure whose slender, apparently uncorseted body represented the new physical ideal.

Since the 1930s, photography has largely replaced the art of fashion illustration. The French fashion magazine *La Mode en Peinture* is atypical in that it continues to commission paintings such as Jean-Paul Raymond's *Bonjour Renoir*. This witty revision of an Impressionist painting features a dress from Sonia Rykiel's 1985 autumn collection. It is reproduced here courtesy of Jeff Didelot, photographer for *La Mode en Peinture*, PROSPER S.A.R.L. Paris. Photograph © Jeff Didelot, 1987.

In the nineteenth century, women were perceived as the kind and gentle sex. This fashion plate by Héloïse Colin Leloir from *La Mode Illustrée* (circa 1875) is typical in showing a charitable theme. Middle-class viewers would not have seen anything inappropriate about wearing expensive clothing when visiting the poor, since wealth was thought to be the result of virtue and divine providence. No doubt Héloïse thought that she was simply depicting a kindly act. Conceivably, the editor of a fashion magazine might also have believed that such a subject would tend to counteract the negative stereotype that women were vain and selfish.

La Vie Parisienne

One thing fashion plate mannequins *never* did was to lie down, or sprawl, like odalisques, across the page. That was left to the figures in *La Vie Parisienne*. In fact, as the *Playboy* of its day, *La Vie Parisienne* provides a useful masculine counterpart to the overwhelmingly feminine fashion press. Moreover, in its own way, *La Vie Parisienne* was also devoted to fashion reportage. The descriptive subtitle listed: "Elegant manners—fads—fantasies—travel—theatre—music—fashions" (later also "sport"); and although fashion was mentioned last, it was probably the most important. The extent to which magazines like *La Vie Parisienne* dealt with fashion—both feminine and masculine—and the fact that they treated it as a source of amusement and pleasure, indicates the relatively greater significance of fashion in a more structured and hierarchical society. Even the idea of *jokes* about fashion is an indication of the existence of strong social pressures.

The centerfolds in *La Vie Parisienne* frequently featured risqué fashion themes, such as underwear and corsets. "How They Go To Bed," for example, dealt with nightgowns. ("They," of course, refers to women.) The undeniably phallic "How They Eat Asparagus" was censored. Indeed, censorship apparently influenced the treatment of fashion. During the 1860s, when censorship was fairly strict, outerwear was featured—ball dresses, décolletage, fantasy costumes. In the centerfold "Dresses and Coiffures. Memories of the Ball," there is the comment: "Is it a dress or a *maillot*? . . . Costume extra tight-fitting." Then, in the later 1870s and especially after 1881, government censorship relaxed, and first lingerie and then nudity was shown more often. Of course, this was also the beginning of the great era of erotic lingerie, when colors and silky fabrics became more common, and this trend in sartorial sexuality was undoubtedly also a factor in editorial policy.

Essentially, fashion commentary appeared in *La Vie Parisienne* whenever women did—which was constantly. The centerfold dealing with the Salon of 1877, for example, dealt exclusively with paintings of women—or, rather, as the title had it, "Modes and Confections, 1877." Thus, the well-known painter Carolus-Duran was described as "our eminent . . . Couturier," and his picture of a lady lounging on a sofa was said to be dedicated "to the profit of the [silk] workers of Lyons." "The *grande toilette* of M. Carolus-Duran caused a sensation: 75 metres of silk to make it!" Manet's *Nana*, the picture of a courtesan in her boudoir, was described as a "little sketch of an intimate toilette. Corset by Mme. X. Lingerie by Mme. Y."[14]

A similar joke appears in Bertall's *La Comédie de notre temps*, in which two ladies are shown looking closely at a painting in an exhibition, and one says, "I tell you, that's a dress by Worth. I recognize his touch."[15] Bertall,

As the *Playboy* of its day, *La Vie Parisienne* emphasized the erotic appeal of the intimate peignoir (above) while exaggerating the form-fitting character of evening dress (below). The illustrations also implicitly focus on the act of dressing and undressing.

in fact, occasionally did cartoons for *La Vie Parisienne*, but more important he shared with Marcellin and others at *La Vie Parisienne* a certain irreverent approach to social and sartorial phenomena that was wholly lacking in most women's magazines.

Caricatures of fashion blunders vied with the magazine's text, which often featured fawning descriptions of "a charming new fashion inaugurated by the Countess Shouvalof at her little morning reception at the Russian Embassy in London," or of an opera costume "worn by the young baroness de J." In fact, *La Vie Parisienne* is full of what were probably paid announcements masquerading as impartial editorials: "The lingerie of Mme. Albert Leblanc is poetry, dream, the perfume of Parisienne dress."[16] Most of the fashion commentary, however, could be characterized as a social and erotic physiology, somewhat in the tradition of Balzac. A series of illustrations shows the different toilettes worn in a single day, whenever possible with an emphasis on the sexual body. Moreover, the particular scenes—going down to breakfast, riding in a carriage, arriving at the theatre—always focus on a man and a woman together. The text makes the sexual connection explicit, between, for example, a dressing-gown and post-coital pleasure:

> 10 o'clock in the morning—Peignoir . . . opening over a skirt decorated with cherry-colored satin bows. Sleeves . . . exposing the arms, white silk stocking. . . . Dips a biscuit in her hot chocolate and finds life good.
> He: Grey trousers, velvet jacket, night shirt; reads the newspaper, does not understand the necessity for constitutional laws, confuses all the amendments, and thinks that if the [parliamentary] deputies were amorous, France would find herself doing marvellously well.[17]

It is not just that this particular peignoir is more luxurious and physically revealing than the usual dressing-gown. The woman's entire body language is relaxed, as she leans back (supported by a light morning corset) and lifts her legs up and slightly apart. Both all the silky frothy fabric and all the exposed flesh indicate sexual abandon. The brunette maid who kneels at the blonde woman's feet, gazing adoringly at her, was a standard figure in advertisements and some fashion plates, but here she plays the role of a proxy lover, as she slips a white and cherry stocking onto a naked leg.[18]

At eleven o'clock, the hairdresser arrives and the lover departs. At noon, the woman comes downstairs for lunch in an indoor dress with a train; and the lover returns, wearing an informal blue suit. He kisses her hand. The descriptions of their day clothes receive only marginally more attention than their luncheon menu of cutlets, jellied chicken, paté de fois gras, salad, and English pastries. At one, they go outside to the garden, she in a walking dress and a short coat trimmed with the fur of a Siberian wild-

cat, he in a Scottish cap. Notice that she has had to change her dress, whereas he only adds the appropriate accessory. At three, they go out visiting, she in a fairly formal black striped dress, he in equally formal afternoon attire—a black redingote, high collar, top hat, and so on.

At six, the sun sets in the Bois de Bologne, and they ride home in a carriage. Somewhere or other along the way she has changed her dress again. He wears "the same costume as at 3 o'clock [but with] 200 louis less in his wallet." A little later they arrive at the theatre, and he helps her take off her coat of grey velvet and blue fox. Underneath she wears a form-fitting dress with a pearly bodice and a skirt of black velvet with white satin flounces. His black suit and black cravat "tied simply in a rosette" are not actually shown, since he is still wearing his overcoat. At the theatre, "They amuse themselves and laugh like fools," then stroll around the foyer "to see who's there, and to tell themselves that no one is as happy as they are." At eleven P.M. they go to a ball, she in a white ball-gown, low-cut in back and tight over the hips, but no more so than was really fashionable then. This is a relatively realistic illustration. He is in a black suit, this time with a white cravat. His hat, which he holds under his arm, has his monogram in diamonds. They don't stay long, however; preferring their own company, they hurry home.[19]

Different fashions served to mark off the stages of the day, from intimate to informal, from formal daytime to formal evening occasions. However, although middle- and upper-class people certainly did change several times a day, they seldom changed *this* often. It seems to me that implicit in all these changes is the subject of *dressing and undressing*, and with such an amorous couple, presumably also a series of sexual encounters punctuating the day. The maid putting on the lady's stocking, and the lover taking off her fur coat, are emblematic of the day's multiple striptease. Beyond that, of course, at least several of the dresses are body-revealing and luxurious, and in a more subtle way they add to the general sexual beauty of the woman especially, but also of the man.

Modern Art and the Fashion Plate

Traditionally, art critics and historians have argued that avant-garde painters in the nineteenth century were uniquely inspired by the direct observation of reality. Emile Zola was one of the first of many to insist that

[The Impressionist painters'] works are not unintelligent and banal fashion plates, nor drawings of current events similar to those published in illustrated journals. Their works are alive, because they are taken from life and because they are painted with all the love that they feel for their modern subjects.[20]

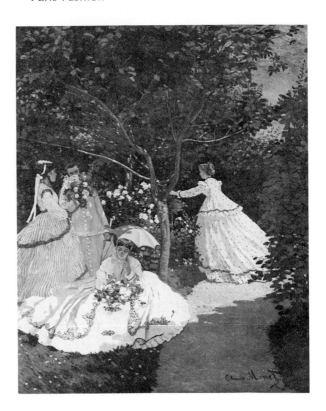

The paintings of the Impressionists "are not unintelligent and banal fashion plates," wrote critic and novelist Emile Zola. "Their works are alive, because they are taken from life." Yet recent research indicates that avant-garde artists were, in fact, influenced by popular illustration—including the despised fashion plate. Claude Monet's *Femmes au Jardin* (1866–1867) takes one of the most popular fashion-plate subjects—women in a garden—and treats it in true fashion-plate style. Musée d'Orsay; photograph courtesy of the Musées Nationaux de France, Paris, © SPADEM 1987.

Realists, like Courbet, and Impressionists, like Monet, supposedly looked at the world around them and *painted what they saw*, unlike conventional artists who based their work on ideal models. Certainly the spirit of their work was different. But the issue is more complex than this. As we have indicated, during the "media explosion" of the July Monarchy, a vastly expanded range of images appeared in the popular illustrated press, including a gallery of stereotyped female figures. When Baudelaire invoked his "cult of images, my only . . . my primitive passion," he almost certainly meant to include these images of the modern city's inhabitants. Recent research has demonstrated conclusively that both Realists and Impressionists grew up seeing popular illustrations (including fashion prints) and were clearly influenced by their style and iconography.

The fashion plate dealt in a particular way with a restricted set of themes, yet although its technique, presentation, and subject matter were stereotyped, the iconographical tradition and general pictorial sources of the fashion plate were shared with other types of art.

The best essay on this subject so far is Mark Roskill's article, "Early Impressionism and the Fashion Print,"[21] in which he demonstrates the influence of the fashion plate on Monet's work. A painting like *Femmes au*

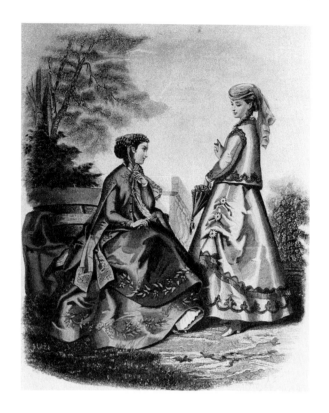

Fashion illustration was characterized by virtually interchangeable figures, posed stiffly and in positions designed to display the dresses, which formed flat and interlocking silhouettes. This fashion plate by Anaïs Colin Toudouze from *La Mode Illustrée* (1867) shares these conventions with Monet's painting. Courtesy of the Coleman Collection.

jardin (1866–67), for example, takes one of the most popular fashion plate subjects—women in a garden—and treats it in true fashion-plate style. The setting, of course, is an obvious extension of the interior feminine sphere, and it is not surprising to see a painting of pretty young women in fashionable dresses. It is rather more surprising, however, to see the same model in a variety of different dresses. Roskill suggests, however, and I believe convincingly, that it was not merely a dearth of models or a lack of money to hire them that led Monet to use his mistress Camille as the model for all the figures in the painting. After all, there was already a precedent in fashion illustration for the use of interchangeable and virtually identical figures.

Moreover, the *way* the figures are painted is in accordance with fashion plate conventions, and can only be understood in this light. To begin with, there is the "stiff artificial character" of their poses; and the "psychological disconnection between the figures"—an arrangement originally designed to show as much as possible of every dress. To those familiar with fashion-plate conventions, "the artificial stances of separately posed figures would not appear peculiar and incongruous, but rather conform to well established imagery." The dresses form clear and rather flattened silhouettes,

like two-dimensional cut-outs in the shallow space of the painting. Within each shape, attention is paid to pattern and textile, "the appeal of the materials." The "typical coloring of the fashion print is also relevant in this respect." In short, the costumes "assert" themselves. But not only do they stand out from the background, but the skirt silhouettes are also so arranged as to lock the figures together. Now some of this use of shapes may have come from Japanese prints, but fashion plates were undoubtedly a more immediate source for the conventions of "arrested poses and graphically rendered textiles."

Incidentally, the three main dresses used in *Femmes au jardin* also appear in *Dejeuner sur l'herbe*. But this does not necessarily mean that Camille owned these dresses, especially in light of their poverty at the time. Nor does it seem that Monet simply copied them from fashion plates. Since one of Bazille's letters mentions renting a green satin dress that Monet then borrowed, it is likely that all the dresses were rented in Paris, which itself throws an interesting light on nineteenth-century fashion behavior.

Boudin's *Beach Scene* also looks very much like the sketch for a fashion plate: We see the clothing both in general outline and in detail. Moreover, we see it from several angles—and as the eye moves from left to right, it seems as though the three primary figures are turning slowly like fashion models on the runway. The positions and spacing of the figures only make sense in terms of a fashion display. The woman in the dotted fabric is not really talking to the woman with the parasol; they are too far away from each other for that. Rather, they face each other so that we can see the *side and back* of the first dress and the *front* of the second dress. If this really were a fashion plate, the design of the dresses would probably be more similar—perhaps even identical.

The central figure (the only woman who stands) presents us with a perfect view of the construction and arrangement of her fashionable costume. Her seaside hat has long streamers—which in England were known as "follow me, boys"—and which here blow gently in the wind, carrying the eye down her jacket bodice with its figure-flattering trim and decorative buttons. The skirt and bodice were separate garments, although usually made of the same material. This particular example is the popular double skirt, whose overskirt has been looped up and caught in place with ribbons. The figures form a sort of frieze, as each flat triangular silhouette locks into the next. The surface pattern rises to a gentle peak with the standing woman and fades away on the right with the two background figures—also a common feature in "real" fashion-plate art.

Eugène Boudin (1825–1898) did many paintings of Trouville, of fishing boats as well as the middle-class vacationers on the beach. It must be admitted, however, that his finished oil paintings, like *Beach at Trouville* (1863), are much less like fashion plates. Anaïs could have painted watercolors

Monet's teacher, Louis Eugène Boudin, also produced paintings that resembled (at least in their early stages) the art of fashion illustration. *Beach Scene* (1865) shows fashionable dresses in close-up and from a variety of angles. Ultimately, however, most of his painting subsumed the dresses into the larger landscape, emphasizing, for example, the expanse of beach and sky. Courtesy of the Saint Louis Art Museum.

like *Beach Scene,* but she never attempted an ambitious canvas peopled with some two dozen beachgoers—one, moreover, where the empty sky takes up three-fourths of the canvas, a feature that automatically would have disqualified it as fashion-plate art.

Surprising as it might seem, beach scenes occurred regularly in fashion plates of the later nineteenth century. It was not so much that ladies were shown in their bathing suits—that was more typical of humorous and risqué popular illustrations. Rather, vacationing Parisians went to popular seaside resorts, to sit and stroll fully clad along the edge of the ocean, and it was this scene that attracted the painters and illustrators of fashionable life, from August Sandoz to Albert Lynch and Edouard Toudouze. But whereas fashion illustrators focused closely on a handful of dresses, most other painters did social scenes or seascapes with figures. They might do fashion studies, but those were later incorporated into a painting with some large theme.

Monet may have gotten the idea of using fashion plates from his former teacher, Boudin, or by consulting with artists like Toulmouche, a student of Gleyre, who specialized in pictures of lovely ladies. A contemporary said of his work: "It's pretty, charming, highly colored, refined—and it's nauseating." Of course, from Gleyre's point of view, the realistic study of human figures could all too easily result in "ugly" pictures: "Nature," he

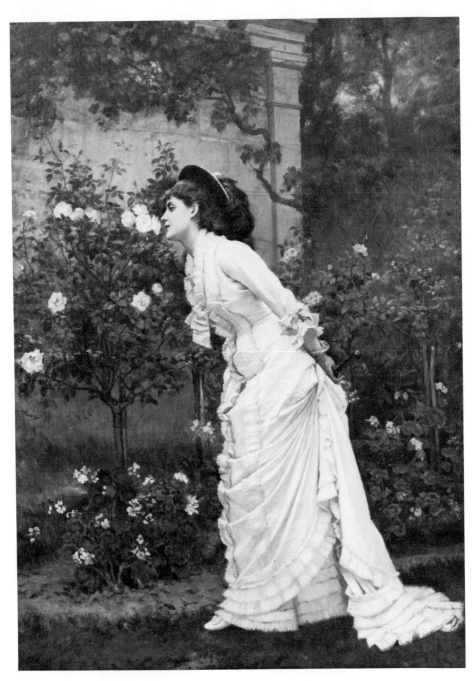

Certain artists, such as Gleyre and Toulmouche, specialized in pictures of attractive, fashionably dressed young women. One contemporary said of Gleyre's work: "It is pretty, charming, highly colored, refined— and it's nauseating." Yet *A Girl and Roses* (1879) by Auguste Toulmouche is invaluable from the point of view of the fashion historian, reproducing, as it does, with almost photographic verisimilitude and little personality, both the fashion and the ideal of feminine beauty then dominant. Courtesy of the Sterling and Francine Clark Art Institute.

Like the Toulmouche painting, this fashion plate by Isabelle Toudouze Desgranges from *La Mode Illustrée* (1882) uses dress to reinforce the image of sweet and pretty femininity. At about the same time, Isabelle's brother, Edouard Toudouze, was doing paintings such as *Salomé triomphante*.

told Monet, "is all right as an element of study, but if offers no interest. Style, you see, is everything."[22]

The style of Toulmouche's pictures is heavily dependent on fashion illustration—from the slender elongated figure to the precious pose, the sweet colors, and the detailed representation of the dress itself. Consider, for example, his *Girl and Roses* (1879). The dress, of course, is quintessentially late 1870s, with its long, skintight bodice moulded over a *cuirasse* corset. The skirt also seemed daringly skimpy after the voluminous crinolines of a few years past. (The heroine of a contemporary English novel was described as wearing a ball-gown of "white silk, so tightly drawn back that every line of her supple thighs and every plumpness of her superb haunches was seen."[23]) The day dress by Toulmouche, however, has an apron overskirt which made it a little more modest.

At this time, the bustle was rapidly (although temporarily) disappearing. But in place of the back protruberance were a variety of other embellishments, including poufs and trains that were intended to render the figure more "graceful." Toulmouche has positioned the figure perfectly to display all the most fashionable features of her dress.

129

Some avant-garde painters were also influenced by fashion-plate imagery and style. The most surprising example is, perhaps, Cézanne, who actually *copied* at least two fashion plates from *La Mode Illustrée* of 1871. As John Rewald puts it:

> When he fell short of inspiration, which did not happen often, he thought nothing of copying the insipid ladies in these plates, infusing them with a strange and dramatic power. Just as Manet frequently adopted certain elements from the masters, Cézanne found in these fashion prints pretexts for creations of his own.[24]

From our perspective, it is especially interesting that Cézanne happened to copy from this particular magazine, for which Anaïs did so many pictures. What did Cézanne see in them? Certainly not the fashionable details that preoccupied the painters of elegant life (like Toulmouche), since he omitted most of these. On the other hand, he *was* interested in the positions and gestures of the figures, the way they lifted a skirt or gestured with a parasol. These conventional gestures, found so ubiquitously in fashionable art, tend to be less common in Impressionist paintings (which is one of the reasons those paintings seem much more "modern" to us). Yet to Cézanne, these gestures may themselves have seemed more modern than those of figures in classical art. After all, he deliberately chose this model to practice the construction of a contemporary scene with figures. Then, too, for a shy provincial young man, the contemporaneity of fashion plate figures may have looked seductively feminine and quintessentially Parisian.

When we look at the fashions of the past (or at stylized images like the fashion plate), we are usually struck by their strangeness, especially if they are very old. "How odd and uncomfortable," we think. As Uzanne observed, mournfully and a little unfairly:

> The beauties of bygone days—those whom we have met on our journey down the stages of the past century—only appear to us in stiff engravings yellowed by time, which, though picturing the garb that they wore, lack all the mobile grace of living attitude, and the unreproducible expression of face and form.

The clothing of the more recent past we tend to dismiss as, at best, amusing and, at worst, ludicrous. If we remember wearing such clothes ourselves, we may even feel slightly embarassed. It was again Uzanne who first observed that

> An ancient fashion is always a curiosity. A fashion slightly out of date is an absurdity; the reigning fashion alone, in which life stirs, commands us by its grace and charm, and stands beyond discussion.[25]

From the perspective of the modern viewer, this is no doubt correct—and

Paul Cézanne might seem an unlikely candidate to have been influenced by fashion illustration, but *La Promenade* (ca. 1871) was actually copied from a fashion plate. Unlike the painters of elegant life, Cézanne largely ignored the texture of the fabric, the line of the silhouette, and the details of fashionable dress. But he was interested in reproducing the positions and gestures of the figures, the way they lifted a skirt or gestured with a parasol. Perhaps for a shy young man from the provinces, the fashion-plate mannequins represented the modern woman in her seductive and elegantly Parisian incarnation. From the collection of the late Joan Whitney Payson; photograph courtesy of the Knoedler Gallery, New York.

Although unsigned, this fashion plate from *La Mode Illustrée* (1871) was almost certainly the work of either Héloïse Colin Leloir or Anaïs Colin Toudouze. Courtesy of the Costume Institute, The Metropolitan Museum of Art, New York.

131

not simply because the fashion press conducts a constant propaganda war against the old and in favor of the new.

But nothing could be more of a mistake than to assume, arrogantly, that previous generations would have preferred to look like us, had they been able to. Just as legions of tourists continue to condescend to the inhabitants of "less developed" cultures, so also do many of us denigrate the inhabitants of past cultures. But the only way we can begin to understand the fashions of the past is to study what their wearers and original viewers actually *thought* about them. Within the framework of a particular clothing tradition, they made *choices* about what they wanted to wear and how they wanted to look. We are entitled to believe that, from our point of view, they sometimes made the "wrong" choices, but we cannot, in honesty, imply that they were "forced" or "brainwashed" into wearing "ugly" or "restrictive" clothes—a point of view that has tended to dominate modern histories of women's dress.

Furthermore, we must resist the impulse to assume that "people didn't really wear those clothes." Certainly, "high fashion" was (and is) only worn by a minority of people, but the clothing of ordinary people was (and continues to be) derived from high fashion, which it closely resembles in general form. The fashion plate merely emphasized the salient characteristics of the latest fashion. Finally, although it should seem obvious, we must remain aware that the fashions of the past were once the height of modernity. They were made and worn by living men and women—which can be difficult to imagine when all that remains to us are some carefully posed images and a few clothes, hanging as limply as the skin of Saint Bartholomew.

I would like to suggest that, while artists were not modernists simply because they painted figures wearing contemporary fashions, nevertheless there is a significant relationship between modern Paris, modern fashion, and the rise of artistic modernism—and that this provides another clue to why Paris was the capital of style. Although Anaïs was no Monet, I would suggest that even the humble fashion plate contributed to "the vanguardists' search for images to define the real and contemporary."[26] Baudelaire was probably right to insist that "All fashions are charming"—if we remember that his conclusion was based on the feelings of the original wearers and viewers. He himself admitted, however, that if this seemed "too absolute, say, if you prefer, 'All were once justifiably charming.' You can be sure of being right."

7
Fashionable Rendez-vous

"The Last of the Boulevard 'Lions' " is a typical illustration from Uzanne's *Fashion in Paris*. Set in 1853, it depicts a scene in front of the Café Tortoni, on the corner of the boulevard des Italiens and the rue Taitbout—in the heart of fashionable Paris. Yet François Courboin actually drew the picture in 1897, and it bears a noticeable resemblance to the poster art of the day. Thus, it may not be quite such "a faithful witness . . ." of some corner of Paris" as Uzanne had hoped. Nevertheless, it does emphasize the importance of a particular kind of dramatic setting within which fashion flourishes.

C'est ici pour des goûts divers
Le théâtre de l'univers.
A seventeenth-century poem

The Cours la Reine was the most fashionable promenade in seventeenth-century Paris, but it was not the only place in Paris that could be described as "the theatre of the universe." In the course of the *grand siècle* Paris acquired a number of settings—the Cours, the Palais, the Tuileries gardens, the Opéra, the theatres and the early boulevards—in which to act out the drama of seeing and being seen. Moreover, although promenades appeared in other cities as well, notably in London, Parisians were especially enthusiastic about the new forms of urban leisure. Historian Mark Girouard suggests that, more than people in other cities, "Parisians treated life as a spectacle . . . and intensely enjoyed their own and everyone else's performance."[1]

The drama analogy for social life has been a commonplace for centuries: "All the world's a stage." And the idea that men and women play "roles" has been a cliché of sociological writing since the 1930s, although the corollary—that they "dress for the part"—has received somewhat less attention. Yet the subject of fashion in Paris almost requires some kind of dramatic analogy—not in the sense that Parisians were poseurs, but because it seems that fashion can only exist and flourish in a particular kind of dramatic setting with knowledgeable fashion performers and spectators. Nor do these theatrical terms imply that the participants were engaged in some duplicitous charade. In anthropologist Victor Turner's words, the Parisians were "making it, not faking it." What they were making was the cultural significance of fashion.

During the seventeenth century the ancient capital—half medieval and half monarchical—began to be transformed into a modern city. But it was during the nineteenth century that change became most dramatically evident. And one of the most striking characteristics of nineteenth-century Paris was the way in which the design of the new city offered a vastly expanded stage for the public drama of modern life.

Contemporaries spoke of the "Haussmannization of Paris" and the "age

of Worth," but both Haussmann and Worth built on established foundations. Already under the Restoration (1815–1830), "the ring of the Grands Boulevards became the most animated part of Paris." The Champs-Elysées, then called the Avenue Neuilly, was one of a number of fashionable meeting-places, and recognized couturières like Madame Palmyre and Madame Camille dressed a fashionable clientele. But the development of a new Paris, characterized by the proliferation of public fashion arenas, was intensified one hundredfold under the parvenue empire of Napoleon III—when, between 1852 and 1870, much of the city was physically demolished and rebuilt in a deliberate experiment in urban planning more radical than any previously attempted. And at the same time, the Englishman, Charles Frederick Worth, went into the French "stronghold" and established himself as "the King of Fashion"—a phenomenon with a profound and continuing effect on international fashion.

The Geography of Fashion

The face of the city changed dramatically over the course of the nineteenth century. Physically, Paris grew outwards, in a series of concentric circles. Yet fast as it grew, the city was inundated by new arrivals, as the population doubled between 1830 and 1860, from half a million to a million. Thus, the old city became ever more crowded and unsalubrious—a rabbit-warren of dark, narrow, filthy alleys with no pavements, punctuated by the occasional new boulevard covered with macadam and with ample room for carriages and promenades—complete with benches for spectators, under rows of trees. This was Balzac's Paris, which was soon to disappear.

"The old Paris no longer exists," wrote Baudelaire in 1861. "The form of a city changes more quickly, alas, than the heart of a mortal." The poet was not exaggerating: Under the direction of Napoleon III's Prefect of the Seine, Baron Georges-Eugène Haussmann, entire neighborhoods were leveled to the ground and their inhabitants evicted to make way for the erection of a monumental and spacious city of public buildings, commercial centers, and broad, straight boulevards. Some 20,000 buildings were torn down, and another 40,000 constructed. Of course, Haussmann's predecessor under the July Monarchy, the Comte de Rambuteau, had already tried to give Parisians "water, air, and shade," but had been reluctant to authorize any but petty expenditures. Haussmann, however, spent the fabulous sum of 2,500,000,000 francs on rebuilding the city, with the result that the "stinking" city was now "sweet."[2]

"Paris demolished is one of the questions of the day," observed the authors of *Paris and the Parisians*. To some of the city's inhabitants, it ap-

peared to be "a mosaic of ruins," but others admired the "New Paris" as an example of the "supreme coquetry of great cities."

> Paris makes her toilette and wants to show herself to foreigners in her great finery. . . . She wants not only to be magnificent but also to be clean.[3]

In the geography of fashion, Paris was the center of the universe. But even within the "kingdom of fashion," there was an inner city (comparable to the Forbidden City within old Peking) from within which issued "the decrees of the sovereign." According to Uzanne,

> This area is the quarter of the city lying between the Rue de Rivoli on the south, the Chausée d'Antin on the north, the Rue Taitbout on the east, and the Rue Royale on the west. . . . The Rue de la Paix, connecting the brilliant quarter of the Opéra with the old royal promenade of the Tuileries by the Rue Castiglione, may be called the center of [the fashion] industries.[4]

Here, on the rue de la Paix, the rue Royale, and the area around the place Vendôme, were the smartest and most expensive fashions, perfumes, silks, jewels, furs, hats, and lingerie.

Downtown Paris was already a center of commerce by the early nineteenth century. Under the Second Empire, the economic power of the bourgeoisie was even more evident in the additional factories and work-shops, commercial establishments and financial corporations that changed the face of the city. Hitherto virtually islands unto themselves, the various Parisian neighborhoods increasingly became subsumed into a citywide net-work of production, consumption, and the pursuit of pleasure.

In the first half of the nineteenth century, the working class made up some 75 to 80 percent of the total population, the bourgeoisie only about 15 percent. But while there were some working-class neighborhoods (like the Faubourg Saint-Antoine), in much of Paris members of different classes lived in the same buildings, on different floors: the bourgeois on the second floor, the seamstress in the attic. Now, under the Second Empire, there was increasing class segregation, sharper distinctions between wealthy residential districts in western and central Paris, and the working-class "Siberias" in the *banlieue* where the city merged with the surrounding countryside. Since the construction projects of the Empire attracted even more workers to the city, the population doubled again between 1850 and 1870 (to some two million inhabitants).

There were fashionable places, fashionable times of day: Four in the afternoon was the correct time to take a carriage ride in the Bois de Boul-ogne, a former royal hunting ground that was revitalized under the Second Empire. After 1857, it was also the site of the yearly Grand Prix de Paris, a great social event in the fashionable calendar. There was an ap-

propriate fashion for each occasion, season, and time of day. As Uzanne wrote:

> These successive fashions, so strange, so curious . . . we marshall . . . before our readers' gaze, amidst those various surroundings of Paris, amongst which, in the course of these last hundred years, they have moved and had their being.

Fashion plates frequently at least alluded to the various scenes of fashionable rendezvous—the park within which one appeared in walking or riding costume or through which one glided in carriage dress; the opera where one ascended the staircase in view of all spectators, and so on. But Uzanne preferred to use pictures that were more detailed and less "commonplace" for his fashion histories:

> Each of the colored illustrations is a faithful witness, a complete representation, of some corner of Paris, vanished now, or utterly changed. Fashion figures therein only as a logical and indispensible accessory, and all the interest is centered in the background of the picture, which reveals one of the most fashionable aspects of our ancient city.[5]

It is idle to regret that he found the fashion plate to be "commonplace," especially in light of the quality of his illustrations. It is more important that he recognized the deep significance of the fashion arena.

A bird's-eye view of Paris would reveal that by the second half of the nineteenth century, the western districts were wealthy and distinguished, the center more heterogeneous, and the east working-class and petit bourgeois. The Left Bank included the bohemian Latin Quarter, some quieter and more "conventional" districts, and the highly aristocratic and correct Faubourg Saint Germaine. The relative geographical isolation of the Faubourg Saint Germaine corresponded to its exclusivity and emphasis on private social rituals and "in-group" fashion references. The wealthy financiers living in the Chaussée d'Antin area on the Right Bank were thought to favor a more extravagant mode of life.

The fashionable world, as such, was primarily situated on the Right Bank, which was associated with

> movement, pleasure, noise, and frivolity; it is distinctly southern in its characteristics. The women there are more fashionable, better dressed, and have all the characteristics of the true Parisienne.[6]

The rue de la Paix was a central axis with many of the most fashionable shops, "remarkable for the beauty of their frontage." Not only was shopping one of the most popular new semipublic occupations for women, but, of course, the relative exclusivity of the neighborhood added to its attraction. Many fashionable theatres, restaurants, and cafes (such as the Café Tortoni, on the corner of the boulevard des Italiens and the rue Taitbout)

were concentrated in this small area, which had been a center of social life since the Restoration and continued to be so under the July Monarchy and the Second Empire.

The geography of fashion could be traversed by moving from the outer suburbs of the city in toward the center:

> In the morning, between seven and nine o'clock, the streets of Paris present a spectacle without analog anywhere else in the world, one made to charm the eye of the artist and attract the moving eye of the dreamer. . . . Women descend, dressed somberly, the majority with pale faces and serious expressions, from distant faubourgs toward the center of the city. . . . These women are . . . the workers of elegance. The apprentices, the "arpettes" . . . enter among the graver figures of the workers, mingling with these women's black dresses, which are almost uniforms, almost religious, some truly amazing dresses and costume inventions. . . . The apprentices are . . . completely unique . . . thin little birds, with unclassifiable clothing . . . and the funniest hats. . . .
>
> Montmartre and Batignolles, Belleville and Bastille, Montrouge and the Avenue d'Orléans, these are the three most abundant sources from which precipitate the morning rivers. . . . One could baptize this . . . route, from the Place Clichy to the Place d'Opéra, the Milliners' Way.[7]

Moving from east to west, the stroller came across many of the city's social types. Along the Faubourg Saint-Antoine (always a revolutionary district) were the working women, such as shop girls and washerwomen. Near the Bastille were the clerks, saleswomen, and lace workers. From the north, moving toward the center, were the market women, small tradeswomen, cooks, and housekeepers.

> On nearing the Palais Royale, there is a complete transformation in the type and physiognomy of the passer-by. They become better dressed and even smart; dressmakers . . . young married women to shops or amusements, governesses and children's nurses, foreign visitors . . . all gloved and correctly dressed in well-fitting clothes . . . going either towards the Bon Marché or the Opéra. . . . Then ascending the Champs-Elysées towards the Place de l'Étoile, we see all the morning occupations of fashionable life, . . . from the lady on horseback to the carriages . . . bearing pretty *demi-mondaines* . . . on their way to the Bois de Boulogne.[8]

Unlike the collection of little neighborhoods that made up the old Paris, the new Paris was essentially a public arena—although sentinels stood at the gateways of the Tuileries Garden, to prevent the intrusion of "men in blouses, persons with heavy parcels, and dogs." Only relatively well-dressed persons were permitted to enjoy the flower beds and afternoon band concerts outside the imperial residence. That dress marked the dividing line was a long-established French convention going back to the prerevolutionary period when anyone could enter Versailles, providing they were suit-

ably attired. Now, however, suitable dress was far more easily obtained, and patterns of entertainment increasingly took people out of their homes and neighborhoods into the wider urban world.

Unlike the situation in most countries, women also participated in the pleasures of Paris, although respectable Frenchwomen almost always did so as part of a family group. As the Goncourts wrote in 1860:

> Social life is going through a great evolution. . . . I see women, children, households, families in this café [the Eldorado]. The interior is passing away. Life turns back to become public.[9]

New forms of recreation developed that shifted away from the old, more-or-less private contexts of family and neighborhood, to become public, commercial, even standardized entertainment. *Semi*-public areas, however, were safer for women: Precisely because only those in "decent apparel" were allowed to enter the Tuileries, it was one of the best places to see "French women, especially those of the middle class." "Throughout the summer season, young mothers and their children may be found spending the whole day . . . unostentatious yet elegant in their dresses, graceful and orderly in their deportment."[10]

The people who were best placed to exploit fashion to alter their apparent identity were often those who belonged to new social strata, people whose class positions were ambiguous, because people like them had not really existed before. The new white-collar workers, people like office clerks and shop assistants, entered into the fashion game often more wholeheartedly than the members of the old bourgeoisie. Although deep class divisions still existed, individuals had far greater freedom to present themselves as they wished to be seen. Fashion served both to maintain the hierarchy and, subtly, to weaken it—as anonymous individuals were increasingly judged on the basis of their appearance, of who they appeared to be.

Imperial Masquerade

A number of historians have interpreted the empire of Napoleon III in terms of a masquerade—as a bit of play-acting, both ominous and farcical, in a make-believe court filled with loose women, foreigners, and adventurers. There is an element of truth in this characterization. Certainly, conspicuous consumption and fantasy were noticeable in the social life of the court. And Worth's fame rested in large part on his status as courturier to the Empress Eugénie. Before looking at some of the more important public arenas—such as the theatre, the boulevards, the races, and the Bois de Boulogne—we should first glance at the court of Napoleon III which was,

in many respects, the center of social life in a way that the court had not been under the July Monarchy.

In her memoirs, the wealthy American Mrs. Moulton vividly portrays the importance of clothing at the parvenue French court, where guests were expected to wear a different outfit on every occasion. For a week's visit at the Palace of Compiegne, Mrs. Moulton brought twenty dresses:

> Eight day costumes (counting my travelling suit), the green cloth dress for the hunt, which I was told was absolutely necessary, seven ball dresses, five gowns for tea.

Most of her dresses were by Worth. When she and her husband were invited to Compiegne again, two years later, Mrs. Moulton's father-in-law refused to let them go. Immensely rich as he was, he thought it was simply too expensive. Eventually, however, he backed down and Mrs. Moulton happily rushed off to see Worth about *this* trip's clothing. She wrote to tell her mother what she was bringing:

> Here is the list of my dresses . . . (the cause of so much grumbling):
>
> *Morning Costumes.*
>
> Dark blue poplin, trimmed with plush of the same colour, toque and muff to match.
>
> Black velvet, trimmed with braid, sable hat, sable tipped and muff.
>
> Brown cloth, trimmed with bands of sealskin, coat, hat, muff to match.
>
> Purple plush, trimmed with bands of pheasant feathers, coat, hat to match.
>
> Grey velvet, trimmed with chinchilla, chinchilla hat, muff and coat.
>
> Green cloth (hunting costume).
>
> Travelling suit, dark-blue cloth cloak.
>
> *Evening Dresses.*
>
> Light green tulle, embroidered in silver, and for my locks, what they call *une fantaisie.*
>
> White tulle, embrouidered with gold wheat-ears.
>
> Light-grey satin, quite plain, with only Brussels lace flounces.
>
> Deep pink tulle, with satin ruchings and a lovely sash of lilac ribbon.
>
> Black lace over white tulle, with green velvet twisted bowls.

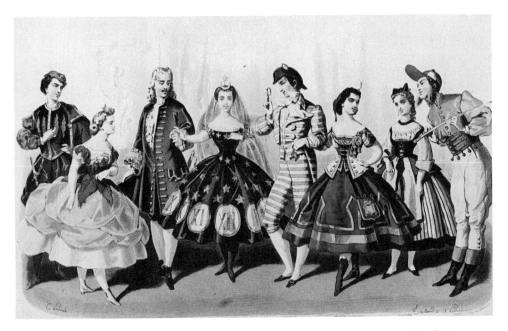

Fancy-dress costumes were immensely popular in the nineteenth century. This fashion plate by Préval from *Le Monde Élégant, Courrier de la Mode* (1865) depicts a variety of such costumes. From left to right: a page from the time of Henri III, a Bengal rose, a *seigneur* from the time of Louis XV, "the hours of the night," an *incroyable*, a canteen-keeper for the Hussars, a peasant girl from Alsace, and a jockey. The women's dresses are characterized by very short skirts.

Light-blue tulle with Valenciennes.

Afternoon Gowns.

Lilac faille.

Light café au lait with trimmings of the same.

Green faille faced with a blue and a red Charlotte Corday sash (Worth's last gasp).

A red faille, quite plain.

Grey faille with light blue facings.[11]

Occasionally even Mrs. Moulton grumbled about the cost of dresses by Worth. For a fancy dress ball at the Tuileries, Worth assigned her the dress of a Spanish dancer, a rather ordinary costume of yellow satin and black lace:

> Worth told me that he had put his whole mind upon it. It did not feel much heavier for that. . . . Some compliments were paid me, but unfortunately not enough to pay the bill.

142

She may have been disappointed that her dress was less magnificent and fascinating than others at the ball. (As a relative nonentity, she was simply *assigned* a costume by the great couturier.)

> The Empress was dressed as the wife of a doge of Venice of the 16th c. . . . She was literally *cuirassé* in diamonds and glittered like a sun goddess. . . . Princess Mathilde looked superb as Holbein's Ann of Cleves. She wore her famous collection of emeralds, which are world known.[12]

Ever outrageous, the Princess de Metternich chose to come as the Devil in a black velvet suit with jet horns and clawed gloves. Ugly but quintessentially *chic* (calling herself the "monkey à la mode"), the Princess was the one who introduced the Empress to Worth's dresses. Far more than Eugénie, she was the leading trendsetter of the Second Empire. The notorious *demi-mondaine* (and Italian spy), the Countess de Castiglione, came as Salammbo, the heroine of Flaubert's erotic historical fantasy. Had she not been the Emperor's mistress, she would probably not have been admitted.

To dress as Marie Antoinette or a dairy maid, an *incroyable* or a jockey was to escape momentarily from the restrictions of time and place. Opportunists dressed as kings and queens, and sprinkled themselves with Napoleonic symbols (like the bee). Ordinary rules of dress were suspended: Men could wear kilts, knee-breeches, even costume themselves as animals. "Fantasy costumes" for men featured items such as an ermine-trimmed hip-length coat ("style Francis I"), a long blue vest, tight white pants tucked into knee-length boots, and a "Spanish cravat" (like a soft, floppy pink bow tie). Not surprisingly, such costumes failed to supplant the modern masculine ensemble.

Even in women's everyday clothing, an element of historical "fantasy" was normal (and Worth was known to study the paintings of the past for artistic inspiration). But at fancy-dress parties, women could wear skirts as short as those of fishwives. Sometimes they could even wear trousers—for example, when posing as Near Eastern women. All players understood the rules of the game. Here, in a semiprivate setting, they were in no danger of really being taken for jockeys or peasants. It has also been suggested that during the Second Empire the French were particularly fond of fancy dress, as a form of escapist fantasy, because they lived under a political dictatorship.

It is easier to observe Napoleon III's *conscious* use of dress to bolster his political prestige. He deliberately introduced various uniforms to be worn at court, as a way of emphasizing Imperial grandeur and hierarchy. He also encouraged the Empress to use Lyons silk, in order to demonstrate imperial support for the silk industry and to prevent further rebellions by textile workers. Perhaps most profoundly, the very existence of a court tended to form a natural center for social and sartorial display. Although

the French aristocracy tended to shun Napoleon III, the general public (and even more the American public) assumed that the Court *was* high society—and where society went, there went fashion. Some of the conspicuous luxury of the period was probably directly related to the patterns of sartorial behavior at Court.

The Boulevard and the Street

The streets themselves were a kind of theatre. In his "History and Physiology of the Boulevards of Paris," Balzac wrote:

> Every capital has its poem . . . where it is most particularly itself. The boulevards are today for Paris what the Grand Canal was for Venice . . . what Regent Street is for London. . . . [But] . . . none is comparable to the boulevards of Paris. . . . In Regent Street . . . [there is] always the same Englishman and the same black suit, or the same macintosh! . . . The Grand Canal is a cadaver . . . while in Paris! . . . Oh! in Paris, there is liberty of intelligence, there is life! a strange and fruitful life . . . an artistic and amusing life of contrasts . . . drunkards, grisettes, notaries, tailors . . . friends, enemies.[13]

Balzac specifically described the life of the boulevards in terms of clothes: "It is there that one observes the comedy of dress. Many men, many different outfits, and many outfits, many characters!" On the boulevard St. Denis alone, one could see "a variety of blouses, torn suits, peasants, workers, lunatics, people who make of a not very clean toilette, a shocking dissonance, a very conspicuous scandal." But if some places revealed "the inelegant and provincial masses . . . badly shod," other stretches of boulevard were "a dream of gold," jewels, and rich fabrics, where "everything . . . overexcites you."

The 550 meters of the boulevard des Italiens were especially fashionable and animated. According to Edmund Texier, "The promenade [along the boulevard des Italiens] . . . is a tranquil river of black suits, sprinkled with silk dresses . . . a world of pretty women and gentlemen who are sometimes handsome but more often ugly or uncouth." A *lion* with wild and messy hair was followed by a well-dressed man trying to pose as a baron. "The dandy displays his graces, the lion his mane, the leopard his fur—all exhale the smoke of ambition." The "majority" of clothes "have not been paid for." Meanwhile, not far away, "The lions of the boulevard de Gand, more sober than their brothers from the Sahara, live exclusively on cigars and meaningful glances, on politics and idling. Hunger . . . pushes them . . . to the asphalt, theatre of their exploits."[14]

"Since 1852, new and magnificent boulevards have been and still are being opened every day and in all directions," reported a guidebook of

1877, which interpreted the development in political terms. "Paris, the city of equality, the democratic city *par excellence,* has wanted to have . . . a promenade . . . which serves the needs of the crowd and which belongs to everyone." Old centers like the Tuileries and the Palais Royal are respected, but the boulevards, "which only really existed after the Revolution," are more beloved. Carriages, omnibuses, crowds of strollers, "people of all classes and nations fill the boulevards."[15]

The physical changes in the form of the city were evidence of the development of capitalism. In 1860, the Goncourts observed that the new boulevards "smack of London, some Babylon of the future." But by the time Edmund Goncourt edited the journal for publication in 1891, London no longer served as the paradigm of modern capitalism, so he changed the entry: "These new boulevards . . . implacable in their straight lines, which no longer smack of the world of Balzac . . . make one think of some American Babylon of the future."[16] It was not the existence of the boulevard that was new, however, although the tremendous expansion of the network of boulevards certainly opened the city up. More significant, as Balzac had already recognized, the boulevard was modern, because it offered the stroller the chance to see the panorama of modern urban life in a concentrated and ever-changing flood of images.

The words "Paris and the Boulevards" conjure up a host of images for us as well, principally because so many artists depicted them. Following on the heels of fashion performers and spectators, artists portrayed the scenes of fashionable rendezvous, which epitomized the character of modern urban life. To understand the meaning of fashion in Paris, we must also study the changing geography of the city, and investigate those aspects devoted to the pursuit of pleasure and display—the theatres, cafes, boulevards, parks, racetracks, and shops. In addition, we must look carefully at the various fashion performers themselves, and at the clothes that added verisimilitude to the roles they played. It is not surprising that the painters of elegant life should focus on boulevard scenes—with their activity, curiosity, *flânerie.* A little milliner goes down the street carrying a hat box— how busy she looks, but perhaps she could be persuaded to stop and talk. At lunchtime, there is a mass exit of workers from the Maison Paquin— they look remarkably well dressed, pausing on the sidewalk of the rue de la Paix. A carriage stands nearby, perhaps waiting to pick up one of Madame Paquin's customers.

But there was not only the boulevard, there was also the street—and when revolution broke out, they were the same thing. Anxiety about revolution kept cropping up in bourgeois publications throughout the century. According to one fashion magazine in 1854, Paris was "the rendez-vous of all celebrities, the dream-star of all young and ardent imaginations, the paradise of luxury and pleasure, the capital par excellence of

the fashionable world, *the queen of civilization.* . . . Above all, Paris amuses itself." And yet, the writer hinted, Paris amuses itself despite catastrophe and revolutions. "The day after the Terror, didn't Paris have its *bal des victimes?*" [17]

The Second Empire was launched on the ruins of the Revolution of 1848, when a bourgeoisie and peasantry terrified by the insurgents of the June Days threw their support to Napoleon III. After almost two decades of dictatorship, the Empire ended equally catastrophically: In 1870, French soldiers marched off happily, shouting "To Berlin!" But the Franco-Prussian War exploded the farce of French military prestige. Napoleon III surrendered to the Prussians at Sedan, and shortly thereafter abdicated. As the Prussians moved on Paris, the newly formed French government prepared for a seige, hoping that they could tie down the invaders until help arrived from the provinces. It never came.

The seige of Paris began on September 19, 1870. Weeks turned to months. The wealthy left Paris. The poor starved. On January 28, the government agreed to all of Bismark's demands—Prussian troops paraded in triumph down the Champs-Elysées. The members of the government and most of the rest of France wanted peace, and they preferred to reach an agreement with the Prussians than to continue dealing with an increasingly radicalized Parisian population: For, amazingly enough, despite all they had suffered, working-class Parisians wanted to fight on. The government moved its headquarters to Versailles, and sent troops into Paris to disarm the working-class neighborhoods. On the night of March 17–18, fighting broke out between government troops and the populace of Montmartre. A revolutionary Commune was proclaimed in the city of Paris, and Parisians who had just ceased being bombarded by Prussian artillery were now assaulted by right-wing French forces based at Versailles. The class war that followed resulted in the death of some 20,000 Communards or suspected revolutionaries.

Even a political reactionary like Edmund Goncourt was horrified by the ferocity of the bourgeois forces. He described the sight of 407 suspected Communards:

> They were just as they had been captured, most of them without hats or caps. . . . There were men of the people . . . they came from every class of society; hard-faced workmen, bourgeois in socialist hats, National Guards who had not had time to change out of their uniforms. . . .
>
> There was the same variety among the women. There were women wearing kerchiefs next to women in silk gowns. I noticed housewives, working girls, and prostitutes, one of whom was wearing the uniform of a National Guard.[18]

Most of these people were executed—simply because they looked poor and therefore revolutionary. One of the reasons for the new wide, straight

boulevards, after all, was strategic: to hinder revolutionary street-fighters from erecting barricades against the Imperial troops.

The whole story of war, revolution, and dress deserves more attention than I can give in this book, but two points, in particular, need to be stressed. During periods of social revolution, the clothing worn tended to become simpler and more egalitarian. When Flaubert described the Revolution of 1848 (in his novel *Sentimental Education*), he recalled how middle-class Parisians temporarily eschewed many sartorial symbols of their class status, either because they feared the workers or because at least some of them felt an unusual degree of fraternity with their fellow revolutionaries. Moreover, during periods of social upheaval, the normal rules of dress—even the *laws* of dress—could be disobeyed. Thus, during the great French Revolution, as well as during the Revolution of 1848 and the Paris Commune of 1871, a certain number of women seized the opportunity to wear masculine clothing.

We will return later to the question of women in trousers. For the moment, however, it is worth pointing out that anecdotes about unbridled luxury during the Empire need to be analyzed with caution. The Prussian defeat of France engendered a prolonged fear of French "decadence," which was often expressed in diatribes against excessive luxury of dress.

Au Bonheur des Dames

Although both Haussmann and Worth were, to some extent, creatures of Napoleon III and the Empress Eugénie, their impact continued even after the fall of the Empire and the rise of the Third Republic. Beyond politics and personalities, fashion entered a new economic phase during the second half of the nineteenth century, the period of "high capitalism." The traditional production of clothing developed in two new directions: toward *grand couture* (the exclusive productions of great dressmakers like Worth and Madame Paquin) and *confection* (the mass production of ready-made clothing). Simultaneously, there was a retailing revolution and a vast expansion of ancillary fashion trades such as the fashion press.

The pleasures of shopping were a recognized part of Parisian life for centuries, but the styles of shopping changed dramatically as the city was rebuilt. Mark Girouard wickedly suggested that perhaps "Paris became the shoppers' Mecca because of its appalling pre-Second Empire street system." According to his theory, "because walking in its narrow streets without sidewalks was a pedestrian's nightmare . . . the best shops tended to be off the streets"—in passageways and arcades, like the passage des Panoramas. The next stage in off-street shopping was the bazaar, in the form of a large building filled with galleries and stalls set around an open nave. As early as the 1830s, "the architectural format of the bazaar had been

adapted for big stores under single ownership, called *magasins des nouveautés.*"[19] Zola's impassioned description of the rise of the "monster" department store and the consequent demise of the little neighborhood shop is a reflection of this development.

Veritable palaces were erected, devoted to shopping as a leisure activity. In his novel *Au bonheur des dames* (1883), Zola described with horrified fascination the excitement caused by the department stores, and how they destroyed the pattern of little specialized shops. The first thing that caught the attention of the passerby was the window-display, modest or non-existent in the ordinary shop but a main feature of the department store. Zola's characters are drawn irresistibly to each window, seduced and astounded by the complicated, overwhelming array of beautiful objects:

> Above, umbrellas posed obliquely, seeming to form the roof of a rustic cabin; underneath, silk stockings, hanging on a line, showing the rounded profile of calves, some sprinkled with bouquets of roses, others in all shades . . . the flesh-colored ones whose satin texture had the softness of a blonde's skin.[20]

But the next window—"an exhibition of silks, satins, and velvets"—was even more ravishing, and the young heroine murmurs in astonishment: "Oh! That faille at five francs sixty!"

It would not be an exaggeration to describe the development of the department store as a retailing revolution. Whereas the ordinary shop carried only a small and limited stock, the department stores bought in bulk—and all manner of objects and *confections*. It may not sound impressive that a single store would sell umbrellas, stockings, silk, and so on, but previously the customer would have had to go to several stores, each selling a particular item. Traditionally, you entered a shop, asked to see, say, a length of silk, and haggled over the price. The department stores had fixed prices and, since they bought in quantity, the prices tended to be significantly lower. (It is true that some of the shops in the Palais Royal had fixed prices, but those were luxury shops with fixed, *high* prices.) Moreover, the department stores sought to lure the customer in with sales and specials, even on occasion selling goods below cost. The new entrepreneurs gambled—correctly—that the customers would be so pleased with their bargains, so seduced by the array of luxuries, that they would come in for a sale and go out with the other purchases.

Browsing was strongly discouraged in the old-fashioned shops. Indeed, it was next to impossible when goods were carefully locked up behind the counter. But in the department stores, customers were encouraged to wander from one department to another, "just looking," but soon buying more and more, on impulse. The layout of the store was designed to entice the customer in—just to see, for example, the Oriental salon, draped

in Persian rugs—to lure her into a labyrinth punctuated by splendid displays.

Even the most sophisticated customer would be overwhelmed by "a waterfall of fabric . . . falling from above and spreading out over the floor. Limpid satins and tender silks gushed forth . . . silks as transparent as crystal, Nile green, Indian blue, May pink, blue Danube." Then came the heavier fabrics, the damask, the brocade, the velvet, forming "a still lake where reflections seemed to dance . . . The women, pale with desire, leaned forward, as if to see their reflections."[21]

The department store was a world in itself, with a staircase almost as grand as that in the Opéra, with tea-rooms, children's rooms, lingerie displays that looked "as though a group of pretty girls had undressed, layer by layer, down to the satin nudity of their skin." There were rooms where men, "even husbands," could not enter, but the prohibition was almost unnecessary, since, then as now, the department store was an overwhelmingly feminine world. The garçons de magasin, the salesmen, formed the primary exception. According to Zola, those at the Bonheur des Dames were dressed in livery of green coat and trousers, a vest striped in yellow and red. Other illustrations show salesmen and saleswomen alike in sober black quasi-uniforms. By modern standards, there were a great many of them, waiting, unobtrusively, to serve the customers, but (unlike traditional merchants) never to push, wheedle, or bargain. There was no need, for "beyond the murmur of the crowd" lay the vast city of Paris—"so vast it would always supply customers."[22]

It has been suggested that the international exhibitions so popular in the nineteenth century may have influenced the department store displays. Even a year before the World's Fair of 1855, the fashion magazine La Corbeille described how Paris had taken on

a feverish . . . aspect at the approach of these great events. The department stores display all their splendor, masterpieces shine behind the shop-windows, soliciting the admiration of all this curious enchanted world. . . . the windows of our big department stores are true poems of good taste, science, and coquetry.[23]

All of the international exhibitions—in 1855, 1867, 1878, 1889, and 1900—prominently displayed Parisian fashions and accessories, which attracted large and enthusiastic crowds. At the Paris exhibition of 1900, a fifteen-foot-high statue of La Parisienne stood at the top of the Monumental Gateway, representing a lady wearing a dress by Madame Paquin. Indeed, over the next few years, "La Parisienne's sculptor, Moreau-Vauthier, specialized in making small full-length bronze figures of actual Parisian ladies of fashion, which were exhibited by these ladies in their salons. Most of these figures too were dressed in Pacquin gowns."[24]

All of the international exhibitions held in Paris—in 1855, 1867, 1878, 1889, 1900, 1925, and 1932—featured displays of fashion. An illustration from the *Almanach de La Vie Parisienne* (1868) shows ladies looking at a display of Leoty corsets. By the exhibition of 1900, there were galleries of haute-couture dresses shown on life-sized mannequins. In addition, a statue dressed by the couturière Madame Paquin represented "La Parisienne" herself.

The *Pavillon de la Mode* at the 1900 exhibition featured some thirty scenes with life-sized wax mannequins clothed in historic dress, provincial costumes, and the latest fashionable toilettes. Among the organizers of this very popular display were the couturiers Gaston Worth and Madame Paquin, the director of the Magasins du Bon Marché, and Héloïse Colin Leloir's son, the painter Maurice Leloir. The historic scenes included the Empress Theodora in Byzantine costume, Queen Isabeau of Bavaria wearing medieval dress while watching a tournament, and, of course, Marie Antoinette. Indeed, there were several eighteenth-century ensembles, including a silk dress from the collection of Maurice Leloir, which was displayed on a mannequin positioned in front of a full-length mirror. Other historic costumes included a child's dress from the Renaissance, a court uniform from the Napoleonic era, and a man's dressing gown of embroidered yellow silk from the July Monarchy.

Even more popular, however, were the scenes representing modern fashion and high society, such as "Departure for the Opéra." There were clothes by Doucet, Callot Soeurs, and others. "Fitting the Wedding Gown" depicted a scene at the Maison Worth. But perhaps most striking was a mannequin intended to represent Madame Paquin herself, elegantly attired and seated in front of her dressing table.[25]

Ʊ
Le High Life

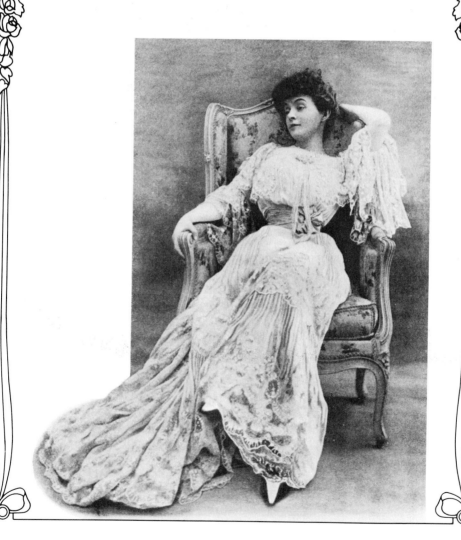

Actresses were among the most important "arbiters of elegance." This photograph by Reutlinger of Madame Réjane appeared in *Figaro-Modes* (1903), along with a list of questions concerning Réjane's fashion preferences: Her favorite couturier? "21 rue de la Paix"—that is, Jacques Doucet, who collaborated with Réjane to create her famous stage costumes. Her favorite milliner? "My hair." Her jeweler? "The czar." Her favorite corset? "No need," etc. Other actresses were more forthcoming with specific information: Mademoiselle Eve Lavallière, for example, chose Paquin as her favorite couturier, Suzanne and Darault as her favorite milliners, Francis as her favorite tailor. She praised Grunwaldt for furs and Doucet for lingerie. When asked about her favorite corsetiere, she, too, maintained, "I don't wear corsets"—although, in fact, both Lavallière and Réjane appear in their photographs to be wearing corsets.

In other capitals, the stranger has to go in quest of amuse-
ment. In Paris, he cannot stir a step without coming in con-
tact with the clashing cymbals of the votaries of pleasure.

Thomas Forrester, *Paris and Its Environs*, 1859

The pursuit of pleasure was an important key to fashion behavior. Ac-
cording to the guidebook *Les Plaisirs de Paris* (1867), you must "deprovin-
cialize yourself before you *emparisienner.*" Read the fashion journals and
patronize the tailors used by the nobility and the "gentlemen of the club
and turf"—tailors such as Humann-Kerkoff, Renard, Dusantoy, and Po-
madère. Delion makes good hats, Sakowski boots, and Jouvin gloves. They
will all dress you in *le dernier chic.*

"*Go ahead!*" the author urged (in English), enjoy the "*high life*" of Paris—
"and by *high life,* I mean the demi-monde." If you want a guide to mu-
seums, look elsewhere, because this book is devoted to theatres, balls, and
horse races. Just remember, you will only have success with the loose la-
dies of Paris when you are properly dressed. If you look like a provincial,
they will just laugh at you.[1]

Of course, the foreigner and the provincial, like all outsiders, tended to
be excluded from the private life of Paris. Important social arenas, such
as the salon and the "white ball," were for fashion insiders only. Mere
tourists would not see the debutante at her first ball, wearing a symbolic
white dress: "She has worn this chaste and poetic white on the day of her
first communion; and she will wear it when she comes to the foot of the
altar, to unite her life with that of the man she marries. This evening, it
seems to be a sort of uniform . . . the color of hope . . . [and] inno-
cence."[2] Fortunately, most tourists were having too much fun in the public
fashion arenas of the big city, to regret these private performances.

The Theatre of Experience

"The success of plays is certainly not purely literary," declared the Vicom-
tesse de Renneville, a well-known fashion reporter for the *Gazette Rose:*

> In most cases the theatre can be certain of big crowds when sumptuous dresses
> can be seen on stage. . . . Hardly has the rumour gone round that in a

certain play many new toilettes will be shown, than a considerable part of the population is in a frenzy of excitement—dressmakers, modistes, makers of lingerie and designers.

Actresses were among the most important "arbiters of elegance." Not only were their stage costumes described and illustrated in the fashion press, but they themselves were interviewed about their fashion preferences. It was said of certain actresses that: "If they were entrusted with Racine or Corneille they prefer Paquin or Doucet." Madame Réjane, for example, favored the couturier Jacques Doucet, while Mademoiselle Eve Lavallière chose Paquin. Elonora Duse collaborated closely with Jean Philippe Worth; once she sent him a telegram, complaining. "When you do not help me the magic leaves my roles." Sarah Bernhardt quarreled with Worth, when she refused to use only *his* dresses on stage.[3]

But not only was there a cult of stage costume, the audience itself was on display. As one of the most important forms of entertainment for people of all classes and nations, the theatre was featured as the setting of innumerable novels, paintings, and fashion plates. Here, too, the symbiotic relationships between fashion performers and fashion spectators was especially clearly expressed.

People did not only go to the theatre to see the performances on stage. It was at least as much a social ritual, and there were fairly strict rules concerning who could sit where and what was the appropriate mode of dress to be worn. On the other hand, in the days before movies, people of all but the poorest classes attended the theatre, and there existed a much wider range of theatres, many of them distinctly popular. The theatres of the boulevards were low in the theatrical hierarchy—and the clothing worn to them did not at all correspond to that depicted in fashion plates. There was also considerable clothing variation within any one theatre— from court dress to workers' blouses—depending on whether the spectator was in a private box or the orchestra pit.

Certain theatres were particularly fashionable, however. The Paris Opéra was "one of the temples of fashion," and in his book *The American in Paris*, Jules Janin refered confidently to the popular illustrations of this scene:

> Even now I hear Eugène Lami, the tempter, calling me to the splendid enclosure. "Come," says he, "come, the [foyer] is brilliant with light; the ladies are beautiful and well-dressed.[4]

The original opera was on the rue Lepelletier, near the boulevard des Italiens, in the heart of the fashionable district. A guidebook of 1867 described it as "the most beautiful theatre of Paris," but noted that it was soon to be replaced by the even more "immense and superb monument that is being constructed on the Boulevard des Capucines."[5] This building

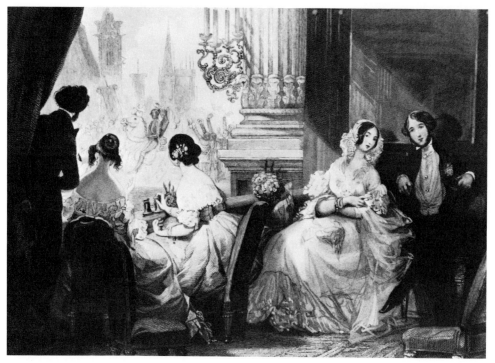

This illustration of a box at the opera by Eugène Lami appeared in Jules Janin's *American in Paris* (1844): "Even now I hear Eugène Lami, the tempter, calling me to the splendid enclosure. 'Come,' says he. . . . The ladies are beautiful and well-dressed. . . . Come to the Opera.' "

(magnificent or ostentatious, depending on one's taste), was designed by the architect Charles Garnier, and ultimately cost some sixty-five million francs.

It had a poor stage, but excellent audience visibility. Mary Cassatt's painting, *At the Opera* (1880), for example, shows a woman looking through her opera glasses—not at the stage, but across at another box. In the distance, a man is looking through his opera glasses at her. The enormous foyer and even more the splendid staircase provided the ideal setting for fashionable display.

An earlier guidebook (of 1855), *The Ins and Outs of Paris; or, Paris by Day and Night,* described the old opera house and other theatres in some detail—and with an emphasis on fashion. According to the author, Julie de Marguerittes, the "higher spheres" of the opera were divided into private boxes, each holding four to six people, but

> it is *mauvais ton* to have more than two ladies in one box, as the display of grace and draperies would be impeded. . . . In these boxes the toilettes are decidedly ball, or even court, costumes. You will see many of these ladies

rise, before the last act, and leave the house, for the various embassies, the Faubourg St. Germaine, or the Tuileries.

Parisians did not hesitate to come late or leave early if they had other engagements that evening. Indeed, such behavior rather raised the individual's status. Visiting from box to box, there to chat with friends, was also completely acceptable. It was, in fact, almost unfashionable to pay much attention to the show.

> Above, in the second tier, are simpler dresses. The boxes are filled. . . . The attention to the performance is greater, and the visitors are fewer.
>
> Below, in orchestra and pit, are none but men. No women is admitted to such very uncomfortable places as a perpetually changing pit affords. . . . But there is an intermediate state—a sort of purgatory between the paradise of the boxes and the pandamonium of the pit—called the amphitheatre. This is five or six rows, raised at the back of the pit, fenced in with gilded balustrades, and containing comfortable armchairs.[6]

The amphitheatre, although good for seeing the stage, was a very unfashionable place, filled with dowdy provincials and ignorant foreigners, people who had no friends in "the world" who might invite them to their private box.

Of course, the highest elite sat in the four proscenium boxes, "so gorgeous with mirrors, velvet, and gilding." Here was the imperial box, and those reserved for ambassadors and wealthy financiers. Members of the Jockey Club tended to inhabit the *loge des lions*, also known as the *loge infernale*, where they were at eye level with the dancers, their mistresses— or anyway, at eye level with the dancers' legs.

Meanwhile, the little "theatres of the boulevards," like the Gaîté, were "the domain of the people—the true Parisian, hard-working, barricade-making people. The blouse prevails. The women, though neatly, are coarsely clad." Apparently, the men seemed more threatening in their "toilstained blouses," with "unshaven beards" and "fur caps." They "look as if they might have pistols in their belts," worried Marguerittes.

Somewhat more prepossessing was the Odéon, a "large, handsome" theatre in the Faubourg Saint Germain, which had an audience of "students and grisettes" (although no one really used the word grisette anymore). "Unacquainted with *savoir-vivre*," they laughed and cried at the performances, ate chestnuts, and pointed. The young working girl frequently wore clothing given to her by her student lover—"a *barege* shawl (16F) or a print bonnet (10F)"—but she was "quite as ready to give him a black silk cravat [or] gloves." Of the student at mid-century, Marguerittes wrote:

> There is a peculiarity, an exaggeration of costume which is unmistakable. In undress, he is tawdry and slovenly—in *grand tenue*, he is dressed as those impossible gentlemen in the prints of the fashions.

A slap at the fashion plate! Of course, fashion *was* primarily the domain of the young man (with older men tending to wear somewhat fossilized versions of the fashions of their youth), but her objections seem exaggerated.

> For the students were invented the rainbow-colored stuffs . . . with which he makes his trousers [in the style *à la Cossack*]. . . . His waistcoat is generally much too smart for the daylight, being possibly the last remains of his ball costume.[7]

Clearly, theatre fashions were something of a mixed bag.

Because the theatre was still regarded as slightly sinful, many young women simply did not attend until after they married, so that their "innocence" would not be compromised. The magazine *La Vie Parisienne* made fun of one recently married husband, who fondly believed that his new wife was too "naive" to understand the play's dialogue, whereas, in fact, she was simply "stupid." When young and unmarried women *did* go to the theatre, their clothing differed significantly from that of the fashionable matron: "Look—do you not see that box?" wrote Marguerittes.

> There are two ladies. Both young, both graceful, both pretty, both exquisitely dressed; but oh, how different they are! The one to the right has flowers in her bonnet. Her dress is in the most recent fashion, open in front—and amidst the falls of beautiful lace, the white throat is visible, and the swelling bosom just perceptible. The rich and waving lace sleeves, the handsome bracelets, the jewelled lorgnette, the falling cashmere draperied so artistically . . . and the gay . . . conversation with the men who fill the box—all this reveals a woman in . . . the first few years of her married life.
>
> Now look at her sister. The dress of sober-colored silk, high to the throat . . . no lace anywhere, not even on her handkerchief . . . no bracelets . . . no flowing shawl. . . . Her bonnet is of plain crape, with a white, pink, or blue ribbon, (the only three colors allowed to girls—white, the color of innocence; pink, the insignia of youth; and never worn by any woman over thirty; and blue, the color consecrated to the patronness of young girls, the Virgin Mary). She has no flowers, no lorgnette. Heavens! She might discover there were other men in creation, besides her brother and her *cher papa!* a fact she is now supposed to ignore. Her eyes are modestly cast down, or immutably fixed upon the stage.[8]

Unlike men, whose clothing styles changed with age, education, and experience, a woman was defined by her relationship to her natal family or her family by marriage. It was common, for example, to dress sisters alike, to emphasize their emotional closeness. "In bourgeois families, young girls remained largely in the home circle . . . debarred from the liberty of choosing their associates, going into public, or into the streets." If they did go out, it was "always under the safe-guard of their mothers," with whom

they were supposed to have a "tender friendship . . . which binds them together through their lives." Moreover, in an era of arranged marriages and dowries, the mother was largely responsible for marrying off her daughters—all of which was expressed in their respective dress.

Fashion for *demoiselles* was supposed to make them look "quietly unobtrusive" and virginal. Their mothers were intended to look like "animated and elegant editions of themselves, looking five years older."[9] Since the daughter seldom found her own husband, she did not use fashion to make herself sexually attractive to men, just as she was not supposed to be a lively conversationalist. Fashion, eroticism, and charm were all supposed to emerge *after* marriage, under the influence of the husband. But, although a woman was not supposed to speak much to her fiancé, her mother was supposed to be charming to him, as a kind of promise of what her daughter would soon become. In fact, once a woman had safely married off her daughters, she might abandon many of her social and sartorial obligations, and (as Uzanne suggested) devote herself to charity. Until then, she was her daughter's best advertisement, as well as the guardian of her sexual innocence. By contrast, the daughter's appearance at the theatre was less important; it was merely a statement that she existed.

Actresses, on the other hand, appeared both on stage and as members of the theatre audience. They, if anyone, were public figures, and, as such, not respectable women. In Zola's novel *Nana* (which was set during the Second Empire) the theatre owner keeps referring to his establishment as a "brothel," and many theatrical performers were, in effect, a species of prostitute. Popular illustrations frequently depicted them making assignations behind stage with members of the audience. When they wished to go to the theatre themselves, they tended to prefer those, like the Variétés, referred to by Marguerittes as the "favorite resort of the 'friend.' " There a man ran "no risk of meeting any of the society in which his mother, wife, or daughter moves. Men of his own class are there—but they are bent on expeditions similar to his own, so all's safe." From the point of view of the actress-mistress, she could attend the performance in the company of her lover without fear of being snubbed.

In the boxes at the Variétés, the men sat in the back, the actresses in front, their dresses clearly visible:

> Here, at length, you will, for the first time since you have been in Paris, see those toilettes displayed in the fashion plates, and studiously copied 3 months after . . . by the belles of Broadway, Chestnut Street and Washington Street. Here, as there, neither flounce nor furbelow is spared.

Poor Anaïs! One may hope she never knew that her theatre pictures were regarded by some as depicting the fashions of the *demi-monde*. But Marguerittes continued, censoriously (and writing for an American audience):

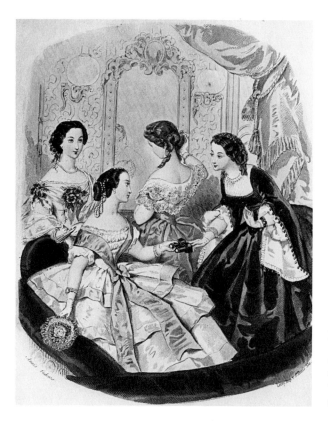

A fashion plate by Anaïs Colin
Toudouze from *Le Conseiller des
Dames et Damoiselles* (1857)
shows theatre dresses. The
woman on the right is probably
an attendant at the theatre.

These fair ladies, too, invented those marvellous morning wrappers, with
beflounced under-skirts. . . . A Parisienne knows them, and eschews them,
as she would the people who alone delight in them. But an American or an
Englishwoman will pounce upon them.[10]

Here, in a nutshell, is the argument that Parisian courtesans and actresses
set the fashions, which were then naively adopted around the world. The
corollary is that "true" Parisiennes shunned such *outré* styles, and the for-
eigner would be wise to do the same. How accurate was this picture?

Although prostitution has existed for centuries, a visible *demi-monde* only
became a prominent feature of Parisian life under the Second Empire. By
the second half of the century, the famous *grandes horizontales* were as no-
torious for their sartorial splendor as for their amatory abilities. Indeed,
as a sort of advertisement of her fame, "her clothes must always be in the
fashion of the day after tomorrow and never that of yesterday." Once she
had a liaison, her clothes become even more important, since:

The men of the world who form a liaison . . . with a *horizontale* . . . keep a
woman as they keep a yacht, a stud, or a sporting estate, and they require of

One of the illustrations in Uzanne's book, *La Femme à Paris* (1894) shows two courtesans at the famous music hall, the Moulin Rouge. The author of *A Woman's Guide to Paris* advised foreigners that it was "very important to be quietly though well dressed for such entertainments," since music halls were "the haunt and hunting-ground of the *demi-monde*."

her everything that can augment the reputation of their fortune and improve their *chic* in those circles where one is observed and esteemed according to the scale on which one lives. Thus, they are more susceptible to the toilettes of their fair friend than even to her beauty or youth. . . . What they want of her is neither love nor sensual pleasure, but the consecration of their celebrity as *viveurs*.[11]

The status value of clothing was more important for a mistress than for a wife.

The feminine author of *Le Code de la mode* complained bitterly: "The ravishing promenades of the Bois de Bologne . . . the racetrack . . . the theatre . . . [every place] whose principal attraction is the splendour of costumes—the two worlds mix, those of honest women and courtesans." Turning to address the male readers directly, she asks: "In good faith, what do you love in those whom you prefer to your wives? Is its beauty? Spirit? Talent? Poor, poor people! In that case, your wives are . . . superior to your mistresses." No! she concludes, "It is those flashy dresses . . . which seduce you" (dresses, moreover, which you forbid your wives, for reasons of economy). Their jewels, their make-up, their "strange but real brilliance . . . fascinates your eyes and your imagination."[12]

In the early twentieth century, Alice Ivimy wrote *A Woman's Guide to Paris,* in which she gave advice on the places where American and British women could safely and pleasantly go alone. "In selecting a night to go to the theatre," she advised, "remember that Sunday and Monday are considered the people's days, and you will see no elegant toilettes." On the other hand, if you chose the right evening to attend a little theatre like Les Capucines, you would see a "light drama" and a "very fashionable audience."

> To go to . . . these houses you must make a more or less elegant toilette; the tailor-made is not admissible. On the other hand, a décolletée dress would not be correct.

And if you are so adventurous as to go to a music hall like the Olympia, the Moulin Rouge, or the Folies Bergère, "It is very important to be quietly though well dressed for such entertainments." Such places, after all, were "the haunt and hunting-ground of the *demi-monde.*" During the entre-act, when the audience promenaded through the foyer, *demi-mondaines* swept about "in gorgeous dresses and the latest of millinery." It was better not to look too fashionable! In fact, a woman "would undoubtedly enjoy the spectacle more if accompanied by a friend."[13]

Most of what has been written about Paris has emphasized the *male* experience of the metropolis: Paris was the goal and climactic experience for the young provincial on the way up (and sometimes down again) in dozens of novels, and in real life as well. "Each can come with his baggage of

intelligence, industry, or talent."[14] In the stimulating atmosphere of Paris, each would flourish as never before. The sensual pleasures of erotic Paris, the struggles and achievements of bohemian and artistic Paris, the political intrigues and street-fighting of revolutionary Paris, all were male terrain.

The significance of the metropolis for women is more opaque. Even when Baudelaire used a domestic metaphor, such as *"setting up house in the heart of the multitude,"* he clearly envisioned the passionate spectator as male. Works like Ivimy's guidebook thus are doubly important, because they provide a glimpse of what Paris seemed like to a woman. If the author of *Les Plaisirs de Paris* was looking for prostitutes, Ivimy's women were trying not to look *like* them. The fact that Ivimy was a foreigner meant, of course, that she was an outsider; even the possibility of traversing the city *alone* was almost inconceivable to many respectable Frenchwomen. It is difficult to pin down specifically, but such unspoken limits undoubtedly restricted the art produced by female painters. Moreover, the extent to which female clothing, per se, restricted women needs to be explored.

Women in Trousers

Looking back on the nineteenth century, many historians have concluded that dress reform went hand in hand with the advance of women's rights. Yet such was not the case. The dress reform movement was a failure. Despite its notoriety (or because of it) the "Bloomer" costume utterly failed to supplant ordinary fashionable dress. Even in the United States, it was a short-lived phenomenon. Subsequent Anglo-American (and German) attempts to promote "rational" female dress were also unsuccessful, while in France there was even less interest in "reformed" dress. On both sides of the Atlantic, cartoonists ridiculed the idea of women in trousers, implying that if women "wore the pants," then all sex roles would be reversed and men reduced to weak and effeminate creatures.

Yet although women did not wear trousers or short skirts *as a general rule*, many women did occasionally adopt them under particular circumstances. In the provinces, of course, some working-class women wore trousers. One thinks, for example, of the women in the coal fields of northern France (and England). Indeed, there was something of an outcry in England about the scandal of female coal mine workers in trousers. More visible were the fisherwomen of Normandy, whose traditional costume included both trousers and very short skirts. Women in a number of other trades also wore short skirts, and could be seen hawking their goods on the streets of Paris. Regional and occupational costume had little influence on fashion, however, except on fancy dress.

Under normal circumstances, a woman simply could not have appeared on the boulevards in trousers without being arrested. The prohibition against

cross-dressing was not merely a tradition going back for centuries; transvestism was actually illegal. Unlike the situation in, say, China, where upper-class men and women wore long robes while lower-class men and women wore trousers, in Europe trousers were identified exclusively with men. And yet over the years, some women "passed" as men, usually to work in a masculine trade and thus make more money. At least occasionally, some of them even received permission to wear men's clothing.

According to a small French monograph on the history of women in trousers, in the Year 9 of the French Revolution, "The police were informed that many women were wearing men's clothing, and convinced that few abandoned the clothing of their sex for reasons of health," they instituted laws annulling all earlier permits and requiring women to obtain the written permission of the Prefect of Police to wear masculine attire. This would only be given on the submission of a doctor's certificate attested to by a commissioner of police. All other women in men's clothing would be subject to arrest.[15]

Permission was difficult to obtain: Between 1850 and 1860, for example, only about a dozen women received such permits. Thus, records show that one Mademoiselle Guiman Balpe of the Circus Franconi was refused a permit, but a bearded woman identified as Celestine R. was given one so

"Bourgeois, if you want to get your hat back, it will be five sous!" A caricature by Beaumont for *Le Charivari* (1848) shows a "Vesuvienne" of the Second Republic. In the revolutionary world turned upside down, working-class women not only wore trousers, they also carried rifles and threatened middle-class men.

that she would not be publicly humiliated. The successful animal painter Rosa Bonheur had a permit, as did Margueritte Boulanger, one of Napoleon III's innumerable mistresses, who was allowed to wear men's clothing in order "to facilitate her entrance into the Tuileries." In the 1880s, a handful of women, such as Madame Astye de Valseyre, tried to obtain authorization, but it was still rarely given.

The most notorious woman to wear trousers (without permission) was the novelist George Sand, who was also famous for her love affairs. Although she normally wore dresses, Sand was known to go out disguised as a man. In this way, for example, she could accompany male friends into the pit of the theatre. Balzac also travelled to Italy accompanied by a mistress who was disguised as his valet. Later in the century, the actress Sarah Bernhardt was frequently photographed wearing men's clothing, both for some of her performances and in private life. As these examples indicate, the practice was associated with bluestockings and actresses. Accounts of bohemian "lionesses" wearing trousers and smoking cigars were succeeded by equally compromising pictures of *cocottes*.

Erotic art was filled with images of women in trousers. Theoretically, of course, even theatrical and carnival costumes fell under the law prohibiting transvestism. In fact, however, women in trousers seem to have been a prominent feature of licentious public balls. One nineteenth-century print shows a woman in trousers, dancing wildly; the accompanying picture shows her the next morning, dressed demurely in a long skirt and bonnet. Another print shows a woman getting dressed for the Opéra or Carnival ball; wearing skin-tight black pantaloons, she gazes into the mirror, saying, "I look good." Yet a third lithograph shows an amorous couple who have exchanged clothes; she has put on his trousers and shirt, he wears her dress. For an additional *frisson*, she is shown reaching up under his skirt. Male transvestism, however, was portrayed relatively seldom, while female cross-dressing was an immensely popular theme.

The sexual appeal of women in male attire was—and remains—very powerful, since such cross-dressing violates some of our culture's most strongly held taboos. Yet it does so in a spirit of make-believe. The *cocotte* wearing a man's suit, who gaily remarks, "It's fun to be a man!" is not really threatening male supremacy. On the contrary, it appears that a great many women in the *demi-monde* dressed in men's clothing to titillate their clientele.

Even feminine underpants were regarded as "demi-masculine" apparel, and it was only gradually over the course of the century that they entered the respectable woman's wardrobe. At mid-century, they were still mostly worn by little girls, sportswomen, and *demi-mondaines*. Dances like the *can-can* and the *cahut* exploited the "naughty" image of underpants, as dancers raised their legs to display knee-length *pantalons*.

"It's fun to be a man!" declared the caption of a caricature by Grévin from *Les Parisiennes* (1872). Courtesans and actresses frequently exploited the sexual appeal of cross-dressing, although, strictly speaking, it was illegal.

Contrary to popular belief, men and women in the nineteenth century were not pathologically prudish about female legs. But the fact that trousers and short skirts carried so many "immoral" connotations made it difficult for respectable women to adopt either mode of dress. And when the associations were not overtly sexual, they tended to be infantile or working class. A nice little middle-class girl might wear a short skirt and visible pantaloons, but her mother could hardly do so without appearing to be masquerading as a child. The only other people commonly seen wearing short skirts were little boys, certain working-class women, and some theatrical performers (such as ballet dancers), none of whom were appropriate models. If a woman were to wear trousers at home, friends or members of her family who came to visit would have to conclude that she was expecting a lover—and one, moreover, so jaded that he required his mistress to wear the most shocking clothing imaginable. After all, didn't the Bible say that it was "an abomination" for a woman to wear man's clothing, or for a man to wear woman's dress?

One group of people who were relatively unconcerned about bourgeois proprieties and Biblical injunctions were the more radical socialists and

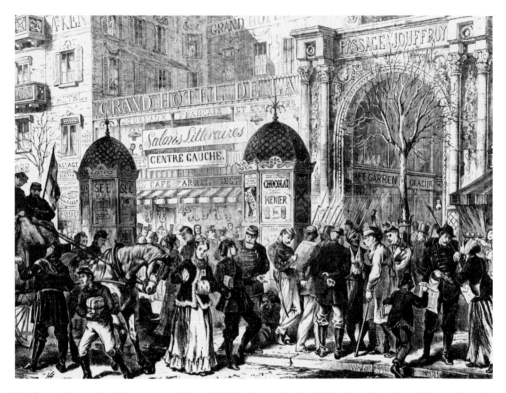

"Before the capitulation—a stroll on the boulevards, Paris" is the title of an illustration in the American newspaper *Every Saturday* (11 March 1871). Only extraordinary circumstances, such as the Franco-Prussian War and the Paris Commune, permitted women to appear on the street in trousers.

revolutionaries. During the Revolution of 1848, clubs for the emancipation of women were organized. Both women's rights activists and certain "utopian socialists" debated ways to improve female clothing. Indeed, some women revolutionaries apparently adopted the trousers, blouses, and caps that were normally worn by working-class men. Beaumont's caricatures for *Le Charivari* depict these *Vesuviennes* wearing improvised National Guard uniforms. In the revolutionary "world turned upside down," working-class women not only wore trousers, they also carried rifles and threatened bourgeois men (who were immediately recognizable by their top hats). Some years later, female Communards also often wore masculine costume.[16]

One striking image of a woman in trousers appeared in the American newspaper, *Every Saturday* (11 March 1871), which was covering the story of the Franco-Prussian War and later the Commune. The caption read: "Before the Capitulation—A Stroll on the Boulevards, Paris." The illustration shows a crowded street scene in front of the Grand Hotel and the Passage Jouffroy. The majority of pedestrians are soldiers; also visible are

a waiter, a newsboy, an African, a working-class woman wearing a head-scarf, a destitute woman collapsed on the street, a bourgeois woman in a fur-trimmed coat and carrying a muff—and next to her, amazingly, another woman dressed in full trousers tucked into high boots, a vaguely military-looking jacket decorated with braid or frogging, a woman's hat, and dangling earrings. She appears to be speaking to a bearded man, also in vaguely military attire. Both wear clothing suggestive of the kinds of uniforms that blossomed during the seige of Paris. But the woman has also taken advantage of the social upheaval to wear masculine clothing. More questions are raised by this unsettling image than can be answered, but it is clear that under normal circumstances a woman could not have worn such clothing on an urban street. Yet with the city under seige, her clothing apparently caused no stir at all. No one turned to stare at her or throw stones. Shortly after this illustration appeared, the revolutionary Paris Commune came into power, and clothing rules relaxed even further.

Although war and revolution frequently disrupted the Parisian scene, can we say that they "caused" revolutionary change in women's dress? Such interpretations of the French Revolution and the First World War are common enough, but they are highly misleading. Neither the revolutions of 1830 and 1848 nor the Paris Commune led to the acceptance of trousers for women. After each upheaval, fashion returned to its normal course. Indeed, any association, however tenuous, between revolution and dress reform could only make the average middle-class woman *less* attracted to unconventional dress. Despite the many democratic reforms initiated under the Third Republic, the question of women's rights seemed to unite radicals and conservatives alike—in the desire to keep women in their place.

But if radical politics did not liberate women, the growing popularity of sports provided an expanded arena for women to experiment with new forms of dress. Nevertheless, we should not oversimplify and exaggerate the influence of sport on dress. Certainly, most contemporary commentary on sport and fashion focused on quite different concerns.

Fashion and Sport: At the Races

The Parisian fascination with sport had little to do with athleticism, as we understand it today, and much to do with the urban fashion parade. Thus, Uzanne argued that "The majority of Frenchmen do not care much for sport." Few actually "like the horse and horse-exercise." But they very much liked being "gentleman-riders" (or in the case of women, "amazons"). It was fashionable to *seem* "more or less fond of sport, to ride gracefully [and] to fence elegantly." Moreover, spectator sports (such as horse-racing) were as important as participatory sports (like horseback riding). Indeed, Uzanne was hardly exaggerating when he argued that "In France *sport* is

synonymous with *the turf.*" And he quoted another French writer to the effect that "Sport implies three things, either simultaneous or separated: open air, betting, and the application of one or several physical qualities."[17]

In France, sport also implied fashion, not only in the sense that it was fashionable to engage in certain sports, but because prestigious sports required particular costumes. The riding habit announced the wearer's status as a modern-day *chevalier.* Even spectator sports were transformed into a species of fashion parade. As a journalist for *La Vie Parisienne* noted in 1864: "At Longchamp, a good many chroniclers gladly give up the jockey's cap and jacket to see only the dresses and hats of the famous Parisian ladies."[18] But why were equestrian sports so fashionable? And why was clothing such an important element in Parisian sporting behavior?

The prestige of *le sport* (like the word itself) was very much an English importation, and the expression of a continuing aristocratic Anglomania. Yet the old French word *desport,* meaning "to play, divert, amuse oneself," more closely expressed actual French sentiment—even as Parisians adopted the forms, language, and sporting costumes of the English. French Anglomaniacs had organized private horseraces as early as the reign of Louis XV. The Revolution put a temporary stop to such frivolities, but they revived under the Restoration—and even more so under the Second Empire, when the rebuilding of Paris afforded greater scope for sporting activity. Although the racetrack at Longchamp opened in 1827 (and that at Chantilly shortly thereafter), it was only in the 1850s that Longchamp's "sad and miserable" track was rebuilt, and new reviewing stands erected. The "resurrection of Longchamp" was, thus, part of Haussmann's creation of a system of urban parks devoted to leisure activities.

The Bois de Bologne was an especially fashionable new park, located just beyond the western walls of the city. Formerly a royal forest, under Napoleon III it was turned into one of several large public parks. Lakes were dug and fine carriage roads established—with soft tracks alongside for horseback riding. Cafés and restaurants were built, and, of course, the racetrack was completely refurbished. Longchamp itself was situated at the far western edge of the park, easy to reach "by the most charming route."

Equestrian sports were fashionable in large part due to their aristocratic associations. *La Mode* praised the "rich dandies" who were promoting the sport, and suggested hopefully that with "a few more amateurs of the race as passionate [as this], the English will be able to count us among their rivals." In 1833, La Société d'encouragement pour amélioration des races de chevaux en France—better known as the Jockey Club—was founded and took charge of organizing the races. There were three meetings every year—in April, early June, and September or October. Each lasted six days,

and attracted enormous crowds. According to one history of racing, "Les sportsmen whom one also calls *gentlemen-riders* (gentilshommes cavaliers) do not disdain to take their place among the jockeys." Of course, the great *sportsmen à la mode* tended to own the horses, not ride them, while the Jockey Club itself was primarily known as the most exclusive male social organization in Paris.[19]

But racing also had the potential for becoming a more general type of commercialized leisure and social display. During the July Monarchy, Jules Janin proudly asked, "Where will you find a more animated sight [than at] the promenade of Longchamp?" On racing day, there was intense competition "of elegance, of luxury. . . . People are no longer there merely to exhibit themselves but to be judged." People were as interested in the contest of fashions as in the contest of horses on the turf. Janin even maintained that among the crowd were "the milliner and seamstress," proud to see their handiwork displayed.[20] Indeed, many ordinary people made the long walk to Longchamp through the Bois de Bologne, while the wealthy took carriages, or came on horseback. There were reserved seats in the stands, but ordinary people crowded on the grounds around the course.

The racetrack at Chantilly was arguably somewhat less fashionable than Longchamp, but was still "very brilliant," and was patronized by "the elite of sportsmen and the brilliant pleiad of amateurs." Moreover, the rules there were less strict than at Longchamp, and "beautiful persons who . . . are unaccompanied" were less likely to be ostracized—although they were supposed to sit in the reviewing stand at the left, leaving the one on the right to ladies with escorts.

Rules or no rules, prostitutes also flocked to Longchamp. One of the most famous scenes in Zola's novel *Nana* (1880) depicts Nana watching the Grand Prix at Longchamp, seated prominently in a fine carriage and surrounded by masculine admirers. Her expensive but rather flashy clothes are described in some detail. "She was wearing the blue and white colours of the Vandeuvres stable in a remarkable outfit. This consisted of a little blue silk bodice and tunic, which fitted closely to her body and bulged out enormously over the small of her back, outlining her thighs in a very bold fashion."[21] Nana, however, was always something of a vulgarian; indeed, in Zola's heated prose, she comes across as essentially a vicious animal.

In describing the rise of the *demi-monde*, the journalist and man-about-town Arsène Houssaye emphasizes the stylishness of the Second Empire courtesan, as well as her appearance at the races:

> The ladies of society and the *demi-monde* began to rub shoulders at the charity balls and at the races. At first glance they were the same women dressed by the same dressmakers, with the only distinction that the *demi-mondaines* seemed a little more *chic*.[22]

The author of *Les Plaisirs de Paris* agreed: "Respectable Parisiennes dress well . . . but I am forced to declare that the . . . other Parisiennes dress a hundred times better." The image of the Parisian prostitute, however, encompassed both the stately "courtesane" who inhabited the upper reaches of the shadowy demi-monde and the "proletariat of love." Most prostitutes were of working-class origin (occasionally bourgeois), but the "high-class" prostitute had been polished into the semblance of a lady by learning how to ride, speak, and so on.[23]

There was no specific costume that announced: "*This* is a prostitute." Rather, there was a subtle and constantly changing network of signs: Thus, some of Constantin Guys's sketches, which Baudelaire admired so much, have been identified as portraying prostitutes not because of the figures' clothes, but because of the contexts and sometimes by the ways in which the clothes were worn. The deliberately raised skirt, for example, and the apparently prolonged exposure of the lower legs, was a part of the prostitute's body language, and differed in significance from the ordinary woman's raising of her skirts to cross a possibly muddy or dusty road. These women, too, went to the races, but mingled on foot with the crowd, rather than sitting in a carriage or in the stands.

As couturiers became more sophisticated in their promotional techniques, the racetrack became a favorite setting for another sort of professional fashion display. Already under the Second Empire, Worth insisted that his wife appear there in his latest creations, although according to her son, she was embarrassed to be a step *ahead* of the current style. Alice Ivimy also gives a full picture of the racetrack as fashionable rendezvous: "You will find all the leaders of fashion displaying the latest creations of the Rue de la Paix. You need not hesitate to stroll about and gaze your fill . . . these women have come on purpose to arouse your admiration. . . . In fact . . . the most striking and audacious gowns are worn by 'mannequins' or dressmakers' models who are paid to be stared at." And she concludes:

> There are two attractions for women on the race course; I think it is true to say that the first and strongest is *fashion* and the second is *sport*.[24]

A Ride in the Bois de Boulogne

Leaving the racetrack at Longchamp to go elsewhere in the Bois de Boulogne, the Parisian came across other scenes both sportive and fashionable. Everywhere there were people walking, riding in carriages, and on horseback. According to *La Vie Parisienne*, for many people, going to the Bois was the principal occasion of the day: The elegant woman thought it was boring to take a carriage ride in the Bois, but she went because it was the

fashion. The young married girl would have preferred to rent a horse and go riding, but her mother insisted they circle the lake in a carriage. Mademoiselle KISMIKWIK, the courtesan, always appeared wearing a dark carriage dress, set off with a bouquet of violets.[25]

Clothing that was acceptable for an afternoon carriage ride in the Bois might be unsuitable and provocative in the morning or on foot. Thus, the Parisienne of the 1880s was firmly instructed that

> One does not wear sparkling stones on foot in the street. The only earrings permitted are enamel flowers, turquoise, opals, etc.; but one must not exhibit diamonds, rubies, sapphires, [or] one would be taken for a foreigner, and an exotic foreigner at that, or for a questionable woman.

The correct street dress was "without superfluous ornament," of sturdy material, and short for ease of walking. The correct gloves and hat, perhaps a coat and muff, solid little boots, and little or no jewelry. This very important ensemble was reproduced "in richer materials for going to the Bois or on visits."

Thus, for a walk in the avenue des Acacias (the most fashionable promenade in the Bois), a person like the Baroness de K. might wear "a damask skirt the color of scorched earth" with "drapery à la anglaise," a bodice of the same color with collar and cuffs of Indian muslin and old lace, and a "very original and tasteful . . . suede bonnet trimmed with otter." Bracelets might be worn, when walking "the thousand metres recommended by hygiene."[26]

The hour to go to the Bois changed according to the season, and varied according to one's activity. Afternoon was generally correct for a carriage ride, but the fashionable hour for horseback riding changed in the second half of the century from afternoon to morning. Horseback riding was already a popular recreation for women under the July Monarchy, and the scene was depicted in numerous fashion illustrations. It became ever more popular later in the century, when women began to be permitted to ride unchaperoned. Renoir's painting *A Morning Ride in the Bois de Boulogne* (1873) shows a typical Amazon, accompanied by a young boy who is probably her groom. Many artists dealt with this theme, which was regarded as typically modern and attractive. According to the art historian Anne Hansen, pictures of Amazons "depict fashionable young ladies who are representative of specific types, and who therefore speak of the human condition in a new modern idiom." A number of artists regarded the female riding habit as an especially modern style of self-presentation.[27]

The riding habit was, of course, a quasi-masculine ensemble, consisting of a severely tailored jacket bodice and a voluminous trained skirt (worn over chamois undertrousers which were buttoned onto the riding corset). Due to the complicated cutting and tailoring of the suit, it was usually

In striking contrast to the fossilization of riding apparel, the nineteenth-century hunting costume frequently included a short skirt—or even breeches—as can be seen in this fashion plate by Le Francq from *Le Salon de la Mode* (1889).

made by (male) tailors who specialized in riding habits. In accordance with the masculine style, serious horsewomen wore plain wool suits in dark colors, such as blue or black (occasionally, dark brown, bottle green, or claret). The general fashion trend of the 1870s, toward a highly decorated and self-consciously "feminine" look, temporarily affected some riding habits, but this was not usually considered to be in good form. Riding habits were *supposed* to be masculine; this had been true as early as the reign of Louis XIV, and the style was only strengthened by succeeding generations of Anglomania. By the mid-nineteenth century, the costume *à l'amazone* also included the ultimate symbol of upper-class masculinity: a man's "high silk hat," which was worn, however, "with or without a veil."[28] The fact that a veil might obscure visibility apparently was never an issue.

The hazards of riding in a long skirt did receive some attention, and eventually the so-called "safety skirt" was invented (probably in England). But until the early twentieth century, there was seldom any question that equestriennes would wear *skirts*. Moreover, since the sixteenth century, European women rode side-saddle, so the actual shape of the skirt was very long and somewhat irregular. (When walking, the *amazone* had to carry a length of skirt over one arm.) Thus, despite the apparent "masculinity" of the riding habit, both the skirt and the manner of riding were

distinctively feminine. It was really only in the early twentieth century that a few Frenchwomen began to ride astride, wearing a split (or "culotte") skirt, in the "American style."

In striking contrast to the fossilization of riding apparel, the nineteenth-century hunting costume frequently included a short skirt—or even breeches. Fashion plates and other popular illustrations frequently showed women hunters striding along, rifle in hand. (*La Vie Parisienne* found their trousers titillating, of course, but most people considered them perfectly respectable.) Why was there this distinction between riding habit and hunting costume?

The following may be a partial explanation: The hunter appeared in the country, most likely on the private grounds of a château, in the company of her social peers and such underlings as could be counted on to show respect when confronted with bizarre costumes. Riding, however, was an urban as well as a country pastime; people could even *rent* horses in the Bois de Boulogne. Thus, despite its appearance of exclusivity, horseback riding was necessarily a more public exhibition. Moreover, the riding habit had become set in a conventional mold as early as eighteenth century—had become, in effect, a kind of *uniform,* and all attempts to modify it were greeted with scorn.

Fossil though it might be as a type of sportswear, the riding habit was almost certainly the origin of a new (and still crucially important) type of clothing: the woman's tailored business suit. The Americans seem to have been in advance of the French, for it appears that American women eagerly adopted the tailored suit from the 1860s on, and increasingly after the 1880s—whereas as late as 1901 the French fashion magazine *Les Modes* was still describing the tailored suit as a revolutionary development: "The great 89 of feminine costume has been the tailored suit" (1789, of course, being the year the French Revolution began). "It has triumphantly remedied the abuses of the old regime [such as vulgar overdecoration] . . . Only this 89 has found its Dixhuit Brumaire, that has put it back a step." (Here the reference is to Napoleon's rise to power.) "Gentlemen have not fully appreciated the tailored costume. They have found it too closely resembling their own."[29]

Paris All A-Wheel

By 1895, "all Paris [was] a-wheel," and women could "unblushingly don man's dress, or something alarmingly like it." Bicycling was also initially a private, upper-class affair. As Arsène Alexandre told the American readers of *Scribner's* magazine: "Fashionable women first tried the bicycle in the country in the grounds of the château." There they had more leeway to experiment with short skirts and bloomers, since "What would have

been in Paris a sinful outrage to the prejudices of good society became possible behind one's own gates. One is not always upon dress parade in the country."

"The Paris streets" posed a "serious obstacle" to the would-be bicyclist, not only because of the "danger in the crowd of vehicles and the rush and confusion of the boulevards" (not to be underestimated by anyone familiar with Paris traffic). At least as important, however, were social and psychological considerations:

> Madame, who likes to be noticed and admired when she takes her walks abroad, does not like to think that she attracts attention because of her bicycle costume and wheel. . . . So she rides to the Bois in her coupé, and meets the groom who brings her bicycle. The man, if he can ride, follows at a respectful distance, and the return to town is made in the same discreet manner. Often a party of friends meets daily for a spin of a dozen miles, leaving their bicycles at the gates of the Bois and finding cloaks in their carriages. Thus Mme. Menier and Mme. de Camondo, two of the most distinguished amateurs of the sport, follow this practice.[30]

An illustration from Uzanne's *La Femme à Paris* (1894) shows the costume for bicycling. Other versions of the costume, with longer, fuller trousers, were reproduced in American magazines, such as *Harper's Bazaar*.

The Bois provided at least a *semi*private setting for unorthodox fashion display, although some aristocratic bicyclists tried to organize, in the corner of the Bois, a special "bicycle rink for the exclusive use of society ladies . . . where the fashionable world a-wheel will feel at home." There were already a few rinks such as the Velodrome Buffalo, near Neuilly, and the Velodrome de la Seine, but "the company is apt to be mixed." One rink in the Champs-Elysées was better, "thanks to high prices," and women could "take their lessons and practice without too much publicity" there.

Such demands for privacy and exclusivity were characteristic of much upper-class sporting behavior, but became more pressing when women were wearing potentially shocking costumes. As Barbara Schreier has demonstrated in her work on sports clothing, women in America and Europe were wearing bloomer-type garments for gymnastics as early as the 1830s and 1840s. But such exercise was generally performed in private settings among women only.[31] By the 1890s, women bicyclists increasingly wore bloomers in public, and in the company of men as well as other women.

I believe that this development was possible for bicycling—as it was not for horseback riding—in part because bicycling was a *new sport*. Since there already existed a recognized and prestigious equestrian costume, calls for reform easily went unheeded. But when the bicycle appeared, there was no traditional feminine costume for it. According to *Scribner's* magazine.

> When the bicycle craze began there were no women's dresses. . . . Just imagine one of the leaders of society going to her dressmaker and requesting a suitable costume to ride a steel wheel. . . . So the first costumes were mostly home-made affairs, designed by the riders and made up by work-women.

By 1895, certain tailors specialized in bicycle outfits, and they were easy enough to obtain:

> Already the skirt is fast going; another step and it will be but a memory. Here is the orthodox and really fashionable costume: very full knickerbockers, the folds falling below the knee, the appearance being that of a skirt, and yet without the skirt's inconvenience; the waist may vary, but the most popular, especially with slim-waisted women, is that known as the Bolero. And above all a man's cap or hat, in warm weather of straw, at the other seasons of felt. The stockings may be of fine wool, black or dark blue; silk stockings are tabooed, and any color but black or dark blue, such as striped or "loud" colors, are considered deplorable.

Soon the traditional fashion advice on how to dress *à l'amazone* was accompanied by information on dressing for *la bicyclette*. The colors were similar, black and dark blue, although there was somewhat greater choice for bicycling. The bicycling cap, however, was far less formal than the equestrienne's top hat, and some bicyclists wore a blouse "rather resem-

bling an elegant bathing costume." Significantly, the majority of French writers agreed that "short trousers" were the usual nether garment.[32]

Bloomers, indeed, seem to have been far more commonly worn in Paris than in England or the United States (despite the apparently greater athleticism of the Anglo-Saxons). And this was the case despite the fact that many fashion writers strongly disliked the costume, regarding it as ugly and unfeminine. But unlike the case in England, where *ladies* seldom wore bicycling bloomers, in France bicycling in trousers became "really popular and at the same time really fashionable." Everyone wore bloomers, from "the great ladies of the land" to the "pretty" middle-class bicyclists who "have added one charm more to the Bois de Boulogne." Very likely, this was precisely *because* bloomers were presented in France as a fashionable item (rather than as a quasi-feminist statement).

The reverse side of the coin was that trousers, per se, were still not acceptable. Even in 1895 (when bicyclists in bloomers were frequently seen pedalling through the Bois de Boulogne), "*pseudo-bicyclists* in trousers" caused a scandal by "promenad[ing] on the boulevards" without any bicycle. The Prefect of Police entered the scene once again, this time to forbid the women from wearing trousers unless they were on a bicycle.[33]

9
Le Five O'Clock Tea

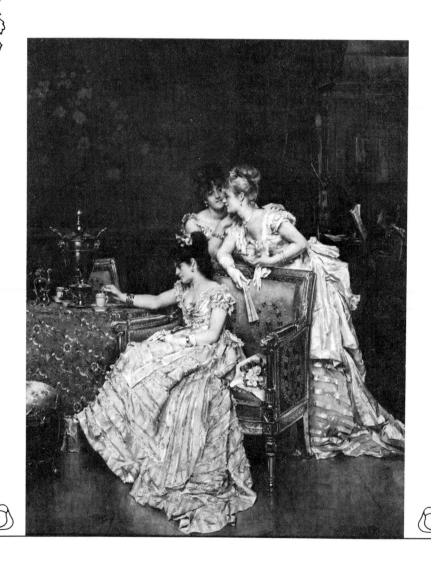

Alfred Stevens was known as a painter of elegant life. According to contemporaries, his "eternal model" was "the woman of the world, dressed in velvet, satin or silk . . . in all her artificial splendor." *The Cup of Tea* (ca. 1874) conveys this sense of elegance, and compares nicely with Mary Cassatt's paintings on the same theme—for she, too, was described as having portrayed "the modern woman as glorified by Worth." Courtesy of the Musée Royale du Mariemont, Morlanwelz, Belgium.

A man is not a modernist because he paints modern cos-
tumes. The artist in love with modernity should, first of all,
be impregnated with modern sensations.

<div align="right">Alfred Stevens, Impressions on Painting, 1886</div>

Although the Impressionists are famous today for having been the first
to paint what Baudelaire called "the heroism of modern life," other, more
academic painters such as Alfred Stevens also prided themselves on being
modernists—and not only because they painted contemporary dress. Yet
if we investigate why so many of Steven' contemporaries perceived him as
"a painter of modernity," the issue of fashion constantly recurs. Certainly
by 1855, Stevens had found his subject: He "applied the brilliant resources
of his superior art to the representation of the modern woman, especially
the Parisienne." His "eternal model" was "the woman of the world, dressed
in velvet, satin, or silk . . . in all her artificial splendor."[1]

The American expatriate artist Mary Cassatt was also famous for her
paintings of well-dressed Parisiennes: According to one of the New York
papers, her subject as "The Modern Woman as glorified by Worth."[2] The
two artists dealt with many of the same themes: The cup of tea, woman
with a fan, mother and child, the visit, and so on. But if we compare their
treatment of, say, the cup of tea, it is clear that they approached their
subjects very differently. A fashion plate by Anaïs depicts yet another ver-
sion of the same scene. The way they dealt with fashion is revealing of
broader differences in artistic style, personal temperament, and images of
the modern woman.

Le five o'clock tea was a highly fashionable and much-imitated cere-
mony that was represented in many contemporary illustrations. It was
preeminently a social gathering for women, although there were often
also a few men in attendance. The hostess might wear a special at-home
gown, unless the friends had decided to meet at a smart tea-shop or patis-
serie. Alternatively, tea might be served at an evening soirée, when, of
course, evening dress was *de rigeur*.

Stevens' painting, *The Cup of Tea* (which dates from about 1874) shows
three young women in sumptuous and *décolleté* evening gowns. One of
them sits in an embroidered arm chair, idly stirring her tea, while behind

<div align="center">179</div>

her two other women lean slightly forward and exchange significant glances. One of the standing women has her hands on the other's shoulders, and appears to be on the verge of telling her something. The implication is that their conversation concerns the preoccupied and somewhat unhappy looking woman in front of them. Although the blonde standing woman holds a teacup and saucer in one hand (and a closed fan in the other), the theme is not simply friends having tea together: The womens' poses and expressions indicate that something is happening to the seated women beyond what is immediately illustrated. The *soirée* potentially offered a field for romantic intrigue, and Stevens stresses this aspect of the social gathering.

Stevens' treatment of fashion in this painting focuses emphasis on the seated woman's dress. Meticulous attention is paid to the sheen of the material and to the multiplicity of details, the trimming and the lace. Furthermore, the dress is shown in its entirety, from a medium distance and glowing against the dark background. The skirt is carefully arranged to form a sweeping curve of material. In addition, although the front of the blonde woman's dress is hidden behind the chair, she is positioned in such a way that there is a clear side-view of her skirt; Stevens lavishes attention on the "pouf" of fabric that is tied back and draped over her derrière. As art historian William Coles says of a similar dress (in Stevens' *The Reader*), this was the type of

> richly fashionable costume to which Stevens could do full justice. He made the costume of his age—particularly the height of the Second Empire and the decade following—historical, as it were, by using it and documenting it in modern pictures. But he did not do so as a mere reporter of fashion, but as a painter who thoroughly understood and appreciated the wealth of colors and textures offered to his eye and brush by the splendid fabrics and costumes of the day.[3]

Stevens' use of fashion in his art was not, perhaps, quite as "serious" and painterly as Coles implies. In a sense, he uses fashion as a purely decorative element, in the same way that he very frequently uses pieces of oriental art: because they are beautiful and chic objects. His attention to detail, for example, is as close to that of the fashion illustrator as to that of the history painter; he brings the painting of contemporary history close to that of sentimental genre painting.

The dresses in *The Cup of Tea* are not really integrated into the composition, but seem somehow autonomous, related neither to the wearers nor to the interior. Stevens appears to be conscious of them as beautiful objects, which he collects and arranges for their decorative effect. Some of the same models, dresses, and furniture reappear in works such as *Cruelle certitude, Désespéré,* and *Après le bal* (or *La confidence*), which also share a

note of unhappy love.[4] The compositional structure of *The Cup of Tea* both emphasizes and isolates the dresses. On the other hand, Stevens' attention to furniture and room details is uncharacteristic of fashion-plate art, which barely sketches in these relatively unimportant—and potentially distracting—features.

Stevens also uses fashion in this painting to impart information about his subjects: to tell a story. In this, as in much of Stevens' work, the anecdotal element is conspicuous. Stevens almost always painted girls and young women, but not in their "accurately observed daily life." Rather, he habitually infused his scenes with emotional overtones, being concerned with "woman's life, her caprice, her dream, her desire, her consolation; all that her senses desire and love"—and, specifically, "those fabrics, those adornments, those thousand exquisite nothings purchased at Giroux."[5] Thus, he directly linked emotions (often explicitly romantic or sensual) with personal adornment and fashion. For Stevens' women, life seemed to revolve around love and fashion.

Stevens' models were intended to represent elegant beauties, but one can not simply assume that they represented upper-class Parisian women, such as those painted by Winterhalter. For although Stevens' women are presented "under an aspect of perfect propriety," no husband is ever present, and there are often indications of a love affair (such as a letter). They may even represent women on the edge of the demi-monde:

> That woman is, physically, close to the type of celebrated beauties of the Second Empire who inflamed Paris in its yearly period of pleasures and luxury.[6]

Or at least, this may be true of a few of them, such as the woman in *Memories and Regrets*. (The paintings of mothers show respectable upper-middle-class women.) The absence of a "bourgeois air" is explainable by Stevens' emphasis on the erotic ideal more than the complementary domestic ideal; even here he shows only young, pretty mothers.

The fashions that Stevens painted would not, by themselves, lead viewers to assume that his figures were courtesans—and contemporaries seldom drew such conclusions. But sexual attractiveness was at the heart of his image of femininity. For the women that Stevens portrayed (whether in the great world, the world, or the half-world), fashion was crucial, because it served to increase their sexual attractiveness. He seems to identify feminine beauty with elegance. Certainly, he uses fashion to help produce figures that reflect the current, fashionable ideal of beauty.

Anäis's treatment of the tea party for the fashion magazine *Le Conseiller des Dames et Demoiselles* (December 1855) was rather different. Four pretty young women sit or stand around a tea table. They are positioned as if posing for a photograph. The women are not shown full length (which is

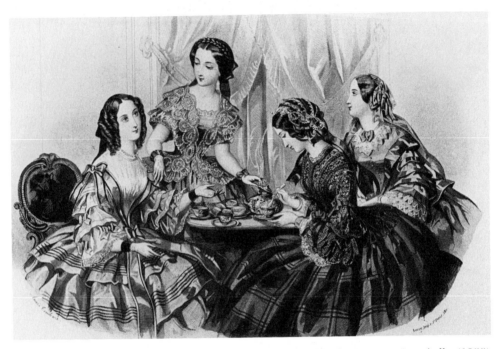

A fashion plate by Anaïs Colin Toudouze from *Le Conseiller des Dames et Demoiselles* (1855) shows several ladies having tea. Although her dresses are just as elegant as those in *The Cup of Tea*, Anaïs avoids the anecdotal element so characteristic of Stevens' work. There is no implicit romantic story that might disturb the viewer's meditation on the clothes themselves.

somewhat unusual for a fashion plate), but we see most of the two front figures and the torsos of the other two. Because the date is 1855, it is not necessary for us to see more than two skirts anyway—one flounced, the other a plain checked fabric—for although the skirt is certainly a prominant design element (expanded as it is over a crinoline), there is not much in the way of draping or cutting that we need to examine in detail.

It is far more interesting to pay attention to variations on the bodice: There is the gauzy white bodice, the modest décolletage of which is partly belied by the visual effect of plunging mauve "shoulder straps," with sleeves consisting of flounces interspersed with mauve bows and ribbons. There is the expensive-looking black lace bodice trimmed with dark green ribbons that match both skirt and cap. There is the relatively plain purple bodice, which would today be considered wildly extravagant and must even then have been thought beautifully constructed, with its fluttering triangular torso, flounced pagoda sleeves, and lace collar and cuffs. A neat little gold bow at the throat is echoed by flowing hair ribbons. But the hostess

has perhaps the prettiest bodice—the only one that is rather low cut, of pale blue silk with a square décolletage and short sleeves—and covered with a little sleeveless "jacket" of white lace in a large medallion pattern.

The hostess stands looking down at the woman in mauve, gently touching her arm to offer her a cup of tea. Unfortunately, her guest is gazing into the distance with an ethereal expression. The woman in black lace stirs her tea, her tiny hands holding an equally diminutive cup. Only the plump woman in purple looks at her hostess with an adoring expression. Of the room, we see nothing except the little tea table and its accessories, an extra chair, and the faint outline of a curtain over a window.

The women look as pretty as porcelain dolls. If their heads tilt slightly back, their eyes open; if they look down, their eyes begin to close. Perhaps they look a little too sweetly insipid for modern tastes, but their candy-box delicacy was the ideal of the 1850s, and their clothes are very beautiful indeed. Their calm serenity is timeless and reassuring. It comes as something of a relief, in fact, compared to the arrogant *sangfroid* of fashion models of a century later. The mauve lady's gentle expression might conceivably be romantic in origin, but she might simply be thinking of something vaguely pleasant. *There is no story here,* no slice of life, no anecdote (romantic or otherwise) to tell that might disturb the viewer's meditation on the clothes themselves. All is calm, beautiful, and luxurious.

Like Anaïs, Stevens used fashion to idealize and stylize the female body, to make it more "beautiful," as well as to give an impression of opulence and personal chic. Whether or not he was conscious of the influence of fashion plates on his work, the similarities—in silhouette, function, and obsessive detail—are obvious in retrospect. But so are the differences.

The eroticism of his figures does not necessarily imply any sexual impropriety, but rather the appraising eye of the flâneur, always ready to see and appreciate feminine erotic beauty. For Stevens observes the women in *The Cup of Tea* in the manner of a gentleman observer at the soirée. Male art critics of the Belle Epoque seem to have regarded his pictures in much the same way, admiring the way cashmere shawls were draped over the models' "svelte forms." The Stevens' woman, perhaps, "a blonde woman who stirs her tea," wearing "a dress slightly undone, allowing one to see the blonde, tender flesh," spends her time like an "unhappy lover."

> She dreams, smiles, prays, cries, thinks of someone who is absent or of someone who is supposed to come, thinks of her pleasures, of her beauty.[7]

This image of fashion and beauty is in striking contrast to their portrayal in the work of Mary Cassatt. Perhaps in part because she was herself a woman, she seems to have viewed fashion (and womanhood) in a different, often a more casual and matter-of-fact way. Certainly, fashion could increase a woman's apparent attractiveness, but it did not determine it.

There is, in her work, an apparent lack of interest in using dress to create an image of fashionable and artificial eroticism. More often than Stevens, Cassatt places herself vis-à-vis her models in the position of a friend, someone who is also, say, drinking tea. This difference, of course, is not absolute or simple; Stevens also was sometimes in the position of a friend, and Cassatt notoriously romanticized the state of maternity, but viewers of their paintings were definitely presented with two different perspectives on the modern woman.

Whereas Stevens almost always shows young women dressed in the height of fashion, Cassatt varies her emphasis on fashion—and varies the fashions that she portrays—according to the situation. Thus, the women's dresses in Cassatt's *Five O'Clock Tea* (1880) are stylish but discreet afternoon dresses. The woman in the dark blue wears a hat and gloves, and is presumably the visitor. Her companion, in brown, might be the hostess or another guest, but she is also in afternoon dress, not loose at-home attire—still less

The American painter Mary Cassatt was personally interested in fashion, but her paintings are not *about* fashion. The apparent "casualness" of her arrangements and her use of close-up tend to de-emphasize dress. Moreover, in *The Five O'Clock Tea* (1880), she chose to depict quietly elegant, even rather severe, afternoon dresses, rather than the elaborately feminine styles that Stevens favored. Courtesy of the Museum of Fine Arts, Boston.

an actual *tea-gown*. When comparing artists' treatment of fashion, it is necessary to beware of attributing to differences of temperament or intention what were often simply differences in fashion itself. Thus, the simplicity and severity of these dresses by Cassatt is partly explainable by the dominant style of daytime fashion in the early 1880s.

Nevertheless, differences in current modes aside, Cassatt clearly treats fashion differently than Stevens does. To begin with, she portrays her figures in greater close-up: as half-figures rather than full-figures, their costumes are almost automatically emphasized less. Unlike Stevens, she does not include the entire fashion ensemble in her composition. Indeed, the women themselves only occupy the left-hand side of the picture, and are balanced on the right by a beautiful silver tea service. (By contrast, the tea service in Stevens' picture is barely noticeable, placed off in the shadows at the left.) Cassatt's studied "casualness" of arrangement (in fact an artful formal structure) in this case also results in a de-emphasis of dress. As the inclusion of the tea service shows, Cassatt also includes beautiful objects in her paintings, but they seem more obviously to serve specific formal functions, and are not primarily decorative items.

She treats fashion also more as a formal element in a closely knit composition, subordinating it to problems of organization, design, and color arrangement. In *Five O'Clock Tea* there is less emphasis on details of dress, and more on the use of clothing as pattern and close form, as broad areas of color with clear contours. The women's dresses form shapes that interlock with other shapes and patterns. Thus, the rounded forms of the women's bodies are echoed in the curves of the sofa, while the brown and dark blue dresses are contrasted with the flowered chintz upholstery. One woman's small, round hat radically breaks the pattern of vertical stripes on the wallpaper.

The formal use of fashion is even more striking in some other works, such as the prints, *The Letter* and *The Fitting*, wherein clothing and interiors are locked into flat patterns. Nevertheless, just as it would be a mistake to overemphasize the anecdotal, decorative, and academic use of fashion in Stevens' work (some of his paintings, like *The Ladybug*, are looser in brushwork, more "intimate" and "friendly" in character, and closer to Cassatt's style), so also would it be misleading to argue that Cassatt uses fashion solely as a formal element, with no reference to her use of fashion as a means of imparting information and creating a particular atmosphere.

Cassatt was not an abstract painter. She chose to paint particular people in specific settings. As the writer and critic Joris Karl Huysman wrote about *Five O'Clock Tea,* "Here it is still the bourgeoisie . . . it is a world also at ease, but more harmonious, more elegant."[8] (More elegant, that is, than the work of some of her contemporaries.) Her subjects were also elegant: Many were friends and relatives, others models for whom she bought, on

occasion, dresses by Madame Paquin. It is clear, however, that they belonged to a somewhat different social group than the women painted by Stevens. Stevens' women appear to be wealthier and seem to lead a more active social life. This is apparent not only in the differences in fashion, but also in the different interiors in which the figures are placed. Cassatt and her models wore stylish and expensive dresses, but Stevens' models often wore extremely fashionable dresses borrowed from the wardrobes of the Princess de Metternich and other court ladies.[9]

Uzanne distinguished carefully between the various class fractions in Parisian society: His picture of "la bourgeoise parisienne" seems to describe Steven's women, while he had another category of "middle bourgeoisie" that appears to correspond to the social class portrayed in the work of Cassatt. The life of the Stevens' woman is characterized by events in high society while Cassatt's work illustrates the proper and fashionable but predominantly domestic existence of middle-class women.

Fashion played various roles in women's lives, of greater or lesser importance, depending on the particular woman's immediate situation—her age was as significant as her class. It was regarded as highly unsuitable, indeed ludicrous, for older women to dress like young women. Unlike Stevens, Cassatt also painted little girls and older women: The subject of *Lady at Tea Table* (1885) is an older woman, and it is appropriate that fashion should be a less conspicuous element in her persona. Rather than presenting herself in fashionable, up-to-the-minute dress, the sitter chose to wear an elegant but essentially timeless black dress with old-fashioned but expensive white lace cuffs and a white lace cap. Although the portrait is of an American woman, her clothes were very similar to those regarded as appropriate for older Frenchwomen, who appeared, once in a blue moon, in contemporary fashion plates.

A third painting by Cassatt, *The Cup of Tea* (1879) emphasized to a greater degree the charm of a particular dress and its role in the enhancement of female beauty. The picture shows Cassatt's sister, Lydia, sitting in a striped arm chair, holding a cup of tea. Behind her is a platter of white hyacinths. Lydia wears a shell pink dress, long gloves, and a pink bonnet. Huysman noted approvingly that Cassatt "added to this tender, contemplative note the fine sense of Parisian elegance."[10] Lydia, of course, was a young American woman, not a true Parisienne, but like her sister, she had lived for years in France and wore Parisian fashions. It is also possible that Huysman was sensitive to the sensuality of brushwork and color that was a part of Cassatt's work, and which was so different from Stevens' kind of sensuality. The obvious sexual undertones in Stevens' work would have been odd, indeed, the work of a woman painter. But Cassatt also paid attention to aspects of the sartorial sexuality that Stevens emphasized—such as the

Another painting by Cassatt, *The Cup of Tea* (1879), shows the artist's sister Lydia wearing a pink dress and bonnet "of Parisian elegance." This work emphasizes to a greater degree the charm of a particular dress and its role in the enhancement of female beauty. Courtesy of The Metropolitan Museum of Art, New York. From the collection of James Stillman, Gift of Dr. Ernest G. Stillman, 1922.

themes of décolletage, déshabillé, and the relationship between fabric and skin.

What a woman did each day helped determine the clothes she wore. According to Uzanne, the "great lady" of the aristocracy and the financial world (the high bourgeoisie) led a life of *soirées,* balls, receptions, and visits to the theatre, to see her friends, to promenade.

> In these elevated spheres, the role of woman is entirely one of charm and seduction. She has no other duties than those of society. . . . To be seen and to shine, such is the existence of these *élégantes.*

Since they were "constantly endeavoring to idealize themselves," fashion was crucial. It served to increase their erotic beauty, status, and *tone.*

Among the "middle bourgeoisie," women led a more private life, centering around their children, a fashionable but more modest toilette, shopping at the new department stores, visiting friends, and so on.

> After having spent the morning attending to her house, the tradespeople, her children, and her dress . . . she spends the afternoon at her dressmaker's . . . her hairdresser's, paying a visit to some friends, lunching at a tearoom, shopping, putting in an order at the the grocer's, buying flowers, trying on a coat at the tailor's, a hat at the milliner's, looking at her watch . . . rushing off to the *Louvre* or to the *Bon Marché*.[11]

Then, in the evenings, she might dine out, have little receptions at home, or go to the theatre. But a dinner for six or eight people demands a different dress than that worn by the great lady, who might go to several large parties in a single night. And much of her time was spent with her children, teaching them to read and taking them for walks in the Jardin des Plantes or the Tuileries Gardens. Thus, although women of the middle bourgeoisie were very interested in fashion, the fashions they wore tended to be rather different from those of the society lady.

The treatment of fashion in French paintings of the nineteenth century is closely related to the image of the woman shown wearing it and, by extension, to the attitudes of the painter. In these particular paintings, fashion plate style and iconography are more evident in Stevens' work— especially in his emphasis on clothing details, physical types, and body language. On the other hand, his romanticism and implied story line are not characteristic of the fashion plate, which is, in its own way, as "matter-of-fact" as Cassatt's paintings.

Cassatt had considerable personal interest in fashion, patronizing the best dressmakers and even portraying some of her models in dresses by Paquin. But her paintings were not *about* fashion. She was under no explicit obligation to adhere to conventions. Indeed, as a self-consciously avant-garde artist, an independently wealthy individual (and an expatriate, and an unmarried women), she had relatively great freedom to follow her painterly inclinations.

No painter who wished to portray women of the bourgeois or elite classes could avoid the issue of fashion in any case, but Stevens made it integral to the expression and intention of his art. He documented modern dress with all the care that history painters lavished on the costumes of the past. His approach to pose and expression is likewise indebted to traditional and fashion-plate conventions. Yet he wrote that he chose to portray modern women rather than women from ancient or exotic civilizations, because "The most beautiful odalisque, adorned with jewels, will never move me as much as the women of the country in which I was born."[12]

The conception of the modern woman held by Cassatt was less exclusively romantic and idealized. The primarily erotic function of fashion is downplayed, together with other anecdotal and informational aspects of dress. Although less overtly documentary in her approach, Cassatt also said of herself that she "tried to express the modern woman in the fash-

ions of our day and . . . tried to represent those fashions as accurately as possible." [13]

Ultimately, the influence of fashion-plate art may go beyond the adoption of conventions of pose, arrangement, and detail (important as these are) to a more philosophical concern with fashion as an expression of modernity. Beauty, after all, is not an immutable concept. The aesthetic ideal of each period is different, and fashion both reflects and helps determine that ideal. As Baudelaire wrote: "What poet would dare, in the depiction of the pleasure caused by the apparition of a beauty, separate the woman from the dress?" Even nudes wear the invisible fashions of their period, which subtly alter their anatomy. [14]

Nevertheless, over the course of the nineteenth century, the fashion plate remained conservative—even retrograde—in style and presentation. The technology that reproduced images in multiple copies corresponded to the development of mass fashions, but the pictures themselves changed more slowly than the clothes. It seems surprising that artistic and sartorial modernism was so little evident in the imagery of fashion, but the function of the fashion plate—to illustrate and sell clothes—probably restricted tendencies toward innovation.

The Tea-Gown Itself

One thing, however, is missing from all of these pictures. Despite its fame, the *robe d'intérieur* was seldom portrayed in art, whether as a humble dressing-gown or a splendid tea-gown. Indeed, its relative absence is rather surprising. The dressing-gown had appeared frequently in popular prints of the July Monarchy: lorettes, lionnes, and bluestockings all wore it. Manet's *Woman with a Parrot* shows a woman is a dressing-gown, and was clearly influenced by such graphic predecessors. But for similar paintings of tea-gowns, we are largely restricted to second-rate works, such as Jules Cayron's *An Elegant Tea-Party: The Gossip* (1907), or Francisco Masriera's *A Melody of Schubert* (1896).

The great exception was the Japanese peignoir, which was depicted by a number of artists, most notably Whistler. If the artist were attracted by *Japonisme*, women were clearly attracted by the kimonos themselves (which were, however, virtually never worn "correctly"). When Proust's narrator first visited Madame Swann, she favored "Japanese wrappers" and cushions emblazoned with "Chinese dragons," but later she abandoned these now "horrid vulgar things" in favor of receiving her familiars "in the bright and billowing silk of a Watteau gown whose flowering foam she made as though to caress where it covered her bosom." [15]

Le tea-gown or *robe d'intérieur* was a very significant garment, but one difficult to define and even to identify. As its name implies, it was above

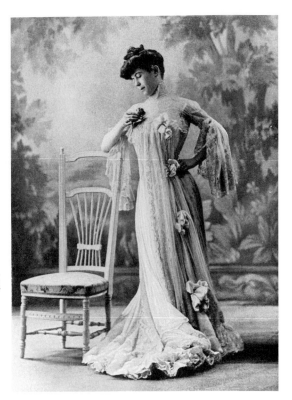

Le tea-gown or *robe d'interieur* was a special garment, intimate, "poetic" and "often more luxurious than an evening toilette." Fashion writers vied with one another in praising these "diaphanous robes, a product of our age, and calculated so specially to show off the grace of the modern woman." This photograph by Paul Boyer of a tea-gown by Redfern appeared in *Figaro-Modes* (1903).

all an indoor dress. Properly speaking, *déshabillé* refers to "several different garments, utilized only in the house, from the *robe de chambre* in rather thick material . . . or the more light-weight *peignoir* . . . to the elegant *robe d'intérieur*." [16] Because they were only worn indoors, in at least semi-private settings, these garments retained much of the intimate quality associated with underwear. Although dressing-gowns existed as early as the eighteenth century, and peignoirs as early as the 1830s, being frequently portrayed in the libertine prints of the Romantic era, the tea-gown, as such, developed in the 1870s, when both day and evening dresses were quite tightly fitted:

> The growing severity of the tailor-made dresses in the 1880s also gave the tea-gown a special place as the most elaborate garment of daytime wear, as well as the most relaxed and easy style of dress. [17]

The tea-gown could also be more fanciful or "artistic" than ordinary dress, and this was another reason for its popularity—as well as its importance in the history of dress.

The Baroness d'Orchamps, a turn-of-the-century fashion writer, saw a number of uses for the indoor dress. Rather unromantically, she sug-

gested that since ordinary dress was often fragile and physically hamper-
ing, women often adopted the *peignoir* or the *matinée* "for indoor tasks." If
soberly unadorned, the peignoir could be worn "for messy chores or for
visits to the kitchen." This type of semi-dressing-gown could be made of
wool, flannel, broadcloth, surah, zenana, or crepe de chine. On the other
hand, the peignoir also lent itself to "all the fantasies of cut and all the
luxuries of decoration." D'Orchamps distinguished between the peignoir
and the matinée, on the grounds that the latter was worn with a petticoat
and corset: "It is, then, when all is said and done, only a *demi-déshabillé*."
The matinée could be put on for those "intervals of rest between the ex-
cursions of the day." It was a garment in which one could, "if necessary,
show oneself to intimate friends," but it was also "the dress of sick people
and convalescents." It could be "luxurious and made of rich fabric, em-
bellished with lace and embroidery."[18]

The Countess Tramar also distinuished between simple and more elab-
orate peignoirs. In the morning, she wrote, one takes off one's nightgown
and puts on an "ample saut-de-lit with large sleeves." After washing, one
takes off this "woolen peignoir" and either dresses to go out, or puts on
"an elegant peignoir." According to Tramar, the peignoir "poeticises" its
wearer; it is "the luminous nimbus" that "halos her beauty, in a voluptuous
languidness that the austerity of the bodice does not permit." (In other
words, the looseness of the peignoir can be more flattering than the close
fit of the boned dress bodice.) "Woman's beauty receives a special charm
. . . from this disquieting apparel." Here Tramar was considering the
peignoir in its widest sense—as including everything "from the saut-de-lit
in surah, wool, Liberty satin, [or] muslin, to the robe d'intérieur [that is]
often more luxurious than an evening toilette." All were "indoor gar-
ments, born of fantasy."[19]

But "Les robes d'intérieur, ou *Tea Gown,* sont la fantaisie de la fantaisie."
The tea-gown called for "an original creation, froufrous, a dream full of
emotion"; "overloaded with exquisite adornments." As d'Orchamps put it,
the tea-gown was intended to express "a very personal character, corre-
sponding to [the wearer's] intimate tastes, and at the same time flattering
the natural aspect of her beauty." Like the intimate, at-home social rituals
that were their intended setting, tea-gowns seemed to their wearers to em-
body a peculiarly modern consciousness: "Diaphanous robes, a product of
our age, and calculated so specially to show off the grace of the modern
woman."[20]

10
Proust's World
of Fashion

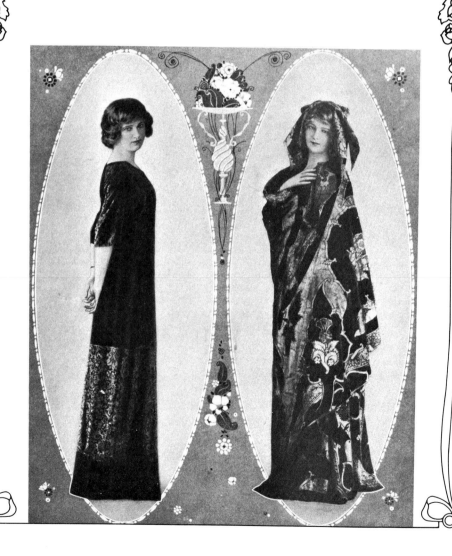

Among the many fashion references in Proust's great novel, those devoted to the dresses of Mariano Fortuny are especially significant. The narrator first encountered Fortuny's "unique" garments at the home of the Duchesse de Guermantes. What was "that indoor gown that you were wearing the other evening," he asked, "dark . . . streaked with gold like a butterfly's wing?" "Ah! that is one of Fortuny's. Your young lady can quite well wear them in the house." Soon Albertine also dressed in gowns that "swarmed with Arabic ornaments, like the Venetian palaces hidden like sultanas behind a screen of pierced stone." An illustration from *Femina* (1913) shows two of Fortuny's creations, a dress and a cloak, both in velvet, and decorated with designs that suggested Venice and "the gorgeous East."

Chacune de ses robes m'apparaissait comme une ambiance naturelle, nécessaire, comme la projection d'un aspect particulier de son âme.

Proust, *Le Côté de Guermantes*, 1920–1921

Y ves Saint Laurent has said that *A la recherche du temps perdu* is his favorite book. In it, fashion references occur so often that, were they collected, they would make a small book of their own. Like Balzac, an author he deeply admired, Marcel Proust frequently refers to the clothing his characters wear, and to the idea of fashion as a social force.

"In the novels of Balzac," he writes "we see his heroines purposely put on one or another dress on the day in which they are expecting some particular visitor."[1] Thus, when Balzac's Princess de Cadignan is meeting d'Arthez, she chooses to wear "a harmonious combination of grey tones"— a gown that expresses the idea of "half-mourning." When Proust's heroine, Albertine, appears in a beautiful grey skirt and jacket, the Baron de Charlus immediately makes the connection: "You are wearing this evening the very same clothes as the Princess de Cadignan, not her first gown, which she wears at the dinner party, but the second."

And when Albertine takes off her jacket, revealing "sleeves . . . of a Scottish plaid in soft colours, pink, pale blue, dull green, pigeon's breast, the effect was as though in a grey sky there had suddenly appeared a rainbow." Charlus is delighted with this unexpected "prism of colour," and notes that Albertine does not have "the same reasons as Mme. de Cadignan for wishing to appear detached from life, for that was the idea which she wished to instill into d'Arthez by her grey gown." As he and Albertine begin to discuss the "mute language of clothes," they are interrupted by two minor characters, who fail to understand that one might be interested in a dress as a work of art.[2]

Proust's biographer tells us that the remarks made by the Baron de Charlus were derived from those actually said by Count Robert de Montesquiou, an extraordinary individual who served as a model for the great comic-tragic figure of Charlus. Proust initially made fun of Montesquiou for going into raptures over the grey dress of the Comtesse Greffulhe. But near the end of his novel, Proust has his narrator declare that, if he can not build his work as a cathedral, he will construct it simply "like a

dress." And although Proust seldom describes an entire costume, he frequently comes back to certain details of dress. As a recent study shows, both "psychological revelation through clothes" and the use of "clothes as masks" play a significant part in Proust's work.[3]

If Proust is indebted to Balzac for much of his social and psychological analysis of fashion, his philosophy of fashion seems to have come from Baudelaire. Just as Baudelaire interpreted fashion as an integral part of the civilizing process, so also did Proust write of Madame Swann that "She was surrounded by her garments as by the delicate and spiritualized machinery of a whole form of civilisation."[4] Moreover, just as Baudelaire found all fashions "delightful—*relatively* delightful, that is," so also was the temporal quality of fashion important for Proust. Indeed, his whole theme of "the past recaptured" is closely associated with fashion in art and memory.

Odette, in Mauve and Pink

Fashion is particularly significant for three of Proust's heroines: the courtesan, Odette de Crécy (later Madame Swann); Oriane, Duchesse de Guermantes; and the narrator's bourgeois mistress, Albertine. Odette is perhaps the most interesting, because she undergoes so many changes. Beginning as the anonymous "lady in pink" (mistress to the narrator's great-uncle), she appears later in male *travestissement* in Elstir's painting of Miss Sacripant. As Odette de Crécy, she becomes first Swann's mistress and then his wife. After Swann's death, she remarries and, as Madame de Forcheville, she becomes the mother-in-law of the Marquis de Saint-Loup. But although she moves from being a *demi-mondaine* to being a member of the most aristocratic Parisian society, in a sense she always remains *la dame en rose.*

The chronology of Proust's novel is rather confusing in places, but it appears that Odette began her affair with Swann in the early to mid-1880s. At this time, although slavishly following what she believed to be the latest fashion, Odette as yet failed to be truly fashionable or elegant.

> As for her figure, and she was admirably built, it was impossible to make out its continuity (on account of the fashion then prevailing, and in spite of her being one of the best-dressed women in Paris) for the corset, jutting forwards in an arch, as though over an imaginary stomach, and ending in a sharp point, beneath which bulged out the balloon of her double skirts, gave a woman, that year, the appearance of being composed of different sections badly fitted together.[5]

Even the currently fashionable hairstyle with its "fringe" and "crimped waves" was unflattering to Odette, making her face appear "thinner and

more prominent than it actually was." Partly for these reasons, Swann was slow to fall in love with her. And much later, he regretted bitterly that he had ever become involved with someone who was *not even his style*.

Yet when she "received him in a tea-gown of pink silk, which left her neck and arms bare," Odette was more appealing, since, as a courtesan, she instinctively understood the charm of these intimate garments. And when they talked, she occasionally showed something of the subtlety of Swann's own mind. Her favorite flowers, for example, were orchids, cattleyas especially, because they didn't look like other flowers—but appeared to be made "out of scraps of silk or satin." "It looks just as though it had been cut out of the lining of my cloak," she said to Swann. She still retained, however, the kind of naive foolishness that made her "respect" so "smart" a flower, just as she initially respected Swann, without ever understanding how distinguished he really was.[6]

Although she "thirsted to be in the fashion . . . her idea of it was not altogether that held by fashionable people." As Proust explained: "For the latter, fashion is a thing with emanates from a comparatively small number of leaders, who project it to a considerable distance—with more or less strength according as one is nearer to or further from their intimate circle." Whereas people like Odette imagine fashion to be something very different and "directly accessible to all"—with, it must be admitted, some "inevitable delays." Odette believed that fashion could be *bought,* and that someone with money and "swagger clothes" who threw big parties was "smart." When she passed the Marquise de Villeparisis in the street, "wearing a black serge dress and a bonnet with strings," Odette thought she looked "like an old charwoman, darling! That a marquise!" Odette would never wear those horrible clothes.

As a member of the highest (and most fashionable) Parisian society, Swann recognized Odette's mistake. He "made no attempt, however, to modify this conception of fashion; feeling that his own came no nearer to the truth, was just as fatuous," he saw no advantage in telling Odette—with the result that she took no interest in his social connections.[7]

To modern Americans, this view of fashion may seem snobbish and out of date. After all, fashion no longer "trickles down" from a remote social pinnacle. Yet both the phenomenon of fashion diffusion and Proust's analysis of it are more complex than they at first appear. Certainly the desire for prestige and distinction was (and is) part of the fashion process, although this need not entail an imitation of the upper class. Other social groups may be fashion leaders; today, for example, various subcultures (youth or ethnic) and parts of the upper-middle class are important. Moreover, some sociologists have found that "the motive *to be fashionable* was more prevalent than the desire to imitate the upper class. That is, fashion per se renders prestige to an individual." Nevertheless, even the

theory of "collective selection" within a mass market refers obliquely back to the elite group(s) setting the fashion, and to a social structure in which they have prestige.[8]

Like Proust himself, Swann was able to analyze the fashionable world from both the position of a knowledgeable insider and that of a critical outsider. Yet he remained uncomfortable with what he regarded as Odette's "vulgarity"—for example, the way she would go on an outing "in a dress far too smart for the country." Her very desire to look fashionable at all times could imply a certain *nouveau-riche* insecurity, or an unawareness of the minute distinctions that regulated occasion-specific dress.

Her dress the night they became lovers was typical of her talent for over-decorating everything:

> She had in her hand a bunch of cattleyas, and Swann could see, beneath the film of lace that covered her head, more of the same flowers fastened to a swansdown plume. She was wearing, under her cloak, a flowing gown of black velvet, caught up on one side so as to reveal a large triangular patch of her white skirt, with an "insertion" of white silk, in the cleft of her low-necked bodice, in which were fastened a few more cattleyas.[9]

Yet her costume also epitomized the seductive power of fashion: The black dress may conceal her body, but the white silk triangles "act as beckoning forces," as do the "orchids inserted in the cleft." Moreover, the "velvety surface" of the dress, with its "sensation of softness," like the skin itself, functions as the "reflection and manifestation of desire."[10] It was in arranging her orchids that Swann first caressed her; and for some time thereafter they used the expression "do a cattleya" to mean "make love."

Flattered and spoiled by previous lovers and increasingly ambivalent about Swann, Odette stubbornly resisted Swann's attempts to educate her taste. "Swann had a wonderful scarf of oriental silk, blue and pink, which he had bought because it was exactly that worn by Our Lady in the *Magnificat*. But Mme. Swann refused to wear it. Only once she allowed her husband to order her a dress covered all over with daisies, cornflowers, forget-me-nots and campanulas, like that of the Primavera." Odette was a slow learner, unlike Albertine, who was quick to understand the subtleties of true elegance. But eventually, "having reached the turning point of life, Odette . . . discovered, or invented, a style of her own. By the 1890s, Odette appeared to the youthful narrator as the quintessence of a certain type of fashionable beauty.

> [The] preposterous 'bustle' had disappeared, as well as those tailed corsets. . . . The vertical fall of fringes, the curve of trimmings had made way for the inflexion of a body which made silk palpitate as a siren stirs the waves, gave to cambric a human expression now that it had been liberated . . . from the long chaos and nebulous envelopment of fashions at length de-

throned. But Mme. Swann had chosen, had contrived to preserve some vestiges of certain of these, in the very thick of the more recent fashions that had supplanted them. . . . I used often to find Mme. Swann in an elegant dishabille the skirt of which, of one of those rich dark colours, blood-red or orange, which seemed always as though they meant something very special, because they were no longer the fashion, was crossed diagonally . . . by a broad band of black lace which recalled the flounces of an earlier day.

The narrator concluded, triumphantly:

She need only "hold out" like this for a little longer and young men attempting to understand her theory of dress would say: "Mme. Swann is quite a period in herself, isn't she?"[11]

For Proust, her dresses embodied all the poetry and romance of a "whole form of civilisation," and Odette herself was like "the heroine of a novel," who "did not dress simply for the comfort or the adornment of her body," but to convey some secret meaning. Going far beyond conventional rules of dress, "her clothes were connected with the time of year and of day by a bond both inevitable and unique." The very flowers on her hat seemed more symbolic of May than those that grew naturally in gardens and woods.[12] Indeed, flower imagery dominates:

Mme. Swann appeared [in the spring, strolling on the Avenue du Bois], displaying around her a toilet which was never twice the same, but which I remember as being typically mauve; then she hoisted and unfurled at the end of its long stalk, just at the moment when her radiance was most complete, the silken banner of a wide parasol of a shade that matched the showering petals of her gown.[13]

Again and again, she appears in conjunction with the "moist purple" of Parma violets, in "washed-out liquid mauve" (a violet color tinged with red), or in girlish pink, like roses in "the glowing flesh tints of their nudity." As one scholar points out, the "aqueous and hesitant color, so often found in Odette's clothes, reflects the ambiguous quality of her demeanor."[14]

The symbolism of her dresses, like their color, varied from day to day: "one would have said that there was a sudden determination in the blue velvet, an easy-going good humour in the white taffeta, and . . . a sort of supreme discretion full of dignity in . . . the black *crêpe-de-chine*." If, instead of wearing a loose indoor gown, she chose one that "buttoned up tight as though she were just going out," it "gave to her stay-at-home laziness . . . something alert and energetic." The very profusion of complicated trimmings, "some row of little satin buttons, which buttoned nothing and could not be unbuttoned," seemed indicative of secrets and promises—since they were so patently nonfunctional. Historicizing elements taken from past fashions—"a hint of 'slashes', in the Henri II style," a puffed

sleeve *à la 1830*, a certain fullness of the skirt that recalled Louis XV pan-
iers—"gave the dress a just perceptible air of being 'fancy dress' and . . .
by insinuating beneath the life of the present day a vague reminiscence of
the past, blended with the person of Mme. Swann the charm of certain
heroines of history or romance." And when the narrator called her atten-
tion to this, she replied, simply, that since she didn't play golf, she had no
excuse for going about in sweaters, like so many of her friends.[15]

But "more exquisite than any of her dresses" were Odette's tea-gowns
and loose silk wrappers. For despite her fragile (and still marginal) re-
spectability, she dearly loved these garments, associated with the bedroom
and the boudoir, which played so crucial a role in the life of the courtesan:

> The culminating point of her day is not the moment in which she dresses
> herself for all the world to see, but that in which she undresses herself for a
> man. She must be as smart in her wrapper, in her nightgown, as in her
> outdoor attire. Other women display their jewels, but as for her, she lives in
> the intimacy of her pearls.[16]

Aware of the erotic connotations of her indoor gowns, Madame Swann
was both flattered and embarrassed by the narrator's unconcealed enthu-
siasm, and his "protestations that no 'outdoor' clothes could be nearly as
becoming." Indeed, he went so far as to suggest that she ought to go out
in a tea-gown, a bit of advice that she wisely laughed off, for had she done
so, she might have been arrested for indecency. Instead, "She apologised
for having so many wrappers, explaining that they were the only kind of
dress in which she felt comfortable."[17]

A few years later, when the narrator has progressed beyond an infatu-
ation with a former *demi-mondaine*, and has a young mistress of his own,
the tea-gown assumes still greater significance, as we shall see. Meanwhile
in the late nineteenth century, as the old distinction between the private
interior world of women and the public world of men began to break
down, the tea-gown played an important role in fashion. Not only was the
tea-gown perceived as intimate (and therefore erotic), it was also subject
to fewer restrictions of propriety. To be respectably dressed *in public*, a
woman had to wear a corset and a certain traditional style of clothing. But
in private or semiprivate interior settings, she could dispense with the cor-
set and experiment with high-waisted Empire dresses, billowing Watteau
gowns, even quasi-kimonos. As a garment of poetry and romance, the tea-
gown legitimized such personal experiments—and eventually moved out
of the boudoir, first to the dinner table and the drawing-room, then to the
dance floor, and eventually, in the 1920s, into still more public realms.
Intimate garments, as well as sportswear, helped bridge the gap between
the clothing of the nineteenth and that of the twentieth centuries.

Proust suggests that, because of her essentially sexual mode of existence,
a (former) courtesan like Odette may develop "a fondness for luxury which

is secret, that is to say which comes near to being disinterested."[18] Insofar as this manifested itself in a fondness for luxurious intimate garments, Odette was a harbinger of social change. For one of the primary characteristics of turn-of-the-century fashion was its emphasis on lingerie and dishabille. From the 1880s on, not only women of easy virtue but also respectable married ladies followed the "cult of chiffon." The "mania" for tea-gowns, petticoats, and silk nightgowns went together with an increasing emphasis on sexual happiness within marriage.

Secret luxury, for Proust, encompassed far more than what manufacturers today refer to as "intimate body fashions." Equally important was the attention to detail that has now virtually disappeared from all but the most expensive clothes. But the elegance of Odette's dresses lay precisely in these minute details, which were hardly ever even seen, except, as it were, by accident. If, while out strolling together, Odette should feel too warm, and so open or take off her jacket (which she had intended to keep buttoned up), only then would the narrator

> discover in the blouse beneath it a thousand details of execution which had had every chance of remaining there unperceived, like those parts of an orchestral score to which the composer has devoted infinite labour albeit they may never reach the ears of the public.

And if he should carry her jacket, only than would he see it closely:

> in the sleeves of the jacket that lay folded across my arm I would see, I would drink in slowly, for my own pleasure or from affection for its wearer, some exquisite detail, a deliciously tinted strip, a lining of mauve satinette which, ordinarily concealed from every eye, was yet as delicately fashioned as the outer parts, like those gothic carvings on a cathedral, hidden on the inside of a balustrade eighty feet from the ground, as perfect as are the bas-reliefs over the main porch.[19]

Fashion is, potentially, a work of art, declares Proust. It is more like a musical composition, a piece of sculpture, or the highest example of western architecture than a mere body-covering or a portable status symbol. The cathedral, especially, was for Proust, the symbol of the glory of French art and civilization. So it is extremely significant when he insists that, it was for "her own satisfaction" that Odette obeyed the "canons" of dress, "as though yielding to a Supreme Wisdom of which she herself was the High Priestess." Baudelaire essentially reserved this creative act for the male dandy, and exhibited far more ambivalence toward the female of the species, who had to conceal her primitive naturalness behind a wall of artifice and make-up. But Proust asserted that fashion was a form of self-creation for persons of either sex. Both men (like the painter Elstir) and women (like Odette) initiate the narrator into the subtleties of dress, and Charlus is as much a connoisseur as the Duchesse de Guermantes.

A la recherche du temps perdu is the story of how the narrator idles away his youth in love affairs and fashionable society, and only at the last moment discovers his vocation as an artist. As he grows old, the memory of Madame Swann's clothes torments him with the sense of lost time. In 1912, he walks in the Bois de Boulogne, recalling how, twenty years earlier, he set out with the intention of seeing Madame Swann go past, lying back in "a matchless Victoria," wearing violets and carrying a lilac parasol. Or again, how he himself used to stroll with her along the Allée des Acacias, when she would let "trail behind her the long train of her lilac skirt, dressed as the populace imagine queens to be dressed." Some man or other "in a grey 'tile' hat" might greet her, or the narrator might catch a fragment of masculine conversation:

> "Odette de Crécy! . . . I remember, I had her on the day that MacMahon went."
>
> "I shouldn't remind her of it, if I were you. She is now Mme. Swann, the wife of a gentleman in the Jockey Club, a friend of the Prince of Wales. Apart from that, though, she is wonderful still."
>
> "Oh, but you ought to have known her then; Gad, she was lovely!"[20]

And so the memories go back ever further in the past, to a time before the narrator was born. But he would be happy if only he could see again the fashions of the Nineties, "that I might know whether they were indeed as charming as they appeared to the eyes of memory, little hats so low crowned as to seem no more than garlands about the brows of women." Alas! In place of Odette's lilac bonnet or her tiny hat decorated with "a single iris," the women now wear "immense" hats, "on which have been heaped the spoils of aviary or garden-bed."

As motor-cars speed past, the narrator observes with shock that the men no longer wear any kind of hat: "They walked the Bois bare-headed," while in place of Odette's lovely trailing gowns, the women "hobble by" in Directoire-style "Liberty chiffons."

"Oh, horrible!" exclaims the narrator, "there is no standard left of elegance." "But"—and here he made a far more profound connection between clothes and time—"it would not have sufficed me that the costumes alone should still have been the same as in those distant years." *Everything* would have to have been the same: He would have had to be able to come back from the Bois, to pass the afternoon over a cup of tea in Madame Swann's drawing-room, in the house she had then, with everything the same. "The reality I had known no longer existed. It sufficed that Mme. Swann did not appear, in the same attire and at the same moment, for the whole avenue to be altered." Remembrance of her clothes was only regret for that particular moment—"as fugitive, alas, as the years."[21]

And yet the narrator still derived pleasure and awareness from the "memories of poetical sensations," stronger even than the "memories of

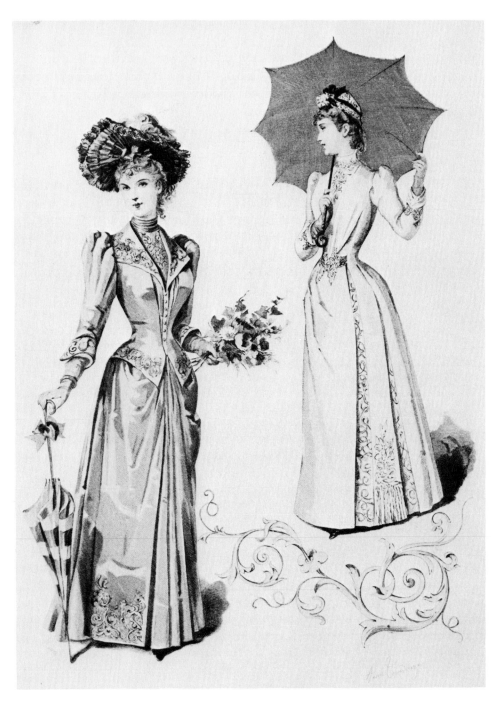

A fashion plate by Anaïs Colin Toudouze from *La Mode Illustrée* (1890) conveys something of the charm of Proust's heroines. Of the Duchesse de Guermantes, he wrote: "Each of her dresses seemed to me . . . like the projection of a particular aspect of her soul." Odette was also "surrounded by her garments as by the delicate and spiritualized machinery of a whole form of civilisation." And when he closed his eyes, he could recapture the sensation of strolling with her "beneath her parasol, as though in the coloured shade of a wisteria bower."

what the heart has suffered." And when he closed his eyes, he could see himself once again, "strolling and talking thus with Mme. Swann beneath her parasol, as though in the coloured shade of a wisteria bower."[22]

The Red Shoes of the Duchesse de Guermantes

One of the most famous scenes in Proust's great novel involves the red shoes of the Duchesse de Guermantes. Most people seem to regard it as purely a social and sartorial cameo: Oriane, the beautiful Duchesse de Guermantes, is a member of the highest Parisian society and Swann's best friend. She is also "the best dressed woman in Paris." One evening, she is about to leave for a party, given by her cousin, the Princesse de Guermantes, when her husband notices that she has committed the sin of wearing black shoes with a red dress:

> She was just getting into the carriage when . . . the Duke cried in a terrifying voice: "Oriane, what have you been thinking of, you wretch! You've kept on your black shoes! With a red dress! Go upstairs quick and put on red shoes. . . ." The Duchess went up to her room. "Well," said M. de Guermantes to Swann and myself, "we poor, down-trodden husbands, people laugh at us, but we are of some use all the same. But for me, Oriane would have been going out to dinner in black shoes." "It's not unbecoming," said Swann, "I noticed the black shoes and they didn't offend me in the least." "I don't say you're wrong," replied the Duke, "but it looks better to have them match the dress . . . Good-bye, my children," he said, thrusting us gently from the door, "get away before Oriane comes down again . . . If she finds you still here she will start talking again."[23]

So much everyone knows. This passage has even been quoted as evidence that shoes were important to elegant aristocrats! Yet no one who has actually read the book can regard the scene as anything less than devastating. But to understand why, it is necessary to see just how important the Duchess was to the narrator. Along with his mistress, Albertine, the Duchess is probably the most significant figure in the book.

Who was the Duchess? From childhood, the narrator regarded her as almost a mythological figure, a representative of the glorious French aristocracy. This feeling is reconfirmed when the narrator's family moves to Paris, and he hears her spoken of as "the first lady in the Faubourg Saint-Germain." Like Proust himself, the narrator wants nothing more than to become a part of this exclusive society. Indeed, his image of the ideal aristocrat is so exalted that he is rather disappointed by the Duchess herself. He is surprised that she exhibited "in her dresses the same anxiety to follow the fashions" as if she were an ordinary woman. He spies on her, and sees her on the street, gazing "admiringly at a well-dressed actress," and is shocked that she might compare herself with passers-by and con-

sider them "a tribunal competent to judge her." "This . . . part of a fashionable woman" was "so unworthy of her"

> and in this mythological oblivion of her natural grandeur, she looked to see whether her veil was hanging properly, smoothed her cuffs, straightened her cloak, as the celestial swan performs all the movements natural to his animal species . . . without remembering that he is a god.[24]

Again and again, Proust uses avian imagery to establish her position as a living goddess—a status she shares only with a few members of her family. It is not surprising, therefore, that Proust has often been dismissed as merely a snob (and also often read primarily for his picture of high society), but the truth is more complex.

The Duchess was not only the representative of a class, she was also a unique individual with a particular fashion sensibility. And as the narrator becomes himself a member of her society, this individual aspect assumes greater importance. Moreover, although he is still inclined to idealize the aristocracy, other characters, who do not, also greatly admire the elegance and style of the Duchess. Thus, when he tells Albertine about the Duchess, her initial response is hostile, "but remembering that [the painter] Elstir had spoken to her of the Duchess as the best dressed woman in Paris, her republican contempt for a Duchess gave place in my mistress to a keen interest in a fashionable woman."

Soon Albertine was eagerly questioning the narrator about the Duchess and her clothes, and she gladly accepted his suggestion that he go to Oriane for advice about Albertine's clothes. Initially, he had considered asking Odette for assistance. "But Mme. de Guermantes seemed to me to carry to an even higher pitch the art of dressing." Indeed, by this point, the narrator was hardly interested in the Duchess for her own sake, although she still seemed attractive. Instead, obsessed with Albertine, whom he was keeping a virtual prisoner in his home, the narrator bought the most beautiful fashions he could find, as a way of bribing Albertine to stay with him. Under the circumstances, he used the Duchess primarily as a source of information about fashion:

> "For instance, Madame, that evening . . . you had a dress that was all red, with red shoes, you were marvellous, you reminded me of a sort of great blood-red blossom, a blazing ruby—now, what was that dress? Is it the sort of thing that a girl can wear?"[25]

Delighted that he remembered her dress, the Duchess has entirely forgotten " a certain incident which . . . ought to have mattered to her greatly." Instead, she replies, laughingly, that, yes, a girl could wear such a dress, but only when it was appropriate to wear full evening dress. (And, of course, such an occasion could hardly arise, since Albertine would not have been a welcome guest at the evening parties that the narrator attended.)

205

Because he remembers primarily her evening dresses, the Duchess suggests that her maid could show the narrator some of the less formal dresses currently in her wardrobe. "Only, my dear boy, though I shall be delighted to lend you anything, I must warn you that if you have things from Callot's or Doucet's or Paquin's copied by some small dressmaker, the result is never the same."[26] But, of course, the narrator has no intention of having copies made, he is quite willing to take Albertine to the best couturiers, and only wants advice on where to go.

He and Albertine had already begun to learn about art and dress from the painter Elstir, a man "so hard to satisfy that [almost] all women appeared to him badly dressed," among the few exceptions being the Duchess. Although not a very wealthy man, Elstir ordered for his wife certain "charming" clothes "at fabulous prices." Proust clearly agreed with Elstir's pronouncements about the minute details which made all the difference between the horrible clothing worn by most women and the rare thing which enchanted by its beauty:

> There are very few firms at present, one or two only, Callot—although they go in rather too freely for lace—Doucet, Cheruit, Paquin sometimes. The others are all horrible.

Already Albertine was more sophisticated than the narrator, with a natural "eye" for elegance, although she could not yet afford to indulge her desires.

> "Then, is there a vast difference between a Callot dress and one from any ordinary shop?" I asked Albertine. "Why, an enormous difference, my little man! . . . Only, alas! what you get for three hundred francs in an ordinary shop will cost two thousand there. But there can be no comparison; they look the same only to people who know nothing at all about it." "Quite so," put in Elstir, "though I should not go so far as to say that it is as profound as the difference between a statue from Rheims Cathedral and one from Saint-Augustine."[27]

Proust was quite serious in comparing the *grands couturiers* of the Belle Epoque with the medieval artists he most admired. Perhaps the Callot sisters did "go in rather too freely for lace," but was it surprising? After all, the four sisters—Marie, Marthe, Regine, and Josephine—were the daughters of an illustrator and a lace-maker. Before three of them opened their own dressmaking shop in 1895 on the fashionable rue Taitbout, they had worked in a shop selling lace and trimmings. Influenced by this history, their dresses, tea-gowns, and blouses were ravishing confections, featuring the most delicate and refined details. In her youth, Madeleine Vionnet was the *première* at their workshop, and she recalled the eldest sister, Madame Gerber, as "A great lady totally occupied with a profession that consists of

adorning woman . . . not constructing a costume." She was "a true dress-maker, not a decorator or a painter like those of today."[28]

We have already mentioned Madame Paquin, but Madame Cheruit was another famous dressmaker—now forgotten. Cheruit, however, was apparently known primarily as "her own best mannequin." Stylish and attractive, she was not actually a designer, but only supervised "the draping and fitting by skilled hands of the fabric on herself." The young Paul Poiret recalled that he "had never seen anything more disturbing than this lovely woman in the midst of so much elegance." She wore a deep blue dress with a simple white ruff and invisible fastenings—a style of simplicity rather uncommon in the 1890s. To Poiret's delight, Madame Cheruit agreed to buy a dozen of his fashion sketches—at twenty francs apiece.[29]

Jacques Doucet was the only male dressmaker whom Proust mentioned, and he remains the best known today—probably in large part because he was famous as the couturier of the *seductive* woman. Actresses and courtesans—like Liane de Pougy, Emilienne d'Alençon, La Belle Otéro and, above all, the great Réjane—came almost weekly to the Maison Doucet at 21 rue de la Paix (formerly a luxury lingerie shop, founded by Doucet's grandparents). It is true that, in her memoirs, Liane de Pougy argued that, "As a couturier Doucet was only mediocre and as far as we women in the public eye were concerned his taste could add nothing to our elegance." Still, she admitted that the materials he used were beautiful,

> the dresses were well-made, the saleswomen were well-spoken—and anyway we were mugs! Doucet's was a good meeting-place, we could make the rounds of the neighboring jewelers; actresses and great ladies brushed shoulders and the new rich had no need to manoeuvre their way in—they were welcomed.[30]

Such a hostile portrait of Doucet was most unusual. According to Poiret, "He was the perfection of handsomeness and elegance, exceedingly *soigné*, and looking as if he had just come out of a bandbox." Moreover, although their dresses were very different in style, Poiret always regarded Doucet as his "master" and was grateful that he had been able to work for him: "In my imagination I was already the Doucet of the future." Considering Poiret's enormous ego, there could have been no greater compliment.[31]

These, then, were the dressmakers whom Proust most admired, and if he seldom mentioned them by name, we may nevertheless be justified in reading between the lines and picturing Oriane in one of Doucet's tailored suits or Odette in one of his Watteau tea-gowns. Alone, perhaps, for Albertine, the designer's name was important, since something like "a Doucet wrapper, its sleeves lined with pink" was, for her, an object of intense desire, in a way that it could never be for the Duchesse de Guermantes who took such things for granted. If Proust did not analyze in detail the

real differences in the couturiers' respective styles, this was because he believed that fashion was ultimately created by a handful of fashionable women—and not by the dressmakers who served them.

In one of his most striking scenes, Proust compares the style of the Duchesse de Guermantes with that of the Princesse de Guermantes. Its psychological brilliance is only slightly marred by the fact that, for once, Proust has abdicated his role as an historian of fashion—for although the action ostensibly takes place in the 1890s, the clothing is a composite of the 1890s and about 1912. It is a magical scene, in which the theatre appears as a mysterious aquatic realm. Out of the semidarkness, he focuses on the stage box of the Princesse de Guermantes, forever separated from the abode of mortals sitting below in the orchestra stalls. "Like a mighty goddess," the Princess is seated on a sofa, "red as a reef of coral." The mirror behind her casts "a splash of reflexion" like "the flashing crystal of the sea"—and there she is:

> At once plume and blossom, like certain subaqueous growths, a great white flower, downy as the wing of a bird, fell from the brow of the Princess along one of her cheeks. . . . Over her hair . . . was spread a net upon which those little white shells which are gathered on some shore of the South Seas alternated with pearls, a marine mosaic barely emerging from the waves.

But when the play was due to begin, the Princess sat forward in her box, as though she herself were part of the performance. The box emerged from "the watery realm," and the Princess came into focus, "turbanned in white and blue like some marvellous tragic actress" and crowned with "an immense bird of paradise."

As the certain rose on the second act, there was a movement in the box, as everyone stood up to let the Duchess enter. The differences in their costumes immediately expressed their very different personalities:

> Instead of the wonderful downy plumage which, from the crown of the Princess's head, fell and swept her throat, instead of her net of shells and pearls, the Duchess wore in her hair only a simple aigrette, which . . . reminded one of the crest on the head of a bird. Her neck and shoulders emerged from a drift of snow-white muslin, against which fluttered a swansdown fan, but below this her gown, the bodice of which had for its sole ornament innumerable spangles (either little sticks and beads of metal, or possibly brilliants), moulded her figure with a precision that was positively British.

It was as though "the Duchess had guessed that her cousin . . . would be wearing one of those costumes in which the Duchess thought of her as 'dressed up,' and that she had decided to give her a lesson in good taste"—or, at least, different taste. For the Duchess was "inclined to make fun" of what she regarded as her cousin's "exaggerations." So "typically French and restrained" was the Duchess that her cousin's style seemed too poetic, enthusiastic, overcomplicated, Teutonic—although still "quite lovely."

Whereas, to the Princess, Oriane's style looked "a little cold, a little austere, a little 'tailor-made' "—and yet, without any hypocrisy, she could also recognize "in this rigid sobriety an exquisite refinement." And so, "they could be seen turning to gaze at one another in mutual appreciation."

Lesser mortals might attempt to imitate them, but

> an 'arrangement' supposed to suggest that of the Princesse de Guermantes simply made the Baronne de Morienval appear eccentric, pretentious and ill-bred, while an effort as painstaking as it must have been costly, to imitate the clothes and style of the Duchesse de Guermantes only made Mme. de Cambremer look like some provincial schoolgirl, mounted on wires, rigid, erect, dry, angular, with a plume of raven's feathers stuck vertically in her hair.

Naturally, it did not keep them from "trying to make out exactly how the cousins were dressed," but any imitation was doomed.

For his part, the narrator was convinced that the garments worn by the Duchess and the Princess "were peculiar to themselves," just as a bird has its own plumage: "the bird of paradise seemed inseparable from its wearer as her peacock is from Juno, and I did not believe that any other woman could usurp that spangled bodice, any more than the fringed and flashing aegis of Minerva." As the narrator was engaged in thought, the Duchess caught sight of him, "pointed in my direction" and "showered upon me the sparking and celestial torrent of her smile."[32]

In this scene, Proust based his account on real people, clothes, and events, but all of them were transformed. Although the Comtesse Greffulhe was in many ways the model for the Duchesse de Guermantes, here she serves as the model for the Princess—for, like the Princess, Madame Greffulhe favored a very extravagant style of dress. Indeed, according to Proust's biographer:

> A characteristic anecdote of Comtesse Greffulhe is told of the Princesse de Guermantes in a rejected passage of *Sodome et Gomorrhe*. "I shall know I've lost my beauty when people stop turning to stare at me in the street," the Comtesse told Mme Standish; and Mme Standish repled: "Never fear, my dear, so long as you dress as you do, people will always turn and stare."[33]

In the theatre scene, the flamboyance of Madame Greffulhe (as the Princess) is contrasted with the austere chic of Madame Standish (as the Duchess)—the two real personages appearing much this way at the theatre in May 1912. Proust's reference to the "positively British precision" of the Duchess' dress pointed directly to Madame Standish, a former mistress of Edward VII, who modelled her style on that of Queen Alexandra.

Yet as early as 1892, Proust had composed a portrait of his friend, the Comtesse de Chevigné, which foreshadowed his imagery of the Duchesse: She was dressed in gauzy white clothes "like folded wings . . . her feathered fan fluttered. . . . She is . . . a peacock with wings of snow, a hawk with precious stones for eyes." Indeed, recognizing herself in the Duchess,

Madame de Chevigné was later hurt by certain developments in the plot, not realizing that Proust had by then turned to other models for the Duchess.[34]

Leaving history to return to the novel, we see that many years later, after the First World War and the death of Albertine, the narrator goes to one last party, a reception given by the Princesse de Guermantes—but not the same Princess: She is dead. The narrator and the Duchess are talking, and he remarks that the scene recalls the first evening he went to the Princesse de Guermantes, "and when you wore the red dress and red shoes." "Good heavens, how far back all of that is!" replied the Duchess. He asks her to describe the dress, which she does obligingly and in some detail, adding a question of her own:

> "You are sure they were red shoes? I thought they were gold ones." I assured
> her that it was most vividly present in my mind, without reminding her of
> the circumstance which made me so positive about it.[35]

But what does he remember that she does not? The red shoes of the Duchess have some significance that she has entirely forgotten. Remember, she was Swann's best friend, and that evening she was trying to coax him into coming with them to Italy. Pressed repeatedly, Swann was finally forced to admit that he could not plan to accompany them six months hence, because by then he would be dead. But the Duke and Duchess were late for their party. They did not want to take the time to respond to such tragic news—so they dismissed it—it couldn't be true. And yet they took the time necessary to change her shoes. In their scale of things, that was more important than the imminent death of a close friend.

No wonder the Comtesse de Chevigné was distressed. Proust's novel was no *roman à clef,* however. Another of Proust's friends, Madame Strauss, did once put on black shoes with a red dress, and her husband angrily ordered her to change; "but it was under no such circumstances of cruelty and selfishness. Proust ran upstairs to fetch the shoes and all was well."[36] Such are the materials from which art is created.

Revealing and Concealing: The Clothing of Charlus and Saint-Loup

The subject of homosexuality is at the heart of Proust's novel. Not only was Proust homosexual, but several of his most important characters turn out to be, too, and he understood the fashions that simultaneously concealed and revealed their sexual proclivities. Thus, the "young Marquis de Saint-Loup-en-Bray was famed for the smartness of his clothes." When the narrator first saw this handsome blond aristocrat at the seaside resort of Balbec, Saint-Loup was dressed "in a clinging, almost white material such as I never have believed any man would have had the audacity to wear."

Was Saint-Loup "effeminate," insinuated Proust, or was he (as he then appeared to be) a notorious "womaniser"? Over the course of the novel, it would emerge that Saint-Loup's scandalous affair with the actress Rachel merely concealed his homosexuality, while his flamboyant dress accurately displayed his true identity.[37]

By contrast, the stiff dark clothing of the Baron de Charlus functioned more subtly as a deceptive mask. In his youth, it is true, Palamède de Charlus had been known as a fashion trendsetter, who launched a vogue for "blue and fringed, long-haired [vicuna] coats," but by the time the narrator met him, Charlus had adopted sober, ultra-masculine twill. And yet his carefully chosen, *soigné* apparel was revealing in its details:

> I saw that he had changed his clothes. The suit he was wearing was darker even than the other; and no doubt this was because the true distinction in dress lies nearer to simplicity than the false; but there was something more; when one came nearer to him one felt that if colour was almost entirely absent from these garments it was not because he who had banished it from them was indifferent to it but rather because for some reason he forbade himself the enjoyment of it. And the sobriety which they displayed seemed to be of the kind that comes from obedience to a rule of diet rather than from want of appetite. A dark green thread harmonized, in the stuff of his trousers, with the clock on his socks, with a refinement that betrayed the vivacity of a taste that was everywhere else conquered, to which this single concession had been made out of tolerance for such a weakness, while a spot of red on his necktie was imperceptible, like a liberty which one dares not take.[38]

As Diana Festa-McCormick notes in her fascinating book, *Proustian Optics of Clothes:* "Charlus' dark suit, in fact, has the connotations of an adopted mask, serving the double purpose of deceiving and of revealing the deception." For while insisting on his sartorial "masculinity," Charlus also desired to convey his homosexuality—but only to potential sexual partners. He had to hope that other "inhabitants of Sodom" would see through his disguise, and recognize that such a "contrived and artistic simplicity" implied homosexuality. In his old age, however, Charlus reverted to the flamboyance of his youth, exchanging his black suit for "very light trousers, recognizable a mile off."

> there was also the change that had occurred in his intonations, his gestures, all of which singularly resembled the type M. de Charlus used most fiercely to castigate; he would now utter unconsciously almost the same little cries . . . as are uttered consciously by the inverts who refer to one another as 'she'. . . . As a matter of fact—and this is what this purely unconscious 'camping' revealed—the difference between the stern Charlus, dressed all in black, . . . whom I had known, and the painted young men, loaded with rings, was no more than [a] purely imaginary difference. . . .[39]

In his description of Charlus, and in his characterization of the younger generation of homosexuals, we see some of Proust's ambivalence about his own homosexuality (just as his unfavorable picture of Bloch reveals Proust's complex feelings about being Jewish). The portrait of Charlus was based in part on the notorious dandy (and homosexual), Count Robert de Montesquiou, whose outrageously colorful ensembles were gradually replaced by an impeccable chic, punctuated by pastel cravats.

Proust, himself, was not at all fashionable, let alone audacious. Indeed, the memoirs of his friends paint a uniformly rather shabby and eccentric image. In his youth, Proust "went in for pale green ties," and stylishly baggy trousers. He wore orchids or white camellias in his buttonhole, and twirled a fine malacca cane. But as a dandy, he was a failure. Several friends suggested that he could use a better tailor. His top hats, although expensive, "very soon took on the appearance of hedgehogs or Skye terriers." His gloves were "always crumpled and dirty"—and he was constantly losing them. His beautiful dark hair was frequently long and disordered, so that even his mother wrote to plead with him: "*Please,* no more Frankishking haircuts." And he greatly impressed several visitors, who declared that they had never seen anyone have dinner wrapped in an overcoat.[40]

But whatever his personal appearance, Proust seems to have believed that most homosexuals used fashion simultaneously as a disguise and as a revelation of their inner selves. To the shared language of clothes, they added more or less secret refinements. Like heterosexuals, however, they worked within a context in which dark, stiff clothing signified masculinity, while light or bright colors and ornamentation signified femininity. Thus, when Charlus attempted to seduce the narrator, he greeted him, lying on the sofa like an odalisque, clad in a Chinese dressing gown which was open at the throat. In the exoticism, looseness, and body exposure of his dressing gown, he recalled Odette in her Japanese tea-gowns. Oriental dressing gowns had long been part of the upper-class masculine wardrobe, but under the circumstances, dishabille signified intimacy, while the exotic translated into the erotic.

Nearby, on a chair, lay Charlus' dark suit and top hat—a disguise discarded. And the narrator who had for so long naively misinterpreted the baron's attentions, finally understood, and angrily kicked his shiny top hat.

Albertine and Fortuny

Albertine appeared initially as one of a group of young girls, all dressed *pour le sport* and pushing bicycles or carrying golf clubs; "their attire . . . was in contrast to that of the other girls at Balbec, some of whom . . . went in for games, but without adopting any special outfit." Precisely what Albertine wore is unclear, apart from a polo-cap that made her look like

the juvenile mistress of a professional bicyclist. Later, when she and the narrator became friends, Albertine dismissed the more orthodox young women with disdain: "They dress in the most absurd way. Imagine going to play golf in silk frocks!"[41]

But despite her golf clubs and bicycle, it would be a serious mistake to regard her as a sort of French Gibson Girl. Albertine was much more sophisticated, and had no desire to alternate between the skirt and shirt-waist "uniform" of the sporting American girl and her expensive Worth ball-gown. Not only athletic, Albertine was also artistic, and under Elstir's tutelage, her "taste for pictures had almost caught up [with] the taste for clothes."

Elstir, himself, deserves some mention. Based on several "real-life" models (such as Paul Helleu and Claude Monet), his work combines elements from both Impressionism and the painting of elegant life. When he painted regattas, he noticed with approval the ladies' white yachting dresses. At the races, he saw that the courtesan Mademoiselle Léa had "a little white hat and a little white sunshade, simply enchanting." When asked what made them different from ordinary accessories, he could only say (like the narrator's cook when asked about her excellent soufflés): "It's the way you do them"—which may be as good a definition of style as you are likely to find.

Proust was obviously thinking of Degas when he made the narrator say that he "could no longer despise the milliners, now that Elstir told me that the delicate touches . . . which they give . . . to the ribbons or feathers of a hat . . . would be as interesting to him to paint as the muscular actions of the jockeys."[42] The modernity of Degas' milliners contrasted noticeably with the implicit sexuality of earlier pictures about milliners, and, as with Degas' work, that of Elstir took a long time to be appreciated. The Duchesse bought one painting by Elstir, on Swann's advice, but she hid it away in an obscure room, until after he had become fashionable, when she displayed it as evidence of her unerring taste.

One day Elstir was talking about Venice, and about the rare and beautiful textiles that appeared in the work of Renaissance painters like Carpaccio, adding: "But I hear that a Venetian artist, called Fortuny, has recovered the secret of the craft and that before many years have passed women will be able to walk abroad, and better yet sit at home in brocades as sumptuous as those." Proust antedated Fortuny's experiments by several years, but by 1907, the virtuoso artist Mariano Fortuny was "working like an artisan and researching like an alchemist" to perfect his dyeing and painting techniques, many of which were then lost after his death. Not only were his pleated silks and brocaded velvets exquisite, but Fortuny also designed dresses and cloaks unlike any conventional fashions. Elstir's apparently casual reference set the stage for an entire Fortuny theme, inextricably associated with Albertine's captivity.[43]

The narrator first saw a Fortuny gown when visiting the Duchesse de

Guermantes. Susceptible to the charm of *robes d'intérieur,* he responded instinctively to a grey crêpe-de-chine that seemed to exhale the atmosphere "of certain late afternoons cushioned in pearly grey by a vaporous fog." When she wore a Chinese indoor gown decorated with red and yellow flames, he "gazed at it as at a glowing sunset; these garments were not a casual decoration alterable at her pleasure, but a definite and poetical reality." Yet of all her gowns, "those which seemed most to respond to a definite intention, to be endowed with a special significance, were the garments made by Fortuny." Unlike most other modern dresses, those by Fortuny seemed to capture the significance of the dresses in Balzac's novels. Whereas the "dresses of today have less character," are "more or less alike," each of Fortuny's garments was *unique.*

Soon he was questioning the Duchess about "that indoor gown that you were wearing the other evening . . . dark . . . streaked with gold like a butterfly's wing?" "Ah! That is one of Fortuny's. Your young lady can quite well wear that in the house. I have heaps of them." Once they began to be fashionable, Albertine "remembered Elstir's prophecy," and wanted to have one. The narrator eventually bought not only the one Albertine chose, but also "the other five which she had relinquished with regret, out of preference for this last."[44]

He bribes Albertine to stay with him, by giving her Fortuny dresses. Yet the sight of them reminds him that he can never go to Venice, as long as Albertine is his mistress. (This was a very Proustian dilemma, involving not only the illicit nature of his relationship with Albertine, but also the narrator's extreme sexual jealousy.) Thus, not only were Fortuny's dresses objectively Venetian, created there and inspired by the art of the Venetian Renaissance, they also represented the narrator's personal and ideal Venice, which he had dreamed of since childhood:

> The Fortuny gown which Albertine was wearing that evening seemed to me the tempting phantom of that invisible Venice. It swarmed with Arabic ornaments, like the Venetian palaces hidden like sultanas behind a screen of pierced stone . . . like the columns from which the Oriental birds that symbolized alternatively life and death were repeated in the mirror of the fabric.[45]

By the end of their unhappy relationship, all of Albertine's dresses represent deception, captivity, or flight: When she wears black satin, she looks to him "like a pallid, ardent Parisian lady, etiolated . . . by the atmosphere of crowds and perhaps the habit of vice." When she gets dressed, he is afraid that she planning to meet a lover. As Festa-McCormick writes: "Clothing nourishes jealousy." And the narrator pleads with Albertine, "Don't put your gown on yet." Terrified of losing her, "he wishes to see Albertine imprisoned in the heavy folds of the precious materials." But his

"slavery in Paris" was also "made heavier by the sight of those dresses that evoked Venice."[46]

This very personal response to Fortuny's dresses might seem irrelevant to the history of fashion, but, in some respects, it was symptomatic of a revolutionary wave of Orientalism that swept through the world of fashion in the years just before the First World War. Working alone, far from Paris, trying to create "timeless" garments rather than modish fashions, Fortuny nonetheless designed dresses that bore an unmistakable resemblance to the avant-garde creations of Paul Poiret and others. We must not forget, however, that Fortuny's gowns were never intended to be worn as street dress, or even as ball-gowns. On one occasion, it is true, Proust's narrator asks Albertine if she would like to accompany him to Versailles, and she says: "I can come as I am, we shan't be getting out of the car." So she throws a cloak over her Fortuny, and goes out. But they decide not to go to dinner with the Verdurins, because Albertine was "not dressed" and "would have to go home and dress," which would make them very late.[47]

In Odette's generation, tea-gowns were an expression of the growing emphasis on female sexuality. For Albertine and her friends, tea-gowns were the harbinger of a wider fashion revolution and the beginning of modern dress. These experimental indoor robes by Fortuny, Poiret, and others helped pave the way for avant-garde evening fashions, and eventually day dresses as well. As early as 1916, a few American women began to wear their Fortunys outdoors (sometimes rather oddly covered by cardigan sweaters). Meanwhile, in Europe, classical tea-gowns led to high-waisted evening dresses and then day dresses, a development that went together with the decline of the corset and the rise of the brassiere. By the Twenties, Oriental robes had led through harem pants to lounging pyjamas, providing another prototype for women in trousers. In this respect, Poiret was far more radical than Fortuny, since Poiret scandalized Paris by showing his harem skirts on the street and at the races.

If Proust ignored Poiret, he was nevertheless very much aware of another pivotal development in the world of fashion and culture. In 1909, the *Ballets Russes* made their first appearance in Paris, creating a sensation with their ballets, *Cléopâtre* and *Les Orientales*, to be followed the next year by *Schéhérazade* and then the Greek ballets like *Daphnis et Chlöe* and *Après-Midi d'un Faune*. "Exotic" costumes in "barbaric" colors appeared to an enraptured audience, as did the kind of classical tunics favored by both Fortuny and the dancer Isadora Duncan. Although Orientalism had been a minor recurring theme throughout the nineteenth century, and although Aesthetes had been advocating untrammeled classical garb since the 1870s, it was only with the *Ballets Russes* that the message affected an entire generation. It may seem strange that the future was reached through visiting the long ago and far away, but such was the case. As Proust wrote:

215

Like the theatrical designs of Sert, Bakst and Benois who at that moment were recreating in the Russian ballet the most cherished periods of art—with the aid of works of art impregnated with their spirit and yet original—these Fortuny gowns, faithfully antique but markedly original, brought before the eye like a stage setting, with an even greater suggestiveness than a setting, since the setting was left to the imagination, that Venice loaded with the gorgeous East from which they had been taken.[48]

II
Fashion Revolution

In the early twentieth century, both fashion and fashion illustration experienced a revolution that marked the beginning of the modern style. Avant-garde fashion designer Paul Poiret was among the first to recognize that neither the old style of fashion illustration nor the early examples of fashion photography could do justice to the bold lines and brilliant colors of his dresses. In 1908, he commissioned Paul Iribe to do the drawings for a deluxe booklet, *Les Robes de Paul Poiret,* which inaugurated the last and most brilliant flowering of fashion illustration.

Je ne suis pas fâché déclaircir ici un point d'historie, qui vient d'être soulevé par un journal venimeux de Paris, cherchant à insinuer que "mon génie personnel" n'était autre chose que le talent d'Iribe. . . . Je ne peux pas croire qu'il entre sérieusement dans les intentions de Paul Iribe de me contester la paternité de mon oeuvre.

Paul Poiret, *En habillant l'époque*, 1930

The years just before the First World War saw the development of a radically new style of women's dress, which has been called "the beginning of modern fashion." A fashion world dominated by the S-shaped corset, by *frou-frou* skirts, and pastel shades turned into a city where women increasingly wore straight high-waisted frocks or "Oriental" fantasies in bright, "barbaric" colors. This revolution in fashion was accompanied by a significant breakthrough in fashion illustration.

Just as Paul Poiret was among the leading avant-garde dress designers, so also was he the first to recognize that neither the old style of fashion illustration nor the early examples of fashion photography could do justice to the bold lines and brilliant colors of his dresses. In 1908, he commissioned a deluxe album of drawings, *Les Robes de Paul Poiret, racontées par Paul Iribe*, which revolutionized the art of fashion illustration. Not only were the dresses themselves different, but Iribe's style of drawing and his choice of colors flouted the conventions of traditional fashion illustration. Whereas the nineteenth-century illustrator had concentrated on conveying as much fashion information as possible, the "Art Deco" illustrator largely ignored details like buttons in favor of expressing the modern spirit of the dress. By 1911, Poiret had fallen out with Iribe, so he asked Georges Lepape to produce a similar album, *Les Choses de Paul Poiret vues par Georges Lepape:* "He undertook it in the same fashion; he came to see my creations, and drew them with feeling."

In light of his patronage of the most advanced fashion illustrators, it is hardly surprising that Poiret was furious when a "venomous Paris newspaper" declared that these illustrators—not Poiret himself—were the real fashion innovators. How could anyone claim that Poiret's " 'personal genius' was nothing but the talent of Iribe"?[1]

Many years later, Georges Lepape's son reported that his father had said that at least four of the designs in *Les Choses de Paul Poiret vues par Georges Lepape* were actually devised by Madame Lepape.

My wife—an entirely untrained artist—showed me four simple drawings of women wearing trousers, with short hair and red lips. This was something highly bizarre at the time, even compared with the revolutionary creations of Poiret himself. I thought it was an amusing and fresh idea and tidied up her sketches. . . . I showed [Poiret] my four designs.

"Aha! That's quite an idea! It shows a lot of imagination. . . . Will you leave them with me?"

"But of course."

"Good. Come back in a week and you'll see your designs on my mannequins. You have just given me the idea for a divided skirt."[2]

Yet even if the Lepapes did create (rather than simply inspire) these particular designs, Poiret certainly already knew about divided skirts: That idea had been in the public domain for decades. And were it not for Poiret, the illustrations would never have appeared at all.

Despite such quarrels, the real point to be made is that the so-called "Art Deco" fashion plate significantly influenced the development of modern fashion. Indeed, one has only to compare photographs and Art Deco prints depicting similar clothes to see how much the illustrator helped create the new look. (The term "Art Deco," of course, does not really apply to many of these illustrations, but since it is widely used to describe them, I employ it here as a kind of shorthand.)

Art Deco Fashion

Inspired by the success of the Iribe and Lepape albums, the publisher Lucien Vogel launched an entirely new type of fashion magazine in 1912. *La Gazette du Bon Ton* was intended to unite couturiers and artists, and was sponsored by seven of the most important Parisian designers: Cheruit, Doeuillet, Doucet, Paquin, Poiret, Redfern, and Worth. Each issue featured not only up to seven full-page fashion plates showing the latest couture models, but also several additional fashion plates depicting imaginary clothing "invented by the artists themselves."

Thus, the first issue of the *Gazette* proudly announced that

When fashion becomes an art, a fashion magazine must itself become an arts magazine. . . . It will offer, on the one hand, the most recent models to emerge from the ateliers of the rue de la Paix and, on the other hand, in the painters' watercolours, that fashion sense, that charming and bold interpretation that is their hallmark. Artists of today are in part creators of fashion: what does fashion not owe to Iribe, who introduced simplicity of line and the oriental style, or to Drian, or to Bakst.[3]

It was certainly not unheard of for artists to exert a direct influence on fashion—Gavarni had designed imaginary fancy dress costumes for *La Mode*, some of which were probably actually made and worn. Anaïs and her con-

"Au Jardin des Hesperides," a fashion plate by Georges Barbier, depicts a tailored suit by Paquin. It appeared in one of the new Art Deco fashion magazines, the *Gazette du Bon Ton* (1913), which was intended to unite artists and couturiers.

A dress by Paquin looked much less modern when photographed by Félix than when illustrated by Barbier. This particular "ravishing model" was worn by actress Lucienne Guett for a production at the Théâtre Michel, and was featured in *Comoedia Illustré* (5 November 1912). Ultimately fashion photography would replace illustration, but early photographs were designed to look as much as possible like a combination of fashion plates and portraits.

temporaries may also sometimes have created or altered the fashions they portrayed. But Vogel's group of artists demanded far greater freedom.

According to *Vogue's* editor, Edna Woolman Chase, the initial group of artists were all young men under thirty, who "called themselves Beau Brummels or the Knights of the Bracelet."

> A certain dandyism of dress and manner . . . makes them a "school." Their hat brims are a wee bit broader than the modish ones of the day and the hats are worn with a slight tilt, a very slight tilt but enough to give the impression of fastidiousness. Their coats are pinched in just a little at the waist, their ties are spotless and their boots immaculate. A bracelet slipping down over a wrist at an unexpected moment betrays a love of luxury.
> The great difference between these Beau Brummels and their ancient name-sake is that . . . they are also hard . . . workers.[4]

According to her account, Vogel's plan to display their drawings in his new magazine ran into an unexpected snag when they realized that he expected them merely to illustrate other people's dresses. Eventually, however, the artists were "mollified" by the promise that the *Gazette* would also publish their original designs—"and it was hoped that the *haute couture* would copy them."Apparently, this did occasionally happen.

Of course, not everyone approved of these amateur dress designers. Gustave Babin wrote an article on the new fashion plates for *L'Illustration*, in which he said that the idea of "dresses invented by the artists" was intriguing in theory but generally unsuccessful in practice. Although "certain hats imagined—apparently without great effort— . . . are amusing," the artists' dresses appeared "very much inferior to those conceived by the couturiers alone." Perhaps the main problem was that "the artists seem to manifest a superb disdain for realities." Thus, for example, "the *Gilles*, 'a big winter coat,' by George Lepape (whose talent is beyond dispute) is only a picturesque fantasy." Babin became noticeably more hostile, however, when considering projects by Bakst (a designer for the *Ballets Russes*)— nothing could be "more barbarous, less French." Such designs were far from "the simple, clear logic of the pure French tradition." Since Parisian couturiers knew their craft, why not leave them to it? Still, despite these caveats, he approved of "the art [and] care with which these images are executed." And although he found the colors too glaring, he thought that many of the modern dresses were attractive.[5]

Nor was *La Gazette du Bon Ton* the only forum for avant-garde work. *Le Journal des Dames et des Modes* and *Les Modes et Manières d'Aujourd'hui* also began publication in 1912. In 1911 (the same year that Lepape produced *Les Choses de Paul Poiret*), the house of Paquin commissioned a deluxe album called *L'Éventail et la Fourrure chez Paquin*, by Paul Iribe in collaboration with Georges Barbier and Georges Lepape. Poiret may have been the

first, but other couturiers were quick to follow and even to surpass him. Iribe portrayed Paquin's couture designs in flaming colors and on figures whose slender, apparently uncorseted bodies represented the new physical ideal.

Without downplaying Poiret's very significant innovations, we must be careful not to overemphasize the differences between traditional and avant-garde designers. In her dissertation, "French Couturiers and Artist/Illustrators: Fashion from 1900 to 1925," Dorothy Behling demonstrates that "In the years between 1902 and 1908 a definite trend toward an empire silhouette began to emerge from many of the couture houses. Some of the gowns were neither an 'S' silhouette nor a true empire, but were rather a transition between the two styles. . . . [But] by 1907, a number of couturiers were creating gowns with a 'new look'." Along with Poiret, the couturiers Doucet, Drecoll, Beer and Lanvin were especially avant-garde. The various experimental skirt silhouettes—including the much publicized lamp-shade tunic—were seen in many fashion illustrations. Among the artist/illustrators who contributed to the evolution of fashion, Behling cites the colorists Iribe, Bakst, and Lepape (especially from 1908 to 1911); George Barbier (who influenced especially the prewar silhouette); and the Russian, Erté, whose influence on fashion began in 1913 when he worked with Poiret on the stage costumes for *Le Minaret,* and reached its height in the 1920s when he worked for the American magazine *Harper's Bazaar.*[6]

By 1914, the avant-garde style had become so acceptable that *La Gazette du Bon Ton* included a semi-cubist fashion plate that gave only the vaguest sense of the construction and details of the Poiret dresses ostensibly being illustrated. Low-budget imitations of the *Gazette* style of fashion illustration proliferated. The artist A. Soulie, for example, did illustrations for *Femina* in which he flagrantly copied Drian's type of mannequin, while simultaneously managing to make his signature look as much as possible like that of another great illustrator, A. Sandoz. The modern style of fashion was spreading rapidly through society, promoted by means of avant-garde art.

How did this transformation of fashion—and fashion illustration—come about? If we look at the history of fashion illustration, we see a precipitous decline in the quality of fashion plates during the last decade of the nineteenth century. By the 1890s, the charming figures depicted by Anaïs and her contemporaries were increasingly replaced by awkward wooden mannequins that were carelessly drawn and ever more cheaply produced.

In many cases, the decline in the quality of fashion illustration was the result of a team of illustrators working collectively on the same picture:

> There is often a special artist who does nothing but layouts, grouping the figures and planning the page; another who makes sketches of the garments;

A mediocre fashion illustration from *Figaro-Modes* (1903) shows how far traditional fashion-plate art had declined. Indeed, by this time, many fashion plates were produced by teams of illustrators working collectively on the same picture, one artist doing layouts, another sketches of the clothes, a third details, and so on.

another who draws them on the laidout figures; another who puts on the large washes; another who does details such as lace and embroidery; another who finishes the head and still another who finishes the hands and feet.[7]

Barely adequate to display the new fashions, such prints were artistically mediocre, and actually gave little sense of the "feeling" of the dress. Into such a dismal field, the Art Deco fashion plate burst with the force of an explosion.

Art Nouveau—*le style 1900*—influenced surprisingly few fashion illustrators, and its influence on fashion was also limited. Although the Great Universal Exhibition of 1900 featured Art Nouveau architecture, jewelry, and other decorative arts, the dresses displayed by the couture houses were not "Art Nouveau dresses." Of course, it has been said that the sweeping S-curve of ladies' dresses were derived from the sensuous curved lines of the new style—and this may well be true. But since Art Nouveau was primarily a fashion of decoration, its influence on clothing fashion was essentially restricted to surface ornamentation, such as the use of lace with patterns of water lilies and swans. Accessories—especially fans—were also sometimes painted in the Art Nouveau style.

But full-fledged Art Nouveau illustration was more commonly seen in

posters and advertisements than in fashion plates, per se. Among the few exceptions was the work of Georges de Feure, whose elegant (and slightly sinister) women appeared occasionally in *Les Modes, Le Figaro-Modes,* and *Le Figaro Illustré.* Most turn-of-the-century fashion illustration, however, was much less artistic, and was characterized by a cluttered and fussy style.

The rise of fashion photography was partly responsible for the deteriorating quality of fashion illustration—although it is also significant that the decline occurred during the last phase of the Victorian "fashion cycle," when the style of dress was itself becoming "tired." Photography existed, of course, since the mid-nineteenth century, when studio portraits and *cartes-de-visite* first became popular. In 1880, the rather expensive and worldly magazine *L'Art et la Mode* experimented with utilizing fashion photographs in place of traditional fashion plates. But it was not until the 1890s that technical improvements in photographic reproduction made the journalistic use of photographs easy and economical. By 1892, *La Mode Pratique* punctuated its text with numerous photo-engravings. By 1900,

The Art Nouveau style was more popular for posters and advertisements than for fashion illustration per se. Occasionally, however, the artist Georges de Feure did publish in a fashion magazine, as in this unidentified illustration.

the prestigious journal *Les Modes* was illustrated almost entirely with large fashion photographs, formally posed and featuring well-known actresses in *haute-couture* creations.

Early fashion photographs were designed to look as much like the better quality fashion plates as possible. Not only did they utilize the same conventions of pose and expression, but many examples were so heavily retouched that "the original photograph forms only the framework for the finished 'fashion study'." Backgrounds were painted out (or in) or the subjects posed in front of painted back-drops. Fabrics were smoothed and trimmings heightened; faces were formalized, figures corrected. As one nineteenth-century photographer instructed his colleagues: "The retoucher may slice off, or curve the lady's waist after his own idea of shape and form and size." Similarly, the cartoonist Grevin portrayed a young woman at the photographer's studio, saying: "You know, don't pay any attention to my hair-style, give me a lot more hair than this."[8]

In this interim period, even the most avant-garde photographs paled beside Art Deco illustrations. One need only compare this photograph of a Poiret dress by Edward Steichen from *Art et Décoration* (1911) with Iribe's picture of Poiret's clothes to see which is more successful.

The fashion photograph did not yet have an aesthetic of its own. Even the most advanced "art" photography seemed incapable of expressing the new look. When Edward Steichen photographed Poiret's dresses in the 1911 *Art et Décoration*, his soft-focus approach was not as effective as Lepape's drawings. Nor did coloring the photographs work nearly as well as the *pochoir* color printing method, whereby up to thirty different stencils were used to reproduce the freshness of the original watercolor.

Fashion and Modernism

Why had illustration declined so far, and why was there one last flowering of artistic fashion illustration (which coincided with the continued rise of photography)? In her book *Seeing Through Clothes*, art historian Anne Hollander suggests that the nineteenth-century portrait ideal gave way to the modern photographic ideal, which simultaneously killed the old fashion plate and gave rise to the Art Deco fashion plate. Furthermore, "the new photography and the new mode in decorative art were in fact the newly wedded parents of the new fashions. The clothes Poiret offered looked best either rendered in the flat areas of color used by his artists or photographed in the abstract manner of Lartigue." It was only gradually, by seeing the streamlined image of clothed humanity so characteristic of the Art Deco print, that real people began to acquire "a new kind of visual imagination about the physical self."[9] The modern silhouettes *à la Drian*, so tall and svelte, were certainly more characteristic of this idealizing graphic art than of real life. But they accurately foreshadowed the "slimming craze" that accompanied the machine-age fashions of the 1920s.

Traditional designers sometimes found it difficult to adjust to the changing mood. At the beginning of his career, for example, Paul Poiret was hired by the Maison Worth, then directed by the two sons of the great couturier. Gaston Worth was practical, and bluntly told Poiret:

> Young man, you know the Maison Worth . . . possesses the most exalted and richest clientele, but today . . . Princesses take the omnibus, and go on foot in the streets. My brother Jean has always refused to make . . . simple and practical dresses which none the less we are asked for. We are like some great restaurant, which would refuse to serve [anything] but truffles. It is, therefore, necessary for us to create a department of fried potatoes.

Poiret found it rather difficult to be "the potato frier" for the House of Worth, especially since Jean Worth loathed his new-style dresses. Once when Poiret was showing him "a little tailor-made," Worth looked positively ill and burst out: "You call that a dress? It is a louse." By 1914 Jean Worth proclaimed unhappily that fashion had become "one meaningless jangle hopelessly out of tune," although he reluctantly admitted that it

The caricaturist Sem mockingly depicted a fashion show for *L'Illustration* (1913). According-
ing to the text, the latest fad was for fashion designers to "organize the presentation of
their new models like the spectacle at a *café-concert,* having their mannequins parade—to
music—the better to seduce their clients." These performances, of course, are today an
integral part of the fashion industry.

seemed "to synchronize with the growing restlessness of this age, an age
of fast motoring and flying machines." [10]

Fashion illustrations that bordered on caricature were sometimes espe-
cially accurate in depicting the transitional and experimental characteris-
tics of prewar dress. If Iribe's streamlined images portray the ideal essence
of the modern look, drawings by Sem and Saccheti depict the more "par-
adoxical silhouettes," the flounces and paniers still superimposed on the
dress form, to say nothing of the "casseroles, flower-pots, and lamp-shades"
that passed for hats. Indeed, the caricaturist Sem produced a number of
telling images under the title *True and False Chic,* including one of a clown
throwing a variety of pots and pans at a woman's head—to see which would
make the best hat.

L'Illustration did a piece on "Le Vrai et le Faux Chic" which praised
Sem's "lively satire of fashion's exaggerations" and what was widely per-
ceived as the "hideous crisis of bad taste." The anonymous author main-
tained that "the great couturiers" had "succeeded in escaping the conta-
gion," but that many second-rate designers had launched "all kinds of

eccentricities," which were all too widely adopted. Such designers "organize the presentation of their new models like the spectacle at a *café-concert*, having their mannequins parade—to music—the better to seduce their clients." Sem's illustration of fashion models in lamp-shade tunics writhing to the strains of a dance band strikes the modern viewer as especially amusing—because such performances are an integral part of today's fashion shows.

"In the haunts of pleasure, at the theatres, in fashionable restaurants," the observer was confronted with "a multitude of bizarre creatures." Clearly, fashion had moved beyond the display of Veblen's "conspicuous consumption," "conspicuous leisure," and "conspicuous waste" to what Quentin Bell labeled "conspicuous outrage." This deliberate flouting of conventional standards of good taste was qualitatively different from nineteenth-century patterns, such as the inflationary expansion of the crinoline (which was also widely caricatured). Twentieth-century "fashion victims" were proclaiming (perhaps unconsciously) their disinterest in such conventional standards and, by doing so, they confused the more conservative observer who had to admit that "the most extravagant, the most audacious taste can seem becoming when worn by young pretty women." Ultimately, the writer, being Parisian, had to accept "the fashion of today" (however bizarre it seemed), hoping only that the "truly chic" woman would remember to exercise some moderation and avoid the most "awkward" exaggerations of the modern style.[11]

Conspicuously outrageous dress bears a noticeable family resemblance to the kinds of "outrageous" stylistic experimentation evident in all the arts in the pre-war years. The glaring colors of the Fauves earned them the name "wild beasts." Poiret also described the fashion shift from refined, "eighteenth-century" pastels to vivid colors, in terms that emphasized their savage connotations:

> Nuances of nymph's thigh, lilacs, swooning mauves, tender blue hortensias . . . all that was soft, washed out, and insipid, was held in honour. I threw into this sheepcote few rough wolves; reds, greens, violets, royal blues . . . orange and lemon . . . the morbid mauves were hunted out of existence.[12]

The Fauve painter Raoul Dufy did the illustrations for *Le Bestiaire* by avant-garde poet and publicist Guilliaume Apollinaire, which attracted Poiret's attention. In 1911, Dufy began to do textile designs for Poiret, and the next year he became art director for the big Lyons silk firm, Bianchini-Ferier. Iribe began by translating his motif "le rose Iribe" into a fabric design, and soon both he and Charles Martin (another artist for *La Gazette du Bon Ton*) were working as textile designers for Bianchini-Ferier.

The artist Sonia Delaunay also did textile designs which featured a mixture of bright colors and bold geometric patterns. In 1914, Apollinaire

praised both Sonia and Robert Delaunay for abandoning "antiquated" fashion in favor of boldly colored clothing which, in silhouette alone, followed the contemporary style. Indeed, so well known were her clothes (at least among avant-garde painters and writers) that, in 1919, Blaise Cendrars wrote a poem about them, "On Her Dress She Wears Her Body." Experimental fashions were international, and Delaunay's 1920s dresses for women recall the work of advanced Russian designers, such as Varvara Stepanova and Lyubov Popova (whose abstract "proletarian dress" continues to inspire some of today's architectural fashion designers).

Similarly, the brightly colored suit that she made for her husband, Robert Delaunay, resembled the "Anti-Neutral Suit" designed by the Italian Futurist Giacomo Balla—although the Italian version of revolutionary anarchism was already evolving into a kind of protoFascism. Thus, Balla's manifesto described the Futurist uniform as: "dynamic through the patterns and colors of the materials and the use of triangles, circles, spirals and ellipses, inspiring love of anger, speed, and attack, and hatred of place and immobility." Even Futurist shoes "will be dynamic, each one different in form and color and easily suitable for kicking all the neutralists."[13] As it transpired, "Brown Shirts" did the job.

Sexual politics played a relatively minor role in the first stage of the fashion revolution. There were, of course, many women designers and artists. More significant, however, the entire fashion revolution affected women's clothing far more than men's clothing: Delaunay's brightly colored *man's* suit found no widespread acceptance, nor did many men adopt the turban hat that Poiret was sometimes pleased to wear.

Androgeny appears to be the theme of one fashion plate in *Le Journal des Dames et des Modes* (1913). A man and a woman stand side by side, in almost the exact same position, both wearing narrowly cut, high-waisted suits. But a closer look shows that they are hardly in what we would call "unisex" clothes. The woman's skirt may be so narrow as to look like a single trouser leg, but it is a skirt, not trousers. Her soft, melon-shaped hat is only superficially analogous to his bowler hat; their shoes are different. In fact, this type of stylistic correspondence frequently occurs in the history of dress: In the 1830s, for example, both sexes had hourglass figures, padded hips, cinched waists, and puffed sleeves.

If stylistic correspondence is one issue, the development of the woman's tailored suit is another. This did strike contemporaries as being "masculine," but neither then nor now is it evidence of androgeny. Rather, as Anne Hollander has recently indicated, what we today regard as the new androgeny is actually more a function of women imitating the "masculine" look than a parallel movement toward some point midway between masculinity and femininity.

Did men's clothes perhaps change little, because they were already

"practical," whereas women's clothing needed to be "improved"? This is certainly the most popular interpretation today. But the fact is that symbolism and "image" were (and remain) more important to clothing development than functionalism. As Hollander writes:

> Elegant men's clothing during [the nineteenth century] was actually no less complex, demanding and uncomfortable, but it tended to be more subdued and abstract in the way it looked. Women's clothing was extremely expressive, almost literary, and very deliberately decorative.[14]

In the early twentieth century, the woman's version of the quasi-masculine suit combined with what came to be known as Streamlined Moderne, to create a stripped-down style where line and color were more important than applied ornamentation. In twentieth-century men's clothes, too, a

Gentlemen were not sure that they approved of the tailored suit for women, thinking that it too closely resembled their own costume. This fashion plate by Bernard de Monvel Boutet from the *Journal des Dames et des Modes* (1913) shows what we might call the androgynous look.

sleeker, more elongated line prevailed, but bright colors remained taboo, and decoration had already been abolished. *La Gazette du Bon Ton* sometimes featured articles on men's apparel, but Poiret's attempt to launch a high-fashion men's magazine called *Le Prince* fell through for lack of funding.

The new fashions in dress were not based on functionalism or common sense any more than avant-garde art was "functional." The stylistic tendencies that dominated the early to mid-twentieth century can be summarized by the word "modernism," and, however hard it is to define, the very name indicates a deliberate break with the past. The experimentation with new forms became increasingly common in all the arts, including the art of fashion. Like the new painting, the new music, and the new literature, fashion was undergoing an internal stylistic revolution.

The so-called cross-fertilization between fashion and art, however, has been mostly one-way. As the English fashion journalist Ernestine Carter points out:

> The truth is it is virtually impossible for even those most anxious to be convinced to find that fashion [in dress] has ever exerted any influence on the art of this century. Rather fashion has reflected the transitory phases of twentieth-century art as each was swum into its fashionable ken. . . . Fashion has in fact battened on art, especially in France. . . . And at a further remove fashion has simply adapted itself to the influence of art on interior decoration.[15]

Since people wear clothes (rather than hanging them on the wall), the art of fashion is associated with the personal, physical self, in a way that other objects are not—however much men used to identify with their cars! There is an intimate connection between body and clothes, and in my first book *Fashion and Eroticism* I emphasized the sexual element in fashion change. Stylistic change applies to bodies as well as clothes, as the Victorian ideal of voluptuous women in corsets and full skirts evolved into an ideal of young slender women in brassieres and short, sheath-like frocks. I still believe that changing sexual attitudes and changing ideals of sexual beauty were crucially important factors in this transformation. But also significant were more general stylistic trends that applied as much to furniture and illustration as to clothing per se.

The evolution of fashion was especially closely connected to the changing imagery of fashionable people. Something new was happening in both fashion and fashion illustration—and in both cases, the inspiration came from the highest circles of Parisian *haute couture*. It was not, in any meaningful sense, the expression of a self-conscious movement for women's liberation, nor for "practicality" in the world of work. The readers of *La Gazette du Bon Ton* were generally neither feminists nor working women. Needless to say, it was not a response to the exigencies of the First World

War, since the primary movement for change took place before the war—especially in the years between 1906 and 1913—and had roots going back to the 1880s. In short, it was not an *anti-fashion* movement, but rather a development within the world of fashion, and—more generally—it was a part of the entire modernist movement.

The American "Revolt"

The Americans were always somewhat schizophrenic in their response to Paris fashion—and the development of modernist fashion only agitated them more. On the one hand, they held firmly to the belief that "Paris is the capital of fashion." And yet many voices repeatedly urged that "the hour is ripe for a . . . revolt."[16]

The problem of constructing a national identity was especially deeply felt in a new country without an established cultural heritage of its own. In the Gilded Age, the American upper class increasingly tended to "buy into" the European heritage, but many ordinary people clung to the myth that America was a uniquely virtuous and republican nation—one, moreover, that was dangerously threatened by the modes and manners of a corrupt Old World. Thus, while a segment of the population eagerly purchased Worth dresses, another group anathematized the tyranny of foreign fashions. Even apart from questions of patriotism and morality, from a purely commercial point of view, the economic benefits of an American national dress would be considerable.

If only women would "see America's milliners first," perhaps the people in other countries would also "press forward to another historic siege of Paris." The women of America were being called "to a new war of independence." To the victor would go the spoils of an international fashion empire. Thus, in late 1912, *The New York Times* launched a contest to design an American dress and hat that would combine "patriotism, sentiment, and business." According to the editors, the enormous response was evidence of "a real revolt. It will be successful."[17]

Nationalistic sentiment escalated in the prewar years, as Paris fashions became increasingly *outré*. The hobble skirt was a "freak," stated the *Times;* the harem skirt originated in heathen countries where women were enslaved. At last, the French fashion dictators had gone too far. Or had they?

In 1908, *Vogue*'s Paris correspondent declared, "The new styles mark an epoch and will surely go down in the history of dress as the mode of the twentieth century." With journalistic flair, she went on to interview Jean Worth: "It has not escaped my attention," she said, "that a new attempt is being made to introduce a modification in the corseted silhouette."

"It has not escaped mine either!"

"Do you like the changes, Monsieur?"

"Decidedly, Madame, I do not like them!"

"Why? Are they too colorful for you?"

"Too colorful! They are hideous, barbaric!"[18]

But they were the hottest item in Paris.

Poiret toured American in 1913, shrewdly using American mannequins to display his clothes. Even as he sailed for New York, *The New York Herald* printed an open letter from Cardinal Farley warning that "This Evil [fashion] constitutes a social as well as moral danger to the American community for the licentious nature of its creatures." But Poiret deftly turned the Cardinal's words to his own advantage, and—hosted by John Wanamaker—made a triumphal tour of the States. Poiret was less pleased to see how often American manufacturers simply copied his dresses and attached spurious Parisian labels to them. Returning to France, he took the first steps toward establishing a couture group designed to resist such international piracy.[19]

The next year, Madame Paquin sent a group of mannequins and dresses to the United States on a three-week tour that was billed as an "Exposition d'Art." This, too, was an enormous success, travelling from New York to Philadelphia, Pittsburgh, Chicago, and Boston. "The dresses were then returned to New York [where they] were displayed by Altman's for three days, during which, according to *The New York Times*, 60,000 people viewed them." Indeed, as far as *The Ladies' Home Journal* was concerned, "Paquin of Paris, the world's greatest fashion authority, has created for the American woman the ideal Smart Everyday Dress for Autumn."[20]

It may be that Paquin's fame was based, in part, on her ability to modify the new fashions, making them somewhat more practical and conventional: Her hobble skirt, for example, had ingenious hidden pleats that made it easier to walk in, while for evening wear, she eschewed "immodest" slit skirts or harem skirts. By contrast, Poiret's fame was heavily dependent on shock value. But in both cases, the new Paris fashions quickly found their way across the Atlantic, where they were eagerly embraced by fashion trendsetters.

Even without such personal contact, any American who read the fashion magazines knew all about the latest Paris fashions. American fashion *illustration* progressed more slowly, however, and was usually only a watered-down version of the modern style. Even in *Vogue*, artists like Helen Dryden and George Wolf Plank produced pictures far above the American standard, but still considerably inferior to those of French illustrators like Georges Barbier. It was really only toward the end of the First World War and even more in the 1920s that *Vogue, Harper's Bazaar,* and *Vanity Fair* hired European artists like Lepape, Benito, and Erté to do their cover illustrations.

Indeed, Lepape's life history has been summed up in the phrase, "From

the Ballets Russes to Vogue." From 1924 to 1936, in addition to his creative work, Lepape also taught—in Paris—at the New York School of Fine and Applied Art. He left a short but fascinating outline on "fashion drawing," in which he advised the modern fashion artist not to "concentrate exclusively on fashion drawing." Also important were

> all the centers of elegance, of sport, of Society, etc. with their decors . . . theatres, racecourses, salons, sports grounds, airfields, golf courses, tennis courts.

There were "two categories of fashion drawing," he observed, the first being "commercial drawing . . . very factual, no interpretation or stylization that would distort the original." This was "suitable for mass-circulation magazines." The second category was divided into two subgroups:

> A. Realistic drawing, but very stylized, bold, and sumptuous, reflecting a life of elegance and luxury in an appropriate setting. B. Free drawing, also very stylized but in which fantasy [and] imagination . . . are tied in with the luxury . . . of a novel and picturesque setting. Here the artist is no longer inventing a model, he is creating and inventing everything.

"Works in this second category," he noted, "are above all suited to fashion periodicals of the *Vogue* type."[21]

By 1936 (the year he wrote his outline), the Parisian *Gazette du Bon Ton* had long since given way to the American magazine *Vogue*. In fact, *Vogue*'s publisher, Condé Nast, had bought control of the *Gazette* from Lucien Vogel in the early days of the First World War, and produced both a French and an American version. *Vogue* itself was first published in the United States in 1892; the British edition began in 1916, and the French edition in 1921. Soon Lucien Vogel—like Georges Lepape—was an employee of Condé Nast Publications.

War and Fashion

In 1914, Paris was the fashion capital of the world. In 1945, it only gave that impression, although the illusion lasted until the 1960s, and, to some extent, even to the present. We should expect that two world wars would have a profound effect on the history of fashion, and so they did, but not necessarily in the ways we might suppose. The idea that war "liberated" women's fashion from corsets and long skirts is especially erroneous: The curved boned corset had already begun to evolve into a straight elasticized girdle and bust bodice by 1913, although, ironically, the new corsets may have been less comfortable than the old ones. Experimentation with slit and divided skirts was also well under way.

The first great fashion revolution of the twentieth century took place

before the First World War, and within the world of Parisian haute couture. But what effect did the war itself have? On August 3, 1914, Germany declared war on France. In the general mobilization that followed, men like Poiret closed their couture houses and went off to join the army. John Wanamaker placed a melodramatic announcement in the New York papers, in which he described his efforts to secure Parisian models for the American trade:

> I went to the beautiful atelier of Paul Poiret. He was in the blue and scarlet uniform of the French infantry, surrounded by a crowd of weeping women, his devoted helpers. "I am going to join my regiment," he said calmly. ". . . France needs men today, not artists."
> "But have you nothing ready? No models that I may show to America?"
> "No, the atelier is closed. It shall remain closed with nothing touched until I return, if I do return."
> I passed out silently. At the famous rue de la Paix House of Worth I was greeted by Jean and Jacques [actually Gustave] Worth, also in uniform. They were taking a last look at one of their gowns just finished.[22]

Actually, as *Vogue*'s editor observed in her memoirs, the Americans "could not know then that after the first frightening months the French couture would resume virtually normal production." Throughout the war, American magazines and manufacturers were able to obtain French models.

Indeed, the French government regarded the export of couture garments as an important part of the war effort. Despite his warlike statements, Poiret was soon released from an abortive career as an army tailor, in part, perhaps, because he had never learned to sew. Nor were the *Gazette du Bon Ton* and other French fashion magazines a casualty of the war, although fewer issues were produced. There were even new fashion magazines like *Le Style Parisien* (July 1915–February 1916) and *Les Élégances Parisiennes* (1916–1924), which were designed to promote French couture at home and abroad.

Not surprisingly, in September 1914 *The New York Times* suggested that now was the time "for America to develop whatever talent she has for designing clothes." But by February 1915, the *Times* reported glumly that the movement for American styles "died aborning once it was announced that the designers in Paris were keeping on the job."[23]

Nevertheless, the members of the French couture were upset by the news that *Vogue* was sponsoring a Fashion Fête in November 1914 that featured American fashions by designers from Bendel, Bergdorf-Goodman, and other New York stores. The fact that all proceeds went to French war relief was regarded as poor compensation. "To counteract the French displeasure," Condé Nast sent an emissary to Poiret and the rest of the Syndicate for French Couture, suggesting a "French Fashion Fête" to be held

in America. The resulting Panama Pacific International Exhibition opened in San Francisco in 1915, exhibiting dresses by Parisian couture houses such as Beer, Callot, Cheruit, Doucet, Jenny, Martial et Armand, Paquin, Premet, and Worth.[24]

A special souvenir issue of *La Gazette du Bon Ton* (entitled *The 1915 Mode as Shown by Paris*) was published jointly in America and France in collaboration with Condé Nast. Dated 15 June 1915—"the 316th day of the war"—it proclaimed that although part of France might still be in enemy hands, Paris remained the home of fashion and good taste. Indeed, "since the Latin races are fighting to uphold their taste against Teutonic barbarity, was it not to be expected that Paris Fashion should once again take the lead this spring?" Gone were the snide American remarks about "the wicked city of Paris," and about how "no Latin race can ever understand an Anglo-Saxon people in clothes or in any other need." To support Paris fashion was now to uphold the principles of western civilization itself. "Paris has innovated a warlike elegance . . . sportive and easy, leaving every gesture free, either to raise the unhappy wounded, or if need be, to handle a weapon."[25]

Fashion plates by Drian, Barbier, and Lepape increasingly emphasized the patriotic aspects of Paris fashion. A dress might be called "La Marseillaise" or a mannequin posed in front of a military map of France dotted with tiny tricolored flags. The cover of *Femina* might eschew a fashion illustration altogether, in favor of a drawing by Lepape showing a woman in the uniform of a Red Cross nurse. A soldier home on leave appeared in Barbier's illustrations for the almanac *Guirlande des Mois* (1917). Women's hats were certainly military in form, as can be seen in the work of a new and talented fashion illustrator, Valentine Gross (Madame Jean Hugo), hitherto known primarily for her pictures of the *Ballets Russes*. But what of the dresses themselves, so prominently described as "simple," "practical," and "warlike"?

The most striking feature of the 1915 fashion was the short full skirt, which was quickly dubbed the "war crinoline." Historians have tended to interpret this style as a radical response to the wartime situation, but such was not the case. Fashion illustrations from 1914 indicate that the narrow skirt had already begun to go out, while the sight of ankles and even calves was becoming more common. One of the most popular prewar styles featured a short, full overskirt on top of a long, narrow—slit—underskirt. It was an easy step simply to eliminate the underskirt. Another "shocking" prewar innovation was the V-neckline, not for evening dress (where a deep décolletage was traditional), but for daytime. Although generally forgotten today, the neckline controversy received, at the time, almost as much attention as the hemline controversy.

During the Great War, fashion publicists took advantage of the situation

One of the most talented of the new generation of fashion illustrators was Valentine Gross (Madame Jean Hugo), who was also known for her pictures of the *Ballets Russes*. This fashion plate, entitled "It's Still Raining," from *La Gazette du Bon Ton* (1915) depicts the so-called "war crinoline," the new shorter, fuller skirt. From left to right are tailored suits by Paquin, Lanvin, and Doeuillet, and a coat by Paquin. It is probably indicative of wartime conditions that this fashion plate was not colored; perhaps the craftsmen capable of doing the complex series of color applications had already been drafted.

to promote the war crinoline as "patriotic," "practical," and easy to walk in. But the Englishwoman, Lady Cynthia Asquith, was closer to the mark when she expressed her surprise that the 1915 fashions had become "practically early Victorian," and she expressed some reservations about adopting such a different and "ultra-fashionable" style. When she *did* buy a short dress, it was not for work, but as a formal frock.[26]

Despite unprecedented carnage, the Great War was not a total war, like World War II. Soldiers went back and forth to the front, and while they were in Paris (or London), fashionable dinners and dances continued to be held. Indeed, one of the prime arguments for fashionable dress was precisely that it would cheer up the soldiers to see pretty, well-dressed women. Of course, some soldiers were shocked to see how fashion was progressing, and in 1916, *Le Femme Chic* suggested how readers might reconcile their husbands to the short skirt, when they came home on leave. Fashion definitely did not cease to exist during the war; if anything, sartorial experimentation continued to speed up.[27]

Proust's descriptions of the wartime fashions are typically pertinent, combining acute observation with ironical commentary. For as it gradually became apparent that—contrary to all expectations—the war was not about

to end quickly, a more somber note seemed appropriate to fashion. To what extent it dominated fashion is another question entirely. Thus, when Proust's narrator returned to Paris in 1916, he saw women "in high, cylindrical turbans, reminiscent of Directory fashions."

> Showing their civic spirit by their straight, Egyptian jackets of dark color, very military-looking, over extremely short skirts, they wore leather puttees . . . or high leggings like those worn by our men at the front; it was, they explained, because they were mindful of their duty to rejoice the sight of those warriors that they still dressed up, not only in soft clinging gowns, but in jewelry suggesting the army by its decorative theme, if indeed the material itself did not come from the army. . . . There were rings or bracelets made of fragments of shell . . . and it was likewise, they said, because they were always in their thoughts that they wore very little mourning when one of their family was killed, on the ground that their sorrow was mingled with pride.[28]

Proust was not crudely sarcastic; he observed that in 1793 painters had insisted that they should create and exhibit even when the rest of Europe was "beseiging the land of freedom." Similarly, the dressmakers of 1916 declared that they, too, were artists, with a mission "to seek new creations." And yet, he implied, how could writers suggest that "our soldier boys . . . deep in their trenches, are dreaming . . . of modish apparel"? Did they appreciate that "This year the *tonneau* dress is all the rage, its charming, easy-going style giving us all a delightful individual touch of rare distinction"? Under the circumstances, was it not almost perverted for fashion journalists to write: "It will, indeed, be one of the most fortunate incidents of this sad war . . . to have achieved charming results in . . . women's dress with very few materials and, without . . . vulgar luxury"?

Moreover, Proust observed that in the salons of elegance and pleasure, faces, as well as hats, were new. Women like Odette, who had not been "received" before the war, now joined "charitable circles" and mingled with the denizens of the Faubourg Saint Germain. These newcomers quickly learned that to come "flashily gowned, with great necklaces of pearls" was now "taboo." Fashion certainly continued, but the "really chic people" favored the relative "simplicity" of "war fashion." And, in any case, according to the new way of thinking, "dresses are made to be worn but not commented on." When Charlus comments favorably on a lady's dress, both he and she are dismissed as being hopelessly "pre-war."[29]

As hundreds of thousands of Frenchmen were slaughtered in military campaigns of unparalleled stupidity, and as ordinary French soldiers began to mutiny *en masse*, the literature written for women about fashion became increasingly confused. Edna Chase recalled hearing about a young woman babbling to a wounded soldier, wondering "aloud what the new spring wear would be." Shifting his crutches, he replied: "Mourning, ma-

dame, mourning." But the mourning dresses shown in, say, *Femina* were every bit as stylishly modeled as ordinary fashionable dress—with high waists, full skirts, paniers, military collars, odd hats made of black ribbon, and even fairly short skirts.[30]

A column on "Fashion During the War" appeared in *Femina* in March 1917. It began tentatively, saying that the editors felt some apprehension and emotion about discussing fashion at all, since a number of people had insinuated that "the enemy being still with us, these questions of dress are really puerile." They stood "ready to . . . condemn the smallest error" or the "overly lyrical style of [certain] fashion journalists"—and they were not always wrong to do so. But still, it was surely possible to write about fashion, about the fashion industry, in a way that was acceptable—"to speak of simple fashions with simple words" and in all humility. "The war has killed false chic," and there has been a salutary "return to simplicity." *Femina* sought only to remain, as always, a guide for Frenchwomen and foreigners alike.

Having established this position to their satisfaction, they launched into the fashion news: "Materials are soft and flexible.—Natural colors are preferred.—The straight dress and the barrel dress" are most in favor. Couturiers were responding to popular demand—both for something "really new" and for simple, easy clothes, like the "chemise dress," which was "created at the request of a young woman, who, spending most of her days and nights at the hospital, had taken to wearing a nurse's smock, and who came one day to ask her couturier to make her an analogous dress in which she could move freely." Not only was the line loose and easy, but the materials (such as jersey and cashmere) were extremely supple. Muslins and flowered organdies in "happy colors" were also popular for frocks, while grey and beige were used for tailored suits. The very full large skirt was shrinking, and a more or less straight line had emerged, one version of which was known by the rather unflattering name of the "barrel" skirt. Just as the war crinoline had been promoted, in its time, as practical, so now was the straight dress.

> Fashion, under the hard lessons of the war, has sobered down; it is now correct, becoming, and practical. At this time, there is rarely an occasion for making compliments. . . . Free from certain baleful influences, fashion tries to guard this simplicity, this harmony, and this equilibrium which are the reflection of our spirit and our traditions.[31]

Three months later, another article on wartime fashions "reassured" readers that the fashionable line "has not noticeably changed" since the last report. The barrel, draped, pleated, and *Zoave* skirts were still in fashion. The straight silhouette of 1917 was wider than the look of 1914—in retrospect, more like the style of the early 1920s. But most dresses still

had the prewar high waistline, and many also had overskirts or hanging panels. "The waist remains always imprecise and flexible, often a little high, circled by a narrow sash." Light materials were in vogue: Dark blue or jersey for town, and silk shantung, linen, or crêpe-de-chine for afternoon and evening. The House of Worth did a pretty batiste dress decorated with lace, Doeuillet a printed blue linen. "Very amusing and new" were "rustic" embroideries, while Far Eastern designs also inspired couture embroidery. "But it is above all in *le costume d'intérieur* that the Chinese style triumphs." In closing, the author referred to a recent fashion exhibition in Madrid, featuring French couture models, which had proved "that our luxury industries retain their prestige." In fact, the Germans themselves were producing ersatz French fashion magazines with titles like *Les Modeles Parisiens* and *L'Ideal Parisien.*

Except for the emphasis on nursing, fashion magazines largely ignored the fact that many Frenchwomen worked during the war years. But then, many Frenchwomen had *always* worked, and the percentage of working women in the population did not appreciably change, although the types of work they performed necessarily shifted in the absence of so many men. Servants, for example, flocked to other, better-paying jobs that permitted more personal freedom. But such changes hardly justify the popular idea that the war liberated women who had previously been kept at home. Indeed, some of the volunteer work—such as sewing—that middle and upperclass women performed as part of the war effort actually inconvenienced work-class seamstresses, who had previously competed only with working nuns.

Meanwhile, in America, women's magazines paid relatively little attention to the war until the United States entered on the Allied side in 1917. Nor did many American women actually enter the work force *for the first time* during the war years. In fact, the evidence is inescapable that developments in fashion were *not* primarily a response to changing patterns of work and the need for "practical" clothes.

We often hear, of course, that it was Coco Chanel who introduced casual, mannish fashions. As early as 1914 Sem chose as an example of "true chic" one of Chanel's first suits, designed for Emilienne d'Alençon. It was characterized by the same simplicity and greyhound slenderness that became her hallmark in the 1920s. Yet other designers were producing very similar clothes. Several almost identical suits were featured, for example, in an article on "Les Belles du Jour" in *Femina* (1913). So common was the style that the designers were not even mentioned.

12
Haute Couture in the Twentieth Century

Coco Chanel is widely credited with having revolutionized women's fashion by introducing the first truly practical and comfortable clothes. Today there are many fashion designers who are women, but do they create clothing significantly different from male designers? Sonia Rykiel (regarded by some as the Chanel of modern French ready-to-wear) argues: "Men won't be wearing the clothes, therefore practical considerations are secondary and they can create magnificent designs. Women designers define things with a more practical eye." As early as 1914, the magazine *L'Illustration* featured one of Chanel's first suits, which was characterized by the same simplicity and greyhound slenderness that became her hallmark in the years between the wars. In his accompanying article on "Le Vrai et le Faux Chic," Sem praised Chanel's suit as an example of "true chic."

Sandwiched between two world wars, between Poiret's harem and Dior's New Look, two women dominated the field of *haute couture*—Schiaparelli and Chanel.

Cecil Beaton, *The Glass of Fashion*, 1954

Today's premier couturier, Yves Saint Laurent, has said that the two designers he most admires are Chanel and Schiaparelli. The former, the exponent of classical uniformity; the latter, known for conspicuous outrage and a witty commentary on the fashion process: Between them, they map out the two main lines of twentieth-century style.

Yet the literature of fashion has emphasized the creative "genius" of certain couturiers in a way that distorts the real history of fashion. Ironically, it can even obscure the actual achievements of individual designers by inflating their alleged "influence." Imagine if the history of painting were treated in the same way—beginning with a "Age of Manet" (comparable to the "Age of Worth"), and emphasizing a handful of revolutionary innovators: Picasso, say, for Chanel, or Jackson Pollock for Dior. Of course, in proposing a broader approach to the history of fashion, I would not be so churlish as to wish to discard the many entertaining and enlightening accounts that have been written about individual designers, past and present, even if (as I believe) those designers were not as paramount a force in fashion history as they have been made out to be. Nor do I intend, by using Chanel and Schiaparelli to lead into a consideration of the role of women in the fashion industry, to "rewrite" fashion history, emphasizing female designers at the expense of their male colleagues. Nevertheless, it is instructive to ask why Worth gave his name to an "Age," and why Chanel and Schiaparelli became famous when they did.

According to the popular stereotype, it is only fairly recently that women have been able to influence fashion design: Traditionally, fashion designers were men, like Worth and Poiret, who imprisoned women in clothing that expressed the designers' own fantasies of femininity. But once Coco Chanel introduced clothes that were comfortable and practical, it was the beginning of a new era of liberated female fashion designers. But is this stereotype historically accurate? Is there any validity to the popular belief that female designers create significantly different types of clothing than

male designers—more comfortable, perhaps, or less seductive? And what might we learn about the relationship of American and Parisian fashion, if we abandon the "genius" theory of fashion?

Coco Chanel

Gabrielle (Coco) Chanel was the acknowledged dominatrix of fashion during the period between the wars; "The first war made me," she said. "In 1919, I woke up famous." Although she shared the stage with Schiaparelli, Vionnet, Patou, and others, her "comeback" in the 1950s, together with the continued importance of the House of Chanel, makes her a living figure in a way that is not true of her contemporaries. Moreover, her dresses really were innovative in a number of important ways.

Even so, most of the literature on Chanel is closer to hagiography than historiography: She is said to have abolished feminine frills, liberated women from the corset, and almost singlehandedly introduced sportswear, the "poor boy" look, bobbed hair, the color beige, designer perfume, suntans, and the "little black dress." Of course, to take only one example, among the many others who claim to have "abolished" the corset are Poiret, Vionnet, and the English designer Lucille. In fact, the corset never really disappeared, but rather evolved into other types of foundation garments, such as the elasticized girdle and brassiere (and, more recently, undergarments made of Lycra).

With a little research, it is easy to use the facts of fashion history as "sniper's ammunition" to pick off the inflated theories of overly enthusiastic biographers. To take another example, Mrs. Vernon Castle was setting the style for bobbed hair, not in the 1920s, but by 1913—back when Poiret launched his first "couture" perfume. Or again: The evidence from contemporary magazines indicates that during the 1920s, Patou was at least as famous for women's sportswear as Chanel was. After all, to look *sportif* was rapidly becoming a fashionable obsession, even among those whose most strenuous physical exercise was lunching at the Ritz.

Myths need to be replaced by some more coherent explanation, and the logical place to begin is through an analysis of the popular belief that Chanel brought the simple dress of the working girl into the realms of haute couture. Did her fluid cardigan suits actually blur the lines of distinction between the *midinette* and the lady? While researching my first book, I had the opportunity to interview a lady who prefers to remain anonymous, since her name is so well known. I asked her if, during the 1920s, she often wore Chanel's fashions. "Oh, no. They were much too expensive." (This from a woman whose name is virtually synonymous with wealth and aristocracy, and who was speaking from her home in Saint James' Square.) "But the French cousins liked her clothes. Now *they* were

very fashionable." (To be fashionable is nothing if not a relative concept, since the speaker was married in a Callot Soeurs wedding dress, and her favorite designer was Madeleine Vionnet.) But the point was that Chanel's style of "deluxe poverty" (as Poiret put it) was actually recognized as an *extremely* expensive look, produced with consummate artistry and deceptive simplicity. Even her costume jewelry was not cheap.

The real secret of Chanel's success was not that her clothes were simple or even comfortable, but that they made the rich look young and casual. Women throughout the western world had a new image of themselves that made the formal and ostentatious elegance of the prewar period look old-fashioned. Like Iris Storm, the fictional heroine of *The Green Hat*, they modeled themselves on "the women in Georges Barbier's almanacks, *Falbalas et Fanfreluches*, who know how to stand carelessly," and who wear clothes that appear to be *"pour le sport."* F. Scott Fitzgerald made a similar observation in *The Great Gatsby* when he described Jordan Baker as wearing her "evening dress, all her dresses, like sports clothes—there was a jauntiness about her movements as if she had first learned to walk on golf courses on clean crisp mornings." The ideal body was not so much boyish as it was the style of a sophisticated school girl. To appear to pay too much attention to clothes was *démodé*, while to wear one's clothes *avec desinvolture*, in a free and easy manner, was the look of modernity. Because this remains true today, we still admire Chanel.[1]

Already, during the First World War, simplicity of dress had become *bon ton* among Parisian aristocrats. It seemed only suitable to adopt a look of seriousness and subdued elegance under increasingly tragic circumstances. Certain actresses and the *nouveaux riches* wives and mistresses of war profiteers were harshly criticized for their opulent dress. Proust, of course, described how Odette was clever enough to put aside (however reluctantly) her jewels and luxurious dresses, for the sake of being admitted into the company of society ladies organizing to help the war effort. In this respect, the war years helped set the stage for the modification of fashion to which Chanel contributed so much.

Chanel promoted a kind of *uniform*, which was quickly regarded as a modern "classic." Nonluxury became more fashionable than overt display. Not only were Chanel's wool jersey suits as pliable as sweaters, but she was also influential in launching sweater dressing, as such. (Patou's biographer claims that *he* "invented sweater dressing" in 1924, but, like the sweeping statements made by most of Chanel's biographers, this is an oversimplification.) By 1927, *Le Jardin des Modes* declared, confidently, *"Le sweater est devenu un vêtement classique: pratique et charmante."* Of course, the sweater could take on an entirely different character, as it did in the hands of Chanel's arch-competitor, Elsa Schiaparelli, whose humorous *trompe-l'oeil* sweaters also continue to influence modern design.

Classicism alone would be excruciatingly boring, jokes alone would quickly degenerate into gimmickry, but the interplay between them fruitfully builds on Baudelaire's insights into the meaning of fashion. Uniformity is the modern mode, first for men and much later for women, but so is an ironic, self-conscious playing with fashion, whether this is expressed by carrying the classic look "too far" or by sabotaging it by wearing a hat in the form of a lambchop. And no one knew better "how far to go too far" than Schiaparelli. Although Mademoiselle would probably be gratified by the extent to which Karl Lagerfeld's Chanel collections continue to offer hommage to her personal style, she might well be annoyed by the equally evident tribute being paid to Schiaparelli's "surrealist" accessories: In the 1930s, a hat shaped like a shoe—in the 1980s, one in the form of a chair.

Fashion and Fantasy

Chanel hated Schiaparelli, whom she referred to, nastily, as "that Italian artist who makes clothes." Although Chanel was both more successful financially and a more important figure in the history of fashion, Schiaparelli had become, by the early 1930s, the most talked about couturier in Paris. The fashion artist, Drian, composed a song about her:

> *Blague ou génie?*
> *En culbutant la mode,*
> *Elle l'habille en folie*
> *Et signe—Schiaparelli!*

As she herself commented in her autobiography, "curiously enough, in spite of Schiap's apparent craziness and love of fun and gags, her greatest fans were the ultra-smart and conservative women, wives of diplomats and bankers."[2]

Although Surrealist art was supposed to be "subversive," it proved remarkably easy to assimilate. A similar phenomenon had already occurred in the teens, when *Vogue* blandly stated that "The desire for futurist coloring is satisfied by sleeves of gay cretonne." An interest in Surrealism was also satisfied by a peculiar accessory (such as gloves with appliqued fingernails), or by a fashion mannequin photographed in some suitably "surrealist" environment. Schiaparelli herself drew on all the latest artistic trends, from Cubism and African art to Surrealism, and she collaborated with a number of artists, most notably Dali, Cocteau, and fashion illustrator Christian Bérard, who designed the famous Medusa head for the back of one of her evening capes. André Breton, the high priest of Surrealism, might assert that beauty must be "convulsive," but women in high society favored Surrealist fashion because it was chic.

And Schiaparelli's clothes were definitely chic. As Bettina Ballard writes:

Chanel called her "that Italian artist who makes clothes," and Drian composed a song asking whether her clothes were a "joke or genius." Today fashion historians regard Schiaparelli's style as bold and sophisticated. Her suits tend to have exaggerated shoulders and a disciplined fit, while her accessories—such as hats and buttons—are often striking, even "surreal." A typical example of Schiaparelli's "hard, highly individual chic" can be seen in this photograph from *L'Art et la Mode* (1937). Courtesy of the Fashion Institute of Technology Library, New York.

"Looking back over the *Harper's Bazaars* and *Vogues* of the thirties, the hard, highly individual chic of her clothes stands out from the pages like a beacon, making the rest of the couture look pretty and characterless, with the exception of Vionnet, who had a stately beacon quality of her own."[3] In contrast to Chanel's casual style (and Vionnet's shapely bias cut), Schiap's clothes were characterized by bold lines and a disciplined fit—a sophisticated and hard-edged chic that was immediately recognizable. Her "little black dress" and her smart black suit with its exaggerated shoulder-line and decorative buttons were at least as famous as Chanel's classics, and her clothes, too, became a kind of uniform, indelibly stamped with the designer's personality. Her style was also associated with the Honourable Mrs. Reginald (Daisy) Fellowes, who was such an important society figure that Schiaparelli dressed her for free, although, with a fortune based on Singer sewing machines, she could have bought every item that Schiap produced.

Those who see 1930s fashions (whether Surrealist or Hollywood) in terms of an "escape from reality" during an era of Depression have, perhaps, a valid point, but the style cannot simply be reduced to that. Surrealism was initially an attempt artistically to exploit the unconscious; it could not have existed prior to Freud's analysis of dream imagery and human sexual behavior. Because Freudian psychoanalysis has now become (at least temporarily) *démodé*, it is hard for us to imagine the revolutionary effect he produced on educated Europeans and Americans. Coming from a family of intellectuals and artists, Schiaparelli was well equipped to introduce Surrealism into the fashion arena. Moreover, like Poiret, she had a keen sense of the publicity value of such innovations: For her new perfume—"Shocking"—Schiaparelli commissioned a bottle in the shape of a woman's torso by the artist Leonor Fini, who was best known for her erotica.

If the Surrealists were one source of inspiration, another seems to have been the Colonial Exhibition of 1931. As African art and modern technology had influenced the 1925 "Art Deco" exhibition, so "exotic" Asia was the focal point in 1931. Indeed, I would argue that the artificially wide shoulders so characteristic of 1930s and 1940s fashions were ultimately derived not only from men's broader shoulders, but also from the vocabulary of Asian costume. When Cambodian and Balinese dancers appeared in Paris, they wore what the Balinese call a *bapang,* a separate leather collar that projects horizontally over the shoulders. Today's avant-garde designers are also inspired by the rather similar shoulderline found in traditional Japanese masculine clothing. "Exoticism" (in an age of imperialism) is not the only issue; also relevant is an openness to the formal vocabulary of other cultures. In the twentieth century, the cosmopolitan French, above all, have been receptive to such influences—including the influence on Paris fashion of Afro-American culture.

Like Schiaparelli, Chanel was a friend of many artists, and she did the costumes for avant-garde theatrical works like *Antigone* and *Le Train Bleu*. But ideologically she emphasized the differences rather than the similarities between art and couture. According to Jean Cocteau,

> Mademoiselle Chanel declares, rightly, that "couture creates beautiful things that become ugly, while art creates ugly things that become beautiful." Profound words, which, perhaps, will advise her to abandon her reign after having proved to women that jewels can adorn wool and that short hair is not only the privilege of men.

And he added, in an epigram of his own, "Fashion dies very young, so we must forgive it everything."[4]

Beyond Chanel

Comfort and functional logic have a clear place in fashion, but so, apparently, does some other intangible element—call it fantasy, perhaps, or the desire for novelty, which may be closer emotionally to a *rejection* of the old. Later, in the 1950s, fashion reporting (in both newspapers and the more specialized fashion press) focused extremely heavily on innovation: There was the Y line, the A line, the H line, the "sack"; hemlines went up an inch, down an inch, skirts were full, then they were narrow. It began to seem to some observers, particularly, I think, English and American women, that "Dior's alphabetical lines were all examples of a male designer imposing an abstract shape upon the female body." Then in 1954, at the age of seventy, Chanel re-entered the fashion arena.[5]

To her supporters, then and now, Chanel represented comfortable, realistic, "classic" dressing. As one well-known fashion historian puts it:

> The clothes of Coco Chanel were common sense. . . . Pockets must be practical pockets in sensible places, and buttons must button. . . . She made it chic to look poverty-stricken, cutting clothes down to the bare essentials. . . . There were some proud names who had become poor, and Chanel's style was highly appropriate to them. Russian grandees had to work as taxi-drivers, and grand duchesses as models. Chanel herself went out with the poverty-stricken Grand Duke Dimitri, so she could see their problems at first hand. Her clothes were an expression of reality.[6]

Of course, as we have seen, this was not the whole truth. No one ever looked poor in a Chanel suit, and no one poor could ever have bought one. Gambler that he was, Dmitri himself was a rather expensive accessory even for Chanel. But her suits certainly were comfortable, and they were stylish in a way that deliberately exchewed the yearly transformations that characterized the work of may other designers. The fact that they *looked* practical was as much a part of their success as any actual practicality.

Coco Chanel helped set the fashion for women wearing trousers in public. Notice also her famous costume jewelry. In this photograph from the 1930s, she is shown on the Cote d'Azur together with Serge Lifar of the Ballets Russes. Reproduced from Marcel Rochas, *Vingt-cinq ans d'élégance à Paris* (1951).

Ever combative, Chanel angrily dismissed the extravagances of "those gentlemen"—that is, Dior and the other male designers. If one of them used a boned bodice, she demanded to know how the wearer could *bend over.* "And that other fellow with his 'Velásquez style'!" Didn't his customers look like brocaded armchairs? Her first postwar collection was received coldly: The French press dismissed it as old-fashioned—"Ghosts of the 1930s gowns"—or worse, provincial. "A fiasco," said the headline in London's *Daily Mail.* But then, a year later, the American press began to sing another tune. By her third collection, *Life* magazine wrote: "She is already influencing everything. At seventy-one, Gabrielle Chanel is creating more than a fashion: a revolution."[7]

There must be something in the nature of fashion writing that requires this type of hyperbole. In fact, there was room for both Chanel and Schiaparelli in fashion's pantheon, as well as for Dior and Balenciaga, and a host of others, male and female.

Today there are many women designers, among them Sonia Rykiel, who is widely regarded as the Chanel of modern French ready-to-wear. Not

only is she responsible for some of the most elegant sweater-dressing on either side of the Atlantic, but she has thought about the reasons why men have dominated postwar fashion, and why there seem to be at least some differences between the work of male and female designers. She argues that

> Men won't be wearing the clothes, therefore practical considerations are secondary and they can create magnificent designs. Women designers define things with more practical eye because of the limitations of their body. A collar that looks attractive on the drawing board might be difficult to pull over the head. And pants that appear elegant can be constricting.[8]

This sounds sensible and may even be true (although counterexamples spring immediately to mind). But we still need much more research before we can define the differences between male and female design. Only then will we be able to determine to what extent women's designs are more "practical."

At the Fashion Institute of Technology, the students in my graduate seminar were fascinated by this subject, and spent weeks discussing the history of women in fashion. The very successful Fashion Institute of Technology exhibition "Three Women"—on Madeleine Vionnet, Claire McCardell, and Rei Kawakubo—contributed further to the intellectual stimulation: In what ways were these designers, respectively a French couturière of the interwar period, an American sportswear designer of the 1940s and 1950s, and a contemporary, avant-garde Japanese designer, especially innovative? The evidence is not all in—I certainly have more questions than answers—but at the moment, I am inclined to think that there are few significant differences between the contemporaneous work of male and female designers. However, I am increasingly convinced that women designers have played a much greater role in the history of fashion than one might think from reading the average textbook.

There appears to be a complex and fluctuating historical pattern of female participation in fashion design. At various times, the production of clothing has been a home industry, a craft, and a business requiring substantial capital investment and particular kinds of professional training—and social attitudes regarding women's various roles in the industry have evolved accordingly. Until the late seventeenth century, "the professional business of making clothes for ladies . . . was mainly in the hands of men," although ordinary women tended to make their own clothes. Then in 1675, a law was passed in Paris "which was to change this pattern completely. After serving three years' apprenticeship in cutting and dressmaking women were now permitted to go into business as *couturières*, that is, as seamstresses." Over time, the job of making women's clothing became "virtually a female monopoly."[9]

The stereotype of the male fashion "dictator" initially reflected the fame of Charles Frederick Worth. This particular illustration is from Bertall's *La Comédie de notre temps* (1874), but the subsequent rise of Paul Poiret, Christian Dior, and other male couturiers ensured that the subject remained popular. Even Charles Dickens informed his readers: "Would you believe that . . . there are bearded milliners . . . authentic men . . . who, with their solid fingers, take the exact dimensions of the highest titled women in Paris—robe them, unrobe them, and make them turn backward and forward before them."

The nineteenth-century rise of the male dressmaker disrupted the by-then traditional distinction between male tailors and female dressmakers. In 1867, the tailors' magazine *Journal des Modes d'Hommes* struck out at "these bearded couturiers" who were beginning to replace female dressmakers. It was not right, they argued, that "men dress women today." Not only did they lack feminine "innate taste," but they had no right to encroach on the "arts and industries" that provided a living for so many women.[10] Presumably, this type of statement was not so much "feminist" as it was an expression of fear that this disruption would ultimately work to the tailors' disadvantage as well.

Four months later, "worker tailors" went out on strike. *La Vie Parisienne* responded to the tailors' strike of 1867 with jokes about gentlemen being "forced to go out during the day in evening suits" or dressing-gowns, to make their own clothes—ultimately even having to go to women's *couturières* (who would introduce unmistakable feminine details into the masculine ensemble).[11]

The reasons for the rise of the "man milliner" have much to do with general socioeconomic trends that affected nonfashion industries as well. As the organization of work became more clearly professionalized, larger in scale, and more industrialized, men came to dominate the upper ranks

of even hitherto female professions (midwives were replaced by doctors, for example). Meanwhile, women filled the ranks of unskilled or semi-skilled labor: Skilled male weavers were replaced on the new power looms by women and even children; female secretaries supplanted male clerks, but the *duties* of these female workers became far more circumscribed and routine. The development of capitalism meant, in practice, the feminization and proletarianization of much of the labor force.

In France as a whole, women in the paid labor force were overwhelmingly employed in the textile and garment industries.

> In Paris, where garmentmaking was the largest employer of women, women who worked in the *ateliers* (workshops) were typically young and single, but the expansion of ready-made clothing production, beginning in the 1830s, meant more work, too, for married women, who assembled already cut pieces at home.[12]

By 1860, of the 112,000 working women in Paris, fully 60,000 were employed in needlework, and thousands of others in related *métiers de la mode*.

Despite the notoriety of the male couturier, the vast majority of those in the fashion industry were women—the so-called "queens of the needle." Below the level of owners and business managers (who tended to be male), the hierarchy within any dressmaking establishment was largely female, from the saleswomen and forewomen to the humble seamstresses. There were also many women designers, a number of whom opened their own *maisons de couture*. This illustration by François Courboin is taken from Arsène Alexandre, *Les Reines de l'aiguille* (1902).

The Colin sisters were part of a veritable army of women who earned their living through fashion.

The mass production of men's clothing was well under way by the Second Empire, a fact reflected in the decline of the custom tailor. Women's fashions, however, took almost another fifty years to evolve from made-to-order to ready-to-wear. (With the exception of a handful of mass-produced garments like corsets and mantles, even the department stores generally sold clothing that required considerable finishing by hand.) It was partly the slowness of change that enabled a number of women to retain positions of some importance as skilled artisans. But as clothing production became more generally industrialized, women's positions declined.

Charles Frederick Worth is often said to have created *haute couture* singlehandedly, and to have invented everything from the crinoline to the bustle. It should not really be necessary to point out how over-simplified this picture is, but the "Great Man" theory of fashion is strongly entrenched. Worth was an important innovator, but not the originator of couture.

> In fact, there already existed, in the great capitals of Europe, skilful and well-known couturières who dressed women of the highest society; but on the whole the couturière was an executant who strove to interpret her clients' desires for elegant clothes. Worth's idea essentially consisted (and it is this that is the innovation) in asserting his authority as a creator, and proposing that women choose from a series of models, which are then executed according to demand, to the measurements of the clients.[13]

Yet by insisting on his creative "genius," Worth achieved greater fame than other dressmakers. Who but specialists recognize the names of his predecessors or contemporaries, Madame Clementine Bara, Madame Rosalie Prost, and Madame Eugènie Gaudry? By the time he died in 1895, Worth was famous throughout the world:

> The perfection of his success had enabled him to win the infinitely rare distinction of bestowing his name on his period. Just as history talks of the age of Pericles, of the Augustan era, of the times of the Medici, and of le siècle de Louis Quatorze, so also had I often heard the Second Empire described as *l'époque de Worth*.[14]

Because his most famous client was the Empress Eugènie, much of the meretricious glamour of the Second Empire has become associated with Worth. In fact, however, he only opened his own business in 1858, and began to dress the Empress several years later. Eugènie herself was far from being an innately fashionable woman, although she loved clothes, and it is entirely possible that Worth tactfully dictated to her. Certainly, the press considered him to be the personification of the power of fashion.

Indeed, the popular image of the modern couturier was of a man. As Charles Dickens reported in 1863:

> Would you believe that, in the latter half of the nineteenth century, there are bearded milliners—man-milliners, authentic men, like Zouaves—who, with their solid fingers, take the exact dimensions of the highest titled women in Paris—robe them, unrobe them, and make them turn backward and forward before them.[15]

Worth's continuing fame is in striking contrast to the oblivion into which Madame Paquin has fallen. Yet she was perhaps the foremost couturière of the late nineteenth and early twentieth centuries and, if anyone was Worth's successor, it was she. Despite this, most fashion histories mention her briefly, if at all. Since her first name is rarely given, some writers have even assumed that she was a man, or have thought that her husband was the real designer.

Jeanne Becker was born in 1869, and was possibly of Levantine origin. Together with her husband, the businessman Isadore Paquin, she opened a *maison de couture* in 1891 on the rue de la Paix. Later her brother also helped with the business, but Madame was the designer. She rapidly developed a great reputation, and was soon dressing some of the smartest and most aristocratic clients in Europe, such as the Queens of Belgium, Portugal, and Spain, the mistresses of the Prince of Wales, and the famous courtesans Liane de Pougy and La Belle Otéro.

Paquin was the first Parisian couturière to open foreign establishments—in London, and then in Buenos Aires and Madrid. Not only were her dresses prominently featured at the Universal Exhibition of 1900, but she was even elected president of the fashion section of the exhibition, demonstrating that she was highly respected by her peers. Paquin was the first woman decorated with the Legion of Honor for her contributions to the French economy. And toward the end of her career, she presided over the Chambre Syndicale de la Haute Couture. At the height of her success, she employed more than two thousand workers, when most other fashion establishments employed fifty to four hundred.

So why has she been forgotten? Fashion historian Jan Reeder has been studying Paquin, and she believes that part of this neglect is because Paquin was a woman. Possibly related to this was Paquin's own modesty—so different from Worth's self-promotion. As a respectable lady, Paquin seldom gave interviews, although one of the mannequins at the Universal Exhibition was a sumptuously dressed wax figure of Paquin herself. Paquin probably did not introduce any startling innovations in fashion itself, although her styles evolved dramatically in the years between 1910 and 1914. Like Worth, Paquin launched significant institutional innovations, such as setting up branches of her couture house overseas.

Worth's fame contrasts with the oblivion into which Madame Paquin has fallen. Yet she was perhaps the foremost couturière of her day. In 1914, *The Ladies' Home Journal* called her "the world's greatest fashion authority." Fashion historian Jan Reeder suggests that Paquin may have been forgotten because she was a woman. She was undoubtedly also thrown into the shade by the spectacular rise of Paul Poiret. This photograph by Paul Boyer for *Figaro-Modes* (1903) shows a typical Paquin dress of the period.

Like Poiret, Paquin used the best Art Deco illustrators, and like Poiret, she sent mannequins to tour America. Indeed, for many Americans, it was Paquin (not Poiret) who represented the best of the new style. Nevertheless, Poiret's spectacular rise to fame almost certainly contributed to the decline of Paquin's reputation.

In the early twentieth century, both male and female designers shared the limelight: Worth's sons were famous, but so was Paquin; Doucet was important, and so were the Callot sisters. The great designer Madeleine Vionnet began her career at the age of thirteen, when she was apprenticed to a small suburban dressmaker; she then worked for five years as a seamstress for the Callot sisters before going to Doucet, who allowed her to design her own models. Having built up her own clientele, she attempted to open her own shop, but the war temporarily disrupted her plans. In 1919, she tried again. This time she was successful.

Indeed, after the First World War, a great many women once again entered the upper ranks of fashion. This development may well have been associated with the progress of women's emancipation. It is also possible that the disruption of the economy may have offered enhanced opportunities for small new risk-taking entrepreneurs—and, if so, this might have worked to the advantage of women designers. By contrast, after the Second World War, the international economy was increasingly dominated by big business, and fashion by ready-to-wear, which may have adversely affected women's top-level participation—at least until recently.

Jeanne Lanvin also reached the peak of her fame in the period between the wars, although, like Vionnet, she was already a couturier before the war. Again like Vionnet, Lanvin began as an apprentice and worked her way up through her profession—and, like Chanel, she was initially known as a milliner rather than a couturière. Since Chanel has subsequently overshadowed her contemporaries, it is worth pointing out that in the 1920s observers had a different opinion of the relative stature of the various designers of the day.

The author of *Paris on Parade* (1925), listed as "fashion's hierarchs" first the House of Worth, then Poiret, Molyneux, Lady Duff Gordon, Robert Piguet (the young designer at the House of Redfern), Jean Patou, Lucien Lelong, Bernard—and, *finally*, "the women designers who wield such authority in the kingdom." First came Jeanne Lanvin, then Madame Jenny (formerly a *vendeuse* with the House of Bechof-David, who became an independent dressmaker in 1909), and lastly Madame Vionnet. Chanel was not mentioned, except in a list of dressmakers ("Patou, Chanel, Premet, Callot, and others equally famous") who had been "deliberately excluded" from an anti-piracy organization led by Madeleine Vionnet. United to protect the copyright to their dresses were the "truly first-class houses" of Beer, Cheruit, Drecoll, Jenny, Lanvin, Paquin, Poiret, Vionnet, and Worth.

259

The American author of *Paris on Parade* also emphasized the "tradition . . . of Madame Paquin's sole dictatorship in the empire of style." Although Jeanne Paquin did not die until 1936, apparently her house was already in something of a decline by 1925. Nevertheless, we read that "Fashion once simply did not know what to wear until Madame Paquin brought out her season's models; and as for her competitors, their plight was pitiful."

It seems fairly likely that there were always more women fashion designers than a mere list of couture houses might indicate. In 1925, for example, the house of Drecoll was actually run by a Monsieur (and Madame) de Wagner, a Belgian couple. According to *Paris on Parade*, "all Drecoll gowns are designed either by Madame de Wagner or by Mademoiselle Madeleine, who until recently was a partner in the firm of Madeleine et Madeleine."

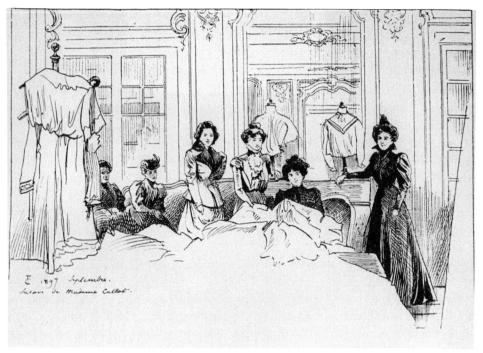

" 'Then, is there a vast difference between a Callot dress and one from any ordinary shop?' I asked Albertine. 'Why an enormous difference. . . .' " This illustration by François Courboin, "The Salon of Madame Callot," is taken from Louis Octave Uzanne, *Fashion in Paris* (1898), and shows the establishment where Madeleine Vionnet learned her craft.

Below the level of owners and business managers, the hierarchy within any dressmaking establishment was primarily female, and "more than one *vendeuse* with a personal following and marked designing ability has been able to get financial backing and open up her own establishment. . . . The house of Madeleine et Madeleine is such a place and so is that of Jenny." Next to the designer, the *premières* or forewomen "are the most expert dressmakers," and "the designer consults with them freely in working out his season's line." Among the "many" *premières* who later opened their own establishments was "the celebrated Madeleine Vionnet," "probably the most scintillating success of recent times in the Paris dressmaking establishment." For that matter, the de Wagners' daughter also became a well-known couturière, under the pseudonym Maggy Rouff. "But please note," her husband said, "she was not in trade, she is an artist."[16]

Clearly, there are certain promising directions for research that may contribute to a convincing revisionist history of fashion. We need to explore what there is in the structure of the fashion industry—at any given time—that would encourage (or discourage) women from becoming fashion designers. Is it a craft? A business? An art? All three? How does the traditional French method of working one's way up in the industry compare with other strategies? Have there been many unknown female designers, working for businesses that carried men's names? Have women in certain periods been steered away from fashion design and toward, say, fashion merchandising or fashion journalism?

For that matter, even in the field of fashion illustration, there seems to have been a trend toward the predominance of male artist-illustrators. In the nineteenth century, both women (such as the Colin sisters) and men (such as Gavarni and Jules David) worked for many fashion magazines. But by the twentieth century, men (such as Iribe, Barbier, Christian Bérard) outnumbered their female counterparts. However, with the rise of a *new* profession—that of the fashion photographer—an increasing number of women began to enter the field.

The career of Elizabeth Hawes throws light on the role of women in the fashion industry, as well as on the relationship between Paris and Seventh Avenue. After graduating from Vassar in 1925, Hawes went to Paris to learn about designing clothes. She got her first job in a copy house, and "after a few months I became sufficiently trusted to become embroiled in the business of stealing. It wasn't considered stealing. It was just business"—and in the fashion business, "you stole what you could and bought what you had to." Then she launched a "very lucrative" career as a sketcher for a New York manufacturer, which involved pretending to be an assistant buyer, but actually memorizing and copying the models shown at Paris fashion shows. Although disgusted by this plagiarism, as an "embryo de-

signer," Hawes seized "the opportunity to see all the work of the Parisian couturiers."

At the end of her first year in Paris, Hawes "still believed firmly" in what she later called "The French Legend"—that "all beautiful clothes are made in the houses of the French couturières and all women want them." She got a new job, designing clothes for the house of Nicole Groult, who was Poiret's sister, but the French couturière she most admired was Vionnet. She even briefly considered going into business in Paris herself, having almost despaired of the American tendencies toward imitation. Ultimately, however, she decided that she would not be happy designing for the formal European way of life, and that not all women wanted or could use clothes designed for such a life. In 1938, she dedicated her book *Fashion Is Spinach:*

> To Madeleine Vionnet, the great creator of style in France, and to the future designers of mass-produced clothes the world over.

And she replaced the French Legend with the motto, "All American women can have beautiful clothes."

She continued to be frustrated by the difficulties the American designer faced. It was "much easier" to work in Paris. "Sometimes you wonder why you ever tried to work anywhere else. Everything is arranged for couturiers to work in Paris." The "great tradition" of craftsmanship was alive, and so was the freedom to experiment, to say nothing of the prestige that accrued to the foreigner who became a "Parisian" designer.

In America, on the other hand, no one mentioned the designers' names, even when banner headlines proclaimed: "American designed clothes."

> "Our own American designs" . . . by whom? Why, by Americans. Who are they? What are their names? Never mind that, these are "Clothes designed in America" whoopee—by perfectly nameless people, robots maybe.

"The American Designers will come along, of course, no matter who inadvertently tries to kill them." It would be better if they were encouraged, given credit and, above all, "allowed to experiment," even though "experimenting costs money." But according to Hawes, the first thing for everyone, manufacturers, journalists, fashion designers, and ordinary men and women, was to "shed the French Legend."[17]

Between the Wars

The years between the wars have been known variously as "the glamour years," "the crazy years," and "the years of anxiety." At the top of the social pyramid, "women of fashion were at their most powerful—dictators, in a sense, of a luxurious and capricious way of life," As Bettina Ballard

"Three Creations by Jeanne Lanvin," a fashion plate from *Art, Goût, Beauté* (1925) depicts the streamlined fashions of "the crazy years." Jeanne Lanvin was one of the most successful women designers of the period, who was also known for her children's clothes and for romantic party dresses.

observed, this "small egocentric group of women" dominated high fashion "by making fashionable what they chose for themselves." Women like the Princesse Jean Louis "Baba" de Faucigny-Lucinge, the Vicomtesse Marie-Laure de Noailles, Princess Natalie Paley, and the Honourable Mrs. Reginald "Daisy" Fellowes were known as *Les Dames de Vogue*.[18]

Fashion trendsetters tended to belong to what was known as "international café society," a relatively small group of the wealthy and titled who entertained themselves at hotels, casinos, and cafés throughout Europe, but especially in Paris. Artists, writers, and intellectuals also flocked to Paris, because of the provincialism and puritanism of American society, because of the favorable exchange rate, and because of Prohibition. For Hemingway, of course, Paris was "a moveable feast," for Thomas Wolfe, "an enormous treasure-hoard of unceasing pleasure and delight." The French writer Jules Romains thought it was "a place and time without equal in the history of the world." Whether or not they were interested in fashion per se, the hordes of tourists who came to Paris—and whom the painter Henri Rousseau used to refer to, collectively, as *les Américains*—thought that Paris

263

was simply fun. Even after the Crash, those with dollars could live quite well in France.[19]

The style of French society had changed, moving even more rapidly away from formal dinners and receptions (as Proust had described them), and towards wild parties often held in semipublic settings such as the Ritz. Fashion reflected these changes, as well as continuing the element of "fancy dress" that was so popular in the Poiret years. There was certainly a note of surrealism in Elsa Maxwell's "Come As You Are" party, when guests arrived in slips or without trousers.

Meanwhile, students and bohemians revelled in various states of transvestism and undress at public balls and carnivals. Although these were a century-old tradition by the 1920s the police seemed to have abandoned all attempts to impose a degree of sartorial propriety.

Not only sun-bathing but nudism became a popular enthusiasm. Not only was the "boyish" look fashionable, but lesbians came "out of the closet" in full masculine attire—usually in the formal clothing of upper-class gentlemen, unlike today's radical lesbians who tend to prefer working-class garb. Not only did the French government strictly enforce laws prohibiting private businesses from discriminating against black customers, but *La Revue Négre* became the smash hit of the Champs-Elysées, and American racists had to cope with seeing French women dancing with black men.

The effects on fashion were nothing as simple as a rise in hemlines, but rather a reassessment of what it meant to be fashionable. Paris was Mecca, but much of new jazz style was American in origin—a combination of Harlem and Hollywood. "In small villages far from the metropolis," wrote translator Samuel Putnam, "young French lads were to be seen imitating the slicked back hair and flaring-bottomed trousers of Rudolph Valentino, while the girls did their best to imitate the mannerisms of Gloria Swanson." Meanwhile, in Paris Anna de Noailles admired Josephine Baker's gold fingernails, and advertisements promoted hair products *pour se bakerfixer les cheveux*.[20] In short, there was a fertile interchange between the rich, the young, artists, and outsiders, such as would not be seen again until the 1960s.

Of course, as early as the 1870s, *"l'américanisation de la femme"* had begun to be an issue—while in 1910, in his book *The Psychology of Fashion*, E. Gomez Carillo went so far as to characterize the situation as a true *"menace yankee"*: "Some multimillionaire yankees, leagued like kings in a crusade against antique beauty, have formed a new pact against us." Couture houses previously dedicated to rivaling each other in the pursuit of chic had capitulated in the face of millions of dollars and were converting themselves into "a single bazar of sumptuous novelties."

"The power of American gold is infinite. See what influence it exercises

on the Champs-Elysées, the avenue de l'Opéra and the rue Royale!" With the money to buy elegance, American women swarm over Paris, perverting and destroying fashion through their taste for the spectacular. "The yankees want to import new sensations, new tastes, new splendours, new pleasures . . . But I ask myself if all these novelties will ever be as good as the charms on the streets of present-day Paris."[21]

Quite apart from the charge of vulgarity—which might more justly be levelled against Hollywood than against the individual American women who dutifully purchased Worth dresses—what the French objected to seems to have been a mode of self-presentation. Young middle-class French-women were becoming more "boyish" (garçonnière), complained the Goncourts in their novel *Renée Maupérin* (1864). They liked to flirt, moaned Marcel Prévost in *Les Demi-Vierges* (1894). They smoked cigarettes and declined to wear corsets, said a host of early-twentieth-century observers. And after the First World War, they became modern with a vengeance.

Modernization arouses deep cultural anxieties—and this seems to be particularly true when it affects women. Within the United States, cultural conservatives simultaneously blamed the "immoral" French and the women's movement for the rise of the New Woman and her new clothes. In France, the villain was America. By the 1930s, French film reviews often included arguments about the Hollywood influence on fashion—which was generally considered to be a bad thing, a vulgar display of overornamentation in contrast to a pure and sober French taste.[22]

The influence of Hollywood is surprisingly difficult to pin down. Many movie costumes were necessarily somewhat outside fashion, because the producers feared that by the time the film was released, the costumes would look out of date. Nevertheless, despite the special requirements of such costumes, American producers (and stars) did commission clothing from Paris couturiers. Gloria Swanson was dressed by Chanel for her first "talkie," *Tonight or Never* (1931); Schiaparelli was hired to dress Mae West in *Every Day's a Holiday* (although the dresses had to be re-fitted for the buxom star). *Artists and Models Abroad* (1937) featured dresses by Patou, Worth, Paquin, Schiaparelli, Maggy Rouff, Lanvin, and Alix, as well as Hollywood designers Edith Head and Travis Barton. But Hollywood's real influence on fashion derived not from its dress designers but from the images of the stars themselves. Chanel might have put some of her clients into trousers, but for the general public the image of Marlene Dietrich in trousers was probably far more influential.

There is no one simple reason why fashion changes. There is no obvious and direct chain of cause and effect between, say, the First World War and the fashions of the 1920s, or between the Depression and the fashions of the 1930s. Rather, there apparently exists a complex web of interlocking influences, ranging from attitudes towards sex to ideas about technol-

ogy. The Victorians experienced their world as hurdling into the future with the speed of a railroad train, their young women as brash and boyish. But the streamlined look of women's dresses and the "built for speed" lines of automobiles and furniture evolved gradually. There was no abrupt break between nineteenth-and twentieth-century fashions, still less between the fashions of the 1920s and those of the 1930s.

Thirties dresses do seem relatively more "feminine" than Twenties dresses: As *Vogue* announced in 1932, "Spring styles say Curves." But the changes were gradual and not necessarily indicative (as some have suggested) of a movement to put women back in the home. Our perspective on past fashions is constantly shifting. Writing in the 1950s, Cecil Beaton argued that

> From the visual viewpoint of clothes, the Thirties was undoubtedly a drab period. . . . Looking at them now, one can see only an uninspired modification of the Revolution of the Twenties: The boyish bob had vanished, but women's breasts were still flat, and the longer skirts and slightly higher waistlines seem merely mechanical additions to the short, tubular dresses they had displaced.[23]

But fashion historians writing in the 1970s were naturally attuned to the similarities between the 1920s and the 1960s, and so they tended to stress the *differences* between the 1920s and 1930s. Moreover, they tended to prefer the "easy, graceful, rather softly shaped" 1930s dresses, which seemed closer in spirit to the longer skirts and more fluid lines of mid-1970s fashion. Whether they perceived the 1930s style as more feminine and therefore more attractive, or as more feminine and therefore less liberated, they did see it as more "feminine." And yet, by 1985, Anne Hollander was interpreting the 1930s style in terms of the latest fashion trend—"the new androgeny"—proving, once again, that much of the meaning of fashion resides in the eye of the beholder.[24]

World War II

The Second World War brought the age of experimentation to an end. The fall of France cut off contact between Paris and the West, killing the export trade (except to Germany) and leaving American designers entirely to their own devices. The Nazis initially ordered the entire Paris fashion industry to move to Berlin. But Lucien Lelong, president of the Chambre Syndicale de la Couture Parisienne, argued so strongly against this transfer that the Germans backed down, and left the industry in Paris and largely under French control. Some couture houses closed down—Schiaparelli fled to America, Vionnet retired, and Chanel went into seclusion with her Nazi lover—but about twenty houses continued to produce a hundred models per year, fashions designed primarily for wealthy collab-

orators and for export to Germany. There were shortages of materials, and the Germans sporadically closed houses that flouted restrictions, but, nevertheless, French couturiers "concentrated on extravagantly flamboyant creations," as they argued later, "in deliberate defiance of the Germans."

Some couturiers claimed afterwards that they were trying to make the Germans look absurd—an argument many foreigners found difficult to accept. (English fashion historian James Laver "reproached them for having invented this argument after the fact in order to justify themselves in the eyes of history.") More credibly, other French designers suggested that "the couture preferred to keep up appearances by cutting down on the number of models instead of spreading the material thin." Certainly, however exaggerated and bizarre the French wartime fashions, they were copied by many ordinary Parisians, who presumably were not trying to make themselves look ridiculous. Perhaps on some semi-conscious level, flamboyant fashions were a way of denying the humiliation of defeat. Since 1940s fashions have recently been revived (notably by Yves Saint Laurent), a third possibility suggests itself: That Parisians at the time really liked their "exaggerated" wartime modes. Moreover, it appears that whereas the English and Americans hoped that saving material would help the war effort, in occupied France "the people assumed that the more material a garment used, the less the Germans would get."

When Paris was liberated in 1944, foreign correspondents were shocked—even appalled—to see how the French "lavished fabric into parachute sleeves, elaborate draped bodices," full skirts, and "out-sized hats that were over-trimmed." One horrified WAC commented: "It seems terrible to see huge velvet skirts and sequins when the world is at war." Some of the French designers seemed embarrassed when they were told about clothes rationing in Britain and austerity restrictions in America, whereby the amount of fabric and the number of buttons, pleats, and other details were limited to save both manpower and supplies.

Returning to Paris from England, the couturier Captain Edward Molyneux hastened to suggest that if clothing restrictions remained in place, the Paris couture could produce simple, restrained fashions that would conform to Allied requirements. But did the war effort really depend on whether "useless" buttons were employed as decoration? The French government announced a halt to the sale of dresses to the wives and mistresses of "black marketeers and war profiteers," although how this was to be enforced remains unclear. Roger Worth defended the couturiers of Paris, arguing that the livelihood of thousands of workers and the future of the couture were at stake, and they were "paving the way for a resumption of French business life."[25]

The history of the French fashion industry during the war years re-

mains obscure, the more so since, afterwards, accusations of collaboration came to the fore. As Michel de Brunhoff, editor of French *Vogue*, recalled:

> There was no honorable way of publishing a magazine under the Germans; there was no way without compromise and collaboration. I stalled and formed slippery answers for the Germans. . . . The problem was to work without selling out. We all helped each other break enemy regulations. Finally I found a way of publishing fashion albums without saying *please* to the Germans. It was all very complicated. It jumped borders and involved quite a lot of risk— but it was exciting. Our secret staff, artists, engravers, printers gave their best. In these books the changing silhouette of the Parisienne reflects the progress of survival and of reaction to the rule of the Boche.[26]

Since Chanel closed her *maison de couture* a year before the war began in Europe, she cannot be said to have collaborated simply to stay in business. Nevertheless, her romantic association with a high Nazi official made her, in the eyes of many, a personal collaborator, and this effectively kept her from reopening for many years. Her biographers have been at pains to ignore or to explain away this episode, but it is clear that she was a fervent supporter of the Vichy regime, and regarded the French Resistance as criminal. "It was France that asked for an armistice," she told the publisher of *Women's Wear Daily*, "and therefore any Frenchman who broke the armistice was a criminal." James Brandy recalled that he was utterly unable to convice her that this position, while correct in narrowly legalistic terms, was ethically wrong. Indeed, a recent American novel about the fashion industry opens with "Chanel's first appearance in New York since she'd gone into exile after the war"—"well-deserved," the narrator quipped, "since she'd shacked up with the biggest Nazi kraut in Paris during the occupation."[27]

If the couture staggered on, the ready-made clothing industry was in worse shape, in part due to the "draconian" rationing of textiles. Moreover, "almost all the women's *maisons de confection* and a number of the men's ready-made shops belonged to Jewish families." According to Bruno du Roselle (Honorary President of the *Union française des Arts du Costume*), the majority of Jewish fashion manufacturers fled abroad, while some retreated to the southern zone around Nice and Marseilles, laying the foundation for new postwar centers of ready-made clothing.

In the Special Collections of the Fashion Institute of Technology Library, the George E. Linton *Scrapbook* of newspaper clippings (from *The New York Sun*, August through September of 1940) chronicles the "movement to establish New York City as the fashion capital of the world, succeeding Nazi-dominated Paris." David Dubinsky, president of the International Ladies' Garment Workers Union, called for someone to "step forward and assume the leadership" of the "creative end of the garment

industry." "It must be done in a business-like way," he said, indicating that merchandisers rather than manufacturers should take the lead.

"With the black-out of Paris, our own designers will . . . dictate the styles," proclaimed a typical newspaper article. But who were these new dictators? A "little-known group of approximately four hundred designers" was mentioned, as was the Designers' Guild (founded in 1932). Apparently, there was "only one woman member" in the Designers' Guild (and she did children's clothes), but other articles mentioned Germaine Monteil, Nettie Rosenstein, Louise Barnes Gallagher, and Sophie Gimbel as being among New York's "top flight creators."

Only the exiled Schiaparelli resisted the slogan "Paris is dead; long live New York!" In a series of public lectures, she repeatedly insisted that "It is not possible for New York or any other city to take the place of Paris." American fashion designers were "hampered" by the requirements of mass production and by the American woman's relative "lack of interest" in fashion. "It is the women of a country," she asserted, "who determine the standard of elegance of that country, and no standard can be built very high when quality is not the first consideration."

Headlines trumpeted: "Paris Still Held Center of Fashion. New York Will Not Replace It Because of Our Commercial Stress, Schiaparelli Says . . . French Industry Will Arise Again Despite Disaster, Designer Adds." Indeed, the designer dismissively announced, "Your press is making a veritable campaign on this subject [of New York fashion leadership], a campaign which is not justified by the facts." The Parisian designer, she said, had a degree of creative "freedom" far in excess of the American constrained by the "profit motive."

"Experts Say American Women Have Duty to Launch Styles," countered another headline. "Cycle of Fashion Requires Group Willing to Assume Responsibility for Being Best-Dressed." A formal social life was necessary, including occasions comparable to "the opening of the racing season at Longchamps." Moreover, American women were warned, "It takes real courage to be a fashion pace-setter, to wear a strange-looking hat or a completely different silhouette for several months before the public eye becomes accustomed to it." Nor is the average "husband . . . willing to see his wife wear [something too avant-garde] in public." American women are "afraid of individuality," complained French-born milliner Lilly Daché; they retreat into "informality and uniformity."

There were occasional articles on the situation in occupied France: "Nazis Buy Heavily at Sulka's, Paris. Officers and Party Officials Take 65% of Goods Sold." "Domestic Buying is Halted by War and Fashion Leaders Cannot Break Through the English Blockade." "Paris Couturiers Plan 'Symbolic' Exhibition." And, one of the most interesting articles, "Paris Papers Score Frivolity in Dress." Apparently, there was a press campaign

being waged "in favor of 'Frenchwomen' as opposed to 'Parisiennes.' 'Ladies,' already supplanted in America by business women, will here be dethroned by mothers." As part of the fascist movement to put women back in the home, the "joys of motherhood" were extolled at length—and to the detriment of fashion. "The only authentic fashion pages . . . are dedicated . . . to bicycle costumes for town wear."

> For some time now tendentious articles on Paris fashion have been appearing in the regular columns of daily papers. They talk of "purifying" the mode. They frown on maquillage and dyed hair. They deplore the "luxury" fashions designed by the great Paris couturiers and push chic for the masses.

So as the American press urged women to become fashion leaders, the French press promoted fashion leveling.[28]

Because the fall of France effectively severed the flow of fashion information from the Paris couture, American and British fashion designers and manufactures were on their own for four years, as had not been the case during the First World War. Textile rationing was established in Britain in 1941, to be followed a year later by the so-called "Utility Clothes," more optimistically known in the United States as the "Victory Suit." This uniform look, made in sensible tweeds with fairly short skirts and broad shoulders, dominated Allied women's fashions. But there were other styles as well, and certain American designers such as Norman Norell and Claire McCardell began to come into their own.

Today in the United States, Claire McCardell, in particular, is regarded as the first great creator of the "American look." Arguing that her clothes stood for "freedom, democracy, and casualness," she specifically saw her prototypical client as the American "career woman." In the autumn of 1986, noted fashion writer and photographer Bill Cunningham offered the highest praise when he argued that Donna Karan "places Seventh Avenue in a position of international authority unknown since the legendary designer Claire McCardell." Both of them succeeded because they combined "the ease and versatility of sportswear" with the businesslike elegance that was also characteristic of Norell's work.[29]

For the first time, American designers were more than temporary substitutes for the French. They began to carve out their own sphere of influence, centering on sportswear and work clothing. During the 1950s they again took the back seat, but in the 1960s and 1970s, they became important once more—at least within certain clear segments of the American market.

Meanwhile, in Paris, a somewhat "masculine" tailored suit was also the dominant wartime fashion, with a continuation of the broad shoulders first introduced by Schiaparelli in the late 1930s. But during the occupation, Parisian women also adopted complicated and extravagant hats and tur-

bans, as well as platform shoes—and this despite the fact that the absence of motor vehicles meant that many women had to bicycle everywhere. Materials were in very short supply, but milliners even used wood shavings to decorate their hats.

Long after the war, Chanel recounted how she had been arrested for wearing trousers. The Vichy regime, she said, had forbidden women to wear men's clothing. While this event may have happened (she couldn't lie about everything), there is photographic evidence that in Paris, at least, trousers for women finally became acceptable. Moreover, during the war years, some French women were literally reduced to wearing the clothing of their husbands, who were absent or dead. In England and America also, a number of women began wearing trousers, especially if they worked in heavy industry or in agriculture.

The Vichy regime did emphasize symbols of *la francité*—from Joan of Arc to that stereotypically French headdress, the beret. As Richard Cobb points out, photographs from *les années noires* show "a multitude of berets," whose "size and shape could indicate a wide range of commitment, from fussy Vichy orthodoxy to the madder fringes of ultracollaborationism." The most acceptable color was dark blue, although "green might do for Dorgère's rural fascists" and "Darnand, emulating no doubt the SS, imposed a black beret on *la Milice.*" Socialist red was "out of the question." Men and women, ordinary people and high officials, all wore "the national beret." But after June 1944, the beret was put away. To quote Richard Cobb:

> One thing that is evident, even to the eye, is that Vichy and Paris collaborationism, for once in agreement in promoting an emblem that both reassured as a reminder that one could still be French, and even more French than ever, despite national humiliation, and that represented the quintessence of *la francité*, eventually finished the beret off, not all at once, but on a steadily declining course. The beret had somehow lost its innocence, it had become politically contaminated . . . henceforth associated with organized killing. . . . Nowadays, in Paris at least, it is rarely seen.[30]

Beginning in 1942, a number of Parisians of both sexes adopted a style called "zazou" which was similar to the "zoot suits" of California. (One can also trace similarities between the French *zazous* and the English "Teddy boys.") As in the United States and Britain, this was primarily a working-class and masculine fashion, consisting of long jackets, shoes with very thick high soles, and wide trousers—or, sometimes, skin tight trousers. Both male and female *zazous* wore pompadour hairstyles, and reacted against the prevailing militarism and austerity by trying to look as flashy as possible. Apparently they got the money to buy their clothes from the black market, and the general public disapproved strongly of their parties, where

they danced to swing music, and which were popularly believed to terminate with wild sexual orgies.[31]

According to *The New Yorker's* reporter, Janet Flanner, the *zazous* had disappeared by February 1945, when the thrift shops were full of their discarded paraphernalia. The fashion scene in liberated Paris was one of threadbare but determined chic:

> Everything here is a substitute for something else. The women who are not neat, thin, and frayed look neat, thin, and chic clattering along in their platform shoes of wood—substitute for shoe leather—which sound like horses' hoofs. Their broad-shouldered, slightly shabby coats of sheepskin—substitute for wool cloth, which the Nazis prefered for themselves—were bought on the black market three winters ago. The Paris midinettes . . . still wear their home-made, fantastically high, upholstered Charles X turbans. Men's trousers are shabby, since they are not something which can be run up at home. The young intellectuals of both sexes go about in ski clothes. This is what the resistance wore when it was fighting and freezing outdoors in the *maquis,* and it has set the Sorbonne undergraduate style.[32]

These attempts to maintain a sense of style in the face of adversity demonstrated a genuine sense of resiliance, while the students' attraction to the style of the Resistance fighters also showed where their political sympathies lay. But for a long time, life in the French capital continued to be a struggle, and when, in June 1946, the Opéra put on a gala ballet for the Big Four postwar conferences, the sign above the box office timidly asked the public to wear evening clothes "to the extent to which it may be possible." Invitations to an opening at the Galerie Charpentier were more peremptory: Dressing up was "acutely desirable."

How was the couture to recover? In 1945, the Chambre Syndicale de la Couture Parisienne organized a traveling exhibition, featuring dolls dressed by the most famous Paris couturiers. *Le Théâtre de la Mode* was presented from Copenhagen to Barcelona, in London, Paris, and New York (financed, in part, by American relief organizations), and succeeded in helping to launch the French back into the international fashion market. Not only were the miniature clothes extremely pretty, but the sets by artists like Christian Bérard and Jean Cocteau recalled the pleasingly audacious style of prewar fashion illustration and photography. To emphasize further the French contribution to civilization, the accompanying catalogue reproduced numerous French paintings and drawings—from Watteau to Boldini—that dealt with the art of fashion.

The message was clear—"France has suffered greatly from the war and the Occupation. . . . She has great difficulty in reconstituting her stocks, even for her personal requirements. But her creative genius is intact." Anticipating perhaps a hostile response, the French Ambassador to London introduced the exhibition there by saying, "Let there be no misunder-

1939	*1940*		*1941-42-43*		*1947*
Ligne diabolo	*Simplicité militaire*	*La jupe paysanne*		*La veste "zazou"*	*Le "New-look"*

A detail from "The Changing Silhouette of Fashion" by R. de Laveierie shows the prewar antecedents of Dior's "New Look," as well as giving a sense of both the military simplicity and the exaggerated fashions adopted during the war. Reproduced from Marcel Rochas, *Vingt-cinq ans d'élégance à Paris* (1951).

standing on the part of those who are going to see these evocations of luxury. These beautiful objects are a labour of love on the part of the Paris *midinettes,* who made them with frozen fingers in their famished city." This, too, he said, was a form of "Resistance."[33]

When the wife of the French Ambassador, Madame René Massigli, appeared in London, her clothes caused a sensation: "a long waisted jacket over a knee-length billowy skirt and one of those undepictable hats," As one fashion journalist recalled, "she looked as if she had landed from another planet."[34] Two years later, in 1947, Dior's "New Look" would burst onto the scene, making the short-skirted, boxy-jacket fashions of the war years instantly *démodé.* But if we look more carefully at the fashions immediately before and after the war, we may wonder why people were so surprised. The look was there, in embryo, in 1939, and began to spread once Paris was liberated. In autumn 1945, for example, Balenciaga showed hemlines fifteen inches from ground.

Already in 1939, Horst shot one of his most beautiful photographs for *Vogue,* titled "From Paris—the New Detolle Corset with Back Lacing." Subtly erotic, reminiscent of the sweetly lascivious prints of the 1830s, it showed a women, naked except for her corset, the back laces of which dangled invitingly. According to the caption, "Paris puts you back in laced corsets . . . to bind you in for the Velásquez silhouette." Indeed, throughout the last year before the war, *Vogue* insisted that "there isn't a silhouette in Paris that doesn't cave in at the waist."[35] The long, slim look of the 1930s was evolving into one featuring more opulent curves, while the broad shoul-

ders that would be frozen in place during the hiatus of the war years were already beginning to soften. Mainbocher's 1939 collection, for example, was described as positively Victorian in its lush femininity. Had the war not broken out, something like the New Look would probably have emerged in any case. But now we cannot help seeing it in terms of a reaction to the Second World War.

From New Look to New Wave

"We were emerging from a period of war," wrote Christian Dior, "of uniforms, of women-soldiers built like boxers. I drew women-flowers, soft shoulders, flowering busts, fine waists like liana and wide skirts like corolla." The more romantic silhouette began before the war, and after the war ended other designers tentatively experimented with longer skirts and cinched waists; but it was this hitherto unknown designer who most clearly sensed the direction that fashion was going and presented it, in all its glory. As Dior explained, "No one person can change fashion—a big fashion change imposes itself. It was because women longed to look like women again that they adopted the New Look."[36]

Certainly, the New Look aroused passionate enthusiasm among women who loved fashion. One young American woman living in Paris wrote to her friend at home:

> [February 15, 1947] The girl friends say I must have a look at a man named Christian Dior, no one ever heard of him before but there is something called "The New Look" which he has invented. Apparently Mrs. Snow of *Harper's Bazaar*, who is here, says that this man Dior has saved the French fashion industry. . . .

> [February 23, 1947] I did go to Dior's first collection, fighting my way through hundreds of richly dressed ladies clamoring to get in. It is impossible to exaggerate the prettiness of "The New Look." We are saved, becoming clothes are back, gone the stern padded shoulders, *in* are soft rounded shoulders without padding, nipped in waists, wide, wide skirts about four inches below the knee. And such well-made armor inside the dress that one doesn't need underclothes; a tight bodice keeps bust and waist as small as small; then a crinoline-like underskirt of tulle, stiffened, keeps the skirt to the ballet skirt tutu effect that Mr. Dior wants to set off the tiny waist.[37]

The prices were high, she admitted, but, fortunately, Dior asked her to wear his clothes that season—free—as "publicity and a bait for other customers" (a practice that was, and remains, common). After all, the future Susan Mary Alsop was young, pretty, and socially prestigious enough for Mrs. Snow to have her photographed for *Harper's Bazaar*, in a Balmain dress, and seated on a sofa in front of an antique mirror. As the photo-

grapher's French assistant put it, the effect was supposed to be *"très David mais très ladylike."*

Dior rapidly became a household name. Mass-circulation magazines printed articles such as "That Friend of Your Wife's Named Dior." Women who could not afford a real Dior bought (or made) copies. Naturally, there was some resistance to the idea of discarding serviceable but now old-fashioned dresses, and apparently a few American women even banded together to form something called "A Little Below the Knee Club," since the long skirt was the most conspicuous feature of the New Look. To those who regarded couturiers as dictators (and Dior, in particular, as the tool of the Boussac textile interests who financed his opening), Dior replied that he risked the salary of his workers every time he made a collection: "The couturier proposes, but the ladies dispose." Certainly, success on such a scale cannot reasonably be interpreted as the product of the fashion industry's propaganda machine. Rather it seems that Dior brought a new excitement to fashion, and one that many people welcomed. Indeed, by the mid-1950s, the low-price American copies cost as little as $24.95, and then other pirates "pirate the pirates and undersell them by $20."[38]

The subject of 1950s fashion and its relation to the "feminine mystique" has been ably dissected in Barbara Schreier's *Mystique and Indentity: Women's Fashions of the 1950s,* while Anne Bony's two books, *Les Années 50* and *Les Années 60* contain substantial sections on fashion in France during these years.[39] But from our perspective, it is particularly interesting to explore why *Paris* fashion made such a terrific international comeback after the war—despite Europe's irrevocable decline in importance, despite the differences in social life, not only before and after the war, but also the differences between life in the the United States and in France, and, most of all, despite the significant progress made by the American fashion industry during the 1940s. After all, in the visual arts, the war marked the end of European dominance and the real beginning of the New York "art scene." But the equivalent transformation did not occur in the fashion arts.

Instead, American magazines published articles such as "How to Buy a Dior Original," which simply assumed that "It's every woman's dream to buy a creation direct from a famous French couturier." Nor was this simply a replay of the old society woman's self-confident pilgrimage to the House of Worth. Rather, it was "the step-by-step story of how it's done—from the first showing to the final fitting." The tourist was given advice about the necessity of arriving in a taxicab or, better yet, "a rented Rolls Royce," after having reserved a seat for the collection through the hotel concierge—"at all the *better* hotels they have arrangements with certain *vendeuses* or salesladies at the various houses." Wearing a "haughty expres-

sion" and carrying "a well-padded purse," anyone can "come out with an incomparable dress that will be immediately recognizable back home as an authentic Paris model." But first she must try on the model she wishes to buy (assuming she is more or less the size of the mannequin), pay a deposit of roughly half the price (in 1955, about $400 to $1,000), return to be measured, and return again for several fittings (first for the linen *toile* and then for the dress itself). "It's a little more complicated and time-consuming and expensive perhaps than buying a dress at the Young Wives Shop at a department store back home. . . . But it will definitely be worth it."[40] The sheer prestige of Paris fashion contributed to its postwar revival.

Everything having to do with Paris *haute couture* apparently fascinated American women, who eagerly read articles about the "little hands" who sewed the dresses, as well as the glamorous mannequins who modeled them. Professional American "model girls" were also increasingly popular figures (who gradually tended to replace the society models of former years), but there was no popular audience for articles about the International Ladies' Garment Workers' Union. And for every interview with an American fashion designer there seemed to be dozens about the big French designers.

In the 1950s, "reporters . . . cover [Dior] as though he were a war," emphasizing both his house's financial clout—$15,000,000 in 1954, or about 66% of the couture's foreign exports—and his alleged affect on male-female relations: apparently "Dior phobia" was rampant among American men. Obviously, much of this reportage was a deliberate attempt to generate controversy—a switch from the H line to the A line supposedly "wipes out curves" and "completely bypasses the bosom," while the structural lining in a ball gown made holding the wearer "like grasping a bird cage." Some also objected to the "sculptural" or "structural" fit of his clothes on the grounds that "the average American woman stands five foot three, weighs 133 pounds, has a 35½-inch bust, a 29-inch waist and 39-inch hips. Try getting that into one of Dior's fuselages." But, again, the *average* American customer bought a U.S. copy that had deliberately been "let out" to fit her. No Seventh Avenue manufacturer was going to produce dresses that no one could wear.[41]

When Dior suddenly died of a stroke in 1957, his twenty-one-year-old assistant was catapulted to the position of head designer at the house of Dior. Saint Laurent's first collection, on 30 January 1958, featured the "trapeze" look, a youthful and easy-fitting modification of Dior's "A" line, which has subsequently become standard maternity wear—no tight girdles necessary here. It was greeted rapturously by Parisians demonstrating in the streets, chanting his name and saying that he had saved the French fashion industry. But when he continued experimenting with different hemlines, and when his "Beat Collection" of 1960 was savagely attacked,

he underwent a series of devastating reversals. First he was drafted to fight in the French-Algerian war, but before returning to his Algerian birthplace he suffered a total nervous breakdown. Then, while still in the hospital, he learned that he had been replaced at the house of Dior by another designer, Marc Bohan. The following year he successfully sued the house of Dior, and opened his own couture house. Over the next quarter of a century, alternately hailed and denounced, he established himself as probably the world's greatest fashion designer.

Even during the 1960s, when French fashion was largely eclipsed by the styles of "swinging London," Saint Laurent continued to be recognized as a genuine creative force. Chanel herself said that Yves Saint Laurent was the best of the young designers—principally because he owed so much to her! John Fairchild of *Women's Wear Daily* announced in 1962: "This guy is the only designer in Paris who really belongs to the Sixties."[42]

André Courrèges was the other great French designer of the 1960s— famous for his mini skirts (the shortest in Paris) and for making trousers an important part of every collection; he was known for the "space age" look, white boots, and "little girl" clothes. In France, it was called the "Courrèges revolution"—"Are you for or against it?" demanded French *Vogue*. Chanel thought the mini was "dirty," even for young girls. Saint Laurent found it stimulating.[43]

But the mini really began, not in Paris, but in London. If Courrèges did a couture version, it was nevertheless much less influential than Mary Quant's ready-to-wear minis, as the French tacitly admitted when they spoke of *"yé yé"* fashion and *"le style anglais."* It was *"à bas le Ritz, vive la rue"*— and the ultimate street was Carnaby Street.

Courrèges, of course, insisted, "I was the man who invented the mini. Mary Quant only commercialized the idea." But Quant confidently replied:

> That's how the French are. . . . I don't mind, but it's just not as I remembered it. Fashion, as I see it, is inevitable. It wasn't me or Courrèges who invented the miniskirt anyway—it was the girls in the street who did it. Designers simply anticipate what the public wants. I really don't believe in designers squabbling like a lot of kids. Maybe Courrèges did do miniskirts first, but if he did no-one wore them.[44]

Meanwhile, America lagged behind. In 1964, when *WWD*'s James Brady returned to New York after six years in Europe, he and his wife were startled by the length of women's skirts: They were "positively dowdy." Of course, despite "sermons and editorials," the mini eventually caught on, and soon *WWD*, *Time*, *Life*, and *Newsweek* featured photographs of Jackie Kennedy's knees. Hemlines crept higher and higher until 1969, when European designers picked up on another avant-garde trend—the long "granny

skirts" worn by hippies. In suitably high fashion versions, the longer, much longer skirts were unveiled in the European collections of January 1970.

The "midi" also caused a sensation—it was flatly rejected. There were "ban-the-midi" clubs. People said the midi was un-American. A woman in Texas wrote to *Women's Wear Daily,* saying: "We love the mini skirt. . . . And we support Nixon and Agnew, too." But the mini-midi controversy made strange bed-fellows: Apparently, "Georges Pompidou and Richard Nixon went on record as being for the midi, Paul Newman and the Lieutenant Governor of Georgia as being against it." Fashion manufacturers (with large numbers of minis still in stock) came out against the midi; so did conservative housewives and socialites (and a lot of men) who regarded the mini as sexy and feminine. A number of feminists also attacked the midi and characterized Brady as a "sexist toad" for encouraging women to follow fashion's hemline dictates. Even the majority of fashion magazines waffled, urging women to decide for themselves. Brady debated the issue on the *Today* show with a young woman who "was on a countrywide crusade in defense of the miniskirt. . . . I asked the young woman when she had begun wearing mini skirts. 'Last year,' she told me." Despite it all, within about a year hemlines began to go down, although the mini retained its place as an informal, summer style.[45]

The (temporary) resistance to the midi skirt did not mean that women had ceased to follow fashion. But it did mark the end of a period in which hemlines dominated the fashion news. Already by the mid-1960s, the meaning of fashion was undergoing a profound transformation. The traditional division between fashionable couture models and ready-made copies was breaking down, as was the whole *idea* of a fashion dictatorship by designers, big manufacturers, and department store buyers, fashion editors, and "women of taste." French film star Brigitte Bardot scornfully dismissed the idea of dressing in couture clothes: *"Ça fait mémé"* ("That's for grannies"). In 1965, Saint Laurent himself announced that "The young lead very different lives from the lives of women who wear couture fashion. Not all of the young would want couture even if they could afford the price." And he opened the first of his boutiques—Rive Gauche—thus associating his endeavor with the youthful Left Bank bohemianism that was the French equivalent of the Anglo-American Beats, Mods, and Hippies.

"Couturiers, haute couture, *la mode*—they're all terms that are outdated," said Saint Laurent. Young people in the street were making their own fashions. "It was a horrible crisis for me," he said later, "I began to realize that fashion can come from anywhere, that daily life is everywhere." He was receptive even to the revolutionary currents of 1968, and felt increasingly ambivalent about working all his life in a luxury industry: "My true public are young women, working women. If I keep certain pri-

vate clients, it's in order to keep my seamstresses, not the other way round." Whereas Coco Chanel was enraged when her workers held a sit-down strike in 1936, the House of Saint Laurent is said to pay the highest hourly wages in the industry.[46]

But if the 1960s were dominated by American blue jeans and by Mary Quant's Carnaby Street styles, what happened in the 1970s? The first thing to remember is that, while the 1960s began with mod fashions, after 1967 or 1968 the hippy look took over. Space-age fashions and mini skirts were increasingly replaced by both a nostalgic Edwardian look (epitomized by the "granny dress") and by a wave of "ethnic" fashions, inspired by the hippies' sojourns in places like India and Morocco. The hippy look influenced high fashion—and then, at third-hand, filtered back down to the middle-class mass market. Thus, what occurred was not merely a case of fashion filtering upward (instead of trickling down), but rather of a complex web of influences. A whole new group of young fashion *innovators* appeared, but for middle-class, middle-aged people to copy them, it was necessary that the "Indian bedspread" look be reinterpreted by more orthodox fashion leaders and propagandists.

After the revolutionary 1960s of minis, trousers, and unisex, the 1970s settled into two basic types of fashion. On the one hand: "There were those who wanted calm" and who adopted a variety of "quasi-official fashions." The midi of 1970 slowly rose to just below the knee by 1975, and remained in that vicinity. Certain barriers were broken down—trousers for women, in particular, were a classic 1970s style (although, interestingly enough, by the 1980s, working women largely renounced the pants suit for a suit with a skirt). The second category of women, however, wore more diverse styles—not with the revolutionary fervor of the 1960s, but with a slightly ironic or "camp" attitude. In many cases, the "straight" look dominated for daytime business dress, while the more avant-garde styles were reserved for evening.

As French fashion historian and journalist Marylène Delbourg-Delphis recalls: in the 1970s, in France (as in America), there was almost an obsession with "wearable" clothes that looked "functional." Women wanted freedom from the supposed "despotism" of fashion—so for a decade they wore what looked like the same pair of pants. In fact, however, "The *diktat* changed its form, but it is all the more imperious for being more diffuse."

Certainly, no one could deny that conformity is one of the primary characteristics of today's professional dress. "By an irony of a sort, it was at the moment when people said 'there is no more fashion' that it appeared suddenly everywhere." But the idea of fashion had been transformed: People now believe that fashion is "optional." Yet certain fashions prevail: Due to the growing prestige of work, professional uniforms are fashionable. Because of the popularity of sports—even a belief in the *virtue*

of exercise—sportswear is also fashionable. A "very American" system prevails, whereby each individual asserts her independence, while "choosing" to conform strictly to public opinion. "Fashion always seems arbitrary, because in the last resort, it is," she concludes. "Why jodhpur pants in 1981? Why get dressed at all?"[47]

I must confess that I have engaged in my share of polemics, both against a prevailing anti-fashion sentiment and against the Panglossian view that absolute freedom has arrived and fashion is daily becoming better and better in every way. Both the belief that fashion is anti-feminist and the equally popular feeling that fashion has finally become "good" are oversimplified, although there are elements of truth in both positions. To understand how fashion really works, it is necessary to identify the motives for fashion change. The two main theories focus on economic conspiracy and on sex. Fashion is, obviously, a business, and the industry has an interest in promoting change—as do automobile and furniture manufacturers. But no one is forced to change their style of dress. For one reason or another, they *choose* to do so.

When I was writing my first book, *Fashion and Eroticism,* I took the position that fashion change is caused primarily by sexual curiosity. Unlike the "sex appeal" theorists, however, I did not accept the so-called "theory of the shifting erogenous zone." If fashion emphasizes the bosom one year and the legs the next, this is not because men become bored with bosoms or legs! Instead, my argument was that sexual curiosity is expressed sartorially by the attraction to novelty—what has been called "neophilia." I still believe that this is an important factor in fashion change, but I now recognize that (as usual) the situation is more complex.

Fashion innovators are neophiliacs. These are the people who eagerly seize on new styles. More recently, they have also revived old styles ("retro") and given them new meanings. Because style is an important aspect of their self-identity, they may become fashion leaders. Even in the nineteenth century they were not always upper class, and nowadays they tend to come from particular segments of the urban upper-middle class. Their influence does not so much "trickle down" through society, as it radiates outward to others with rather similar perceptions of themselves.

But novelty can also seem threatening to many people. In recent years, both Sonia Rykiel and Yves Saint Laurent have said that the fashion press may be the death of fashion "if it doesn't stop rushing to kill off clothes before their time." Radically new styles and fashion controversies (real or drummed up) make headlines, but they also confuse and even anger many women, while putting unnecessary pressure on designers to be original at all costs.

The real motive for fashion change originates in people's changing identities. Just as traditional (premodern or nonwestern) costume ex-

pressed a more static conception of the wearer's social identity, so also does modern fashion express our changing moods. Sociologist Fred Davis suggests that at any given time in history, certain cultural ambivalences become especially prominent and may be expressed sartorially. People want to "say" something about the ambiguities of, for example, youth versus age, work versus play, domesticity versus worldliness, masculinity versus femininity, androgeny versus singularity, license versus restraint, conformity versus rebellion. The concept of "social identity" potentially includes "any aspect of the self about which individuals can through symbolic means communicate with others."

The idea of a *language* of clothes may be too simplistic. Some types of clothing (such as, perhaps, the business suit) communicate a fairly direct message. But most clothing messages are more like music: They are expressive in an indirect and allusive way. Indeed, it might be embarrassing if clothing messages could be easily decoded and observers could identify exactly what the wearer was trying to say: "I am rich," for example, or "I am sexy."

Clothing messages are not only ambiguous, they are also relative and constantly shifting. "Sexy" compared to what? In what context? As perceived by whom? A blouse that seemed sexy at the office might be modest at an evening party, might seem attractive to a middle-aged, middle-class executive but positively boring to an adolescent. The wearer's intentions do not always coincide with the observer's perceptions.

The "meaning" of Paris fashion also varies from year to year—even from season to season—and must be seen in comparison with the meaning of that season's styles in Milan and New York. Moreover, a shopkeeper in Paris, a businesswoman in New York, and a suburban matron in Omaha will have very different interpretations of the same style—if, indeed, the style carries any meaning for them at all, although, as Davis puts it, "non-meaning about something which for others is pregnant with meaning is itself a kind of meaning."[48]

The Future of Fashion

And—the perennial American question—what chance is there of New York becoming the world's style center? The answer can be given with complete confidence—practically none.

"None at all, so far as this generation is concerned," concluded the author of *Paris on Parade*. Writing in 1924, he clearly recalled "the Viennese fizzle during the war," to say nothing of John Wanamaker's "ambitious effort" to import to the United States "a celebrated Parisian designer and a whole atelier of French workpeople." Why did they fail? he asked. "Why has Paris been able to put down so easily these uprisings in the provinces of

couture's empire?" According to the Parisian designers that he interviewed, "It is Paris's *'ambiance'* that makes her supreme—her atmosphere—art everywhere. . . . And, in addition, the French legacy of taste in dress and the French genius for dress design." To his credit, however, he does not accept this self-serving answer.

"But if these were the only defenses of the Parisian citadel, New York would seem to be not without hope." The Parisians, he argues, are wrong in assuming that "style is something created in Paris." Rather, he suggests, "Style is whatever the women of the world accept. It happens that they now accept . . . the Parisian mode" (and have done so for many years), "and so long as this is true, to be out of style simply means to be out of conformity with Parisian style."

"But it is conceivable, at any rate, that style headquarters might move. New York has a stimulating atmosphere, too"—New York has talented designers and chic women. "Fortunately for the great Parisian industry, it has two inner defenses"—the *midinette* (the skilled craftswoman) and the "medieval attitude" of "always trying to reach perfection."[49]

Fifty years later, in 1975, *The New Yorker*'s fashion critic, Kennedy Fraser, dismissed the Parisian couture as a decadent autocracy with a dwindling number of slavish followers: "The haute couture is a degenerate institution propped up by a sycophantic press."[50] Indeed, ever since the late 1960s, journalists have repeatedly described Paris couture as dying or dead. And it is undeniably true that ready-to-wear makes more money than couture (and fragrance even more). Yet recently the couture has been "flourishing," greeted with an "excitement" said to approach that of the 1930s and 1950s.

"Paris Fashion, Beyond Chic, Is also a Major Moneymaker" proclaimed a front-page headline in *The New York Times,* in a beautiful example of "news" that would have been as appropriate a century ago. Thus, we learn that the fashion industry makes "a substantial contribution" to the French economy: "A seamstress at Chanel accounts for 50 times as much in export earnings as the average French worker." In fact, only cars earn more foreign currency. No wonder economist John Kenneth Galbraith has argued that, "Instead of spending fortunes trying to become a high-tech nation, France would do far better to concentrate on what it knows best: women's fashion, wine, good food, and some of the arts."[51]

The mystique of Paris fashion is obviously crucially important: "It just wouldn't be the same in Omaha." But the American fashion industry has tried to identify other factors in Parisian success. Naturally, couture functions as the fashion industry's way of "putting its best foot forward," serving as a showcase for the ultimate in luxury and craftsmanship, and as a laboratory where experimental styles may launch new fashion trends. But America's problem is not that it has no genuine couture—nor that it has

no skilled workers. For that matter, the French are now beginning to imitate the style of fashion education launched in places like New York's Fashion Institute of Technology.

Until recently, wishful thinking and boosterism have been more noticeable than hard-headed analysis in much of the American press coverage of foreign and U.S. fashion. It took an English fashion journalist to point out that

> Periodically the United States of America changes the image of its national bird from a nobly brooding eagle to a lustily crowing cock, whose message is that America leads the world in fashion. Actually this ought to be true when you consider the sheer size of the country. . . . Thus the American ready-to-wear industry is the largest, the most competitive, the most highly geared, the most innovative in marketing methods. In this capacity it is the envy and model for every country with a developed or developing need for mass-produced clothing. But although the wholesalers are masters at producing instant fashion at all price levels, although the industry now possesses an ever increasing cadre of professional and talented designers, the actual influence of their output on international high fashion has been minimal.[52]

According to Ernestine Carter, a lot of people have lost a lot of money trying to sell American fashions abroad, "whether directly to stores or through manufacturing under license." Nor are trade barriers solely to blame—since Japan is the *only* foreign country where the "New York Look" has been fairly consistently successful. The single greatest U.S. success has been blue jeans, followed by other informal styles like cowboy clothes. With more formal styles, there is a continuing (albeit largely unacknowledged) dependence on European fashion ideas.

Each year, American manufacturers, buyers, and journalists come to Europe "seeking fashion's next direction." In March 1986, *The New York Times* reported:

> With their trek on the Milan-London-Paris trail almost done, themes are beginning to emerge. The consensus . . . is that Italy is in a slump, London in a fog and Paris has regained its rightful place atop fashion's pyramid.[53]

Of course, this hierarchy may well have changed by the time this book is published, but if so, Paris will remain near the top and no doubt will eventually make another comeback.

"Paris is still the fashion capital of the world," declared Diana Vreeland in her introduction to the 1983 Yves Saint Laurent exhibition at the Metropolitan Museum of Art.[54] But those who would tend to credit the special genius of the French might bear in mind that Americans, Belgians, Englishmen, Germans, Greeks, Hungarians, Italians, Japanese, Russians, Spaniards, and Swedes have all become famous designing clothes in Paris. To the extent that Paris is still first among equals, this must be due more

A fashion plate by Thayaht from *La Gazette du Bon Ton* (1922) illustrates a dress by Madeleine Vionnet. Recalling the eldest of the Callot sisters, Madame Gerber, Vionnet described her as "A great lady, totally occupied with a profession that consists of adorning women . . . not constructing a costume." She was "a true dressmaker." The same might be said of Vionnet herself, and of certain other great designers of Paris fashion.

to the structure of the fashion industry and the accumulated expertise (and prestige) of centuries than to the creativity of particular designers or the legendary chic of Parisian women. Particularly relevant is the quality of the French textile industry and the other subsidary *métiers de la mode*.

But whatever the charm of Parisian fashion, New York may already have become the capital of style *for Americans*—if American designers are more in touch with the emerging social identity of American women. Identity is the key. But "real-life," "working" fashions express only part of women's self-image.

Dedicated followers of fashion are flirting now with the provocative designs of newcomer Christian Lacroix, who has just established his own firm after having worked at the house of Patou. His clothes may seem like fantasy creations, writes Carrie Donovan, "But he is what couture is all about: an imagination that leaps into unexplored territory, and a theatre in which to realize dreams."[55]

The strength of the French fashion industry, per se, can not explain why Paris was for so long the international capital of style. At least as important was the depth and sophistication of Parisian fashion culture.

Nowhere else did artists devote so much attention to the philosophy of dress. Whereas American society retained a "small town" ambiance and a fairly puritanical attitude towards fashion (until very recently), Parisian society was cosmopolitan and welcomed ritualized fashion display. Social and sartorial distinctions within Parisian society were varied and subtly nuanced. Fashion performers and spectators were knowledgeable and proud of both their great traditions and their most radical innovations. Arguments that focus on the supposed "commercialism" of the American fashion industry versus the "artistry" of the French industry fail to recognize that the ultimate fashion arbiters are the individual men and women for whom fashion either is or is not an important element of civilized life. That pompous old charlatan, Polonius, may have been onto something when he concluded:

> Costly thy habit as thy purse can buy,
> But not express'd in fancy; rich, not gaudy;
> For the apparel oft proclaims the man,
> And they in France of the best rank and station
> Are of a most select and generous chief in that.

Notes

Chapter One

1. M. Angeline Merritt, *Dress Reform Practically and Physiologically Considered* (Buffalo: Jewett, Thomas & Co., 1852), p. 59; Frances Russell, "Freedom in Dress for Women," *The Arena* 8 (June 1893), p. 74; Russell, "Women's Dress," *The Arena* 3 (February 1891), p. 359.
2. Alexandre Dumas, Théophile Gautier, et al., *Paris et les parisiens au XIX^e siècle* (Paris: Morizot, 1856), p. iii; Taxile Delord, *Physiologie de la parisienne* (Paris: Aubert, 1841), p. 23.
3. *Ladies' Home Journal* (April 1893), p. 29.
4. Corinne LaBalme, "Is Paris Still the Capital of Style?" *Accent, The Magazine of Paris Style* (Winter 1987), pp. 16–17.
5. René König, *A La Mode* (New York: Seabury Press, 1973), pp. 122–124, 179.
6. Honoré de Balzac et al., *Le Diable à Paris* (Paris: J. Hetzel, 1846), p. 100; Dumas et al., *Paris et les parisiens*, p. 44.
7. Vyvyan Holland, *Hand Coloured Fashion Plates, 1770 to 1899* (London: B. T. Batsford, 1955), p. 160.
8. Louis Octave Uzanne, *Fashion in Paris* (London: William Heinemann, 1901), p. v.

Chapter Two

1. *Le Tableau de Paris* (Amsterdam, 1782–1788), and *Le Nouveau Paris* (Paris, 1798), abridged and translated by Wilfred and Emilie Jackson, *The Picture of Paris Before and After the Revolution* (London: George Routledge & Sons, 1929), p. 9; and (*Le Tableau de Paris* only) by Helen Simpson, *The Waiting City, Paris 1782–88* (London: George G. Harrap, 1933), pp. 240–241, 52. See also Paul-Louis de Giafferi, *The History of French Masculine Costume* (New York: Foreign Publications, 1927), section 63, and Philippe Perrot, *Les Dessus et les dessous de la bourgeoisie: Une histoire du vêtement au XIX^e siècle* (Paris: Librairie Arthème Fayard, 1981), pp. 33–34.
2. Margaret Scott, *Late Gothic Europe, 1400–1500.* The History of Dress Series. (London: Mills & Boon, 1980), p. 58.
3. J. Augustin Challamel, *The History of Fashion in France* (London: S. Low, Marston, Searle, and Rivington, 1882), p. 51.
4. François Boucher, *Histoire du costume en occident de l'antiquité à nos jours* (Paris: Flammarion, 1965), pp. 191–195; Paul Post, "La Naissance du costume masculin moderne au XIV^e siècle," in *Actes du 1^er Congrès International d'Histoire du Costume* (Venice: Centro Internazionale delle Arti e del Costume, 1955), pp. 28–41.

5. Ivan Morris, *The World of the Shining Prince* (New York: Oxford University Press, 1964), pp. 38, 206.

6. "Fashions and Textiles at the Court of Burgundy," *CIBA Review* 51 (1946); Michelle Beaulieu and Jeanne Bayle, *Le Costume en Bourgogne de Philippe le hardi à la mort de Charles le témeraire (1364–1477)* (Paris: Presses Universitaires de France, 1956), p. 186; Philippe Erlanger, *The Age of Courts and Kings* (London: Weidenfeld and Nicholson, 1967), p. 17. See also François Piponnier, *Costume et vie sociale: la cour d'anjou XIVᵉ–XVᵉ siècle* (Paris: Mouton et cie., 1970), and Richard Vaughan, *Valois Burgundy* (London: Archon Books, 1975).

7. Beaulieu and Bayle, *Le Costume en Bourgogne*, pp. 185–186; "Fashions and Textiles at the Court of Burgundy," pp. 1843, 1847.

8. Anne Hollander, *Seeing Through Clothes* (New York: Viking, 1978), pp. 367–369.

9. "Fashions and Textiles at the Court of Burgundy," p. 1850; Beaulieu and Bayle, *Le Costume en Bourgogne*, pp. 125–129.

10. Michael and Ariane Batterberry, *Fashion, The Mirror of History* (New York: Greenwich House, 1977), pp. 108–109.

11. Batterberry, *Fashion, The Mirror of History*, p. 119.

12. Augustin Challamel, *The History of Fashion in France*, pp. 83–84.

13. Batterberry, *Fashion, The Mirror of History*, pp. 142–145. See also Grazietta Butazzi, *La Mode: Art, histoire, et société* (Paris: Hachette, 1983), pp. 42–63.

14. Colbert quoted in Axel Madsen, *Living for Design: The Yves Saint Laurent Story* (New York: Delacourt, 1979), p. 7. *Le Mercure de France* quoted in Jean-Michel Tuchscherer, "Woven Textiles," in Marianne Carlano, *French Textiles from the Middle Ages through the Second Empire* (The Wadsworth Atheneum, 1985), p. 25.

15. Madame de Motteville, quoted in W. L. Wiley, *The Formal French* (Cambridge: Harvard University Press, 1967), p. 171.

16. Saint-Simon, quoted in Giafferri, *L'Histoire du costume masculin*, section 37. See also sections 38–40.

17. Quoted in Francis Mossiker, *Madame de Sévigné: A Life and Letters* (New York: Alfred A. Knopf, 1983), pp. 224, 226.

18. Leon Bernard, *The Emerging City: Paris in the Age of Louis XIV* (Durham: Duke University Press, 1970), p. 110.

19. Paul Lacroix, *The Eighteenth Century: Its Institutions, Customs, and Costumes. France, 1700–1789* (London: Bickers & Son, n.d.), p. 458; Dangeau, quoted in Boucher, *Histoire du costume*, p. 294. See also below, Aileen Ribeiro.

20. *The Present State of the Court of France, and the City of Paris* (1712), quoted in Aileen Ribeiro, *Dress in Eighteenth Century Europe 1715–1789* (London: B. T. Batsford Ltd., 1984), p. 20.

21. The Marquis de Caraccioli (1772), quoted in Perrot, pp. 34–35.

22. Quoted in Francis Mossiker, *The Queen's Necklace* (New York: Simon and Schuster, 1961) p. 162; Maria-Theresa of Austria, quoted in Emile L'Anglade, *Rose Bertin, The Creator of Fashion at the Court of Marie Antoinette*, trans. Angelo S. Rappoport (London: John Long, 1913), p. 58.

23. Ribeiro, p. 13.

24. Simpson, pp. 273, 135, and quoted in L'Anglade, *Rose Bertin*, pp. 52–53. Oberkirch, quoted in Mossiker, *The Queen's Necklace*, p. 174.

25. Ribeiro, p. 18.

26. Rousseau, *La Nouvelle Heloïse*, quoted in Perrot, p. 301.

27. Mercier, trans. Jackson, p. 18; trans. Simpson, p. 135.

28. Quoted in Ribeiro, p. 17.

29. Quoted in Edward Maeder, ed., *An Elegant Art: Fashion and Fantasy in the Eighteenth*

Century (Los Angeles County Museum of Art in association with Harry N. Abrams, New York, 1983), p. 103. See also Lord Chesterfield, quoted in Ribeiro, p. 17.

30. M. Dorothy George, *English Political Caricature* (Oxford: Oxford University Press, 1959), p. 147; *Macaroni and Theatrical Magazine* (October, 1772), quoted in M. Dorothy George, *Hogarth to Cruikshank: Social Change in Graphic Satire* (London: Penguin, 1967), p. 59. See also Valerie Steele, "The Social and Political Significance of Macaroni Fashion," *Costume: The Journal of the Costume Society* 19 (1985), pp. 94–109.

31. Ribeiro, p. 147.

32. *Town and Country Magazine* (November 1771), p. 598.

33. Isaac Bickerstaff, *Lionel and Clarissa* (a comic opera), c. 1768, quoted in W. H. Rhead, *Chats on Costume* (London, 1906), p. 104; *The London Magazine: or, Gentleman's Monthly Intelligencer* (April 1772), p. 193.

34. *Town and Country Magazine* (May 1772), p. 243.

35. Robert Hitchcock, *The Macaroni. A Comedy*, pp. 1, 5, 70, Prologue, Epilogue.

36. Quentin Bell, *On Human Finery*, 2nd ed. (New York: Schocken Books, 1978), p. 125.

37. Mercier, trans. Simpson, p. 30.

38. De Segur and Charles James Fox, quoted in Ribeiro, p. 17.

39. *Le Petit Dictionnaire*, quoted in Ribeiro, p. 146. See also Giafferi, section 62.

40. Marie J. Ghering Van Ierlant, "Anglo–French Fashion, 1786," *Costume: The Journal of the Costume Society* 17 (1983), pp. 64–77.

41. Quoted in Ribeiro, pp. 36, 40.

42. Ribeiro, p. 54.

43. Oberkirch, quoted in L'Anglade, pp. 136, 140, 150; and Aymex's lawsuit described on p. 160.

44. Archives Nationales O'3,792, described in L'Anglade, p. 153.

45. The Countess de la Motte–Valois, quoted in Mossiker, *The Queen's Necklace*, pp. 19–20, 22; and Olivia, on p. 179.

46. James Laver, *Taste and Fashion*, rev. ed. (London: George G. Harrap & Co., 1945), p. 198.

47. Quoted in Olivier Bernier, *The Eighteenth-Century Woman* (New York: The Metropolitan Museum of Art in association with Doubleday & Co., 1982), p. 138.

48. *The Memoirs of Mme. Elizabeth Louise Vigée-Lebrun, 1755–1789*, trans. Gerard Shelley (London: John Hamilton, 1926), p. 53.

49. Vigée-Lebrun, *Memoirs*, p. 45, 73–75, 81. See also Bernier, *The Eighteenth-Century Woman*, pp. 131, 133.

50. *Times Literary Supplement* (November 8, 1985), p. 1254; Valerie Steele, *Fashion and Eroticism*, pp. 23, 5.

51. Boucher, *Histoire du costume*, p. 338.

Chapter Three

1. Louis Sebastien Mercier, *Le Tableau de Paris* (Amsterdam, 1782–1788) and *Le Nouveau Paris* (Paris, 1798), abridged and translated by Wilfred and Emilie Jackson, *The Picture of Paris Before and After the Revolution* (London: George Routledge & Sons, 1929), p. 193.

2. Lynn Hunt, *Politics, Culture and Class in the French Revolution* (Berkely and Los Angeles: University of California Press, 1984), pp. 52–53. See also François Boucher, *Histoire du costume*, pp. 335–336, 81.

3. Vicomte François Auguste René Chateaubriand, *Memoirs*, trans. and ed. Robert Baldick (London: H. Hamilton, 1961), pp. 108, 107.

4. Jennifer Harris, "The Red Cap of Liberty: A Study of Dress Worn by French Revolutionary Partisans, 1789–1794," *Eighteenth-Century Studies* 14 (1981): 283–312.

5. Chateaubriand, pp. 104–105; Paul-Louis de Giaferri, *The History of French Masculine Costume* (New York: Foreign Publications, 1927), section 74.

6. J. Augustin Challamel, *The History of Fashion in France* (London: S. Low, Marston, Searle, and Rivington, 1882), pp. 182, 180; Raymond Gaudriault, *La Gravure de mode féminine en France* (Paris: Les Éditions d'Amateur, 1983), p. 41.

7. Chateaubriand, p. 166.

8. *Costumes du temps de la Révolution 1790–1793*. Preface by Jules Claretie. (Paris: A. Lévy, 1876); Gaudriault, pp. 42, 44.

9. *Memoirs of Madame de la Tour du Pin*, trans. and ed. Felice Harcourt (London: Harvill Press, 1969), p. 192.

10. Chateaubriand, pp. 171, 170.

11. Helen T. Garrett, "Clothes and Character: The Function of Dress in Balzac." Philadelphia: Ph.D. dissertation, University of Pennsylvania, 1941, p. 35; Philippe Perrot, *Les Dessus et les dessous de la bourgeoisie: Une histoire du vêtement au XIX^e siècle* (Paris: Librairie Arthème Fayard, 1981), pp. 38, 22.

12. Challamel, p. 182.

13. Julius M. Price, *Dame Fashion, 1786–1912* (New York: Charles Scribner's Sons, 1913), pp. 20–39; Martin Battersby, *Art Deco Fashion: French Designers, 1908–1925* (New York: St. Martin's Press, 1974), p. 199.

14. Mercier, trans. Jackson, pp. 246, 149–150.

15. Georges Lefebvre, *The French Revolution 1793–1799* (New York: Columbia University Press, 1962), p. 139. I am indebted to Donna Carmichael for reminding me of this quote.

16. Denis Woronoff, *The Thermidorian Regime and the Directory, 1794–1799* (Cambridge: Éditions de la Maison des Sciences de l'Homme and Cambridge University Press, 1984), pp. 8, 20.

17. Richard Cobb, *Death in Paris* (New York: Oxford University Press, 1978), pp. 73, 76.

18. Cobb, p. 80.

19. Louis Octave Uzanne, *The Frenchwoman of the Century* (London: J. C. Nimmo, 1886), pp. 116–117.

Chapter Four

1. Helen T. Garrett, "Clothes and Character: The Function of Dress in Balzac." Philadelphia: Ph.D. dissertation, University of Pennsylvania, 1941, pp. 9, 13; and Ellen Moers, *The Dandy: Brummell to Beerbohm* (London: Secker & Warburg, 1960).

2. Captain Gronow, quoted in Moers, p. 129.

3. Honoré de Balzac, *Lost Illusions*, trans. Herbert Hunt (Harmondsworth: Penguin Books, 1971), p. 165.

4. *Lost Illusions*, pp. 27, 71.

5. *Lost Illusions*, p. 161. See also pp. 77, 82.

6. *Lost Illusions*, pp. 164–168. See also pp. 168–180.

7. Garrett, pp. 52–53, 64; on p. 83, Garrett quotes Rastignac from *Père Goriot*, and on p. 54, De Marsay from *La Fille aux yeux d'or*.

8. Honoré de Balzac, *La Traité de la vie élégant* (Paris: Bibliopolis, n.d.), p.20.

9. Moers, pp. 108, 121.

10. *La Pandore. Journal des Spectacles* (8 August 1823), p. 3; *La Mode* (October 1830), p. 10; (November 1830), pp. 184–188; (October 1829), pp. 81–82.

11. *Lost Illusions*, pp. 618–619.

12. Louis Octave Uzanne, *Fashion in Paris* (London: William Heinemann, 1901), pp. 81–82.

13. Honoré de Balzac, "Le Notaire," and Paul Duval, "L'Employé," in *Les Français peints par eux-mêmes* (Paris: Furne et cie., 1853), vol. 1, pp. 223–227, 188–192.

14. Honoré de Balzac, "Monographie du rentier," in *Les Français peints par eux-mêmes*, vol. 2, pp. 3–12, on p. 3.

15. *Juste-milieu* quote is cited in Garrett, p. 50; Hulot is described in *Cousin Bette* (Harmondsworth: Penguin Books, 1965), p. 55.

16. Garrett, pp. 61, 56.

17. *Lost Illusions*, p. 651; Honoré de Balzac, *A Harlot High and Low*, trans. Rayner Heppenstall (Harmondsworth: Penguin Books, 1970), pp. 112–113; Garrett, pp. 68–69.

18. The phrases "The dandy goes to France" and "the dandy goes to press" are from Moers, pp. 107, 125. Se also Beatrice Farwell, *The Cult of Images: Baudelaire and the 19th Century Media Explosion* (Santa Barbara: University of California at Santa Barbara Art Museum, 1977), p. 8; Jerrold Seigel, *Bohemian Paris* (New York: Viking, 1986), p. 101.

19. Jules Janin, "Grisette," in *Les Français peints par eux-mêmes*, vol. 1, pp. 311–315; Louis Huart, *Physiologie de la grisette* (Paris: Aubert et cie., n.d.), pp. 12, 63.

20. Henriette Vanier, *La Mode et ses métiers* (Paris: Armand Colin, 1960), p. 19.

21. Louis Octave Uzanne, *The Modern Parisienne* (London: William Heinemann, 1912), p. 83.

22. Janin, "Grisette."

23. Maria d'Anspach, "Modiste," in *Les Français peints par eux-mêmes*, vol. 2, pp. 128–132, on p. 131.

24. Uzanne, *The Modern Parisienne*, p. 86.

25. Anspach, pp. 132, 131.

26. Georges d'Avenel, *La Méchanisme de la vie moderne* (Paris: Armand Colin, 1900–1905), vol. 4, p. 25; and Uzanne, *The Modern Parisienne*, p. 87.

27. Avenel, vol. 4, p. 2; Janin, "Grisette"; Uzanne, *The Modern Parisienne*, p. 79.

28. Anspach, p. 132.

29. Taxile Delord, *Physiologie de la parisienne* (Paris: Aubert et cie., 1841), pp. 12–13; Louis Octave Uzanne, *La Femme à Paris* (Paris: Quantin, 1894), pp. 3–4.

30. Delord, pp. 68, 23; Alexandre Dumas, Théophile Gautier, et al., *Paris et les parisiens au XIXᵉ siècle* (Paris: Morizot, 1856), p. 414.

31. *Paris et les parisiennes*, pp. 403–404, iii, 413.

32. Quoted in Joanna Richardson, *Théophile Gautier* (London: M. Reinhardt, 1958), p. 76.

33. Honoré de Balzac, "La Femme comme il faut," in *Les Français peints par eux-mêmes*, vol. 1, pp. 321–324.

Chapter Five

1. Quotes from Ellen Moers, *The Dandy* (London: Secker & Warburg, 1960), p. 271, and Enid Starkie, *Baudelaire* (Norfolk: New Directions, 1958), p. 76 (emphasis added).

2. Charles Cousin, quoted in F. W. J. Hemmings, *Baudelaire the Damned* (London: Hamish Hamilton, 1982), p. 33.

3. Charles Baudelaire, "The Painter of Modern Life," in *The Painter of Modern Life and Other Essays*, trans. Jonathan Mayne (London: Phaidon Press, 1964), p. 26; Jerrold Seigel, *Bohemian Paris* (New York: Viking, 1986), p. 103; Starkie, pp. 70–83.

4. *The Dandy* (25 May 1838), p. 4; *The Dandy* (January 1838), p. 4; *The Dandy* (February 1838), p. 3.

5. "This black costume," Nadar, and LaVavasseur, cited in Moers, p. 272; Musset quoted in Moers, p. 143.

6. "Costume played," in Champfleury [Jules Fleury], *Souvenirs et portraits de jeunesse* (Paris: E. Dents, 1872), p. 134; "dozen suits," in Starkie, pp. 76–77; "glass-papered," in Mayne, p. 27.

7. Theodore de Banville, Charles Toubin, and Jean Rousseau quoted in Hemmings, pp. 83–88.

8. Quoted in Hemmings, p. 113.

9. Champfleury, p. 134; Gautier quoted in Moers, p. 272; *La Fanfarlo,* quoted in Lois Boe Hyslop and Francis E. Hyslop, Jr., ed. and trans., *Baudelaire: A Self–Portrait. Selected Letters* (London: Oxford University Press, 1957), p. 37.

10. *Pages from the Goncourt Journal,* trans. and ed. Robert B. Baldick (New York: Oxford University Press, 1962), pp. 30–31.

11. Charles Baudelaire, *My Heart Laid Bare,* ed. Peter Quennell, trans. Norman Cameron (New York: Vanguard Press, 1951), section XVI, p. 180. I have altered the translation slightly.

12. Charles Baudelaire, "On the Heroism of Modern Life," in *The Mirror of Art,* trans. and ed. Jonathan Mayne (London: Phaidon Press, 1955), pp. 127–128; Baudelaire, "The Painter of Modern Life," pp. 27–28.

13. T. J. Clark, *The Absolute Bourgeois* (Greenwich, Conn.: New York Graphic Society, 1973), p. 143.

14. Baudelaire, *My Heart Laid Bare,* sections VIII and XXII (pp. 177, 182–183), translations slightly altered.

15. Baudelaire, "The Painter of Modern Life," pp. 27–28.

16. *Ibid.,* pp. 27–28, emphasis added and translation slightly altered. See also Moers, pp. 280–282.

17. Honoré de Balzac, *Traité de la vie élégant* (Paris: Bibliopolis, n.d.), p. 23; Baudelaire, *My Heart Laid Bare,* sections XXII (p. 182), XXXII (p. 187), V (p. 176); Baudelaire, "The Painter of Modern Life," p. 30.

18. Diderot and Manet quoted in Lois Boe Hyslop, ed., *Baudelaire as Love Poet and Other Essays* (University Park and London: Pennsylvania State University Press, 1969), p. 89; Champfleury quoted in Theodore Reff, *Manet and Modern Paris* (Chicago and London: University of Chicago Press, for the National Gallery of Art, Washington, 1982), p. 23.

19. Baudelaire, "The Painter of Modern Life," p. 12.

20. Auguste de Lacroix, "Flâneur," in *Les Français peints par eux-mêmes* (Paris: Furne et cie., 1853), vol. 2, pp. 112–117.

21. Baudelaire, "The Painter of Modern Life," pp. 9, 11, 13.

22. Baudelaire, "On the Heroism of Modern Life," p. 128.

23. Baudelaire, "The Painter of Modern Life," p. 29.

24. Baudelaire, in Mayne, *Painter of Modern Life,* p. 143 (emphasis added); Gautier quoted in Moers, p. 273.

25. Jerrold Seigel, pp. 123–124, 113–114; Baudelaire, "The Painter of Modern Life," p. 9.

26. Linda Nochlin, *Realism* (Harmonsworth: Penguin, 1971), p. 228.

27. *Fashion-Théorie* (June 1862), pp. 1190–1191.

28. Eugene Chapus, *Manuel de l'homme et de la femme comme il faut* (Paris: Lévy, 1862), pp. 1, 96.

29. Alexandre Dumas, Théophile Gautier, et al., *Paris et les parisiens au XIXᵉ siècle* (Paris: Morizot, 1856), pp. 426, 424.

30. *Fashion-Théorie* (February 1863), p. 1258; Bertall, *La Comédie de notre temps* (Paris: E. Plon et cie., 1874), vol. 1, pp. 19–20.

31. Chapus, pp. 29, 51, 61, 63, 67, 76.

32. *Journal des Modes d'Hommes* (January 1867), n.p.

33. Chapus, p. 82.
34. Stendhal, *The Red and the Black*, trans. Lowell Bair (New York: Bantam Books, 1958), pp. 43–44, 282.
35. *La Génie de la mode* (5 April 1862), pp. 1–2.
36. Bertall, vol. 1, pp. 11–12.
37. Bourgeau, *Usages du monde*, quoted in Philippe Perrot, *Les Dessus et les dessous de la bourgeoisie: Une histoire du vêtement au XIX^e siècle* (Paris: Librairie Arthème Fayard, 1981), p. 250.
38. *La Presse* (21 August 1859), quoted in Perrot, p. 249.

Chapter Six

1. Raymond Gaudriault, *La Gravure de mode féminine en France* (Paris: Les Éditions d'Amateur, 1983), p. 8.
2. Charles Baudelaire, "The Painter of Modern Life," in *The Painter of Modern Life and Other Essays*, trans. Jonathan Mayne (London: Phaidon Press, 1964), pp. 1–2.
3. Charles Baudelaire, "Some French Caricaturists," in *The Mirror of Art: Critical Studies by Charles Baudelaire*, trans. Jonathan Mayne (London: Phaidon Press, 1955), pp. 171, 173; Beatrice Farwell, *The Cult of Images: Baudelaire and the 19th Century Media Explosion* (Santa Barbara: UCSB Art Museum, 1977), pp. 7–15.
4. Vyvyan Holland, *Hand Coloured Fashion Plates 1770 to 1899* (London: B. T. Batsford, 1955), p. 152. Information on the Colin family can be found in George Gustave Toudouze, *Le Costume français* (Paris: Larousse, 1945), p. 154.
5. Julie de Marguerittes, *The Ins and Outs of Paris; or Paris by Day and Night* (Philadelphia: William White Smith, 1855), pp. 160–161.
6. *Album du Salon de 1842* (Paris: Chez Challamel, 1842), p. 54.
7. Holland, p. 160; Gaudriault, pp. 78, 209.
8. Baudelaire, "Salon of 1845" and "Salon of 1846," in *Mirror of Art*, pp. 15–16, 108.
9. Jacques Boulenger, *De la valse au tango* (Paris: Devanbez, n.d.), pp. 46–47, 61.
10. Baudelaire, "The Painter of Modern Life," p. 13.
11. See Doris Langley Moore, *Fashion Through Fashion Plates, 1771–1970* (New York: Clarkson N. Potter, Inc., 1971).
12. Arnold Bennett, *The Old Wives' Tale*, quoted in Richard Ormond, "Pictorial Sources for a Study of Costume," in Ann Saunders, ed., *La Belle Epoque* (London: published for the Costume Society, 1968), p. 13.
13. *La Mode Illustrée* (11 February 1877), p. 46; *La Vie Parisienne* (20 February 1875), p. 111; Stephane Mallarmé, *La Dernière Mode*. 1874. (Paris: Editions Ramsay, 1978), n.p.
14. See Valerie Steele, *Fashion and Eroticism: Ideals of Feminine Beauty from the Victorian Era to the Jazz Age* (New York: Oxford University Press, 1985), as well as *La Vie Parisienne* (7 June 1879), pp. 330–331; (23 January 1875), pp. 48–49; (12 May 1877), pp. 258–259.
15. Bertall, *La Comédie de notre temps* (Paris: E. Plon & Cie., 1874), vol. 2, p. 307.
16. *La Vie Parisienne* (20 February 1875), p. 111.
17. *La Vie Parisienne* (20 February 1875), p. 107.
18. For a comparable figure in an orthodox fashion illustration, see Steele, *Fashion and Eroticism*, p. 77. Notice how the maid sits decorously upright.
19. *La Vie Parisienne* (20 February 1875), p. 110.
20. Zola, quoted in Joel Isaacson. "Impressionism and Journalistic Illustration," *Arts Magazine* 56 (June 1982), p. 100.
21. Mark Roskill, "Early Impressionism and the Fashion Print," *Burlington Magazine* 112 (June 1970), pp. 393–397.

22. Quoted in John Rewald, *The History of Impressionism*, 4th ed. (New York: The Museum of Modern Art, 1973), pp. 70–71.
23. George Moore, *A Drama in Muslin*, quoted in Steele, *Fashion and Eroticism*, p. 117.
24. Rewald, *History of Impressionism*, p. 208.
25. Louis Octave Uzanne, *Fashion in Paris* (London: William Heinemann, 1901), p. vi.
26. Noveline Ross, *Manet's 'Bar at the Folies-Bergère' and the Myths of Popular Illustration* (Ann Arbor: UMI Research Press, 1983), p. 42.

Chapter Seven

1. Mark Girouard, *Cities and People: A Social and Architectural History* (London and New Haven: Yale Universty Press, 1985), pp. 168, 170.
2. A. Jardin and André-Jean Tudesq, *Restoration and Reaction, 1815–1848* (Cambridge: Cambridge University Press, 1983), pp. 368–370; David H. Pinkney, *Napoleon III and the Rebuilding of Paris* (Princeton: Princeton University Press, 1958).
3. Alexandre Dumas, Théophile Gautier, et al., *Paris et les parisiens au XIXe siècle* (Paris: Morizot, 1856), pp. 38–43.
4. Louis Octave Uzanne, *The Modern Parisienne* (London: William Heinemann, 1912).
5. Louis Octave Uzanne, *Fashion in Paris* (London: William Heinemann, 1901), pp. v–vi.
6. Uzanne, *The Modern Parisienne*, pp. 45–46.
7. Georges d'Avenel, *Le Méchanisme de la vie moderne* (Paris: Armand Colin, 1900–1905), vol. 4, pp. 1–2, 4, 12.
8. Uzanne, *The Modern Parisienne*, pp. 47–48.
9. *Goncourt Journal*, quoted in T. J. Clark, *The Painting of Modern Life* (New York: Alfred A. Knopf, 1985), p. 34.
10. Thomas Forrester, *Paris and its Environs: An Illustrated Handbook* (London: Henry G. Bohn, 1859), p. 47.
11. Lillie de Hegermann-Lindencrone, *In the Courts of Memory*. 1912. (New York: Da Capo Press, 1980), pp. 188–189.
12. Hegermann-Lindencrone, pp. 32–35.
13. Honoré de Balzac, "History and Physiology of the Boulevards of Paris," in Balzac, et al., *Le Diable à Paris* (Paris: J. Hetzel, 1846), pp. 89–92, 98–100.
14. Edmund Texier, *Tableau de Paris* (Paris: Bureau d'Illustration, 1851), pp. 34–35.
15. Anon., *Grand Hotel Guide de l'étranger dans Paris et ses environs* (Paris: Grand Hotel, 1877), pp. 5, 10, 14.
16. T. J. Clark, *The Painting of Modern Life*, pp. 34–35.
17. *La Corbeille* (1 December 1854), pp. 1–2.
18. Alistair Horne, *The Fall of Paris, The Seige and the Commune, 1870–1871* (New York: St. Martin's Press, 1965), p. 405.
19. Girouard, pp. 291, 293.
20. Zola, *Au bonheur des dames*. 1883. (Paris: Le Livre de Poche, 1980), pp. 7–8.
21. Zola, p. 124.
22. Zola pp. 478, 104, 130.
23. *La Corbeille* (1 January 1854), p. 1.
24. Rosalind Williams, *Dream Worlds: Mass Consumption in Late Nineteenth-Century France* (Berkeley and Los Angeles: University of California Press, 1982), caption to illustration 9.
25. *Les Toilettes de la collectivité de la couture* (Paris: Société de Publications d'Art, 1900); *Musée retrospectif des classes 85 et 86. Le Costume et ses accesoires à l'exposition universelle de 1900 Paris* (Paris, 1900); Philippe Jullian, *The Triumph of Art Nouveau. Paris Exhibition 1900* (London: Phaidon Press, 1974), p. 101.

Chapter Eight

1. Alfred Delvau, *Les Plaisirs de Paris: Guide pratique des étrangers* (Paris: Faure, 1867), pp. 7–8, 10, 66.

2. Vicomtesse Nacla (1897), quoted in Anne Martin-Figier, *La Bourgeoise* (Paris: Bernard Grasset, 1983), p. 21.

3. Quoted in Amy LaTour, *Kings of Fashion* (London: Weidenfeld and Nicholson, pp. 129–130, 146.

4. Jules Janin, *The American in Paris During the Summer* (London: Longman, Brown, Green, and Longman, 1844), p. 37.

5. Anon., *Paris: Guide économique dans le Paris nouveau et à l'exposition universelle de 1867* (Paris: Galerie du Petit Journal, 1867), p. 109.

6. Julie de Marguerrites, *The Ins and Outs of Paris; or, Paris by Day and Night* (Philadelphia: William White Smith, 1855), pp. 39–40.

7. Marguerrites, pp. 39–41, 118, 121–123.

8. Marguerrites, pp. 110–111. See also *La Vie Parisienne* (6 February 1875), p. 76.

9. Marguerrites, pp. 32, 350, 358.

10. Marguerrites, pp. 114–115.

11. Louis Octave Uzanne, *La Femme à Paris* (Paris: Quantin, 1894), pp. 290, 293–294.

12. H. Despaigne, *Le Code de la mode* (Paris: Chez l'auteur, 1866), pp. 8–9.

13. Alice Ivimy, *A Woman's Guide to Paris* (London: James Nesbet, 1909), p. 78–83.

14. Alexandre Dumas, Théophile Gautier, et al., *Paris et les parisiens au XIX^e^ siècle* (Paris: Morizot, 1856), pp. 403–404.

15. Laure-Paul Flobert, *La Femme et le costume masculin* (Lille: Imprimerie Lefebvre-Ducrocq, 1911), pp. 1–31.

16. See also Pierre Dufay, *Le Pantalon féminin* (Paris: Charles Carrington, 1906).

17. Louis Octave Uzanne, *The Mirror of the World* (London: John C. Nimmo, 1890), pp. 99–100.

18. Quoted in Theodore Reff, *Manet and Modern Paris* (Chicago and London: University of Chicago Press, for the National Gallery of Art, Washington, 1982), p. 131.

19. *La Mode* (November 1830), pp. 184–185; *Grande Encyclopédie* (Paris: H. Lamirault et cie., 1886–1902), vol. 5, pp. 375–382. See also *La Corbeille* (1 May 1854), p. 1, and *La Sylphide* (1 June 1845), p. 323.

20. Jules Janin, *American in Paris*, pp. 82–83.

21. Emile Zola, *Nana*, trans. George Holden (1880; Harmondsworth: Penguin, 1972), p. 345. See also *Grande Encyclopédie*, vol. 5, pp. 375–382.

22. *Man about Paris: The Confessions of Arsène Houssaye*, trans. Henry Knepler (New York: Morrow, 1970), p. 76.

23. Delvau, *Les Plaisirs de Paris*, p. 66. See also T. J. Clark, *The Painting of Modern Life* (New York: Alfred A. Knopf, 1985), chapter 2.

24. Ivimy, p. 92.

25. *La Vie Parisienne* (22 May 1875), pp. 286–289.

26. Marguerite d'Aincourt, *Études sur le costume féminin* (Paris: Rouveyre, 1885), pp. 6–11.

27. Anne Coffin Hanson, *Manet and the Modern Tradition* (New Haven: Yale University Press, 1977), p. 66.

28. André-Valdès, *Encyclopédie illustrée des élégances féminines. Hygiène de la beauté* (Paris: Librairie Marpon et Flammarion, 1892), p. 346.

29. *Les Modes* (May 1901), p. 13.

30. Arséne Alexandre, "All Paris A-Wheel," *Scribner's Magazine* (August 1895), pp. 195–201. Unless otherwise noted, all subsequent quotations in the chapter are from this article.

31. Barbara Schreier, "Sporting Wear," in Claudia Kidwell and Valerie Steele, eds., *Men and Women: Dressing the Part* (forthcoming).
32. André-Valdès, pp. 346–348.
33. Flobert, *La Femme et le costume masculin*, pp. 14–26.

Chapter Nine

1. Alfred Stevens, *Impressions on Painting* (New York, 1886), pp. 23, 9; Camille Lemonnier, *Alfred Stevens et son oeuvre* (Brussels, 1906), p. 1; William A. Coles, *Alfred Stevens* (Ann Arbor: University of Michigan Museum of Art, 1977), p. ix; Charles Saunier, "Alfred Stevens," *La Revue Blanche* (15 March 1900), p. 461.
2. Frederick Sweet, *Miss Mary Cassatt, Impressionist from Pennsylvania* (Norman: University of Oklahoma Press, 1966), p. 130.
3. Coles, p. 29
4. Coles, pp. 51–53.
5. Coles, pp. 10, 22.
6. François Boucher, *Alfred Stevens* (Paris: Les Éditions Rieder, 1930), p. 18.
7. Saunier, p. 461.
8. Huysman, quoted in E. John Bullard, *Mary Cassatt: Oils and Pastels* (New York: Watson-Guptill, 1972), p. 31.
9. Coles, p. xviii.
10. Quoted in Sweet, p. 61.
11. Louis Octave Uzanne, *La Femme à Paris* (Paris: Quantin, 1894), pp. 215, 218.
12. Stevens, pp. 42–43.
13. Quoted in Sweet, p. 130.
14. Remy Z. Saisselin, "From Baudelaire to Christian Dior: The Poetics of Fashion," *Journal of Aesthetics and Art Criticism* 18 (1959–1960): 109–110.
15. Marcel Proust, *Within A Budding Grove*, trans. C. K. Scott Moncrieff and Frederick A. Blossom, *Remembrance of Things Past* (New York: Random House, 1927–1932), p. 468.
16. Baroness d'Orchamps, *Tous les secrètes de la femme* (Paris: Bibliothèque des Auteurs Modernes, 1907), p. 41.
17. Anne Buck, *Victorian Costume and Costume Accessories* (London: Herbert Jenkins, 1961), p. 66.
18. d'Orchamps, pp. 98–100.
19. Countess Tramar, *Le Bréviaire de la femme. Pratiques secrètes de la beauté* (Paris: Victor Havard, 1903), pp. 189–190, 180.
20. Tramar, p. 185: d'Orchamps, p. 99; *The Queen* (5 July 1902), p. 12.

Chapter Ten

1. Marcel Proust, *The Captive*, pp. 400–401. All references to Proust's *A la recherche du temps perdu* are taken from the translation by C. K. Scott Moncrieff and Frederick A. Blossom, *Remembrance of Things Past* (New York: Random House, 1927–1932).
2. *Cities of the Plain*, pp. 323–324.
3. George D. Painter, *Marcel Proust*. 2 vols. (New York: Vintage Books, 1978), vol. 2, p. 10. See also Diana Festa-McCormick, *Proustian Optics of Clothes: Mirrors, Masks, Mores*. Stanford French and Italian Studies 29. (Saratoga: Anma Libri, 1984), pp. 4–5.
4. *Within a Budding Grove*, p. 471. See also J. M. Quennell's important essay, "The World of Fashion," in Peter Quennell, ed., *Marcel Proust* (New York: Simon and Schuster, 1971).

5. *Swann's Way*, p. 151.
6. *Swann's Way*, p. 169.
7. *Swann's Way*, pp. 186–187.
8. Susan B. Keiser, *The Social Psychology of Clothing* (New York: Macmillan, 1985), p. 337.
9. *Swann's Way*, p. 178. See also p. 220 for her country dress.
10. Festa-McCormick, p. 17.
11. *Within a Budding Grove*, pp. 469–470.
12. *Within a Budding Grove*, pp. 471, 453, 484.
13. *Within a Budding Grove*, p. 483.
14. *Within a Budding Grove*, pp. 452–453; Festa-McCormick, p. 22.
15. *Within a Budding Grove*, p. 471.
16. *Within a Budding Grove*, pp. 403, 452.
17. *Within a Budding Grove*, p. 412.
18. *Within a Budding Grove*, p. 452.
19. *Within a Budding Grove*, pp. 484–485.
20. *Swann's Way*, pp. 320–321.
21. *Swann's Way*, pp. 323–325.
22. *Within a Budding Grove*, p. 487.
23. *Guermantes Way*, p. 1140.
24. *Guermantes Way*, pp. 733–734.
25. *The Captive*, pp. 400, 403.
26. *The Captive*, p. 407.
27. *Within a Budding Grove*, p. 675.
28. Quoted in *L'Atelier Nader et la Mode 1865–1913* (Paris: Musée de la Mode et du Costume 1978), p. 83.
29. Mary Brooks Picken and Dora Loues Miller, *Dressmakers of France* (New York: Harper and Brothers, 1956), p. 63; Paul Poiret, *King of Fashion* (Philadelphia: J. B. Lippincott, 1931), p. 30.
30. Liane de Pougy, *My Blue Notebooks* (London: Andre Deutsch, 1979), p. 169.
31. Poiret, p. 31.
32. *Guermantes Way*, pp. 742–754; for Albertine's "Doucet wrapper," see *The Captive*, p. 421.
33. Painter, *Marcel Proust*, vol. 1, p. 152.
34. Painter, *Marcel Proust*, vol. 2, pp. 177, 314; Proust, *Le Banquet* (1892), quoted in André Maurois, *Proust: Portrait of a Genius*, trans. Gerard Hopkins (New York: Carroll & Graf, 1950), p. 60.
35. *The Past Recaptured*, pp. 1096–1097.
36. Painter, *Marcel Proust*, vol. 1, pp. 90–91.
37. *Within a Budding Grove*, p. 552.
38. *Within a Budding Grove*, pp. 569–570.
39. Festa-McCormick, pp. 93–103; *The Captive*, p. 527.
40. Maurois, *Proust*, pp. 33–34, 66, 93–94.
41. *Within a Budding Grove*, pp. 595, 664.
42. *Within a Budding Grove*, pp. 674, 677.
43. *Within a Budding Grove*, p. 674; Guillermo de Osma, *Mariano Fortuny: His Life and Work* (New York: Rizzoli, 1980), p. 110.
44. *The Captive*, pp. 400–401, 407, 638–639.
45. *The Captive*, p. 656.
46. Festa-McCormick, pp. 72–87.
47. *The Captive*, pp. 662–663.
48. *The Captive*, p. 639.

Chapter Eleven

1. Paul Poiret, *En habilant l'époque* (Paris: Bernard Grasset, 1930), pp. 84–85.
2. Claude Lepape and Thierry Defert, *From the Ballets Russes to Vogue. The Art of Georges Lepape*, trans. Jane Brenton (New York: The Vendome Press, 1984), pp. 35–37.
3. *La Gazette du Bon Ton*, quoted in Lepape, pp. 72–73.
4. Edna Woolman Chase, *Always in Vogue* (Garden City: Doubleday and Co., 1954), p. 112.
5. Gustave Babin, "Gravures de modes," *L'Illustration* (5 July 1913), pp. 13–16.
6. Dorothy Behling, "French Couturiers and Artist-Illustrators: Fashion from 1900 to 1925" (Ph. D. dissertation, Ohio State University, 1977), pp. 40–41, 91.
7. Quoted in Julian Robinson, *The Golden Age of Style* (New York: Harcourt, Brace, Jovanovich, 1976), p. 10.
8. Nancy Hall-Duncan, *The History of Fashion Photography* (New York: Alpine Book Company, 1979), pp. 13–16; Raymond Gaudriault, *La Gravure de mode féminine en France* (Paris: Les Éditions de l'Amateur, 1983), pp. 102–103; Helmut and Alison Gernsheim, *The History of Photography, 1865–1914* (New York: McGraw-Hill, 1969), p. 235; A. Huart and A. Grevin, *Les Parisiennes* (Paris: Librairie Illustrée, n.d. [ca. 1880]), p. 521.
9. Anne Hollander, *Seeing Through Clothes* (New York: Viking Press, 1978), pp. 334–335.
10. Gaston Worth, quoted in Poiret, pp. 65, 67; Jean Worth (1914), quoted in Robinson, p. 17.
11. "Le Vrai et le faux chic," *L'Illustration* (28 March 1914), pp. 243–248. See also Quentin Bell, *On Human Finery* (New York: Schocken Books, 1976).
12. Poiret, p. 93.
13. Jacques Damase, *Sonia Delaunay* (London: Thames and Hudson, 1972), pp. 37–38; and *Intimate Architecture* (Cambridge: Massachusetts Institute of Technology, 1982).
14. Hollander, *Seeing Through Clothes*, p. 360. See also Anne Hollander, "Dressed to Thrill," *The New Republic* (January 1985), pp. 28–33.
15. Carter, p. 104.
16. "Why Paris is the Capital of Fashion," *The Delineator* (September 1907), pp. 290–291; B. O. Flower, "Fashion's Slaves," *The Arena* (February 1891), p. 359.
17. *The New York Times* (9 January 1913), quoted in Jeannette Lauer and Robert Lauer, *Fashion Power: The Meaning of Fashion in American Society* (Englewood Cliffs: Prentice-Hall, 1981), pp. 182, 192.
18. *Vogue* (1908), quoted in Palmer White, *Poiret* (New York: Clarkson N. Potter, 1973), p. 43.
19. White, p. 73.
20. I am indebted to Jan Reeder for allowing me to quote from her unpublished work in progress, "Madame Paquin"; *The Ladies' Home Journal* (September 1914), p. 58, also quoted in Reeder, "Madame Paquin."
21. Quoted in Lepape, pp. 42–43.
22. Wanamaker announcement quoted in Chase, p. 117.
23. *The New York Times* (27 September 1914 and 21 February 1915).
24. Chase, pp. 118–127; see also Martin Battersby, *Art Deco Fashion: French Designers, 1908–1925* (New York: St. Martin's Press, 1974), p. 78.
25. *The 1915 Mode as Shown by Paris* (New York and Paris: Condé Nast Publications, 1915); *The New York Times* (6 September 1912).
26. Lady Cynthia Asquith, *Diaries, 1915–1918* (New York: Alfred A. Knopf, 1969), pp. 11, 51.

27. *La Femme Chic* (1916), cited in Doris Langley Moore, *The Woman in Fashion* (London: B. T. Batsford, 1949), p. 170.
28. Marcel Proust, *The Past Recaptured*, trans. C. K. Scott Moncrieff and Frederick A. Blossom, *Remembrance of Things Past* (New York: Random House, 1927–1932), p. 893.
29. Proust, *The Past Recaptured*, pp. 894, 899, 921.
30. Chase, p. 118; "Mourning Dresses," *Femina* (June 1917), p. 70.
31. "Fashion During the War," *Femina* (March 1917), pp. 17–19; see also *Femina* (June 1917), pp. 17–18.

Chapter Twelve

1. Michael Arlen, *The Green Hat* (New York: George H. Doran, 1924), pp. 18, 26; F. Scott Fitzgerald, *The Great Gatsby*, quoted in Meredith Etherington-Smith, *Patou* (New York: St. Martin's Press, 1984), p. 66. See also below: *Jardin des Modes* (15 February 1927), quoted in Marylène Delbourg-Delphis, *Le Chic et le Look* (Paris: Hachette, 1981), p. 112.
2. Elsa Schiaparelli, *Shocking Life* (London: J. M. Dent & Sons, 1954), pp. 70, 53.
3. Bettina Ballard, *In My Fashion* (New York: David McKay, 1960), p. 62.
4. Jean Cocteau, quoted in Marcel Rochas, *Vingt-cinq ans d'élégance à Paris, 1925–1950* (Paris: Éditions Pierre Tisne, 1951), p. 58.
5. Diana de Marly, *The History of Haute Couture, 1850–1950* (New York: Holmes & Meier, 1980), p. 208.
6. de Marly, p. 147.
7. Quoted in Edmond Charles-Roux, *Chanel* (New York: Alfred A. Knopf, 1975), pp. 367–368.
8. Sonia Rykiel quoted in Axel Madsen, *Living for Design: The Yves Saint Laurent Story* (New York: Delacourt, 1979), pp. 134–135.
9. de Marly, p. 11.
10. *Journal des Modes d'Hommes* (January 1869), n.p.
11. *La Vie Parisienne* (18 May 1867), p. 358.
12. Claire Goldberg Moses, *French Feminism in the Nineteenth Century* (Albany: SUNY Press, 1984), p. 25.
13. Bruno du Roselle, *La Mode* (Paris: Imprimerie Nationale, 1980), p. 30.
14. Adolphus, *Some Memories of Paris*, quoted in Edith Saunders, *The Age of Worth* (Bloomington: Indiana University Press, 1955), p. xi.
15. Charles Dickens, in *All the Year Round* (28 February 1863), p. 9.
16. Robert Forrest Wilson, *Paris on Parade* (Indianapolis: The Bobbs-Merrill Company, 1924, 1925), pp. 34–84. Amy Latour, *Kings of Fashion* (London: Weidenfeld and Nicholson, 1958), p. 206.
17. Elizabeth Hawes, *Fashion Is Spinach* (New York: Random House, 1938), p. ix, 16, 53, 65, 181, 261–262, 333. See also Mrs. Regina Garretson, *Scrapbook*, in the Special Collections of the Fashion Institute of Technology Library, for newspaper articles about Elizabeth Hawes.
18. Ballard, *In My Fashion*, pp. 71–77.
19. Tony Allan, *Paris: The Glamour Years, 1919–1940* (New York: Bison Books, 1977), pp. 7–11.
20. Allan, *Paris*, pp. 41, 59.
21. *Goncourt Journal* (16 January 1877), and E. Gomez Carillo, *Psychologie de la mode* (1910), quoted in Delbourg-Delphis, pp. 86–87. See also the Goncourts, *Renée Maupérin* (1864), and Marcel Prevost, *Les Demi-vierges* (1894).
22. Delbourg-Delphis, pp. 161–166.

23. Cecil Beaton, *The Glass of Fashion* (London: Weidenfield and Nicholson, 1954), p. 183.

24. See Elizabeth Ewing, *Fashion in the Twentieth Century* (1974); Anne Hollander, "Dressed to Thrill: The cool and casual style of the new American androgeny," *The New Republic* (January 1985), pp. 28–33.

25. Gertrude Bailey, "Paris Fashions, Liberation Style," in *Tricolor* (November 1944), pp. 102–109; Nancy Hall-Duncan, *The History of Fashion Photography* (New York: Alpine Book Company, 1979), p. 122. See also Roselle, *La Mode*, p. 200.

26. de Holden Stone, "Fashion Survives the Nazis," in *Art and Industry* (July 1945), pp. 8–9.

27. James Brady, *Superchic* (Boston: Little, Brown and Company, 1974), pp. 62–63; Francine du Plessix Gray, *October Blood* (New York: Simon and Schuster, 1985), p. 11. See also Charles-Roux, *Chanel*.

28. George E. Linton, *Scrapbook*. In the Special Collections of the Fashion Institute of Technology Library.

29. Batterberry, *Fashion, The Mirror of History* (New York: Greenwich House, 1977), p. 342; Bill Cunningham, "Couture de Force," *Details* (September 1986), pp. 83–84.

30. Richard Cobb, *French and Germans, Germans and French: A Personal Interpretation of France Under Two Occupations, 1914–1918/1940–1944* (Hanover and London: University Press of New England, 1983), pp. 170–175.

31. Roselle, *La Mode*, pp. 209–210.

32. Janet Flanner, *Paris Journal 1944–1965* (New York: Atheneum, 1965), pp. 15–16. See also, below, p. 59.

33. *Le Théâtre de la Mode*, catalogue published in New York in 1945 by American Relief for France under the auspices of L' Association Française d'Action Artistique.

34. Thelma Sweetinburgh in Ruth Lynam, ed., *Couture: An Illustrated History of the Great Paris Designers and Their Creations* (Garden City, N.Y.: Doubleday & Co., 1972), p. 139.

35. *Vogue* (15 September 1939), p. 76. See also James Laver, *Taste and Fashion from the French Revolution to the Present Day* (London: George G. Harap and Co., 1937), p. 218.

36. Christian Dior, *Christian Dior and I* (New York: E. P. Dutton, 1957), p. 35; Christian Dior, *Talking About Fashion* (New York: G. P. Putnam's Sons, 1954), p. 23.

37. Susan Mary Alsop, *To Marietta from Paris, 1945–1960* (Garden City, N.Y.: Doubleday & Co., 1975), pp. 92–93. See also pp. 94, 72.

38. Richard Donovan, "That Friend of Your Wife's Named Dior," *Collier's* (June 10, 1955); Beaton, *The Glass of Fashion*, pp. 254–255. See also Brigid Keenan, *Dior in Vogue* (New York: Harmony Books, 1981).

39. Barbara Schreier, *Mystique and Identity: Women's Fashions in the 1950s*, catalogue for an exhibition at the Chrysler Museum, 1984: Anne Bony, *Les Années 50* (Paris, 1982) and *Les Années 60* (Paris, 1983).

40. Paul E. Deutschman, "How to Buy a Dior Original," *Holiday* 15.1 (January 1955), pp. 44–47.

41. Ethelbert Robinson, "Behind Your Paris Gown," *Holiday* 17.3 (March 1953), pp. 30–31; Donovan, "That Friend of Your Wife's Named Dior," pp. 34–39.

42. John Fairchild, quoted in *Newsweek* (August 12, 1962), and in Madsen, *Living for Design*, p. 98.

43. Delbourg-Delphis, *Le Chic et le Look*, pp. 216–219.

44. Courrèges and Quant quoted in Ruth Lynam, ed., *Couture*, p. 198.

45. Brady, *Superchic*, pp. 155–159; Ellen Melinkoff, *What We Wore: An Offbeat Social History of Women's Clothing, 1950–1980.* (New York: Quill, 1984), p. 165.

46. Brigitte Bardot and Yves Saint Laurent quoted in Madsen, *Living for Design*, pp. 119–120, 152–154, 163, 166.

47. Delbourg-Delphis, *Le Chic et le Look,* pp. 223–233.

48. Fred Davis, "Clothing and Fashion as Communication," in Michael R. Solomon, ed., *The Psychology of Fashion* (Lexington, Mass.: D. C. Heath and Company, 1985), pp. 15–26.

49. Wilson, *Paris on Parade,* pp. 38–60.

50. Kennedy Fraser, *The Fashionable Mind: Reflections on Fashion, 1970–1981* (New York: Alfred A. Knopf, 1981), p. 132.

51. *The New York Times* (October 30, 1985), pp. A1, A5. See also *The New York Times* (February 4, 1986), p. C18.

52. Ernestine Carter, *The Changing World of Fashion,* (New York: G. P. Putnam's Sons, 1977), pp. 57–58.

53. *The New York Times* (March 25, 1986). p. C14.

54. Diana Vreeland, Introduction to *Yves Saint Laurent* (New York: Clarkson N. Potter and the Metropolitan Museum of Art, 1983), p. 7.

55. Carrie Donovan, "The Bubble and Bounce of Paris," *The New York Times Magazine* (September 7, 1986). p. 78.

Selected Bibliography

The following bibliography is not intended to be comprehensive. Whenever possible, I have tried to avoid excessive duplication of sources that have already appeared in the much more extensive bibliography appended to my first book, *Fashion and Eroticism* (New York: Oxford University Press, 1985). Nor are all of the sources cited in the footnotes to *Paris Fashion* repeated here. Instead, I have attempted to focus on the most important primary sources and the most recent secondary sources—especially those that may be unfamiliar to fashion historians.

Primary Sources

Alexandre, Arsène. "All Paris A-Wheel," *Scribner's Magazine* (August 1985): 195–201.

——. *Les Reines d'aiguille: modistes et couturières.* Paris: Théophile Belin, 1902.

André-Valdès. *Encyclopédie illustrée des élégances féminines. Hygiène de la beauté.* Paris: Librarie Marpon et Flammarion, 1892.

Avenel, Vicomte George d'. *Le Méchanisme de la vie moderne.* 4 vols. Paris: Librairie Armand Colin, 1900–1905.

Babin, Gustave. "Gravures de modes," *L'Illustration* (5 July 1913): 13–16.

Bailey, Gertrude. "Paris Fashions, Liberation Style," *Tricolor* (November 1944): 102–109.

Ballard, Bettina. *In My Fashion.* New York: David McKay, 1960.

Balzac, Honoré de. *Traité de la vie élégante.* Originally published in *La Mode,* 1830. Paris: Bibliopolis, n.d.

——. *La Comédie humaine.* Available in several English translations.

Balzac, Honoré de, Jules Janin, et al. *Les Français peints par eux-mêmes.* 2 vol. Illustrations by Gavarni et al. Paris: Furne et cie, 1853.

Balzac, Honoré de, Eugene Sue, et al. *Le Diable à Paris. Paris et les parisiens.* Illustrations by Gavarni et al. Paris: J. Hetzel, 1846.

Baudelaire, Charles. *The Painter of Modern Life and Other Essays.* Trans. by Jonathan Mayne. London: Phaidon Press, 1964.

Bédollière, E. de la. *Histoire de la mode en France.* Paris: Lévy, 1858.

Bertall [Charles Albert d'Arnoux]. *La Comédie de notre temps.* 2 vols. Paris: E. Plon et cie., 1874.

Bertin, Celia. *Haute Couture—Terre Inconnue.* Paris: Hachette, 1956. Translated as *Paris à la Mode: A Voyage of Discovery.* London: Victor Gollancz, 1956.

Bibescu, Princess. *Noblesse de la robe.* Paris: Grasset, 1929.

Bizet, René. *La Mode. L'Art français depuis vingt ans.* Paris: F. Rieder et cie., 1925.

Challamel, J. Augustin. *Histoire de la mode en France.* Paris: A. Hennuyer, 1881. Translated

as *The History of Fashion in France*. London: S. Low, Marston, Searle, and Rivington, 1882.

Chapus, Eugène. *Manuel de l'homme et la femme comme il faut*. Paris: Michael Lèvy Frères, 1862.

Chase, Edna Woolman, and Ilka Chase. *Always in Vogue*. Garden City, N.Y.: Doubleday and Co., 1954.

Delord, Taxile. *Physiologie de la parisienne*. Paris: Aubert et cie., 1841.

Delvau, Alfred. *Les Plaisirs de Paris. Guide pratique des étrangers*. Paris: Faure, 1867.

Damey, Marcelle. *Le Mode en 1912 chez Marcelle Demay, Modiste*. Illustrations by Charles Martin. Paris, 1912.

Demarest, Michael. "Look Out Paris—It's Chic to Chic in Milan," *Time* (6 April 1981).

Despaigne, H. *Le Code de la mode*. Paris: Chez l'auteur, 1866.

Devéria, Achille. *Dix-huit heurs de la journée d'une Parisienne*. Paris: Osterwald, n.d. [1830].

———. *Costumes historiques de ville ou de théâtre et travestissements*. Paris: Goupil et Vibert, n.d. [1831].

———. *Le Goût nouveau*. Paris: Tessare et Aumont, n.d. [1831].

Dior, Christian. *Je suis couturier*. Paris: Conquistador, 1951. Translated as *Talking About Fashion* New York: G. P. Putnam's Sons, 1954.

———. *Christian Dior et moi*. Paris: Amiot-Dumont, 1956. Translated as *Christian Dior and I*. New York: E. P. Dutton, 1957.

Donovan, Richard. "That Friend of Your Wife's Named Dior," *Colliers* (10 June 1955).

Dufay, Pierre. *Le Pantalon féminin*. Paris: Charles Carrington, 1906.

Dumas, Alexandre, Théophile Gautier, et al. *Paris et les parisiens au XIX^e siècle*. Illustrations by Gavarni, Lami, et al. Paris: Morizot, 1856.

Flobert, Laure-Paul. *La Femme et le costume masculin*. Lille: Imprimerie Lefebvre-Ducrocq, 1911.

Forrester, Thomas (ed.). *Paris and its Environs*. London: Henry G. Bohn, 1859.

Garretson, Mrs. Regina. *Scrapbook*. In the Special Collections of the Fashion Institute of Technology Library.

Grand Dictionnaire universelle du 19^e siècle. Paris: Larousse, 1865–1890.

Grande Encyclopédie. Paris: H. Lamirault et cie., 1886–1902.

Harrods. *Fashionable Rendez-Vous*. London: Harrods, 1909.

Hawes, Elizabeth. *Fashion Is Spinach*. New York: Random House, 1938.

Hegermann-Lindencrone, Lillie de. *In the Courts of Memory: Musical and Social Life during the Second Empire in Paris*. 1912. Reprinted, New York: Da Capo Press, 1980.

Huart, A. and A. Grevin. *Les Parisiennes*. Paris: Librairie Illustrée, n.d. [ca. 1880].

Huart, Louis. *Physiologie de la grisette*. Illustrations by Gavarni. Paris: Aubert et cie., n.d.

Iribe, Paul. *Les Robes de Paul Poiret*. Paris: Société Générale d'Impression, for Paul Poiret, 1908.

Ivimy, Alice M. *A Woman's Guide to Paris*. London: James Nisbet, 1909.

Janin, Jules. *The American in Paris During the Summer*. Illustrations by Eugene Lami. London: Longman, Brown, Green, and Longman, 1844.

La Balme, Corinne. "Is Paris Still the Capital of Style?" *Accent, The Magazine of Paris Style* (Winter 1987), pp. 16–17.

Leloir, Maurice. *Histoire du costume de l'antiquité à 1914*. 10 vols. Published under the patronage of the Société de l'Histoire du Costume. Vol. 10, Paris: Erst, 1935.

———. *Dictionnaire du costume*. Paris: Gründ, 1951.

Lepape, Georges. *Les Choses de Paul Poiret vues par Georges Lepape*. Paris: Maquet, for Paul Poiret, 1911.

Linton, George E. *Scrapbook*. In the Special Collections of the Fashion Institute of Technology Library.

McCabe, James D. *Paris by Sunlight and Gaslight*. Philadelphia: National Publishing Co., 1870.

Mallarmé, Stephane. *La Dernière Mode: Gazette du Monde et de la Famille*. 1874. Reprinted, Paris: Editions Ramsay, 1978.

Marguerites, Julie de. *The Ins and Outs of Paris, or Paris by Day and Night*. Philadelphia: William White Smith, 1855.

Mercier, Louis Sebastien. *Le Tableau de Paris* (Amsterdam, 1782–1788), and *Le Nouveau Paris* (Paris, 1798). Abridged and translated by Wilfred and Emilie Jackson, *The Picture of Paris Before and After the Revolution*. London: George Routledge & Sons, 1929. And by Helen Simpson, *The Waiting City, Paris, 1782–1788*. London: George G. Harrap, 1933.

Paquin, *Designs* and *Publicité*. Scrapbooks in the collection of The Costume and Fashion Research Centre, Bath.

Paris. Guide économique dans le Paris nouveau et à l'exposition universelle de 1867. Paris: Gallerie du Petit Journal, 1867.

Paris. Exposition universelle internationale de 1900. *Les Toilettes de la collectivité de la couture*. Paris: Société de Publications d'Art, 1900.

————. *Musée rétrospectif des classes 85 et 86. Le Costume et ses accessoires à l'exposition universelle internationale de 1900*. With an essay by Maurice Leloir. Paris, 1900.

Poiret, Paul. *En habillant l'époque*. Paris: Grasset, 1930. Trans. by Stephen Hadden Guest. *King of Fashion: The Autobiography of Paul Poiret*. Philadelphia: J. B. Lippincott, 1931.

Proust, Marcel. *À la recherche du temps perdu*. Trans by C. K. Scott Moncrieff and Frederick Blossom. *Remembrance of Things Past*. New York: Random House, 1927–1932.

Roger-Miles, L. *Les Créateurs de la mode*. Édition du Figaro. Paris: Charles Eggiman, 1910.

Rouff, Maggy. *La Philosophie de l'élégance*. Paris: Éditions Littéraires de France, 1942.

Rykiel, Sonia. *Et je la voudrais nue. . . .* Paris: Grasset, 1979.

Schiaparelli, Elsa. *Shocking Life*. London: J. M. Dent & Sons, 1954.

Seilhac, Léon de. *L'Industrie de la couture et de la confection à Paris*. Paris: Firmin-Didot, 1897.

Texier, Edmund. *Tableau de Paris*. Paris: Bureau d'Illustration, 1851.

Le Théâtre de la Mode. Catalogue published by American Relief for France under the auspices of L'Association Française d'Action Artistique. New York, 1945.

Toudouze, George Gustave. *Le Costume français*. Paris: Larousse, 1945.

Toudouze, George Gustave, and Charles Autran. *Un Siècle de vie français 1840–1940*. Éditions S.N.E.P., 1949.

Uzanne, Louis Octave. *L'Éventail*. Paris: Quantin, 1882. Trans. as *The Fan*. London: J. C. Nimmo, 1884.

————. *L'Ombrelle, le gant, le manchon*. Paris: Quantin, 1883. Trans. as *The Sunshade, Muff, and Glove*. London: J. C. Nimmo, 1883.

————. *Les Ornements de la femme: l'éventail, l'ombrelle, le gant, le manchon*. Paris: Quantin, 1892.

————. *La Française du siècle: modes, moeurs, et usages*. Paris: Quantin, 1886; also published under the title *Son Altesse la femme* and translated as *The Frenchwoman of the Century*. London: J. C. Nimmo, 1886. Yet another version appeared as *La Française du siècle. La femme et la mode. Métamorphoses de la parisienne de 1792 à 1892*. Paris: Quantin, 1892.

————. *La Femme à Paris. Nos contemporaines. Notes successives sur les parisiennes de ce temps dans leurs divers milieux, états, et conditions*. Paris: Quantin/Libraries-Imprimeries Réunies, 1894. Trans. as *The Modern Parisienne*. London: William Heinemann, 1912.

————. *Les Modes de Paris: variations du goût et de l'esthétique de la femme, 1797–1897*. Paris: Société Française d'Editions d'Art, 1898. Trans. as *Fashion in Paris (in the Nineteenth Century). The various phases in feminine taste and aesthetics from the Revolution to the end of the nineteenth century, 1797–1897*. London: William Heinemann, 1898, 1901, 1908.

305

Selected Bibliography

————. *L'Art et les artifices de la beauté*. Paris: Felix Juven et Bibliothèque Femina, 1902.

Vingt-cinq ans d'élégance à Paris (1925–1950). Album composed at the request of Marcel Rochas. Paris: Tisne, 1951.

"Why Paris Is the Capital of Fashion," *The Delineator* (September 1907).

Wilson, Robert Forrest. *Paris on Parade*. Indianapolis: The Bobbs-Merrill Company, 1924, 1925.

Worth, Gaston. *La Couture et la confection de vêtements de femme*. Paris: Chaix, 1895.

Worth, Jean Philippe. *A Century of Fashion*. Trans. by Ruth Miller. Boston: Little, Brown & Co., 1928.

Zola, Émile. *Au bonheur des dames*. Originally published in 1883. Paris: Le Livre de Poche, 1980.

Periodicals

Accent. The Magazine of Paris Style.

L'Art et la Mode. Journal de la Vie Mondaine.

Art, Goût, Beauté.

Comoedia Illustré.

La Corbeille. Journal des Modes.

The Dandy.

Fashion-Théorie.

Fémina.

Le Figaro-Modes.

La Galerie des modes et costumes français, dessinés d'après nature [1778–1787].

La Gazette du Bon Ton.

Le Génie de la Mode. Journal d'Élégance Parisienne.

Les Idées Nouvelles de la Mode.

L'Illustration.

Le Journal des Dames et des Modes [1797–1839].

Le Journal des Dames et des Modes [1912–1914].

Le Journal des Demoiselles.

Le Journal des Modes d'Hommes.

La Mode.

La Mode Illustrée

La Mode en Peinture

La Mode Pratique

Les Modes.

Moniteur de la Mode.

La Pandore. Journal des Spectacles.

Petit Courrier des Dames.

La Sylphide.

Très Parisien.

La Vie Élégante.

La Vie Parisienne.

Vogue.

Secondary Sources

Agron, Suzanne. *Le Costume masculin*. Paris: Librairie Jacques Lanore, 1969.

l'Anglade, Emile. *Rose Bertin, the Creator of Fashion at the Court of Marie Antoinette*. Trans. by Angelo S. Rappoport. London: John Long, 1913.

Selected Bibliography

Battersby, Martin. *Art Deco Fashion: French Designers, 1908–1925*. New York: St. Martin's Press, 1974.

Beaulieu, Michelle, and Jeanne Bayle. *Le Costume en Bourgogne de Phillippe le hardi à la mort de Charles le témeraire (1364–1477)*. Paris: Presses Universitaires de France, 1956.

Blum, André. *Histoire du costume. Les Modes au XVIIᵉ et au XVIIIᵉ siècle*. Foreword by Maurice Leloir. Paris: Hachette, 1928.

Blum, André, and Charles Chasse. *Histoire du costume. Les modes au XIXᵉ siècle*. Paris: Hachette, 1931.

Boucher, François. *Histoire du costume en occident de l'antiquité à nos jours*. Paris: Flammarion, 1965.

Bricker, Charles. "Looking Back at the New Look," *Connoisseur* (April 1987).

Butazzi, Grazietta. *La Mode: art, histoire, et société*. Paris: Hachette, 1983.

Carlano, Marianne, and Larry Salmon, eds., *French Textiles from the Middle Ages through the Second Empire*. Hartford: Wadsworth Atheneum, 1985.

Charles-Roux, Edmonde. *Chanel: Her Life, Her World—and the woman behind the legend she herself created*. New York: Alfred A. Knopf, 1975.

Cobb, Richard. *Death in Paris*. New York: Oxford University Press, 1978.

Colas, René. *Bibliographie générale du costume et de la mode*. Paris: René Colas, 1933.

Delbourg-Delphis, Maryléne. *Le Chic et le Look: Histoire de la mode féminine et des moeurs de 1850 à nos jours*. Paris: Hachette, 1981.

———. *La Mode pour la vie*. Paris: Éditions Autrement, 1983.

Delpierre, Madeleine. "Ingres et la mode de son temps," *Bulletin du Musée Ingres* 37 (July 1975): 21–26.

———. "L'Élégance à Versailles au temps de Louis XV," *Versailles* 55 (2nd trimester, 1974): 6–14.

———. "Marie Antoinette, reine de la mode," *Versailles* 59 (3rd trimester, 1975): 37–46.

Dupuis, André. *Un famille d'artistes. Les Toudouze-Colin-Leloir, 1690–1957*. Paris: Gründ, 1957.

Etherington-Smith, Meredith. *Patou*. London: Hutchinson, 1983.

Festa-McCormick, Diana. *Proustian Optics of Clothes: Mirrors, Masks, Mores*. Stanford French and Italian Studies 29. Saratoga: Anma Libri, 1984.

Garrett, Helen T. "Clothes and Character: The Function of Dress in Balzac." Philadelphia: Ph.D. dissertation, University of Pennsylvania, 1941.

Gaudriault, Raymond. *La Gravure de mode féminine en France*. Paris: Les Éditions d'Amateur, 1983.

Giafferri, Paul-Louis de. *The History of French Masculine Costume*. New York: Foreign Publications, 1927.

Haedrich, Marcel. *Coco Chanel: Her Life, Her Secrets*. Boston: Little, Brown & Co., 1972.

Hall-Duncan, Nancy. *The History of Fashion Photography*. New York: Alpine Book Company, 1979.

Harris, Jennifer. "The Red Cap of Liberty: A Study of Dress Worn by French Revolutionary Partisans, 1789–1794," *Eighteenth-Century Studies* 14 (1981): 283–312.

Holland, Vyvyan Beresford. *Hand Coloured Fashion Plates, 1770 to 1899*. London: B. T. Batsford, 1955.

Hollander, Anne. "The Great Emancipator, Chanel," *Connoisseur* (February 1983).

———. "Dressĕd to Thrill: The cool and casual style of the new American androgeny," *The New Republic* (January 1985), pp. 28–33.

Hunt, Lynne. *Politics, Culture and Class in the French Revolution*. Berkeley and Los Angeles: University of California Press, 1984.

Isaacson, Joel. "Impressionism and Journalistic Illustration," *Arts Magazine* 56 (June 1982): 95–115.

Selected Bibliography

Jarry, Paul. *Les Magazines de nouveautés: Histoire rétrospective et anecdotique*. Paris: André Barry et fils, 1948.

Johnson, Christopher S. "Patterns of Proletarianization: Parisian Tailors and Lodève Woolens Workers," in John Merriman, ed., *Consciousness and Class Experience in Nineteenth-Century Europe*. New York: Holmes & Meier, 1979.

Langley Moore, Doris. *Fashion Through Fashion Plates, 1770–1970*. London: Ward, Lock, 1971; New York: Clarkson N. Potter, 1971.

Latour, Amy. *Kings of Fashion*. London: Weidenfeld and Nicolson, 1958.

Lepape, Claude, and Thierry Defert. *From the Ballets Russes to Vogue. The Art of Georges Lepape*. Trans. by Jane Brenton. New York: The Vendome Press, 1984.

Lynam, Rugh (ed.). *Couture: An Illustrated History of the Great Paris Designers and Their Creations*. Garden City, N.Y.: Doubleday and Co., 1972.

Madsen, Axel. *Living for Design: The Yves Saint Laurent Story*. New York: Delacourt, 1979.

Magraw, Roger. *France 1815–1914: The Bourgeois Century*. Oxford: Fontana History of Modern France, 1983.

Marly, Diana de. *The History of Haute Couture, 1850–1950*. New York: Holmes & Meier, 1980.

———. *Worth: Father of Haute Couture*. London: Elm Tree Books, 1980.

Mansel, Philip. "Monarchy, Uniform and the Rise of the *Frac*, 1760–1830," *Past and Present* 96 (August 1982): 103–132.

Martin-Fugier, Anne. *La Bourgeoise: Femme au temps de Paul Bourget*. Paris: Bernard Grasset, 1983.

Maury, A. "Quant les aquarellistes creaient la haute couture," *Plaisir de France* 422 (September 1974): 30–35.

Mayeur, Jean-Marie. *Les Débuts de la Troisième République 1871–1898*. Nouvelle histoire de la France contemporaine, 10. Paris: Éditions du Seuil, 1973.

McMillan, James F. *Housewife or Harlot: The Place of Women in French Society, 1870–1940*. Brighton, Sussex: The Harvester Press, 1981.

Merriman, John (ed.). *French Cities in the Nineteenth Century*. New York: Holmes & Meier, 1981.

Milbank, Caroline Reynolds. *Couture: The Great Designers*. New York: Stewart, Tabori, & Chang, 1985.

Miller, Michael B. *The Bon Marché: Bourgeois Culture and the Department Store, 1869–1921*. Princeton: Princeton University Press, 1981.

Moers, Ellen. *The Dandy: Brummell to Beerbohm*. London: Secker & Warburg, 1960.

Perrot, Philippe. *Les Dessus et les dessous de la bourgeoisie: Une histoire du vêtement au XIX^e siècle*. Paris: Librairie Arthème Fayard, 1981.

———. *Le Travail des apparences, ou les transformations du corps féminin XVIII^e–XIX^e siècle*. Paris: Éditions du Seuil, 1984.

Picken, Mary Brooks, and Dora Loues Miller. *Dressmakers of France*. New York: Harper and Brothers, 1956.

Pinkney, David H. *Napoleon III and the Rebuilding of Paris*. Princeton: Princeton University Press, 1958.

Piponnier, Francois. *Costume et vie sociale: la cour d'anjou XIV^e–XV^e siècle*. Paris: Mouton et cie., 1970.

Prevost, John C. *Le Dandyisme en France (1817–1839)*. Paris: Librairie Minard, 1957.

Ribiero, Aileen. *Dress in Eighteenth-Century Europe, 1715–1789*. London: B. T. Batsford, 1984.

Robinson, Julien. *The Golden Age of Style: Art Deco Fashion Illustration*. New York: Harcourt Brace Jovanovich, 1976.

Roselle, Bruno du. *La Crise de la mode: La Révolution des jeunes et la mode.* Paris: Librairie Arthème Fayard, 1973.

————. *La Mode.* Paris: Imprimerie Nationale, 1980.

Roskill, Mark. "Early Impressionism and the Fashion Print," *Burlington Magazine* (June 1970).

Saisselin, Remy G. *The Bourgeois and the Bibelot.* New Brunswick, N.J.: Rutgers University Press, 1984.

Schreier, Barbara. *Mystique and Identity: Women's Fashions in the 1950s.* Norfolk, Va.: The Chrysler Museum, 1984.

Sheridan, George J., Jr. "Household and Craft in an Industrializing Economy: The Case of the Silk Weavers of Lyons," in John Merriman, ed., *Consciousness and Class Experience in Nineteenth-Century Europe.* New York: Holmes & Meier, 1979.

Seigel, Jerrold. *Bohemian Paris: Culture, Politics, and the Boundaries of Bourgeois Life, 1830–1930.* New York: Viking, 1986.

Steele, Valerie. *Fashion and Eroticism: Ideals of Feminine Beauty from the Victorian Era to the Jazz Age.* New York: Oxford University Press, 1985.

Vanier, Henriette. *La Mode et ses métiers: Frivolités et luttes des classes.* Paris: Armand Colin, 1960.

Varagnac, Andre. *French Costumes.* London, Paris, and New York: Hyperion Press, 1939.

Vaudoyer, Jean-Louis. *Les Artistes du livre: Georges Barbier.* Paris: Henri Babou, 1929.

Vincent-Ricard, François. *Raison et passion. Langage et société, la mode 1940–1990.* Paris: Textile/Art/Langage, 1983.

Weber, Eugen. *France, Fin de Siècle.* Cambridge: Harvard University Press, 1986.

White, Palmer. *Poiret.* New York: Clarkson N. Potter, 1973.

————. *Elsa Schiaparelli: Empress of Paris Fashion.* New York: Rizzoli, 1986.

Williams, Rosalind H. *Dream Worlds: Mass Consumption in Late Nineteenth-Century France.* Berkeley and Los Angeles: University of California Press, 1982.

Exhibition Catalogues

Musée du costume de la ville de Paris. *Modes de la Belle Epoque. Costumes français 1890–1910 et portraits.* 1961.

————. *Grands couturiers parisiens 1910–1939.* 1965.

————. *Élégantes parisiennes au temps du Marcel Proust 1890–1916.* 1968.

Musée de la Mode et du Costume. *Paris, 1945–1975. Élégance et creation.* 1977.

————. *L'Atelier Nadar et la mode, 1865–1913.* 1978.

————. *La Mode et ses métiers, du XVIIIᵉ siècle à nos jours.* 1981.

————. *Uniformes civils français, cérémonial, circonstances, 1750–1980.* 1982–1983.

————. *Hommage à Elsa Schiaparelli.* 1984.

————. *De la Mode et des lettres du XIIIᵉ siècle à nos jours.* 1984–1985.

Index